Picasso and the Allure of Language

Picasso and the A

Susan Greenberg Fisher

llure of Language

WITH

Mary Ann Caws
Jennifer R. Gross
Patricia Leighten
Irene Small

AND

S. Zelda Roland
Katherine M. Wyman

Yale University Art Gallery, New Haven
IN ASSOCIATION WITH
Yale University Press, New Haven and London
AND WITH THE SUPPORT OF
Nasher Museum of Art at Duke University

In memory of Walter Bareiss (1919–2007, B.S. 1940s)

Walter Bareiss (far left) with, from left to right, Pablo Picasso, Ernst Beyeler, and William Rubin. Mougins, France, 1971

Susan Greenberg Fisher

llure of Language

WITH

Mary Ann Caws
Jennifer R. Gross
Patricia Leighten
Irene Small

AND

S. Zelda Roland
Katherine M. Wyman

Yale University Art Gallery, New Haven

IN ASSOCIATION WITH

Yale University Press, New Haven and London

AND WITH THE SUPPORT OF

Nasher Museum of Art at Duke University

In memory of Walter Bareiss (1919–2007, B.S. 1940s)

Walter Bareiss (far left) with, from left to right, Pablo Picasso, Ernst Beyeler, and William Rubin. Mougins, France, 1971

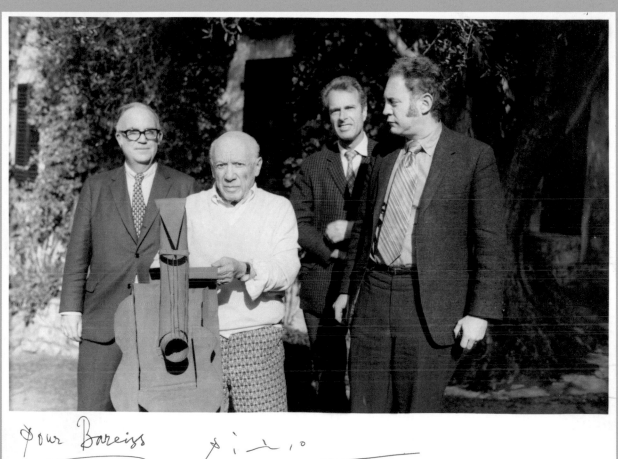

Pour Bareiss

picasso
le 15.2.71.

NATIONAL ENDOWMENT FOR THE ARTS

Exhibition and publication made possible by an endowment created with a challenge grant from the National Endowment for the Arts, with additional endowment support provided by the Horace W. Goldsmith Foundation; Ketcham Family Memorial Fund; George and Schatzie Lee Fund; Carol and Sol LeWitt Fund; Leah G. and Allan C. Rabinowitz, Yale College Class of 1954 Fund; and Edward Byron Smith, Jr., Family Fund; and with support provided by the Nasher Museum of Art at Duke University

First published in 2009 by the
Yale University Art Gallery
P.O. Box 208271, New Haven, CT 06520-8271
www.artgallery.yale.edu

in association with

Yale University Press
P.O. Box 209040, New Haven, CT 06520-9040
www.yalebooks.com

Published in conjunction with the exhibition

Picasso and the Allure of Language

organized by the Yale University Art Gallery.

Yale University Art Gallery, New Haven, Conn.

January 27–May 24, 2009

Nasher Museum of Art, Duke University, Durham, N.C.

August 20, 2009–January 3, 2010

Editor: Tiffany Sprague
Designed and typeset in Bodoni and Proteus Project types by Katy Homans
Printed in Singapore by CS Graphics

Library of Congress Cataloging-in-Publication Data
Greenberg Fisher, Susan.
Picasso and the allure of language / Susan Greenberg Fisher ; with
Mary Ann Caws . . . [et al.].
p. cm.
Catalog of an exhibition at the Yale University Art Gallery, New Haven, Conn.,
Jan. 27–May 24, 2009 and the Nasher Museum of Art, Duke University, Durham, N.C.,
Aug. 20, 2009–Jan. 3, 2010.
Includes bibliographical references and index.
ISBN 978-0-300-13546-6 (pbk. : alk. paper)
1. Picasso, Pablo, 1881–1973—Exhibitions. 2. Picasso, Pablo, 1881–1973—Friends and associates—Exhibitions. 3. Art and literature—Exhibitions.
4. Art—Connecticut—New Haven—Exhibitions. 5. Yale University—Art collections—Exhibitions. I. Caws, Mary Ann. II. Yale University. Art Gallery.
III. Nasher Museum of Art at Duke University. IV. Title.
N6853.P5A4 2009
709.2—dc22 2008009849

A catalogue record for this book is available from the British Library.

The paper in this book meets the requirements of ANSI/NISO Z39.48-1992
(Permanence of Paper).

10 9 8 7 6 5 4 3 2 1

Cover illustration: Picasso, page 87 from Pierre Reverdy's *Le chant des morts* (The Song of the Dead), 1948 (cat. no. 20)
Pages ii–iii: Picasso, letter to Leo and Gertrude Stein (verso), 1906 (Fisher, "Picasso and the Allure of Language," fig. 2)
Page v: Yale University Art Gallery, Gift of Molly and Walter Bareiss, B.S. 1940S, 1999.9.31
Page xviii: Picasso, *Dog and Cock*, 1921 (detail of cat. no. 11)
Page 14: Picasso, *Dice, Packet of Cigarettes, and Visiting-Card*, early 1914 (detail of cat. no. 7)
Page 96: Picasso, *Portrait of André Breton*, frontispiece from Breton's *Clair de terre* (Earthlight), 1923 (Caws, "The Surrealist Impulse," detail of fig. 2)
Page 140: Picasso, *Unknown Letters*, 1949 (detail of cat. no. 22)
Page 202: Picasso, *Portrait of the Author*, frontispiece for Picasso's *Le désir attrapé par la queue* (Desire Caught by the Tail), 1941 (cat. no. 28, fig. 2)

Contents

Director's Foreword

One hundred years after the invention of Cubism, Pablo Picasso's remarkable innovation remains a model for how to think and work imaginatively. Picasso remade not only painting but also sculpture, printmaking, and ceramics. Rather than accepting inherited ideas or approaches, he treated everything that passed through his hands as an immediate experiment and an exciting challenge.

Picasso called his studio a "laboratory," and today we can still learn from the intense discussions, friendships, and collaborations that went on both inside and outside that studio. Those exchanges—among artists, writers, and thinkers of many disciplines, during the Cubist years and after—changed Picasso and, ultimately, the course of modern art. These exchanges are the subject of the present exhibition, *Picasso and the Allure of Language.* What better place to feature an installation on this topic than a university museum that strives, like Picasso, to foster the same collaboration and the same desire to think, in always deeper and more original ways?

The intersections explored in this exhibition result from similar connections made between curators and their collections across Yale's campus and beyond. We are pleased that the exhibition includes not only Picasso works from the Gallery, but also related materials from the Beinecke Rare Book and Manuscript Library, the Sterling Memorial Library, and the Yale Collection of Historical Sound Recordings at the University. We are particularly excited to present the reunification, for the first time, of materials from the Gertrude Stein Archive at the Beinecke Library with paintings and collages by Picasso first owned by Stein and now in the Gallery's collection. I must thank, in particular, Patricia Willis, the former Elizabeth Wakeman Dwight Curator of American Literature at the Beinecke, for generously lending these fragile letters, photographs, and objects from the Stein archive to the exhibition. This collaboration between Yale collections demonstrates the benefit of forging connections between the museums and libraries here on campus, and I am pleased for the Gallery to take part in the current University-wide Collections Collaborative Initiative. The result, as this exhibition demonstrates, is a livelier, fuller understanding of the innovations and communities of our shared cultural past.

Picasso and the Allure of Language is also the result of collaborative research between scholars at Yale and at Duke University, in Durham, North Carolina. The Gallery has long fostered partnerships between curators and professors, and this project demonstrates the fruit of such collaboration. I am especially pleased by the fine work of Susan Greenberg Fisher, the Horace W. Goldsmith Associate Curator of Modern and Contemporary Art and organizer of the exhibition. Her vision for the installation and catalogue has benefited from the extensive knowledge and sound advice of Patricia Leighten, Professor of Art and Art History at Duke. Also contributing to the success of the project were the fresh and insightful ideas of Yale graduate and undergraduate students, and along with Dr. Fisher, I thank Irene Small,

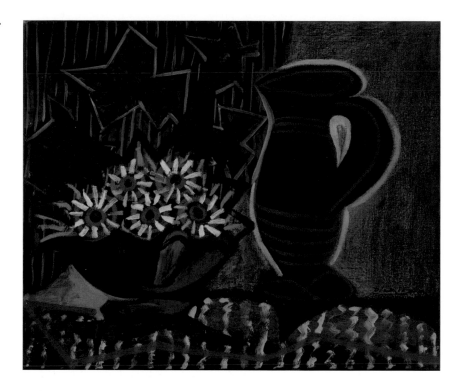

PH.D. 2008, S. Zelda Roland, B.A. 2008, and Katherine M. Wyman, B.A. 2007, for their important contributions that helped shape this project. Their deep involvement with the content of this exhibition is at the heart of the Gallery's educational mission. The hardworking staff here at the Gallery, particularly Jennifer Gross, the Seymour H. Knox, Jr., Curator of Modern and Contemporary Art, and Tiffany Sprague, Associate Director of Publications and Editorial Services, has contributed greatly to the elegant presentation and intellectual rigor of both the exhibition and publication.

This exhibition could not have taken place without our generous donors, whose overwhelming commitment to education continues at an astounding level. The Picasso objects at the Yale University Art Gallery now number over one hundred works—a wide array of materials available for study by our students and faculty that includes paintings, prints, sculptures, ceramics, drawings, illustrated books, and even a tapestry. Our holdings are the result of gifts by major modern art collectors who have widely impacted the shape of Yale's collection as a whole: Stephen Carlton Clark, B.A. 1903, whose major gift of three important paintings by Picasso are the foundation for the collection; Katherine Dreier, Marcel Duchamp, and the Collection Société Anonyme; Katharine Ordway; and Edith K. Wetmore. The 1982 gift of John Hay Whitney, B.A. 1926, M.A. HON. 1956, of Picasso works first owned by Gertrude and Leo Stein has a special significance to Yale, which, as I've said, also houses the Stein archive. Gifts from Mrs. Gilbert W. Chapman, Philip L. Goodwin, B.A. 1907, Jacob and Ruth Kainen, MUS.B. 1950, Ralph Kirkpatrick, Arthur Edwin Neergaard, Dorothy and Marvin Small, and Ernest C. Steefel

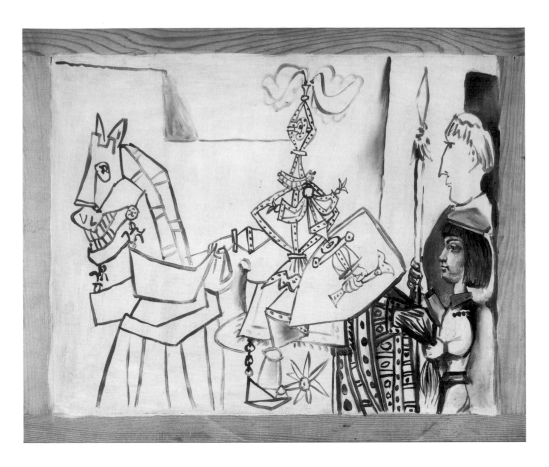

Picasso, *Horseman, Page, and Monk*
Vallauris, February 24, 1951
Gesso and oil on wood panel
17 x 21¾ in. (43.2 x 55.2 cm)
Yale University Art Gallery, Charles B.
Benenson, B.A. 1933, Collection,
2006.52.21

have further built upon these works. We are thrilled that our Picasso holdings were quite recently augmented through the generous gift by the late Charles B. Benenson, B.A. 1933, of three paintings, and I thank his sons Bruce, Frederick, and Lawrence Benenson for their continued support of the Gallery's projects. My warmest thanks also go to Governing Board member Thomas Jaffe, B.A. 1971, for his recent promised gift of *Head of a Jester* (cat. no. 3, fig. 7), the first sculpture by Picasso to enter the Gallery's collection, to Susan and John Jackson, B.A. 1967, for their magnificent promised gift of *Head of Fernande* (cat. no. 3, fig. 1), and to Dr. and Mrs. Lawrence, B.S. 1955, M.D. 1958, and Regina Dubin, for their continued generosity to our Department of Prints, Drawings, and Photographs. Special mention must also be made of Molly and Walter Bareiss, B.S. 1940s, who gifted to the Gallery two dozen works by Picasso from 1969 to 1999, including Bareiss's very first acquisition, Picasso's *Salomé* (cat. no. 2), purchased with money given to him by his father on his thirteenth birthday. We dedicate this book to Walter, who was a member of our Governing Board from 1957 to 2003, and its chairman from 1987 to 1995.

This exhibition was made possible by an endowment created with a challenge grant from the National Endowment for the Arts. We are also very grateful for support for this exhibition from the Horace W. Goldsmith Foundation, the Ketcham Family Memorial Fund, the George and Schatzie

Lee Fund, the Carol and Sol LeWitt Fund, the Leah G. and Allan C. Rabinowitz, Yale College Class of 1954, Fund, and the Edward Byron Smith, Jr., Family Fund.

In closing I would like to thank Kimerly Rorschach, the Mary D. B. T. and James H. Semans Director at the Nasher Museum of Art at Duke University, for her partnership in this exciting project. The Nasher's major support of the catalogue has helped make possible this stunning publication. I strongly share Susan Greenberg Fisher's gratitude to Duke's staff and faculty. I also warmly thank Jed Morse, Acting Chief Curator at the Nasher Sculpture Center, in Dallas, Texas, and Andrea, Joan, and Nancy Nasher for generously lending the extraordinary sculptures by Picasso from their collection to this exhibition in honor of Raymond Nasher, whose benefaction also helped to found the Nasher Museum at Duke University. We all hope Picasso's example as a model thinker and maker continues to inspire our new century.

Jock Reynolds

The Henry J. Heinz II Director
Yale University Art Gallery

Acknowledgments

Picasso and the Allure of Language took shape through the many discussions I have had with Mary Ann Caws, Jennifer Gross, Patricia Leighten, Irene Small, and S. Zelda Roland, and I am profoundly indebted to them. The idea for this exhibition first came about during a 2006 undergraduate modernism seminar, and I would also like to thank the group of superb Yale University students whose innovative ideas inspired it: Daniella Berman, B.A. 2007; Eunice Cho, B.F.A. 2007; Emily Cleveland, B.A. 2007; Daniel Mason, B.A. 2008; S. Zelda Roland, B.A. 2008; Betsy Scherzer, B.A. 2007; Kristen Windmuller, B.A. 2008; Christopher Winkler, B.A. 2007; and Michelle Wofsey, B.A. 2008.

At the Yale University Art Gallery, I would like especially to thank Tiffany Sprague, Associate Director of Publications and Editorial Services, for her sharp ideas and considerable support of this project. John ffrench, Richard House, Janet Sullivan, and Anthony DeCamillo in the Gallery's Digital Media Department have produced the exquisite images of Pablo Picasso's work. I would also like to thank L. Lynne Addison, Registrar; conservators Theresa Fairbanks-Harris, Mark Aronson, and Patricia Sherwin Garland; Anna Hammond, the former Deputy Director for Programs and Public Affairs, Ana Davis, Associate Director of Public Information, Amy Jean Porter, the former Associate Director of Communications, and Christopher Sleboda, Director of Graphic Design; Amy Canonico, Museum Assistant in the Department of Modern and Contemporary Art, and also our former assistants Valerie Richardson and Kristin Henry; Clarkson Crolius, Exhibitions Production Manager, and the installation staff; and Jill Westgard, Deputy Director for Museum Resources and Stewardship. I am further indebted to the input of my colleagues Susan B. Matheson, the Molly and Walter Bareiss Curator of Ancient Art, Frederick John Lamp, the Frances and Benjamin Benenson Foundation Curator of African Art, and John Stuart Gordon, the Benjamin Attmore Hewitt Assistant Curator of American Decorative Arts. I am extremely lucky to have such generous and good-humored colleagues in the Gallery's Department of Prints, Drawings, and Photographs, whose collaboration was crucial to this exhibition: Museum Assistant Suzanne Greenawalt, who so patiently responded to my many requests, Suzanne Boorsch, the Robert L. Solley Curator of Prints, Drawings, and Photographs, Elisabeth Hodermarsky, the Sutphin Family Associate Curator of Prints, Drawings, and Photographs, and Elizabeth DeRose, the former Florence B. Selden Assistant Curator. I am particularly grateful to Diana Brownell, Senior Museum Technician, who so beautifully prepared and framed the works in the exhibition. I am also thankful to Maria Taroutina, PH.D. candidate in the History of Art at Yale, for her assistance with the exhibition and installation, and to the undergraduate students who helped with this publication: Anna Altman, B.A. 2008; Nancy Nichols, '09; Pamela Ruggio, Hamilton College, B.A. 2004; Elisabeth Thomas, '10; and Katherine M. Wyman, B.A. 2007. Sallianne Ontko, while an M.A. candidate at

Brassaï, *Picasso beside a Stove in the Grands-Augustins Studio*
1939
Photograph
Yale University Art Gallery, Henry Sage
Goodwin, B.A. 1927, Fund, 1972.86

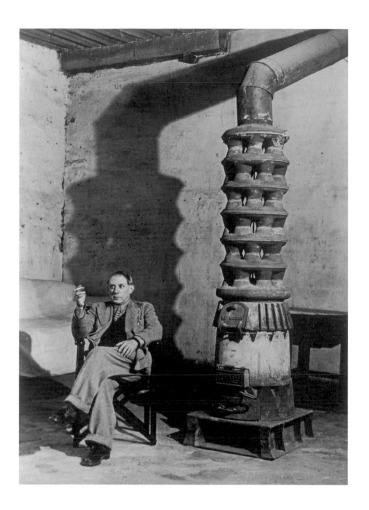

Hunter College, City University of New York, also kindly shared with me
her research on *First Steps*, and I thank her for her generosity.

At Yale, I am grateful to my colleagues at the Beinecke Rare Book
and Manuscript Library, whose support was crucial to the development of
the ideas in this exhibition. Patricia Willis, the former Elizabeth Wakeman
Dwight Curator of American Literature, generously allowed the inclusion of
the remarkable materials from the Gertrude Stein Archive in this exhibition,
and I am much indebted to her. Timothy Young, Curator of Modern Books
and Manuscripts, kindly allowed for the works from the Beinecke's general
collection to be included in the exhibition, and Nancy Kuhl, Associate
Curator of American Literature, shared with me information and a number
of key observations regarding the Stein materials. My research was also
greatly facilitated by the Public Services staff at the Beinecke, and in partic-
ular, I would like to thank Leigh Golden, Morgan Swan, Susan Klein, and
Natalia Sciarini. Richard Warren at the Yale Collection of Historical Sound
Recordings kindly assisted me with the Stein recordings of her poems about
Picasso. At Sterling Memorial Library, I am grateful to Alan Solomon, Head
of Research Services and Collections, for allowing me to include additional
materials from Yale's library collection in the exhibition. I am particularly

thankful to the excellent staff at the Art and Architecture Library, especially Christopher Zollo and Jennifer Aloi.

At Duke University, I must reiterate my sincere gratitude to Professor Patricia Leighten, whose seminal and inspiring work on Picasso has deeply impacted my understanding of his art. The shape of this project was decisively determined during her visits to Yale's campus and to the Gallery, and through our many conversations. Pat's critical and passionate discussions in this book on the works by Picasso in our museum's collection are a true gift to the University that will benefit future Yale students.

I am also very grateful to Kimerly Rorschach, the Mary D. B. T. and James H. Semans Director at the Nasher Museum of Art at Duke University, Durham, North Carolina, to which this exhibition travels, and Sarah Schroth, the Nancy Hanks Senior Curator, for their support of this exhibition and their warm hospitality during my trips to Duke. Jamie Dupre at Duke was most helpful in facilitating those visits. I also thank Professor Mark Antliff for his input at the early stages of this project and his encouraging support of its theme and content along the way. At the Nasher Sculpture Center, Dallas, I am very grateful to Jed Morse, Acting Chief Curator, and to Andrea, Joan, and Nancy Nasher, for generously lending the magnificent sculptures by Picasso to this exhibition. Steven Nash, the former Director of the Sculpture Center, was also kindly supportive of this exhibition at its earliest stages.

At Yale University Press, I would like to thank publisher Patricia Fidler, senior production editor Kate Zanzucchi, production manager Mary Mayer, and photo editor John Long. I am extremely grateful to Pepe Karmel, Associate Professor and Chair of Art History at New York University, for his incisive and thoughtful comments on the manuscript of this book. I am also thankful to Miranda Ottewell for her editing of the manuscript, and to designer Katy Homans for her sensitive response to the words and images of this publication. In addition, I thank proofreader Laurie Burton and indexer Cathy Dorsey.

The staff at other museums have also aided in this project, and I am particularly grateful to the archivists at the Museum of Modern Art, New York, especially MacKenzie Bennett, for assisting me with the Alfred H. Barr, Jr., Papers and other inquiries. Nora Lawrence in the Department of Paintings and Sculpture at MoMA patiently responded to my numerous questions. I am grateful to Anne Baldassari at the Musée Picasso, Paris, for her encouragement of this project, as well as the archival staff, and particularly Laurence Madeline during her tenure there. I would also like to thank Christine Pinault at the Picasso Administration in Paris for making available images for this publication. In New York, Humberto DeLuigi at Art Resource provided crucial assistance with locating images for the book.

Picasso and the Allure of Language would not have been possible without the generosity of many donors, all honored in the foreword to this

catalogue, who have given to Yale the fascinating works by Picasso to help further the teaching mission of the Gallery. This exhibition is as much a tribute to them as it is to Picasso. I must, however, single out the donation to our curatorial department of the full set of Christian Zervos's catalogue raisonné by the late Walter Bareiss, B.S. 1940s, to whom this book is dedicated. This resource was crucial to the research undertaken for this publication. Most important, I am extremely indebted to Jock Reynolds, the Henry J. Heinz II Director of the Yale University Art Gallery. His vision of expanding the parameters of this project beyond the Gallery to partner with the Nasher Museum of Art at Duke University deeply impacted its content and ambitions. Jock's decision taught me a great deal about the importance of collaboration. I must also reiterate my sincere gratitude to Jennifer Gross for her equally enthusiastic support of every aspect of this project from start to finish. My friendship with artist Mimi Gross has helped me to see and understand Picasso, along with so many other artists' works, and I cherish her warmth, ideas, and generosity. Finally, I am grateful to Daniel Fisher for so patiently enduring Picasso's dominance of our first year of marriage, and I thank him immensely for his support of my work.

Susan Greenberg Fisher

The Horace W. Goldsmith Associate Curator of Modern and Contemporary Art

Yale University Art Gallery

Throughout the catalogue, titles in French are those that Picasso gave to a work; all other titles are given in English.

Dimensions are given in inches followed by centimeters in parentheses. For paintings and prints, height precedes width. For three-dimensional objects, height precedes width precedes depth. For drawings, dimensions given are for the sheet; for etchings and engravings, dimensions are for the platemark; for lithographs and photographs, dimensions are for the image.

Provenance is given for catalogued paintings and drawings only.

The References section of each entry notes inclusion in Picasso catalogues raisonnés. Throughout the catalogue, the catalogues raisonnés are abbreviated as follows:

Baer

Baer, Brigitte. *Picasso peintre-graveur: Catalogue illustré de l'oeuvre gravé et des monotypes*. Extending the 2-volume work of Bernhard Geiser (see Geiser/ Baer, below). Vols. 3–7 and *Addendum*. Bern: Éditions Kornfeld, 1986–96.

Cramer

Goeppert, Sebastian, Herma Goeppert-Frank, and Patrick Cramer. *Pablo Picasso, the Illustrated Books: Catalogue Raisonné*. Geneva: Patrick Cramer, 1983.

D.B.

Daix, Pierre, and Georges Boudaille, with Joan Rosselet. *Picasso 1900–1906: Catalogue raisonné de l'oeuvre peint*. Neuchâtel, Switzerland: Ides et Calendes, 1966. Revised and translated as *Picasso: The Blue and Rose Periods; A Catalogue Raisonné of the Paintings, 1900–1906*. Greenwich, Conn.: New York Graphic Society, 1967.

D.R.

Daix, Pierre, and Joan Rosselet. *Le cubisme de Picasso: Catalogue raisonné de l'oeuvre peint, 1907–1916*. Neuchâtel, Switzerland: Ides et Calendes, 1979. Revised and translated as *Picasso, the Cubist Years, 1907–1916: A Catalogue Raisonné of the Paintings and Related Works*. Boston: New York Graphic Society, 1979.

Geiser/Baer

Geiser, Bernhard, revised by Brigitte Baer. *Picasso peintre-graveur*. 2 vols. Vol. 1, *Catalogue raisonné de l'oeuvre gravé et lithographié et des monotypes (1899–1931)*. Bern: Éditions Kornfeld, 1990. Vol. 2, *Catalogue raisonné de l'oeuvre gravé et des monotypes (1932–1934)*. Bern: Éditions Kornfeld, 1992.

Mourlot

Mourlot, Fernand. *Picasso lithographe.* 4 vols. Monte Carlo, Monaco: André Sauret, 1949–64. Translated as *Picasso Lithographs.* Boston: Boston Book and Art, 1970.

Zervos

Zervos, Christian. *Pablo Picasso.* 33 vols. Paris: Cahiers d'art, 1932–78.

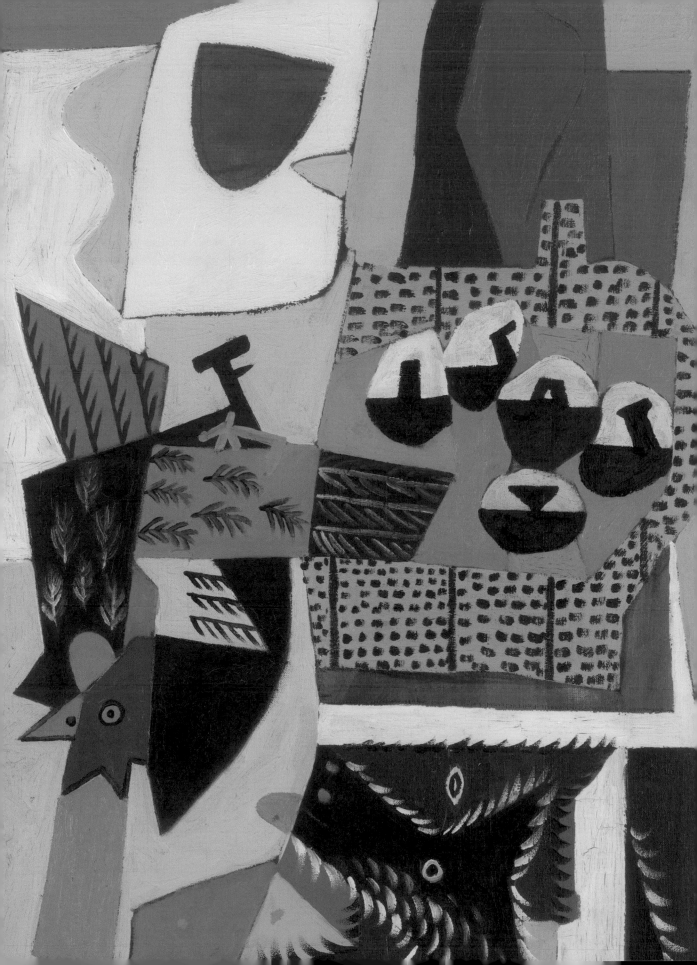

SUSAN GREENBERG
FISHER

Picasso and the Allure of Language

LETTERS AND WORDS are woven through the fabric of Pablo Picasso's art. They are stenciled onto his Cubist paintings and printed on cards pasted into collages. They function as signs of the "real world," and are sometimes call-outs to its atrocities. They joke and pun, or express deeply felt sentiments, especially love. Picasso's poems, begun in 1935, concentrate on words and seek to penetrate the depths of language. When Picasso's oeuvre is seen through the lens of language, letters and unformed words seem to appear in even the most familiar of paintings, to inflect them, or to give them new meaning—like *Dog and Cock* (cat. no. 11), in which strange letterlike orbs mingle with the textured dots and dashes of a newspaper on a table. Here, as in many works in this exhibition, language exerts a strong gravitational pull, an allure, away from the subjects of Picasso's art: the animals and things, and also the wives and mistresses, that are often the focus of studies on the artist.

When Picasso first visited Paris in 1900, his love affair with words began. In 1901 he befriended the poet Max Jacob, and the two shared an apartment on the boulevard Voltaire in 1902. From Jacob, Picasso learned about French poetry: how it was written and how it was spoken. Jacob would soon be joined by Guillaume Apollinaire, and over the next five decades, a long line of poets and writers followed. They were Picasso's closest friends, as many scholars, writers, and friends of the artist have noted. As Leo Steinberg memorably wrote in *Other Criteria*, "No artist was ever more closely surrounded by master wordsmen."[1]

These writers were also Picasso's teachers, since his expertise, as Gertrude Stein pronounced, was painting, not poetry. Picasso took from them what they had to offer, namely a deep knowledge of the mysteries of language. He kept in his personal archive all the letters, postcards, and essays that they sent to him, as if the disposal of these items would break the bonds of friendship, and his early, close relationships with Jacob, Apollinaire, and André Salmon, who all congregated in Picasso's Montmartre studio in the ramshackle building dubbed by Jacob the "Bateau-Lavoir" (Laundry Boat), have been of particular interest to scholars.[2] But how Picasso's ongoing and lifelong discovery of language may have impacted his approach to the making of art is a question that has not been proposed in an exhibition context. This project seeks to understand on a broad level the relation of writers, and especially of writing, to the subject of innovation in Picasso's art. The goal is not to pinpoint chains of "influence" (that is, whether a particular writing influenced a particular work) or to chart the biographical details of these friendships, which can be found in other publications.[3] Instead, the focus is on probing the intellectual exchanges and collaborations (both real and imaginary) prompted by specific works of art, and the challenges and ideas they presented to Picasso.

The works featured in this exhibition are from the collections of Yale University; materials have been included from both the Beinecke Rare Book

and Manuscript Library and the Yale University Art Gallery, with the aim of integrating visual and verbal resources.[4] Two important sculptures from the renowned Raymond and Patsy Nasher Collection in Dallas are also on view in the installation. Of particular note are selected materials from the Gertrude Stein and Alice B. Toklas Papers in the Yale Collection of American Literature at the Beinecke Library, bequeathed by Stein to Yale in 1946 (with subsequent gifts by Alice B. Toklas from about 1946 to 1967), as well as from the Gertrude Stein and Alice B. Toklas Collection, which complements the papers. Stein, whose broad-based fame as a modernist writer followed the publication of *The Autobiography of Alice B. Toklas* in 1933, settled in Paris in 1903 with her brother Leo, a painter. Stein probably met Picasso in spring 1905—a year after he moved to Paris for good in spring 1904— through the journalist, art collector, and dealer Henri-Pierre Roché.[5] Their relationship developed both in Picasso's Montmartre studio, where he painted his celebrated portrait of her in 1906 (fig. 1), and across the Seine in Leo and Gertrude Stein's apartment at 27, rue de Fleurus on the Left Bank. Here the Steins, with Gertrude's lifelong companion Alice B. Toklas (who met Stein right after her arrival in Paris in 1907), held weekly Saturday evening gatherings of artists and writers, including Henri Matisse, Georges Braque, and Juan Gris, as well as Jacob and Apollinaire. The broad array of international figures who attended these gatherings contrasted to the self-dubbed *bande à Picasso* (The Picasso Gang), that Jacob, Apollinaire, and Salmon formed around the artist. The Stein home also offered a striking visual expansion of the works in Picasso's studio; at the rue de Fleurus his paintings were integrated into an astounding private modern art gallery built by Leo and Gertrude Stein, with works by Paul Cézanne, Matisse, and Pierre-Auguste Renoir, among others.[6]

The Steins were Picasso's principal patrons in Paris until 1913, when Leo Stein moved to Settignano, Italy, and their art collection was split up (Gertrude kept the Picassos). The Stein Papers contain letters and postcards from Picasso to the Steins dating from this intense prewar period, when Picasso searched for a new visual language and moved from his Paris studio to small villages in Catalonia and the Pyrenees during the summers.[7] In one letter, written by Picasso to Leo and Gertrude Stein after a return from the village of Gósol in Catalonia (fig. 2), Picasso described a new painting, his *Peasants* (1906, Barnes Foundation, Merion, Pa.), which was purchased by the dealer Ambroise Vollard; in Paris the following spring, he sent a postcard to the Steins (fig. 3), inviting them to his studio to see a painting, perhaps what would become known as *Les demoiselles d'Avignon* (cat. no. 3, fig. 5), for which he began studies in winter 1906–7 (he would complete it in summer 1907).[8] In postcards sent during his subsequent, pivotal summer stays in Horta de Ebro (1909) and Cadaqués (1910) in Catalonia, and Céret in southeastern France (1911, 1912, 1913; figs. 4–5), Picasso doodled on postcards found in local souvenir shops as his mind drifted from the concentrated, diffi-

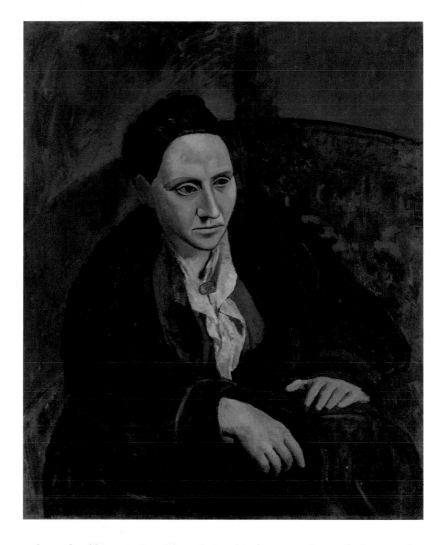

cult work of his painting. The relationship between Gertrude Stein and
Picasso is also evoked on a more intimate level in a small 1914 collage
that Picasso made from Stein and Toklas's actual calling card, left for him
at his studio while he was out (cat. no. 7). The collage, with its pair of dice
and names ("Miss Stein" and "Miss Toklas"), can be understood as a portrait
of the two women and a follow-up of sorts to Picasso's 1906 portrait of
Stein herself. In the famous painting, which Stein bequeathed in 1946 to the
Metropolitan Museum of Art in New York, the writer is a powerful modernist
icon, to be hung on a wall; in the collage (which does not appear on the
walls in any of the photographs of Stein's studio), Picasso considers the com-
plex intersection of Stein's public and private life, with both Toklas and him-
self, and the role of "contributions indirectes" between writer and painter,
alluded to in the printed words on the cigarette wrapper in the collage. These
relations between painter and writer embodied in the Stein Papers and
Collection — and summed up perfectly in the evocation of dialogue, friend-
ship, and conversation in two Louis XV–style chairs embroidered by Toklas
after designs by Picasso (fig. 6) — were a central impetus for this exhibition.[9]

FIGURE 2
**Picasso, letter to Leo and Gertrude
Stein (verso)**
Paris, August 17, 1906

FIGURE 3
**Picasso, postcard to Leo and
Gertrude Stein**
Paris, April 27, 1907

FIGURE 4
Picasso, postcard to Gertrude Stein
Céret, August 3, 1911

FIGURE 5
Picasso, postcard to Gertrude Stein
Céret, March 12, 1913

Gertrude Stein and Alice B. Toklas
Papers, Yale Collection of American
Literature, Beinecke Rare Book and
Manuscript Library, Yale University

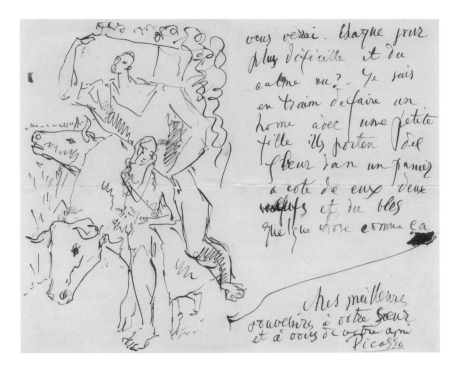

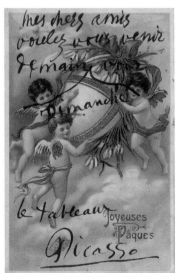

The Stein-Picasso materials at the Beinecke Library are in turn comple-
mented by Picasso paintings and works on paper that were first owned by
Leo and Gertrude Stein and are now in the collection of the Yale University
Art Gallery. These are a jazz-era *pochoir* print acquired by Gertrude after
Leo's departure to Italy (fig. 7) and two key works: Picasso's *Vase, Gourd,
and Fruit on a Table* (cat. no. 4), which the Steins sent to the 1913 Armory
Show in New York, and *Segment of Pear, Wineglass, and Ace of Clubs* (cat. no. 8),
a 1914 collage. The painting and collage were purchased by *New York Herald
Tribune* publisher John Hay Whitney from the Stein heirs after the death of
Toklas in Paris in 1967. In 1982 Whitney bequested the works to the Yale

FIGURE 6

Picasso and Alice B. Toklas,
Two Louis XV-Style Chairs
Ca. 1930
Chairs with embroidery by Alice B.
Toklas over designs by Picasso
Each 29½ x 18⅛ x 15¹¹⁄₁₆ in.
(74.9 x 46 x 39.8 cm)
Gertrude Stein and Alice B. Toklas
Papers, Yale Collection of American
Literature, Beinecke Rare Book and
Manuscript Library, Yale University

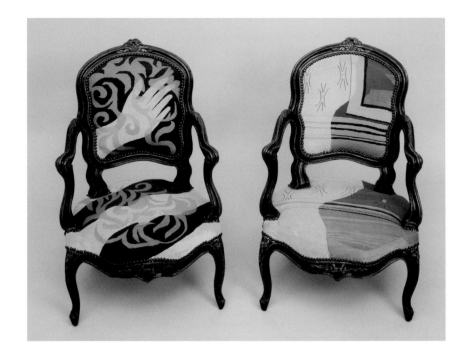

University Art Gallery. In the Stein Papers, the painting and collage appear
in striking and at times poignant images of Stein and Toklas taken at the
rue de Fleurus apartment by photographers including Man Ray and Thérèse
Bonney—archival photographs that are also expressive works of art in their
own right (Caws, "The Meeting Place of Poets," fig. 8; cat. no. 7, fig. 1).

In another photograph, Stein reads a book at a large desk (fig. 8).
Around her, Picasso's paintings unfold in a succession of styles and sizes,
forming a second narrative of Cubism's emergence. The photograph not
only documents her famous collection; more subtly, it foregrounds the act
of reading, entailed in the comprehension of a book but also of a painting,
which can be read like a text. The photograph proposes the idea of a con-
centration on languages, both verbal and visual, that was crucial to both
Stein and Picasso. In a similar way the juxtaposition of Stein's gigantic writ-
ing table and the equally present block of Picasso's artworks on the wall
prompts us to think about the relationship between those two realms—
horizontal and vertical, and writing and painting—as well as the complex
space between the two. This relation of writing and painting, undergirded
by friendships with Gertrude Stein and the poets of the *bande à Picasso*,
fueled Picasso's Cubist innovation. But, as this exhibition seeks to demon-
strate, it continued to inform Picasso's thinking as he developed new friend-
ships between the wars with Surrealist writers, such as André Breton, Michel
Leiris, and Paul Éluard. In the mid-1930s, when these friendships deepened,
Picasso fervently began to write hundreds of poems, an activity that was
interwoven with the making of intensely felt paintings and sculptures, and
which continued until 1959. Picasso's continuing interest in the workings
of language also generated a surge of innovation, particularly in the graphic

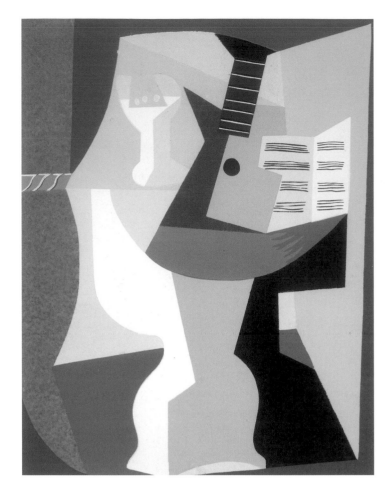

arts and book illustration, in the years immediately following the end of
World War II in 1945, when he was one of many French intellectuals who
joined the Communist Party. All of these relations and relationships,
between people, forms, objects, and ideas—centered around words and their
meaning, and so central to the sweeping innovation and the humanity of
Picasso's art—are evoked by French literature scholar Mary Ann Caws in the
overviews that introduce each section of this book. As Caws sums up at the
close of this volume: "Picasso's language is the language of relation." These
collaborations and relationships are then probed further in the discussions
of selected objects from the exhibition featured in each of those sections.
A complete checklist of all works in the installation may be found at the
conclusion of this catalogue.

PICASSO AND STEIN'S shared interest in language is closely
examined, in the most extensive treatment to date, by Patricia Leighten in
the opening section of this book. Leighten reveals how paintings such as
Shells on a Piano (cat. no. 6), painted in the spring of 1912, embody Picasso's
radical rethinking of psychological viewpoint and the language of art. In
the fall of 1912, Picasso and Braque pushed the innovations of Cubism to an

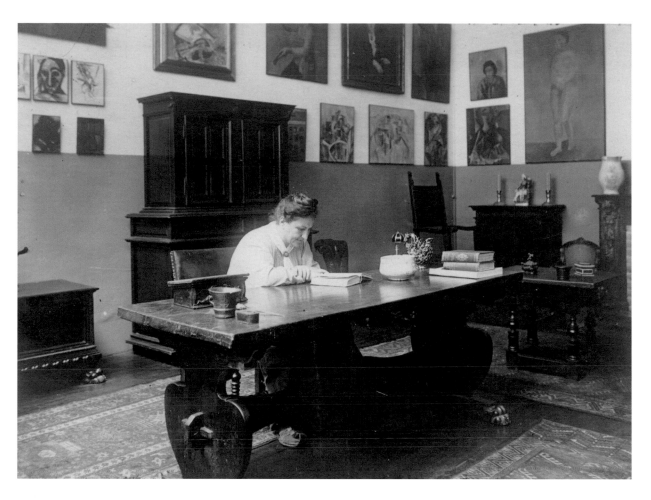

FIGURE 8
**Gertrude Stein Seated at Her Desk,
in 27, rue de Fleurus, Paris**
1920
Photograph
Gertrude Stein and Alice B. Toklas
Papers, Yale Collection of American
Literature, Beinecke Rare Book and
Manuscript Library, Yale University
Picasso's *Vase, Gourd, and Fruit on a Table*
(cat. no. 4) can be seen in the upper
right corner.

extreme and invented a type of collage called *papier collé* (pasted paper), which, as we now understand through the analyses of Yve-Alain Bois and Rosalind Krauss, can be understood as a relational field composed of differential signs, much like a language.[10] As Bois has examined, Picasso's dealer Daniel-Henry Kahnweiler, who began writing in 1915 while in wartime exile in Switzerland, first suggested a link between Picasso's Cubist works and what he called "scripts" or sign systems.[11] Picasso's experimentation with differential signs continued well into the late years of his career, when he produced innovative series that explored a relational graphic language (cat. no. 28). Yet less acknowledged in the Picasso literature is that simultaneous with his rethinking of art and language during the invention of Cubism was a foray into the more traditional practice of book illustration in the spring of 1910. At that time Picasso accepted an invitation from Kahnweiler to provide images for *Saint Matorel* (cat. no. 5), a semiautobiographical narrative by Max Jacob. In a bold move, for this project Picasso put into play the same break with naturalism evinced in his Cubist painting; his images do not illustrate Jacob's story but rather sever themselves from the text, as Irene Small describes in this catalogue. In fact, in a complete reversal of traditional book illustration, where the story inspires the pictures, Picasso's illustrations seem

to have in turn inspired a subsequent narrative by Jacob, as Small also suggests. *Saint Matorel* was not an isolated project, but among the first of dozens of book collaborations during Picasso's career. A central aim of this catalogue is to integrate these book projects into a discussion of Picasso's larger innovation as a painter, draftsman, and sculptor. How, for example, did his invention of a Cubist visual language relate to his consideration of written materials? How, more specifically, did the texts of others inspire Picasso to formulate other, new visual languages, especially after the Cubist years?

The charged dynamic of one "author" reading and interpreting another author's work, and the tensions between image and text, and between visual and verbal languages, raised by *Saint Matorel* fueled Picasso's innovation in his graphic work in the years after Cubism. These experiments began in earnest in the late 1920s and early 1930s, and are the subject of a focused examination in the second section of this book. Picasso's gravitation at this time toward narratives about longing and desire overlapped with the interests and writings of the Surrealists, who formed a vibrant intellectual community for the artist. Picasso's familiarity with their poems and writings, for which he made many frontispieces, such as André Breton's stately profile for *Clair de terre* (Caws, "The Surrealist Impulse," fig. 2) or Paul Éluard's portrait for *Au rendez-vous Allemand* (Caws, "Letters of Mourning," fig. 3), and their evocation of the symbolic interiors of everyday objects, impacted works like the *Cabana* series of 1927–29 (fig. 9)—the looming O and P of the Gallery's related lithograph evoking the complex relationship between Picasso and his wife, Olga Koklova, at the time—as Lydia Gasman has discussed in her monumental study of Picasso and the Surrealist poets.[12] The Surrealists, and above all Breton, saw Picasso as one of them (even if Picasso resisted being one of them, or part of any "movement"), not only in his painting, which was featured in the first Surrealist exhibition at the Galerie Pierre in Paris in 1925, but after 1935, in his poetry as well, which was featured in a special edition of *Cahiers d'art*, with articles by fellow writers, including Breton's "Picasso poète." If Gertrude Stein dismissed the idea of Picasso as a poet, the Surrealists embraced it. With them, Picasso also shared an interest in mythology and its narratives of desire and seduction. But Picasso's etchings for texts like Ovid's *Métamorphoses* (cat. no. 13) also work to seduce the reader, and actively encourage phenomenological participation, as Irene Small discusses. Picasso encourages us to read not only with our eyes, but also with our body. He cultivates in the reader a yearning to be a part of the work, and reveals his own desire to eliminate the divide between work and world. In the graphic works, with their slippage of bodies into other bodies, or the erasure of edges between image and margin, mergings can occur, and boundaries rejected. Picasso's longing for fusion led to the poignant insertion of himself into the painted portraits of his great love Marie-Thérèse Walter, as in the Gallery's *Seated Woman* of 1936 (cat. no. 16), which remained in Picasso's private collection until at least

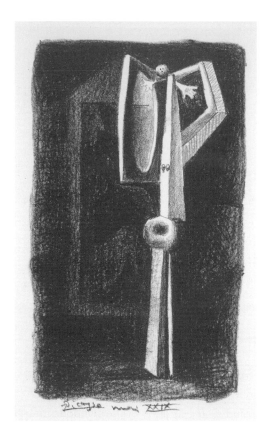

1960, and recently came back into public view when it was gifted to the University by the late collector Charles B. Benenson.

Picasso's graphic Surrealism, with its deeply personal response to classical texts, contrasts sharply to the spacious and immediately accessible works of the years just after World War II, when he emerged from his Grands-Augustins studio after the occupation as a worldwide celebrity. After October 1944, Picasso was also a member of the French Communist Party, joining other French intellectuals such as Louis Aragon (a member since 1927) and the great Surrealist poet Éluard, his close friend since their first meeting in 1933, while working on the Surrealist journal _Minotaure_. Picasso and Éluard's long friendship, which centered around language, art, and political commitment, is memorialized in Picasso's moving portrait (fig. 10), created out of an etched line that speeds up and slows down, like the process of writing itself. They both remained lifelong members of the party, Éluard until his death in 1952, and Picasso until 1973.

In these years of postwar recovery, Picasso turned again to the words of his contemporaries as he had done in the Cubist years, and their descriptions of the struggle to understand their place in the modern world. In several key book projects of the late 1940s, he complemented their words with a visual language newly invented for this radically changed political and social landscape. Importantly, some of these authors, such as the Surrealist poet Aimé Césaire (cat. no. 25) and the Dadaist Tristan Tzara (cat. no. 26),

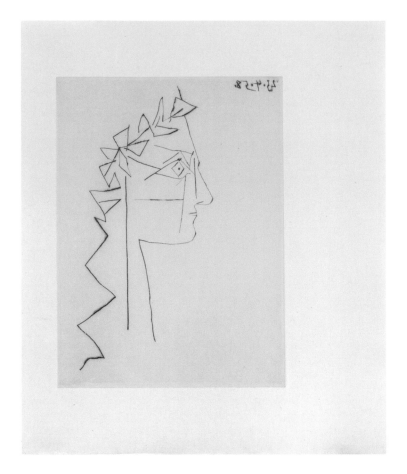

were also members of the Communist Party. Picasso's images for Tzara
reveal an expansive visual language, its accessibility and universality achieved
by Picasso's radical reduction of its elements to just a few markings, includ-
ing his own thumbprint. The culmination of Picasso's investigation of word
and image in the postwar years, however, was *Le chant des morts* (cat. no. 20),
a collaboration with the Cubist poet Pierre Reverdy, analyzed in detail in
this volume by Irene Small. As Small describes, in this project Picasso's
expansive calligraphic painting is not only a form of writing; it also emulates
the form of the notebook, pulling the customarily vertical orientation of
painting into the horizontal realm of writing. It seems fitting that Picasso's
invention of a new pictorial language for this publication occurred in
response to the words of an old friend from the Cubist era forty years
before, when their experimentation with language began. If back then
Picasso broke the narrative link between image and text in Jacob's *Saint
Matorel*, here, with Reverdy, he formulates his own abstract visual language
that nevertheless is fully integrated with the text, on both a formal and
narrative level. The handwriting of the poet and the visual language of
the artist are now in a perfect conversation with one another. They come
together as if in a dance. The one works with the other, creating a third
text, one that exists outside or beyond the work: a shared art of collaboration.

FIGURE 11

Picasso, *Harlequin*
Ca. 1919–20
Watercolor
13 x 9½ in. (33 x 24.1 cm)
Yale University Art Gallery, Bequest of
Edith Malvina K. Wetmore, 1966.80.24

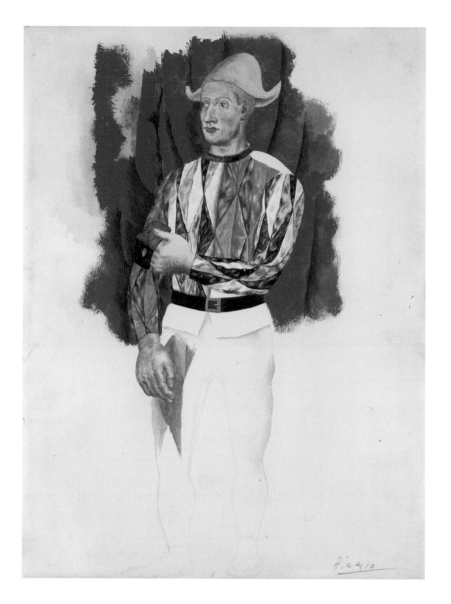

THROUGH A LIFETIME OF FRIENDSHIPS with writers, Pablo Picasso deeply understood language, both visual and verbal, and how it created meaning. But he was particularly sensitized to how language and textuality related to the "work" that was closest to him: himself. Early on, he inserted himself into his art, most famously as the character of Harlequin from the commedia dell'arte in works like *At the Lapin Agile* (1905, Metropolitan Museum of Art, New York), where Picasso, his signature lock of black hair falling over his face, sits at the famous Montmartre café dressed in the character's diamond-patterned costume, accompanied by friend Germaine Pichot and the cabaret's owner, Frédé.[13] Picasso represents himself in the role of a fictional character, and casts himself as part of a story or a text. This outsider figure, full of longing and melancholia, whose black mask embodies the need both to expose and to veil our various selves to the world, was a recurrent character in Picasso's art (fig. 11). Given

Picasso's early insertion of his self into this and other narratives, such as the automythological Vollard suite (cat. no. 14), it is not surprising that later in his life, when he achieved worldwide celebrity, he often reflected in his work on his status and reputation, while also avidly reading museum catalogues and publications about other artists that were brought to him at his retreat in Mougins, as Pierre Daix describes.[14] A pen drawing of 1941, made by Picasso as a frontispiece for his first play, brilliantly and succinctly conveys how Picasso has become the "work" itself, as his body merges with his desk to become a Cubist collage of sorts (cat. no. 28, fig. 2). It is during this time of self-reflection that Picasso also began to produce series after series of works featuring the artist in the studio. The writer Michel Leiris, Picasso's close friend since the 1920s, in turn reflected on these series in his late essays on Picasso (cat. nos. 28–32). As Karen Kleinfelder has more recently described, in these late works Picasso is not so much painting self-portraits as he is refiguring himself as a textual construct.[15] Initiating this prolonged consideration was, appropriately, Picasso's representation in 1952 of the larger-than-life figure who looms over French Romanticism, the movement that valorized the artist as solitary genius: the writer Honoré de Balzac (cat. no. 28). Picasso's subsequent considerations of the artist and artistic identity through the 1950s and 1960s numbered in the hundreds, if not thousands, and the small group of works in the Gallery's collection from these many series of paintings, prints, and drawings, described by S. Zelda Roland and Jennifer R. Gross in the concluding section of this book, can only begin to hint at the complexity and profundity of Picasso's late work. Often rendered with great humor and lightheartedness, they also reveal Picasso's profound understanding of how the identity of the artist is constructed, through various signs and attributes, like a text. Hats, cigarettes, beards, and berets: they could all be moved around, from image to image, to create a Rembrandt, a van Gogh—or a Picasso.

1. Leo Steinberg, "The Algerian Women and Picasso at Large," in *Other Criteria: Confrontations with Twentieth-Century Art* (New York: Oxford University Press, 1972), 161.

2. On Picasso's personal archive, see Laurence Madeline, ed., *"On est ce que l'on garde!": Les archives de Picasso*, exh. cat. (Paris: Éditions des Musées Nationaux, 2003). Key publications on Picasso's relationships with these writers in his early years include, most recently, Peter Read, *Picasso and Apollinaire: The Persistence of Memory* (Berkeley: University of California Press, 2008); Vincent Giroud, *Picasso and Gertrude Stein* (New Haven, Conn.: Yale University Press, 2006); and Mary Ann Caws, *Pablo Picasso* (London: Reaktion Books, 2005), a critical monograph that considers Picasso's relationships with writers throughout his career. See also the important essays in major Picasso exhibition catalogues: Hélène Seckel, "Three Portrait-Manifestoes of Poets: André Salmon, Guillaume Apollinaire, and Max Jacob," in *Picasso and Portraiture: Representation and Transformation*, ed. William Rubin, exh. cat. (New York: Museum of Modern Art, 1996), 180–201; and Jeffrey Weiss, "Bohemian Nostalgia: Picasso in Villon's Paris," and Peter Read, "'Au rendez-vous des poètes': Picasso, French Poetry, and Theater, 1900–1906," in *Picasso: The Early Years, 1892–1906*, ed. Marilyn McCully, exh. cat. (Washington, D.C.: National Gallery of

Art, 1997), 197–201, 211–24. Picasso's relationship with Jacob was also examined in a 1994 exhibition, *Max Jacob et Picasso*, at the Musée des Beaux-Arts, Quimper, Jacob's birthplace. A much earlier book that vividly describes Picasso's circle during these years is that of Fernande Olivier, Picasso's mistress from 1904 to 1911, *Picasso and His Friends*, trans. Jane Miller (London: Heinemann, 1964); originally published in Paris in 1933 as *Picasso et ses amis*.

3. See, especially, Pierre Daix's sensitive and engaging biography of Picasso, *Picasso: Life and Art* (New York: Harper Collins, 1993), and John Richardson's monumental three-volume *Life of Picasso* (New York: Random House, 1991, 1996, and 2007).

4. In addition to the Gertrude Stein Archives, the Beinecke Rare Book and Manuscript Library also houses the Filippo Tommaso Marinetti Papers and the Lydia Winston Malbin Futurism Archive, reminders of the importance of the Futurists' use of language, which relates to the topic of this exhibition. The relationship of word and image was indeed the subject of a 1983 exhibition organized by the late Anne Coffin Hanson; see Hanson, ed., *The Futurist Imagination: Word and Image in Italian Futurist Painting, Drawing, Collage, and Free-Word Poetry*, exh. cat. (New Haven, Conn.: Yale University Art Gallery, 1983). See also the related study by Christine Poggi, *In Defiance of Painting: Cubism, Futurism, and the Invention of Collage* (New Haven, Conn.: Yale University Press, 1992).

5. As Vincent Giroud notes, the precise date of their meeting remains difficult to establish; see Giroud, *Picasso and Gertrude Stein*, 13–17.

6. On the Steins' collection, see *Four Americans in Paris: The Collections of Gertrude Stein and Her Family*, exh. cat. (New York: Museum of Modern Art, 1970). See also Edward Burns, ed., *Gertrude Stein on Picasso* (New York: Liveright, 1970).

7. The letters between Picasso and Gertrude and Leo Stein were recently anthologized in Laurence Madeline, *Gertrude Stein/Pablo Picasso: Correspondance* (Paris: Gallimard, 2005); translated as *Correspondence: Pablo Picasso and Gertrude Stein* (London: Seagull Books, 2008).

8. See the discussion in Madeline, *Stein/Picasso*, 45, for the possible relation of this postcard to the *Demoiselles*.

9. On the chairs, see Ulla E. Dydo, "Picasso and Alice," *Nest* (winter 2002–3): 14–20. In the same issue, see also the original photograph and commentary by the artist Richard Tuttle, "Transparencies and Opacities," 17–18, 21. See also Nancy Kuhl, "She Said, Pablo, Alice Wants to Make a Tapestry," *Sienese Shredder*, no. 2 (2008): 219–22. I am grateful to Nancy Kuhl for bringing these articles to my attention.

10. Yve-Alain Bois, "Kahnweiler's Lesson," in *Painting as Model* (Cambridge, Mass.: MIT Press, 1990), 65–97; Bois, "The Semiology of Cubism," and Rosalind Krauss, "The Motivation of the Sign," in *Picasso and Braque: A Symposium*, ed. Lynn Zelevansky (New York: Museum of Modern Art, 1992). See, more recently, Pepe Karmel, *Picasso and the Invention of Cubism* (New Haven, Conn.: Yale University Press, 2003), esp. chap. 4, "Signs."

11. See Bois, "Kahnweiler's Lesson." Daniel-Henry Kahnweiler, *The Rise of Cubism*, trans. Henry Aronson (New York: Wittenborn, Schultz, 1949); written in 1915 and originally published 1920 in Munich as *Der Weg zum Kubismus*.

12. Gasman's three-volume study is "Mystery, Magic and Love in Picasso, 1925–1938: Picasso and the Surrealist Poets" (PH.D. diss., Columbia University, 1981); on the *Cabana* series, see vol. 1, 265–448.

13. Picasso's identification with Harlequin has long been noted in the literature; see the key essay by Theodore Reff, "Themes of Love and Death in Picasso's Early Work," in *Picasso in Retrospect*, ed. Roland Penrose and John Golding (New York: Praeger, 1973), 31–34.

14. Daix, *Picasso*, 348–54.

15. See Karen L. Kleinfelder, *The Artist, His Model, Her Image, His Gaze: Picasso's Pursuit of the Model* (Chicago: University of Chicago Press, 1993). See also the magisterial essay by Kirk Varnedoe, which explores Picasso's lifelong representation of his various selves; Varnedoe, "Picasso's Self-Portraits," in Rubin, *Picasso and Portraiture*, 111–79.

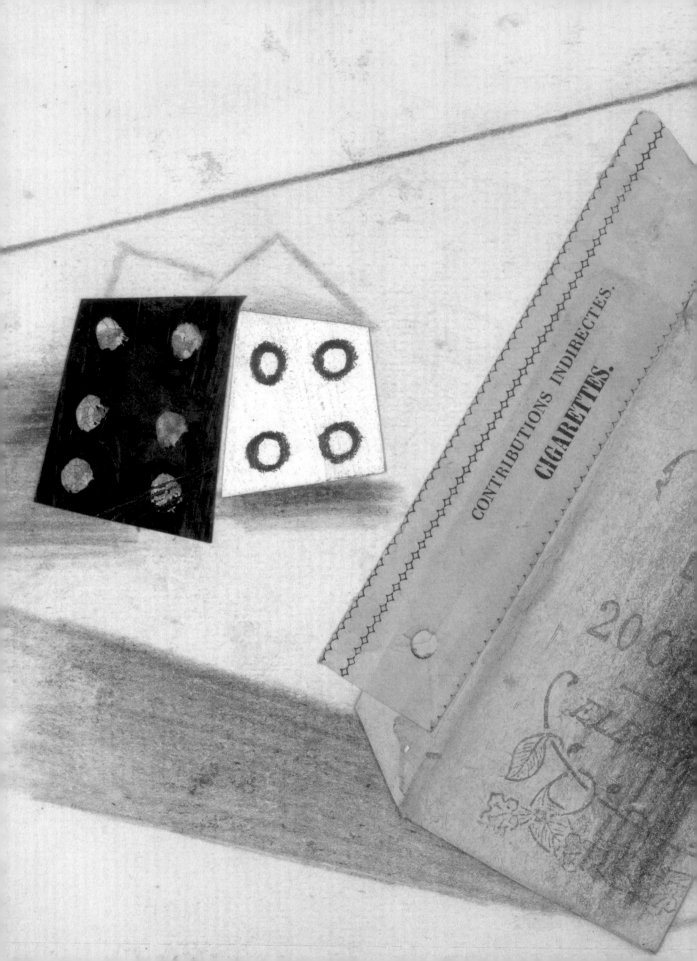

MARY ANN CAWS

The Meeting Place of Poets

PICASSO WAS, FROM THE BEGINNING, one of those persons whom Wallace Stevens defined as a "man whose center is poetry, whether or not he is a poet." Poetry was for Stevens a matter of what he called "exceptional concentration." It was what it feels like being alive, and intensifying the feeling. Picasso's painting and poetry do just that.

Furthermore, Picasso's great friends were—along with Georges Braque, his fellow experimenter in Cubism, and André Derain, who had urged Picasso to see the tribal art shown at the Ethnographical Museum at the Trocadéro, the inspiration for the remodeling of two of the faces in *Les demoiselles d'Avignon* (cat. no. 3, fig. 5)—the poets. First, Max Jacob (fig. 1), Guillaume Apollinaire (fig. 2), and Pierre Reverdy, in the early days of Picasso's Paris, and then Jean Cocteau, Paul Éluard, and Louis Aragon. As Gertrude Stein pointed out, Picasso knew painting, and did not need to know painters; so he lived among poets. This was especially true at the Bateau-Lavoir, that run-down "Laundry Boat," which Apollinaire frequented, where Jacob and André Salmon had studios, and where Reverdy was eventually to come. That one of the best-known photographs of Apollinaire should be of the poet in Picasso's studio has always seemed to me of great import. Reverdy's salute to Picasso, printed in the *Archives de Picasso*, reads:

À Picasso	To Picasso
Mon cher Picasso	My dear Picasso
ceci n'est rien	this is nothing
ni une lettre ni un poème	neither a letter nor a poem
quelques mots	a few words
écrits avec ferveur	written with fervor
pour vous	for you
Pour notre amitié	For our friendship
et mon admiration	and my admiration
qui [*sic*] mérite le grand	which the great unique
l'unique artiste	artist you are
que vous êtes[1]	deserves

As Picasso said, "We had no other preoccupation but what we were doing and . . . saw nobody but each other. Apollinaire, Max Jacob, Salmon. . . . Think of it, what an aristocracy!"[2]

15

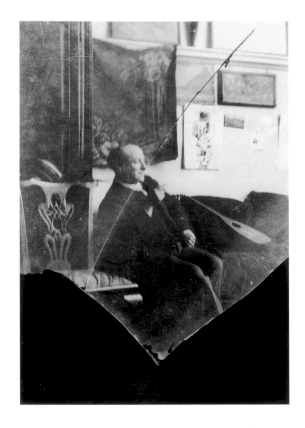

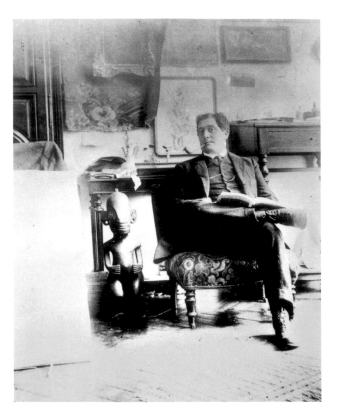

FIGURE 1

Picasso, *Portrait of Max Jacob*

Paris, boulevard de Clichy studio,
fall–winter 1910
Modern gelatin silver print
Picasso Archives, Musée Picasso, Paris

FIGURE 2

**Picasso, *Portrait of Guillaume
Apollinaire***

Paris, boulevard de Clichy studio,
fall 1910
Gelatin silver print
Picasso Archives, Musée Picasso, Paris

What an aristocracy indeed. Such an intense intertwining of personalities and work might well be the envy of any group of writers and painters now or later. It was like a café scene, or a *tertulia*, the Spanish gathering of the same friends in the same café with some regularity, which John Richardson mentions in his definitive biography of Picasso.[3] Max Jacob, overfond of Picasso, shared his hat; in a famous true tale, when Jacob was to fight a duel, he removed the hat, in which, written in capital letters, was the name "Picasso." There could be worse names to find in one's hat, but probably no name harder to escape.

It is as comic as a hat trick, with its own ironic twist. The irony here turns on the importance of naming, for Picasso. "What you have to do is name things. You have to call them by their name. I name the eye. I name the foot. . . . To name. That's all. That's enough."[4] Language has its lure from the beginning for the painter, a painter for our modern times, as Constantin Guys was for Baudelaire. So the *bande à Picasso*, rightly named, already speaks of the capital importance of its chief, around whom the others gathered.

This chief was never especially proficient in the niceties of the French language, to which Max Jacob initially introduced him, in the long evenings

FIGURE 3
Picasso, *Guitar*
Sorgues, summer 1912
Graphite
24 x 18¾ in. (61 x 47.6 cm)
Yale University Art Gallery, Gift of
Mr. and Mrs. Walter Bareiss, B.S. 1940s,
1981.123

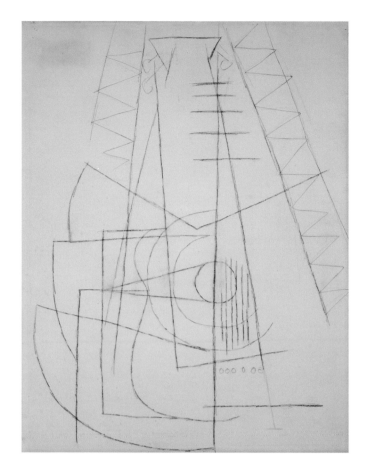

when they read poetry aloud. Some of the poetry of Picasso's painting, about which much has been written and much can be said, must have taken its impulse from the dynamics and the rhythms of that interchange. And the profusion of musical images — *Shells on a Piano* (cat. no. 6), *Guitar* (fig. 3), *Pedestal Table with Guitar and Sheet Music* (introduction, fig. 7), *Flute Player and Reclining Nude* (Caws, "The Surrealist Impulse," fig. 1) — that appear and reappear in Picasso's work, like his *Salomé* (cat. no. 2), are a further testimony to how the hearing of all that poetry was always to matter.

Apollinaire had originally conceived of the idea of a joint volume between himself and the Spanish painter, to be called *Et moi aussi je suis peintre* (I too am a painter) — but the project came to nothing, despite Apollinaire's many painting-poems, like the one called "It's Raining" (cat. no. 26, fig. 4), in which the letters cascade down the page like streams of liquid; "Fountain," in which they spurt upward; or "Heart, Crown, and Mirror," in those shapes, like one of the major ancestors of the later Shaped Poetry. The poet wrote to his friend the painter in enthusiasm, on July 4, 1914: "Dieu: j'ai fait des poèmes encore plus nouveaux de vrais idéogrammes qui

empruntent leur forme, non à une prosodie quelqu'conque [*sic*] mais à leur sujet même. . . . Je crois que c'est une grande nouveauté" (God! I've made some still newer poems, real ideograms that take their form not from any prosody, but from their own subject itself. . . . I think it's a great novelty).[5]

In any case, their interchange never ceased, since Picasso on his own deathbed was still conversing with the poet, dead long before. He was attracted both to the person of Apollinaire and to the idea of and the actuality of his poetry. They made a picturesque threesome, as in Picasso's *Three Musicians* (fig. 4), yet another musical reference, this one representing what Cocteau once described as a trinity: Picasso as the Father, Jacob as the Son, and Apollinaire as the Holy Ghost. Fernande Olivier, Picasso's mistress at the time of the Bateau-Lavoir, underlines the threesome's importance: "Not so long ago, Picasso was thinking about Apollinaire and Max Jacob, whose name he is always invoking. He was wondering what they would have become, if they had gone on living; how they would have reacted to events. He thought about it intensely, trying, he said, to have them traverse the years they did live, stopping at each major happening."[6]

Picasso's own writings, in particular his poems, in continual gestation like his paintings, have the structure of a collage, with elements stuck in here and there.[7] The spaces between the elements open out into other spaces, other relationships. True enough, and in fact that structure could be a model for the entire network of friendships and work in common. We have only to think of their communal lunches with *Les demoiselles d'Avignon* on the wall behind them to get a feeling of the language they shared. They could jest, carrying on Picasso's reputation and self-styling as a harlequin, and Apollinaire's characterization of him as "Arlequino Trismégiste" (or "Harlequin Trismegistus," after the example of Hermes Trismegistus and his three lives: triply a harlequin, wearing a costume and personality of many colors). Their humor was contagious: they laughed and worked together.

All Picasso's still lifes over the years, all those tables to be leaned on and talked around, all those fruits and pitchers and instruments, nourish his work and those partaking of it and observing it. We have only to look at the *Vase, Gourd, and Fruit on a Table* (cat. no. 4), or the magnificent collage of *Segment of Pear, Wineglass, and Ace of Clubs* (cat. no. 8), to feel the way that enclosure of the elements in the rounded shape includes the observer also — we are sharing in this food, wine, and game. And reading, and music

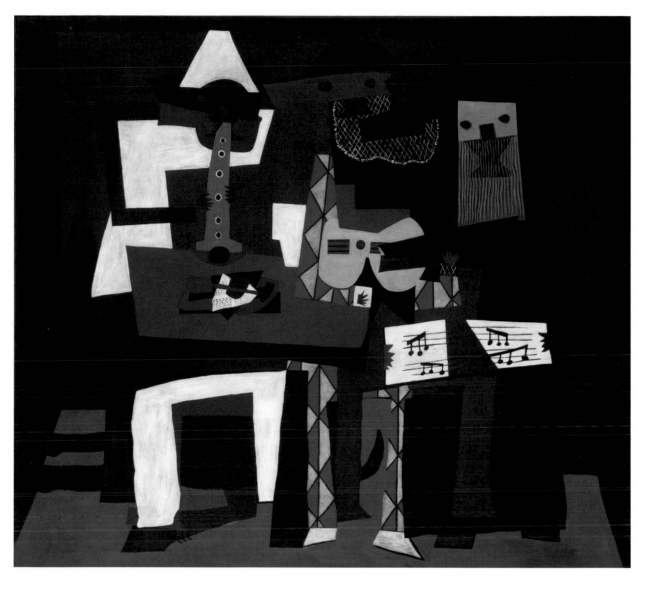

FIGURE 4
Picasso, *Three Musicians*
Fontainebleau, summer 1921
Oil on canvas
6 ft. 7 in. x 7 ft. 3¾ in.
(200.7 x 222.9 cm)
Mrs. Simon Guggenheim Fund, Museum
of Modern Art, New York, 55.1949

also: in Braque's *Bass* (fig. 5), there appears both, on the left, the JOU for the *journal*—the newspaper that indicates not only the daily news but the dailiness of the reading: *le quotidien*, so crucial a concept for contemporary consideration—and, no less significant, the VIN, that "wine" in large letters that so largely informed the conversation around the table. Everything about that tabling for conversation, among the *amiche*, or friends, signaled or half-signaled in the upper left of Braque's *Job* (fig. 6), with all its papers piled up everywhere helter-skelter, like the conversation. This etching too is supported by the table, like that formed by the four tiles of Picasso and Derain (cat. no. 9), with its memory of meals and chatter: SOUVENIR, we read, and even its curling around sweeps us more into the conversation we might well wish we remembered. What a collage of friends and moments, of meals and

FIGURE 5
Georges Braque, *Bass*
Céret, 1911
Etching
25 x 19⅝ in. (63.5 x 49.8 cm)
Yale University Art Gallery, Gift of Walter
Bareiss, B.S. 1940s, 1956.31.12

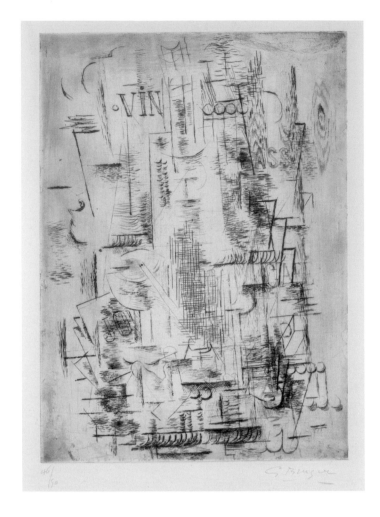

FIGURE 6
Georges Braque, *Job*
Paris, 1911
Etching
5⅝ x 7⅞ in. (14.3 x 20 cm)
Yale University Art Gallery, University
Purchase, 1948.62

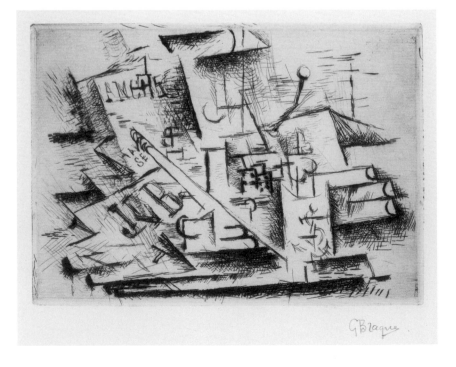

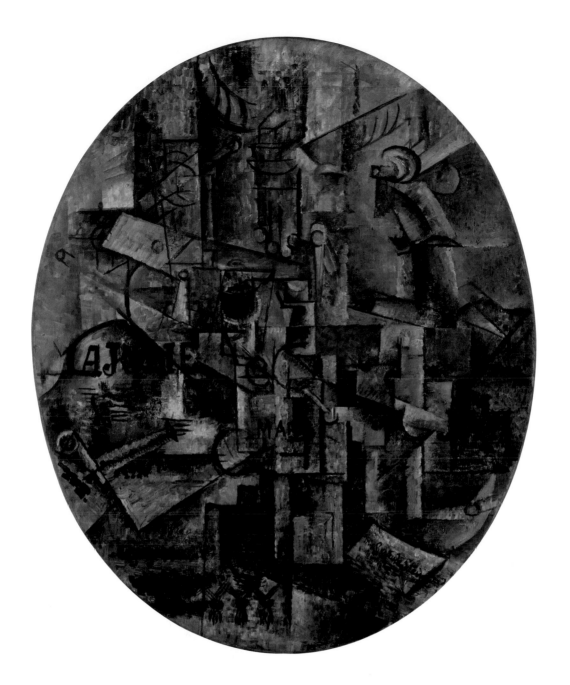

FIGURE 7
Picasso, *The Architect's Table*
Paris, early 1912
Oil on canvas, mounted on panel
28⅝ x 23 in. (72.6 x 59.7 cm)
The William S. Paley Collection, The
Museum of Modern Art, New York,
697.1971

papers and music: all the art of language and its support. When, one day, Picasso was reflecting back on his collages, he turned to his companion and said: "We must have been crazy, or cowards, to abandon this! We had such magnificent means. Look how beautiful this is . . . and we had these means yet I turned back to oil paint."[8]

Picasso, though, was a man less of regrets than of the present—and that included his friendships. Over and over, we find references to his friends in the work: in Picasso's 1912 *Architect's Table* (fig. 7) there is one of Gertrude Stein's calling cards, as there is also in a collage, *Dice, Packet of*

FIGURE 8
Thérèse Bonney, *Gertrude Stein*
Ca. 1925
Photograph
Gertrude Stein and Alice B. Toklas
Papers, Yale Collection of American
Literature, Beinecke Rare Book and
Manuscript Library, Yale University
Picasso's *Segment of Pear, Wineglass, and
Ace of Clubs* (cat. no. 8) can be seen to
Stein's left.

Cigarettes, and Visiting-Card (cat. no. 7), as if friends were always to be call-
ing on the painter, in his works. Elsewhere, we find Max Jacob's cigarettes
linked with the name Job — that Jacob (J — ob) was as poor, and considered
himself as put upon, as Job ties the poet to the artworks, at least by implica-
tion — and one of Braque's etchings, as we have seen, is entitled *Job*. Over
Picasso's door hung a sign reading "Rendez-vous des poètes," and indeed, it
was a perfect meeting place. Marie Laurencin's portrait of the Bateau-Lavoir
group (1908, Baltimore Museum of Art), which hung first on the walls of
Gertrude Stein's salon, says it and shows it all: there they are, gathered
around Apollinaire, as the visual work gathers around the word. That's the
way it seems to be arranged, as if in a collage-montage of friendship, either
explicit or implicit, with the friendship holding the elements together, or

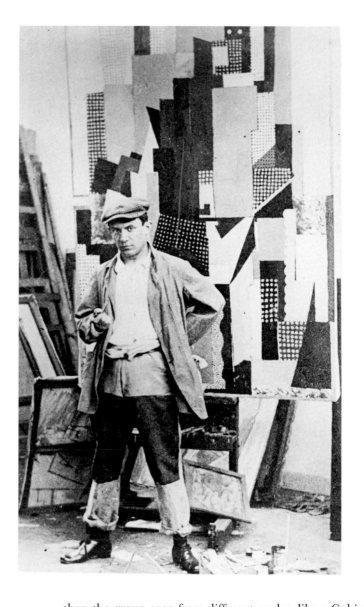

FIGURE 9
Picasso, *Self-Portrait with Man Leaning on Table*
Paris, rue Schoelcher studio
1916
Gelatin silver print
Picasso Archives, Musée Picasso, Paris

then the group seen from different angles, like a Cubist view of the object. It is amusing, even instructive, to contemplate the way the technique of Cubist *passage* between differing planes can be compared to the exchange between these creators, and, more generally still, to that between language and vision, or the marks of writing and those of painting. Picasso's etching *Two Statues* (cat. no. 14a) is a perfect visual representation of the dialogue set up between those two realms, so well met.

Even the notion of the still life as Picasso considers it works in similar fashion. "I put in my paintings everything I love," he said, "and tough luck for the things, they just have to get along with each other."[9] As for getting along together, unsurprisingly, there were some difficulties, personal and psychological. Gertrude Stein, whose famous portrait Picasso painted after

eighty sittings, and only subsequent to rubbing her face out entirely to begin over (introduction, fig. 1), was so prejudiced in favor of Picasso that she attributed to him the creation of Cubism, saying only a Spaniard could have invented such a thing. (Poor Braque, alas, not a Spaniard.) Her adoration of Picasso led her to write a portrait as glowing as one he might have written of himself. His power of concentration impressed her greatly, and his contemporary spirit: "The twentieth century has a splendor which is its own and Picasso is of this century, he has that strange quality of an earth that one has never seen and of things destroyed as they have never been destroyed. So then Picasso has his splendor."[10]

One photograph of Stein (fig. 8) shows her shadow, immense, behind her serious personage: that shadow was to count greatly in the histories of modernism. The photographs of Stein at her desk underscore, as do those of Picasso at his easel, the idea as well as the reality of work—supremely important for both these creators. We might entertain the idea of how the desk image, replacing the window image in Leo Steinberg's analysis of the art of the 1950s, is concretized and predicted by Stein's famous desk (introduction, fig. 8).[11] And the photographs of Stein and Alice B. Toklas seated in front of their extraordinary collection of paintings honor all those painters as well as the idea of painting itself, whereas those many photographs of Picasso and his own paintings (fig. 9) comment upon, of course, his genius, but also his unshakable devotion to the process and the product. Side by side, those photographs afford a rich comparison: double icons of the modernist spirit.

1. Author's translation. Laurence Madeline, ed., *"On est ce que l'on garde!": Les archives de Picasso*, exh. cat. (Paris: Éditions des Musées Nationaux, 2003), 249.

2. Picasso, in Hélène Parmelin, *Picasso dit* (Paris: Gonthier, 1966), 106.

3. John Richardson, *A Life of Picasso*, vol. 1 (New York: Random House, 1991), 5.

4. Picasso, in Parmelin, *Picasso dit*, 29.

5. Author's translation. Pierre Caizergues and Hélène Seckel, eds., *Picasso/Apollinaire: Correspondance* (Paris: Gallimard, 1992), 114.

6. Hélène Parmelin, *Picasso Plain: An Intimate Portrait* (London: Secker and Warburg, 1959), 147.

7. Marie-Laure Bernadac and Christine Piot, eds., *Picasso: Écrits*, preface by Michel Leiris (Paris: Gallimard, 1989); translated as *Picasso: Collected Writings* (London: Aurum Press, 1989).

8. Picasso to Kahnweiler, in Dore Ashton, ed., *Picasso on Art: A Selection of Views* (New York: Viking Press, 1972), 116.

9. Christian Zervos, "Conversation avec Picasso," *Cahiers d'art* 10, no. 10 (1935): 37.

10. Gertrude Stein, *Picasso* (1934; repr., New York: Dover Press, 1984), 76.

11. Leo Steinberg, "Other Criteria," in *Other Criteria: Confrontations with Twentieth-Century Art* (New York: Oxford University Press, 1972). See Irene Small's discussion in cat. no. 20.

1
Café Scene

Paris, October–December 1900
Oil on panel, 10 x 14¹³⁄₁₆ in.
(25.4 x 37.7 cm)
INSCRIPTIONS: lower right:
[*P.*] *R. Picasso*
PROVENANCE: Alice B. Toklas, Paris;
gifted by Toklas to the Gertrude
Stein and Alice B. Toklas Papers,
in 1951
REFERENCES: Zervos I, 33;
D.B. sec. 2, 20
Gertrude Stein and Alice B. Toklas
Papers, Yale Collection of American
Literature, Beinecke Rare Book and
Manuscript Library, Yale University

In the early period of Picasso's life as an avant-garde artist, he lived in Barcelona and Madrid. Spain at that time was going through rapid social change, partly as a result of the loss of the Spanish Empire's last colonies, Cuba, Puerto Rico, and the Philippines, in 1898. The most influential group of avant-garde writers called themselves the Generation of '98, to signify that their concerns emerged from this final decline of Spain's greatness and the enormous economic imbalance and turmoil that resulted. At the end of the century, despite steep rises in the price of food, wages had not risen since 1850; working conditions in factories were among the worst in Europe, and virtually no reforms were effected until well into the twentieth century.[1] Yet if working conditions were dehumanizing, affording only marginal subsistence, not working was infinitely worse. Seasonal and chronic unemployment was unprecedentedly high at this time, and there was little choice for such unfortunates but to beg, steal, or starve. Members of this class on the fringes of society, whom Karl Marx called the *lumpenproletariat*, were among the major concerns of these writers; its main figures included Pío Baroja, J. Martínez Ruiz (Azorín), and Miguel de Unamuno, all of whom were politically engaged writers dedicated to a closely observed realism. In their novels and essays, they critiqued these injustices from an anarchist perspective and sought Spain's regeneration in the modern world.[2] When Picasso and his friend Francisco Asís de Soler moved to Madrid in 1901, they became friendly with several of these writers, especially Baroja and Azorín. The journal they came to Madrid to found — *Arte joven* (Young Art) — was devoted to the regeneration of the arts and society; they published the Madrid writers' anarchist ideas as well as echoing them in their own editorial writing.[3]

As this publishing venture suggests, the concerns of the Generation of '98 were shared by avant-garde writers and artists in Barcelona, who called themselves the *modernistes* and gathered in the café Els Quatre Gats. Much has been written about the importance of this gathering place, where the young Picasso found an artistic, intellectual, and political home starting in 1899.[4] "The Four Cats" was owned by Pere Romeu, who had worked at Paris's famous avant-garde cabaret Le Chat Noir and who modeled himself after its flamboyant owner, Aristide Bruant. Els Quatre Gats was frequented by both a generation of established modernists — most prominently the painters Santiago Rusiñol and Ramon Casas — and an emerging generation struggling to establish itself, of which Picasso was more a follower than a leader at this point. The artist who most influenced his art was Isidre Nonell, whose paintings specialized in images of gypsies, beggars, and other socially marginal figures. Nonell was the acknowledged leader of a small group within the *modernistes*, the Colla Sant Martí, which included Ricard Canals, Joaquim Mir, Ricard Opisso, and Ramon Pitxot (Pichot), who painted in the poor outskirts of Barcelona and focused on subjects of poverty and other antigovernmental themes, rendered in an experimental style for that period.[5] Many writers were also members of the *modernistes*, including Pompeu

Gener (who played a major role popularizing Nietzsche in Spain), Miguel Utrillo (who wrote a laudatory review of Picasso's early career in 1901), and Picasso's close friends Ramon Reventós and Jaume (Jaime) Sabartés.[6]

Barcelona was like Paris in that its cafés served as the gathering rooms for like-minded artistic and political groupings. Els Quatre Gats was designed from the first as a self-consciously avant-garde space, and the building it occupied had recently been completed by one of the three leading modernist architects of Barcelona, Josep Puig i Cadafalch.[7] The café drew writers and artists embracing a range of political positions within the Catalan independence movement, sometimes overlapping with anarchism. Picasso was attracted to the most extreme among those who frequented the café, in terms of both political radicalism and artistic innovation. As an Andalusian he supported the Catalan movement; but it was Spanish anarchism that he took with him to Paris, both in his anarchist outlook and in the subjects and styles of his art.[8] When he arrived in Paris for the first time in October 1900, he sought out the radical culture he was used to in Barcelona—partly through his many contacts among Catalans living in Paris—and painted similar subjects: the cafés, dance halls, and nightclubs as well as the poor outskirts of the city.[9]

Café Scene was painted on one of Picasso's visits to Paris during the period he lived in Barcelona and joined the *modernistes* group in Els Quatre Gats. Josep Palau i Fabre identifies it as having been done on Picasso's first trip to Paris (October to December 1900) and believes that it was likely included in Picasso's exhibition at Galerie Vollard in June 1901 as *The Drinkers*.[10] Zervos identifies it as having been painted a few months later in Barcelona in 1901. Stylistically, the work could belong to the first Paris trip, the subsequent Málaga/Madrid/Barcelona period (December 1900 to May 1901), or the first five months of his second Paris trip (June to December 1901), after which his works reveal the beginnings of the Blue Period, no trace of which appears in *Café Scene*. The signature "[P.] R. Picasso," however, identifies the work as before the second Paris trip, by which time he had shortened his signature to "Picasso," but this does not settle the question of the exact date, as he varied between "Ruiz Picasso" and "P. R. Picasso" throughout the earlier period.[11] Another clue to the date of *Café Scene* is a drawing, *Au cabaret* (fig. 1); this is clearly a study for the painting, with the front figure in profile facing right and the couple in the center leaning in to a kiss. The drawing is inscribed in French "au Cabaret" on the back, identifying it as Parisian. Putting these elements together affirms Palau i Fabre's date of October to December 1900.

Picasso's small painting depicts two male and two female figures seated in a café, in a composition that echoes Edgar Degas' *Absinthe* (fig. 2), though Degas' composition is bolder in its perspective. The Degas depicts the usual placement of the tables in a Parisian café, which highlights the purposeful lack of distinction made by Picasso between the tables of the two couples;

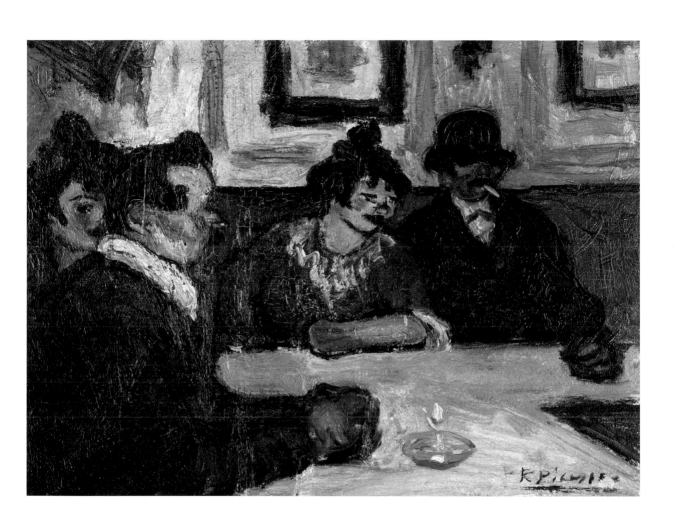

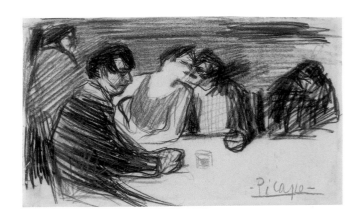

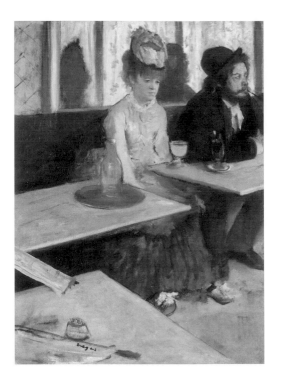

The Meeting Place of Poets

through this device, Picasso ensures that we view them as an intimate four-some. The two figures in Degas' work sit side by side without interacting, and both have drinks associated with alcoholism, while the café is pointedly bathed in early-morning light.[12] The woman sits already stupefied by the addictive absinthe, while the man drinks a well-known hangover remedy of cold black coffee and seltzer water. While Degas' work appears as cool and detached observation, several visual tricks nonetheless work to draw us into the painting, including a lack of supporting legs that makes the tables seem to float, the spatial hole in front of the figures, and the "bridges" formed by the newspapers on their supports, linking us to the figures from whom we are otherwise so alienated. By contrast, Picasso engages us with his figures' action: both couples lean in to each other, establishing camaraderie and intimacy. He rendered the painting with more boldly modernist brushwork, and thick black outlines surround all four figures, fixing them firmly into place and echoing the styles of artists Picasso emulated at this time: most especially Théophile-Alexandre Steinlen and Henri de Toulouse-Lautrec, but also Vincent van Gogh, Paul Gauguin, and the Nabis. Picasso knew their work, as well as works by modernists from all over Europe, from black-and-white reproductions in the journals provided at Els Quatre Gats, but he would only recently have seen the works of these major Parisian modernists in the original for the first time.

The two women in Picasso's painting are clearly depicted as prostitutes, wearing heavy makeup, loud colors, and bright red flowers in their hair.[13] Who are the men? The obvious answer is that they are the prostitutes' customers. They are clearly depicted as working-class, given their ill-fitting

FIGURE 3
Picasso, *Self-Portrait in the Studio*
Paris, 1901
Gelatin silver print
Picasso Archives, Musée Picasso, Paris

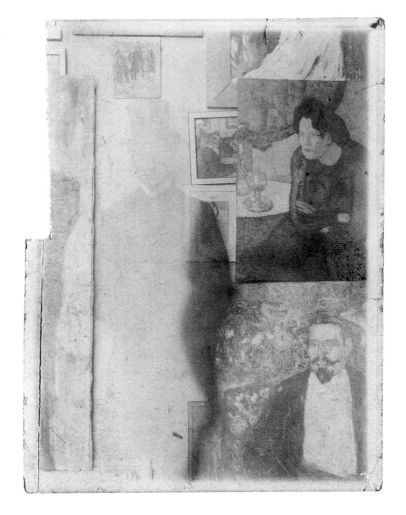

clothes and exaggeratedly swollen, work-darkened hands (the prominence
and placement of the men's hands is already an established feature of the
drawing, though there the men wear white shirtfronts and one has specta-
cles, rendering them bourgeois). The man on the right, with an overlarge
hat pulled down over his eyes and a drinker's reddened nose, has an espe-
cially seedy appearance and may even be the prostitutes' pimp. In either
case, they do not seem far distant from the prostitutes' own social class
on the margins of bourgeois society. Picasso, in choosing to depict a café,
evokes the well-established status of such spaces as bohemian hangouts
where avant-garde writers and artists rubbed shoulders with the proletariat.
One of the prostitutes notices us, possibly watching the artist make a sketch
of the group: thus we seem to be invited to share an insider's vision of the
scene, a glimpse of the radical bohemia in which Picasso moved, rather than
an outsider's cool and judgmental observation, as with the Degas.

This work appears in a ghostly photograph of the artist standing in
evening dress in his Paris studio in 1901 (fig. 3). *Café Scene* appears directly to
the right of Picasso's head, just behind the later Blue Period work depicting
another prostitute, *The Absinthe Drinker* of 1901 (Collection Im Obersteg,

Kunstmuseum, Basel). Above his head is *Group of People on Montmartre* of 1900 (Barnes Foundation, Merion, Pa.), depicting Picasso with his friends Pichot, Pere Manyach, Carles Casagemas, Jaume Brossa, and Gener in Paris; the presence of these works in the photographic self-portrait positions *Café Scene* as an important painting of this early period, with self-conscious links to his milieus in both Barcelona and Paris, as well as to another treatment of the theme of prostitution and bohemian marginalization.[14] It is fitting that *Café Scene* came to be owned by Gertrude Stein and Alice B. Toklas and took its place in that other avant-garde space in Paris, the Stein residence.

— **Patricia Leighten**

1. Raymond Carr, *Spain, 1808–1939* (Oxford: Clarendon Press, 1966), 389ff.; Gerald Brenan, *The Spanish Labyrinth, an Account of the Social and Political Background of the Civil War* (Cambridge: Cambridge University Press, 1943), 22. See also Raymond Carr, *Modern Spain, 1875–1980* (New York: Oxford University Press, 2001).

2. José Alvarez Junco, *La ideología política del anarquismo español (1868–1910)* (Madrid: Siglo Veintiuno de España Editores, 1976); Julián Casanova, *Anarchism, the Republic, and Civil War in Spain, 1931–1939*, trans. Andrew Dowling and Graham Pollok, rev. Paul Preston (New York: Routledge, 2005); Lily Litvak, *España 1900: Modernismo, anarquismo y fin de siglo* (Barcelona, Spain: Anthropos, 1990); and Murray Bookchin, *The Spanish Anarchists: The Heroic Years, 1898–1936* (New York: Free Life, 1977).

3. Patricia Leighten, *Re-Ordering the Universe: Picasso and Anarchism, 1897–1914* (Princeton, N.J.: Princeton University Press, 1989), 25–27; Josep Palau i Fabre, *Picasso: The Early Years, 1881–1907* (New York: Rizzoli, 1981), 214–29.

4. See Joseph Cervera, *Modernismo: The Catalan Renaissance of the Arts* (New York: Garland, 1976); Marilyn McCully, *Els Quatre Gats: Art in Barcelona around 1900*, exh. cat. (Princeton, N.J.: Princeton University Art Museum, 1978); Francesc Fontbona and Francesc Miralles, *Història de l'art català*, vol. 7, *Del modernisme al noucentisme, 1888–1917* (Barcelona, Spain: Edicion 62, 1985); Michael Raeburn, ed., *Homage to Barcelona: The City and Its Art, 1888–1936*, exh. cat. (London: Arts Council of Great Britain, 1986); Leighten, *Re-Ordering the Universe*, 17–19; María Teresa Ocaña, ed., *Picasso and Els 4 Gats: The Early Years in Turn-of-the-Century Barcelona*, exh. cat. (Barcelona, Spain: Museu Picasso, 1996); Marilyn McCully, ed., *Picasso: The Early Years, 1892–1906*, exh. cat. (Washington, D.C.: National Gallery of Art, 1997); and William H. Robinson et al., *Barcelona and Modernity: Picasso, Gaudí, Miró, Dalí*, exh. cat. (Cleveland: Cleveland Museum of Art, 2007).

5. Cervera, *Modernismo*, 62–64; Leighten, *Re-Ordering the Universe*, 6–7, 18–19, and 25–32; and Temma Kaplan, *Red City, Blue Period: Social Movements in Picasso's Barcelona* (Berkeley: University of California Press, 1992), 74–77.

6. On Gener and Nietzsche's importance for the *modernistes*, see Paul Ilie, "Nietzsche in Spain: 1890–1910," *Publication of the Modern Language Association* 79 (March 1964): 80–96; on Picasso specifically, see Leighten, *Re-Ordering the Universe*, 43–46. Miguel Utrillo's essay appeared in *Pèl i Ploma*, June 1901, signed by "Pincell"; trans. in Palau i Fabre, *Picasso*, 513–14.

7. Palau i Fabre, *Picasso*, 126–27; the neo-Gothic style may have purposely evoked the period of Catalonia's independence in the Middle Ages before its dominance by Spain. The other leading modernist architects were Antoni Gaudí and Lluís Domènech i Montaner.

8. Leighten, *Re-Ordering the Universe*, 19–47.

9. Palau i Fabre, *Picasso*, 200–203, documents the numerous Catalans whom Picasso and his companion Carles Casagemas saw in Paris on this trip, including Casas, Utrillo, Nonell, Pichot, Gener, Jaume Brossa, Manuel Pallarès, and the painter Francisco

Itturino. See also Maria Teresa Ocaña, "Chronicle from Paris," in Ocaña, *Picasso and Els 4 Gats*, 52–56; and Leighten, *Re-Ordering the Universe*, 51.

10. Palau i Fabre, *Picasso*, 208, 254.

11. The signature currently appears as "R. Picasso," with the "P." obscured.

12. Robert L. Herbert, *Impressionism: Art, Leisure, and Parisian Society* (New Haven, Conn.: Yale University Press, 1988), 74–76.

13. There has been a great deal of excellent scholarship on prostitution and its depiction in the late nineteenth and early twentieth centuries; see especially Alain Corbin, *Les filles de noce: Misère sexuelle et prostitution aux dix-neuvième et vingtième siècles* (Paris: Aubier Montaigne, 1978); and Hollis Clayson, *Painted Love: Prostitution in French Art of the Impressionist Era* (New Haven, Conn.: Yale University Press, 1991). Specifically on Picasso's depictions of prostitutes in his early career, see Leighten, *Re-Ordering the Universe*, 34–36; Leighten, "The White Peril and *l'Art Nègre*: Picasso, Primitivism, and Anticolonialism," *Art Bulletin* 72 (December 1990): 609–30; and Michael Leja, "'Le vieux marcheur' and 'Les deux risques': Picasso, Prostitution, Venereal Disease, and Maternity, 1899–1907," *Art History* 8 (March 1985): 66–81. For a range of approaches to his major depiction of prostitutes, see Christopher Green, ed., *Picasso's "Les demoiselles d'Avignon"* (Cambridge: Cambridge University Press, 2001).

14. For *Group of People on Montmartre*, see Ocaña, *Picasso and Els 4 Gats*, 155.

Salomé,
from
Les
saltimbanques

Paris, 1905
Drypoint
15¾ x 13¹¹/₁₆ in. (40 x 34.8 cm)
Published by Ambroise Vollard,
Paris, 1913
Printed by Louis Fort, Paris
Edition 250
INSCRIPTIONS: upper right,
in plate: *Picasso 1905*
REFERENCES: Geiser/Baer I, 17iii/iii
Yale University Art Gallery, Gift of
Molly and Walter Bareiss, B.S. 1940s,
1999.9.13

This print of *Salomé* evokes a story from the New Testament, in which Salome causes the death of John the Baptist, who had accused her mother, Herodias, of an adulterous marriage to the king:

> *And when a convenient day was come, that Herod on his birthday made a supper to his lords, high captains, and chief estates of Galilee; And when the daughter of the said Herodias came in, and danced, and pleased Herod and them that sat with him, the king said unto the damsel, "Ask of me whatsoever thou wilt, and I will give it thee." And he sware unto her, "Whatsoever thou shalt ask of me, I will give it thee, unto the half of my kingdom." And she went forth, and said unto her mother, "What shall I ask?" And she said, "The head of John the Baptist."*
>
> *And she came in straightway with haste unto the king, and asked, saying, "I will that thou give me by and by in a charger the head of John the Baptist." And the king was exceeding sorry; yet for his oath's sake, and for their sakes which sat with him, he would not reject her. And immediately the king sent an executioner, and commanded his head to be brought: and he went and beheaded him in the prison, and brought his head in a charger, and gave it to the damsel: and the damsel gave it to her mother.*
>
> (Mark 6:21–28, King James Version)

This story highlighting the theme of female seduction was enormously popular in the late nineteenth and early twentieth centuries, made notorious by a ballet (Florent Schmitt, 1907), two operas (Jules Massenet, 1881, and Richard Strauss, 1905), and numerous written and painted versions, most notably Gustave Flaubert's novella *Hérodias* of 1877; Oscar Wilde's *Salome*, forbidden in Britain and so first staged in Paris in 1896; and Gustave Moreau's celebrated series evoking several parts of the story, including *Salome Dancing before Herod* (fig. 1) and *The Apparition* (1874–76 and 1897, Musée Gustave Moreau, Paris). Maurice Kraft counted 2,789 poets in France alone who conjured with the figure of Salome in this period.[1] The question arises, then, Why did Picasso focus on such a belabored theme? The answer lies in his close friendship with the poet Guillaume Apollinaire.

Picasso and Apollinaire met in 1904 and came to share, throughout the next decade and more, an aesthetic position dedicated to revolution in the arts. Both started their careers as Symbolists and as anarchist artists devoted to overturning tradition, an aim they achieved with increasing finesse throughout the period before World War I as they moved beyond the aesthetics of the Symbolist movement.[2] Anarchism specifically appealed to artists in its critique of the social status quo and in its vision of an egalitarian and stateless future in which art and leisure would take their rightful place at center stage.[3]

An important part of Apollinaire's life and work was his dedication to sexual liberationism, a central aspect of anarchist ideology.[4] Intersecting his admiration for the Marquis de Sade with his anarchist commitment to individual freedom in general, throughout this period Apollinaire wrote

pornographic novels, both to make a living and out of conviction that it constituted an act of moral freedom on his part.[5] He founded a short-lived journal in 1905 titled *La revue immoraliste* to reject bourgeois morality in favor of Max Stirner's "transcendence of morality." He approached very seriously his scholarly editions—translated, annotated, and with bibliographies—of earlier pornography, including de Sade, Charles Baudelaire, and John Cleland's *Fanny Hill, or, Memoirs of a Woman of Pleasure*; and he further undertook a bibliography of all pornographic holdings in the Bibliothèque Nationale—the legendary "L'enfer" collection—compiled in secret and remaining the standard reference to this day.[6] Apollinaire, in his life and work, took sexual liberationism and eroticism seriously. It is clear from Picasso's *Salomé*, as well as from his own life and oeuvre, that this was a political position they shared.

Apollinaire is credited with writing some of the most important poetry in the period between Symbolism and Surrealism, pushing free verse so far as to do away with punctuation and revitalizing the idea of *calligrammes* or picture-poems.[7] His aesthetic embraced the concepts of surprise, novelty, and audacity and encouraged artists to "innovate violently!"[8] The poet also turned his hand to journalism and to art criticism and made an enormous impact on the Parisian art world through his support of modernism in all its forms, mingling art, politics, satire, and an engagement with the quotidian in his writing. In many ways the artistic innovations of Picasso and Apollinaire ran parallel, as they challenged each other in their differing media, from 1904 through Cubism, collage, and the *calligrammes*.[9] But their work was closest during the period in which Picasso made the *Saltimbanques* suite of etchings, which responded to and/or inspired Apollinaire's poems, later collected in the latter's book *Alcools* (1913).[10]

In the instance of *Salomé*, there is a direct relationship between a poem of Apollinaire's and Picasso's conception of the theme. Apollinaire's *Salomé* was published in 1905 and introduced a major innovation: he put the poem in Salome's voice so that we hear the story from her point of view:

> *To make John the Baptist smile another time*
> *Sire I would dance better than the seraphim*
> *My mother tell me why you aren't happy*
> *In a countess's robe by the side of the dauphin*
>
> *My heart beat, beat so hard at his word*
> *When I danced in the herbs listening*
> *And I embroidered lilies on a pennant*
> *Aimed to float at the top of his staff*
>
> *And for whom would you wish me now to embroider*
> *His staff blooms again on the banks of the Jordan*
> *And all the lilies when your soldiers o king Herod*
> *Led him away died in my garden*

Everyone come with me there to the formal garden
Don't cry o pretty king's jester
Take this head in place of your doll-stick and dance
Do not touch mother his forehead is already cold

Sire walk before troops walk behind
We will dig a pit and bury it there
We will plant flowers and dance in a ring
Until the hour when I've lost my garter
The king his snuffbox
The princess her rosary
The priest his breviary[11]

Apollinaire presents Salome as having loved the Baptist and danced in response to this love in her garden. Rather than the heartless femme fatale of most depictions, she has become a tragic figure imbalanced by the grotesquerie of events. The repeated conjuring with lilies—the *fleur de lys* is the emblem of French royalty—evokes political forces at work. John the Baptist having denounced the incestuous marriage of Herod and his sister-in-law Herodias, the whole story of Herod's granting her mother's wish is revealed as so much court intrigue at the expense of a naive young woman. Apollinaire's Salome expresses pure sexuality and innocent love, precisely what Picasso depicts in his image from the poem.

The figures in the print present standard features of works such as Moreau's *Salome Dancing before Herod*: Salome dances before the king and Herodias, with an exotic dark-skinned servant crouching nearby. But Picasso's image has at least two features that diverge sharply from this tradition. First, Salome dances *after* John the Baptist's death, and second, she is nude. Herod watches her dance with no appearance of excitement: aging and obese, he slumps on his seat with a look of ill-tempered satiation, all the treasures of his kingdom literally incorporated in his grotesque figure. Herodias stands beside him, distractedly gazing away from the dance. The black servant holds a platter with the head of John the Baptist on it—positioned so as not to serve as a halo—offering a tendril of his hair to Salome. If Picasso were making a historicist interpretation, we would be tempted to see this as conflating two moments in the biblical story: the dance and its deadly consummation. Knowing Apollinaire's unorthodox reworking of Salome, however, we can recognize that Picasso actually depicts the opening two lines of the poem. She dances "better than the seraphim" in order to "make John the Baptist smile another time," to bring him back to life.

Salome, based on the equestrienne figures from the Cirque Médrano (fig. 2)—which Picasso attended weekly with Apollinaire and the rest of the *bande à Picasso*—is gloriously nude. The equestriennes and acrobats of the Cirque Médrano—several of whom also appeared in the *Saltimbanques*

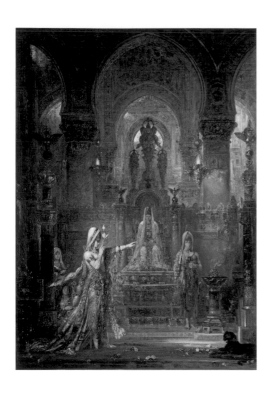

FIGURE 1
**Gustave Moreau, *Salome Dancing
before Herod***
1874–76
Oil on canvas
56¹¹⁄₁₆ x 40¾ in. (144 x 103.5 cm)
The Armand Hammer Collection, Gift of
the Armand Hammer Foundation,
Hammer Museum, Los Angeles

FIGURE 2
Picasso, *Girl Standing on Horse*
1905
Ink
9⅜ x 12⅛ in. (23.8 x 30.8 cm)
The Baltimore Museum of Art: The Cone
Collection, formed by Dr. Claribel Cone
and Miss Etta Cone of Baltimore,
Maryland, BMA 1950.215

suite—figured for Picasso and Apollinaire as manifestations of grace, physical power, and naturalness that broke all the codes of bourgeois propriety and directly bespoke the exoticism of the European and non-European other (Apollinaire had an affair with an American acrobat who appeared there). But Picasso's Salome goes much further than these acrobats. Her dance is shockingly lascivious, as the artist twists and distorts her body—head, shoulders, spine, and hips—as only a master anatomist can, to let us know that her sex is visible to Herod. Moreau's Salome wears clothing from neck to ankle, though the figure is highly sexualized through the use of suggestive "veils" over her nude figure.[12] Picasso and Apollinaire have reinvented for themselves the concept of sexuality as primitive, natural, and free. Herodias's nudity is unidealized. Her time-worn figure, partly obscured by the king's corpulence, is suggestive of her body's use for her own gain in power. The presence of the African, as is common throughout modernism (most notably in Manet's *Olympia* [1863, Musée d'Orsay, Paris]) augments the raw sexuality already expressed by Salome.[13] Salome's freedom and purity oppose the decadent power of the court with tragic intensity. If madness is Salome's refuge, both poem and print attest to her redemptive sexuality as much as to the trap of power in which she is caught.

— Patricia Leighten

1. Cited in Willard Bohn, "Apollinaire, Salome, and the Dance of Death," *French Studies* 57 (2003): 491–500; see also Michel Décaudin, "Un mythe 'fin de siècle': Salomé," *Comparative Literature Studies* 4 (1967): 110.

2. On Apollinaire and anarchism, see Patricia Leighten, *Re-Ordering the Universe: Picasso and Anarchism, 1897–1914* (Princeton, N.J.: Princeton University Press, 1989), 53–63.

3. Eugenia Herbert, *The Artist and Social Reform: France and Belgium, 1885–1898* (New Haven, Conn.: Yale University Press, 1961); Robert and Eugenia Herbert, "Artists and Anarchism: Unpublished Letters of Pissarro, Signac, and Others," *Burlington Magazine* 102 (November–December 1960): 473–82, 517–22; Richard D. Sonn, *Anarchism and Cultural Politics in Fin de Siècle France* (Lincoln: University of Nebraska Press, 1989), 141–80; Allan Antliff, *Anarchy and Art: From the Paris Commune to the Fall of the Berlin Wall* (Vancouver: Arsenal Pulp Press, 2007); and Robyn Roslak, *Neo-Impressionism and Anarchism in Fin-de-Siècle France: Painting, Politics, and Landscape* (Aldershot, England: Ashgate, 2007).

4. Sonn, *Anarchism and Cultural Politics*, 136–37, 153, 176; Jennifer Waelti-Walters and Steven C. Hause, eds., *Feminisms of the Belle Époque: A Historical and Literary Anthology* (Lincoln: University of Nebraska Press, 1994).

5. Leighten, *Re-Ordering the Universe*, 60–61; Roger Shattuck, *The Banquet Years: The Origins of the Avant-Garde in France, 1885 to World War I*, rev. ed. (New York: Random House, 1968), 303ff.

6. Max Stirner, *The Ego and Its Own*, trans. Steven T. Byington (New York: B. R. Tucker, 1907); Shattuck, *Banquet Years*, 269–70. Apollinaire did the bibliography with Fernand Fleuret and Louis Perceau; see Francis Steegmuller, *Apollinaire: Poet among the Painters* (New York: Farrar, Straus, and Giroux, 1963), 167.

7. See Marcel Adéma, *Apollinaire*, trans. Denise Folliot (New York: Grove Press, 1955); Shattuck, *Banquet Years*; LeRoy C. Breunig, *Guillaume Apollinaire* (New York: Columbia University Press, 1969); Peter Read, *Picasso et Apollinaire: Les métamorphoses de la mémoire, 1905/1973* (Paris: Éditions Jean-Michel Place, 1995); Adrian Hicken, *Apollinaire, Cubism, and Orphism* (Aldershot, England: Ashgate, 2003); and Bohn, "Apollinaire, Salome."

8. Shattuck, *Banquet Years*, 294; and Leighten, *Re-Ordering the Universe*, 60–62. The quotation dates from about 1907,

according to André Salmon, *Souvenirs sans fin, première époque (1903–1908)* (Paris: Gallimard, 1955); cited in Leighten, *Re-Ordering the Universe*, 74.

9. Leighten, *Re-Ordering the Universe*, 55–57; Apollinaire, *Calligrammes: Poèmes de la paix et da la guerre, 1913–1916* (Paris: Mercure de France, 1918). See also Read, *Picasso et Apollinaire*; and Hicken, *Apollinaire, Cubism, and Orphism*.

10. *The Frugal Repast* is also part of this series; according to Roland Penrose, the suite was an unsuccessful attempt to foster Picasso's income in a very lean period "with the help of a friend, Relatre, a former Communard, who owned a press and made prints on the rare occasions when they were in demand"; Penrose, *Picasso: His Life and Work* (New York: Harper and Row, 1973), 104. For the complete history of the various states and printing history of *Salomé*, see Geiser/Baer I, 17. On *Alcools*, see Marcel Décaudin, *Le dossier d' "Alcools": Édition annotée des préoriginales avec une introduction et des documents* (Paris: Minard, 1965) and *"Alcools" de Guillaume Apollinaire* (Paris: Gallimard, 1993). On the relationship of the prints to the poems, see John Richardson, *A Life of Picasso*, vol. 1 (New York: Random House, 1991), 334 and 508.

11. Author's translation; first published in *Vers et prose* in 1905 and later included in *Alcools* in 1913. I am indebted to Bohn's persuasive interpretation in "Apollinaire, Salome" for aspects of my reading of this poem.

12. Picasso's stark depiction also contrasts sharply with other aspects of Moreau's Salome works, which are cluttered with symbols like the "lotus of voluptuousness" and the "black panther of cruel strength and perversity." Geneviève Lacambre, *Gustave Moreau: Between Epic and Dream*, exh. cat. (Paris: Réunion des Musées Nationaux, 1999), 163.

13. See Sander L. Gilman, *Difference and Pathology: Stereotypes of Sexuality, Race, and Madness* (Ithaca, N.Y.: Cornell University Press, 1985), 76–108.

3

Head of a Woman

Paris, winter 1906–7
Gouache and ink, 25 x 18¹¹/₁₆ in.
(63.5 x 47.5 cm)
INSCRIPTIONS: on back, upper left:
Picasso
PROVENANCE: Washington Square
Gallery, until 1915(?); John Quinn,
New York, until 1927; purchased
from the Quinn estate by Marcel
Duchamp, in 1927; Collection
Société Anonyme
Yale University Art Gallery, Gift of
Katherine S. Dreier to the
Collection Société Anonyme,
1949.83

This powerful drawing of the head of a nude woman was purchased by Marcel Duchamp in 1927 at the estate auction of American John Quinn, a key early collector of modern art.[1] In the auction catalogue, it was erroneously ascribed to André Derain, though we may surmise that Duchamp recognized Picasso as the artist.[2] This large drawing is one of a long series of portraits of Picasso's partner Fernande Olivier, whom he met in August 1904.[3] Earlier portraits reveal her recognizable features (fig. 1), then morph into that classicizing idealization that Picasso infused into all of his work over the summer of 1906, such as *Nude with a Pitcher* (executed in Gósol, fig. 2).[4] In the latter work, her head is gracefully rotated down while she performs the timeless act of pouring water from a clay pitcher into a bowl. Her features have been simplified into smooth lines and broad areas of light and shade, with her left ear prominent and her hair flowing down her back. Moving away from his Symbolist Blue Period exposés of social injustice and early Rose Period circus figures, Picasso has achieved what we might call modernist classicism. The archaism of this moment in his art, though, swiftly moves on to a more audacious form of primitivism, especially after he saw an exhibition of recent archaeological discoveries of Iberian art from Osuna that opened at the Louvre in spring 1906, which included *Man Attacked by a Lion*, from the late sixth to third century B.C.E. (fig. 3).[5] In this earliest indigenous Spanish art, Picasso found a model of formal simplification and emotional authenticity that he opposed to academic tradition and with which he could specifically identify as a Spaniard. In the Osuna relief, the figure's forms are simplified into geometric regularity: a pattern of small spheres for the hair and smooth, regularly curving lines for the eyelids and eyebrows, with the ridge line of the eyebrow continuing directly down the nose. (This latter feature became a signature of Picasso's art in all subsequent periods.) He most famously abstracted Gertrude Stein's physiognomy in his portrait of 1906 in light of these stylistic features of Iberian art (introduction, fig. 1). Its early influence is subtly evident in *Nude with a Pitcher*— with the continuous line from eyebrow to nose and her prominent left ear—but manifests as a more brutal modernist form in *Head of a Woman*.

An earlier generation of modernists, most notably Paul Gauguin, had led the way in valorizing a variety of nonrealist styles based on the art of cultures distant in time or space.[6] Adaptation of forms to evoke Egyptian or Tahitian art was meant to signify a new, putatively more honest and directly expressive modernism divergent from academic tradition. A similar anti-academicism motivated Picasso to discover for himself ever less naturalist models, and he finally overlaid the Iberian forms in his art of 1906 with aspects of masks and reliquaries from France's colonial holdings in West Africa by 1907.[7] This can be seen by comparing the *Head of a Woman*, with her projecting nose, small mouth near the chin, geometric brows, and overall narrow oval of the face, with a Kota reliquary figure (fig. 4). This innovation culminated in Picasso's major work *Les demoiselles d'Avignon* (fig. 5).

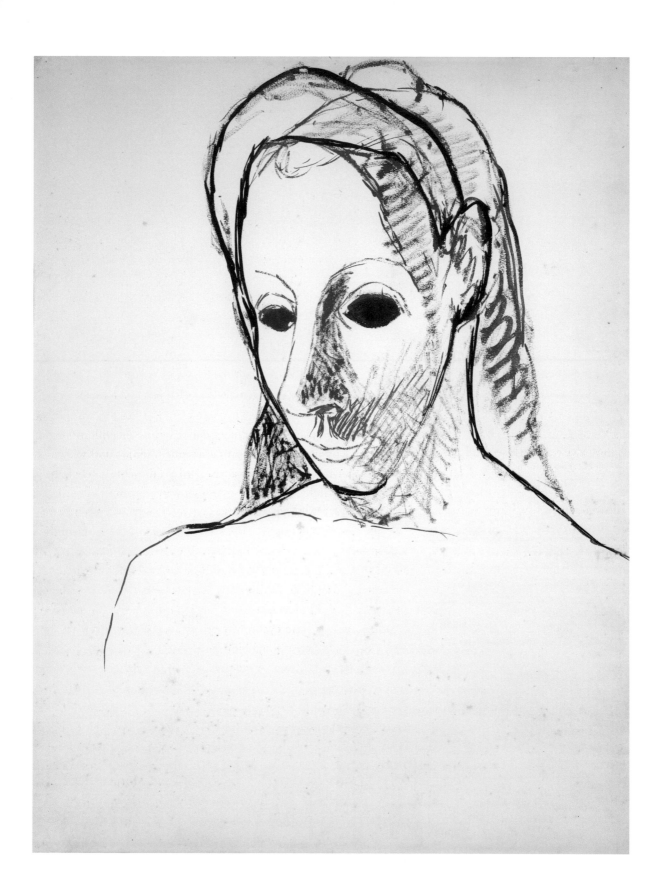

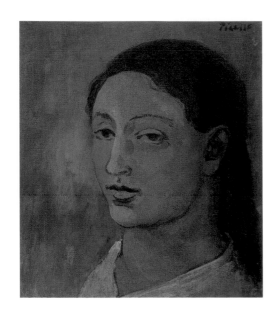

FIGURE 1

Picasso, *Head of Fernande*

Gósol, summer 1906

Oil and gouache on canvas

14¾ x 13 in. (37.5 x 33.1 cm)

Promised gift to the Yale University Art

Gallery of Susan and John Jackson,

B.A. 1967, and the Liana Foundation

FIGURE 2

Picasso, *Nude with a Pitcher*

Gósol, summer 1906

Oil on canvas

39⅜ x 32 in. (100 x 81.3 cm)

Gift of Mary and Leigh Block,

Art Institute

of Chicago, 1981.14

Both Iberian art and African art offered escape routes from the rules and regulations of dominant academic styles as well as from previous versions of modernism, such as Impressionism, with its seeming attachment to the world's appearances. Evoking their forms as modernist primitivism opposed naturalist styles—which were still dominant in the annual salon exhibitions in Paris—with an ever-increasing simplification of style. European primitivist attitudes toward the art of other peoples and other times encode both negative and positive attitudes, including Western assumptions of cultural superiority and admiration for other cultures' presumed ties to primal experience and an innocence long ago lost to European art. In the minds of art critics, avant-gardists, and the general public, such models included child art, cave art, and the art of peoples deemed to be "barbaric" and "savage" in opposition to a moribund civilization dictating unwelcome rules to radical artists. Certainly many academicians rejected modernist art for just this undesirable attitude to tradition, and numerous art critics contemptuously took Fauvists and Cubists to task for their "uglification" of art.[8] In fact, the binary opposition of civilization/barbarism was perfectly continuous with the traditional pairing of civilization/nature: Oceanic and sub-Saharan art was precisely viewed at this time as *natural*—of or pertaining to nature. Duchamp, at the time *Head of a Woman* was incorporated into the Société Anonyme collection, wrote about this period in just such terms:

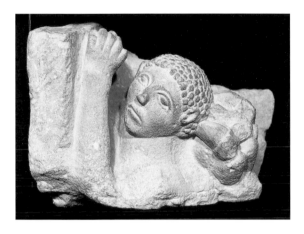

FIGURE 3
Man Attacked by a Lion
Iberian, Osuna,
late 6th–3rd century B.C.E.
Stone
H. 16⅛ in. (41 cm)
Museo Arqueologico Nacional, Madrid

FIGURE 4
Reliquary Figure (Mbulu-Ngulu)
Kota, Gabon, 19th century
Wood, brass, copper, iron, and
cowrie shells
28⅛ x 14¾ x 2⅜ in. (71.5 x 37.5 x 6 cm)
Yale University Art Gallery, Charles B.
Benenson, B.A. 1933, Collection,
2006.51.85

Between 1905 and 1910 Picasso, aided by exotic discoveries, was able to refuse the heritage of the impressionist and "fauvist" periods and to free himself from any immediate influence.

This will be Picasso's main contribution to have been able to start from scratch and keep this freshness about whatever new expressions marked the different epochs of his career.[9]

According to Duchamp, to be "aided by exotic discoveries" was to be "free" of "any immediate influence" and to be "able to start from scratch." We can see that the concept of "influence" is retained for traditional or Western art, while Picasso's response to African and Oceanic art is identical with responding to nature itself.

Thus *Head of a Woman* attempts to counter the Western tradition of female portraiture and the nude and to open a conduit of elemental force. The sensitive red lines of the underdrawing create an elongated visage, with simplified hair, shading, and the basic anatomical features of her face, shoulder, and collarbone. The facial features are monumental, and her forehead, eyes, nose, and left ear are oddly large in scale; in comparison, the mouth is small and de-emphasized. Over this red drawing, already feeling its way toward a new simplification and monumentality, Picasso imposes a thick black line around the figure's face, ear, shoulder, neck, and hair, flattening and distorting the three-dimensionality of the original drawing and conjuring forth a much

FIGURE 5

Picasso, *Les demoiselles d'Avignon*

Paris, 1907

Oil on canvas

8 ft. x 7 ft. 8 in. (243.9 x 233.7 cm)

Museum of Modern Art, New York,

Acquired through the Lillie P. Bliss

Bequest, 333.1939

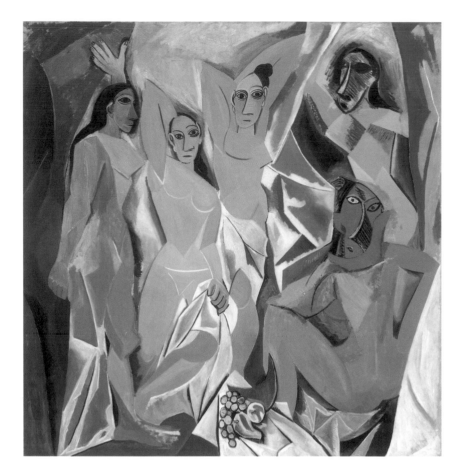

more abstract and masklike oval to outline the face. Other drawings of late 1906 and early 1907, some identical in size, also employ thick black outlines over red, as in *Standing Female Nude* (fig. 6), as if drawing a geometric lesson from the more naturalistic underdrawing. African forms and associations echo through *Head of a Woman*, which is a precursor of—if not also a study for—the head of the figure on the upper right of *Les demoiselles d'Avignon*.

The most striking aspect of this drawing is the unmodulated black ink painted over the whole enormous area of the eyes. Visuality was associated with rationality in Enlightenment tradition, and here Picasso pointedly obliterates the figure's vision, going well beyond the merely closed eyes of earlier versions, of which several examples appear in his sketchbook of this date.[10] The drawing's large, nearly human scale maximizes the shock value of its crude style for the viewer. With the closure of the figure's ability to look outward, the blacked-out eyes necessarily turn inward to the other senses through which we know the world (hearing, touch, motion) and then to other levels of emotional, bodily, and nonrational experience, just those aspects attributed to sub-Saharan Africans and their art. The theme of blindness appeared early in Picasso's oeuvre, in such works as *The Blind Man's Meal* (1903, Metropolitan Museum of Art, New York) and *Head of a Jester* (fig. 7), with its deeply shadowed eye sockets and emphasis on tactility. The

FIGURE 6

Picasso, *Standing Female Nude*
Paris, winter 1906–7
Watercolor
25 x 18⅞ in. (63.5 x 48 cm)
Musée Picasso, Paris, M.P. 529 (recto)

Symbolist movement, from which Picasso had emerged, had already rejected positivism and rationality in favor of such altered states as sleep, religious ecstasy, and even madness.[11] For the Stein circle, who were immersed in the thought of William James and his concept of the stream of consciousness, these other aspects of experience were valorized over vision and rationality.[12] Many of the issues raised by Picasso's primitivist celebration of irrationality prefigured the later turn to "philosophical irrationalism" that pervaded the Stein salon, which Picasso regularly attended. The question remains by what date Stein's undoubted embrace of James's ideas impacted Picasso's art; it may be that a work such as *Head of a Woman* sheds significant light on that question.

Primitivist and antirational ideas were widely held in avant-garde Paris and were specifically shared by many of Picasso's friends among the writers: the poets Guillaume Apollinaire and André Salmon were especially enthusiastic admirers of what they called "barbaric art," and Apollinaire as well as Picasso began to collect African art.[13] Salmon wrote a novel evoking the period of 1907, *La négresse du Sacré-Coeur*, featuring a fictionalized Picasso ("Sorgue, the painter-searcher for idols"), the poets Max Jacob (Septîme Fébur) and himself (Florimond Danbelle), and a "beautiful African dancer" who "willingly left the bourgeois follies of lower Montmartre to

FIGURE 7
Picasso, *Head of a Jester*
Paris, spring 1905
Bronze
H. 16 in. (40.6 cm)
Promised gift to the Yale University Art
Gallery of Thomas Jaffe, B.A. 1971

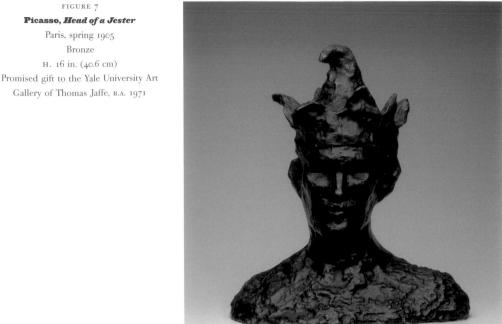

come and divert herself among the painters and poets."[14] Salmon's own
engagement with primitivism informed his critical response to such works
in his "Anecdotal History of Cubism," revealing a fully shared perspective
with Picasso:

> *The artist had already become excited about the black Africans, whom he*
> *placed well above the Egyptians. His enthusiasm was not sustained by a vain*
> *appetite for the picturesque. Polynesian or Dahomean images appeared "sen-*
> *sible" to him. Picasso, in completely changing his work, would inevitably offer*
> *us an aspect of the world not in keeping with what we had learned to see.*[15]

Salmon described heads like these as "masks nearly devoid of all humanity"
and explained that "in choosing the uncivilized artists as guides, he was not
unaware of their barbarism. Quite simply, he logically grasped that they had
attempted the real figuration of being, and not the realization of the usually
sentimental idea we make of it." Salmon acknowledges that Picasso's friends
struggled to accept this new art, concluding that "it was the hideousness of
the faces that paralyzed with fright the not-quite-converted." For the artist
and the writer, however, this was the necessary route to the birth of Cubism,
a movement that transformed modern art by taking radical simplification
much further, as a new and highly subversive language.

— **Patricia Leighten**

1. See Judith Zilczer, *"The Noble Buyer": John Quinn, Patron of the Avant-Garde* (Washington, D.C.: Hirshhorn Museum and Sculpture Garden, Smithsonian Institution Press, 1978).

2. Susan Greenberg, "A Picasso Drawing at Yale, Courtesy of Marcel Duchamp," *Burlington Magazine* (March 2006): 201–2; Katherine Dreier's auction catalogue had a handwritten notation that it was "Picasso—signed on back underneath." Other works by Picasso in the Société Anonyme collection were purchased by Dreier in 1922 from Léonce Rosenberg, including *Bottle, Newspaper, and Musical Instruments* (1913, Indianapolis Museum of Art; D.R. 622); in 1927, Dreier purchased *Bar Table with Musical Instruments and Fruit Bowl* from Arthur B. Davies (1913, current location unknown; D.R. 626).

3. Josep Palau i Fabre, *Picasso: The Early Years, 1881–1907* (New York: Rizzoli, 1981), 380–81. See also Jeffrey Weiss, *Picasso: The Cubist Portraits of Fernande Olivier*, exh. cat. (Washington, D.C.: National Gallery of Art, 2004).

4. The extent to which such works may be called "portraits," especially as Picasso moves into the Cubist period, has been interestingly debated; see Adam Gopnik, "High and Low: Caricature, Primitivism, and the Cubist Portrait," *Art Journal* 43 (winter 1983): 371–76; Weiss, *Picasso*; William Rubin, ed., *Picasso and Portraiture: Representation and Transformation*, exh. cat. (New York: Museum of Modern Art, 1996); and John Klein, "The Mask as Image and Strategy," in *The Mirror and the Mask: Portraiture in the Age of Picasso*, ed. Paloma Alarcó and Malcolm Warner, exh. cat. (New Haven, Conn.: Yale University Press, 2007), 25–35.

5. Scholars disagree to some extent about the dates and sources for the influence of ancient Iberian art on Picasso, though its importance for his art of 1906 and 1907 is not contested; see James Johnson Sweeney, "Picasso and Iberian Sculpture," *Art Bulletin* 23 (September 1941): 191–98; William Rubin, "Picasso," in *"Primitivism" in 20th Century Art*, exh. cat. (New York: Museum of Modern Art, 1984), 247–52; and Patricia Leighten, *Re-Ordering the Universe: Picasso and Anarchism, 1897–1914* (Princeton, N.J.: Princeton University Press, 1989), 79–82.

6. The literature on primitivism is vast; for an overview of the parameters of the concept and a helpful bibliography, see Mark Antliff and Patricia Leighten, "Primitive," in *Critical Terms for Art History*, rev. ed. (Chicago: University of Chicago Press, 2003), 217–33.

7. For the colonial context of Picasso's embrace of African art in 1907, see Patricia Leighten, "The White Peril and *l'Art Nègre*: Picasso, Primitivism, and Anticolonialism," *Art Bulletin* 72 (December 1990): 609–30; and Leighten, "Colonialism, *l'Art Nègre*, and *Les demoiselles d'Avignon*," in *Picasso's "Les demoiselles d'Avignon*,*" ed. Christopher Green (Cambridge: Cambridge University Press, 2001), 77–103.

8. For an overview of this critical response to modernism, see Leighten, "White Peril," 627–28; and Leighten, *A Politics of Form: Art, Anarchism, and Audience in Avant-Guerre Paris* (Chicago: University of Chicago Press, forthcoming), chap. 4. On the history of this concept, see Nina Athanassoglou-Kallmyer, "Ugliness," in *Critical Terms for Art History*, 281–95.

9. Duchamp ms. (written in 1943 for the planned catalogue raisonné of the Société Anonyme collection), box 111, folder 2675, Katherine S. Dreier Papers/Société Anonyme Archive, Yale Collection of American Literature, Beinecke Rare Book and Manuscript Library, Yale University, cited in *The Société Anonyme and the Dreier Bequest at Yale University: A Catalogue Raisonné*, eds. Robert L. Herbert, Eleanor S. Apter, and Elise K. Kenney (New Haven, Conn.: Yale University Press, 1984), 530. The text was finally published, altered by Katherine Dreier, in *Collection of the Société Anonyme: Museum of Modern Art 1920* (New Haven, Conn.: Yale University Art Gallery, 1950), 33. Dreier's edited version reads: "Picasso as a name represents the living expression of a new thought in the realm of esthetics. Between 1905 and 1910 Picasso, inspired by the primitive negro sculpture introduced into Europe, was able to reject the heritage of the Impressionist and Fauve schools and to free himself from any immediate influence. This will be Picasso's main contribution to art. To have been able to start from a new source, and to keep this freshness with regard to

whatever new expressions mark the different epochs of his career."

10. Sketchbook 2, 9R, 10R, 11R, and 12R; see Hélène Seckel, ed., *Les demoiselles d'Avignon*, exh. cat. (Paris: Musée Picasso, 1988), 1:126–27. On visuality and rationality, see Martin Jay, *Downcast Eyes: The Denigration of Vision in Twentieth-Century Thought* (Berkeley: University of California Press, 1993).

11. See Patricia Mathews, *Passionate Discontent: Creativity, Gender, and French Symbolist Art* (Chicago: University of Chicago Press, 1999).

12. Stein had studied with William James while at Harvard, and Leo Stein attested in his memoir *Appreciation: Painting, Poetry, and Prose* (New York: Crown, 1947) to the frequency of discussions of James's philosophical ideas at the Stein residence; see Mark Antliff and Patricia Leighten, *Cubism and Culture* (New York: Thames and Hudson, 2001), 103–10. For another discussion of this topic, see cat. nos. 4 and 6.

13. For the roots of this aesthetic position, see Christopher Miller, *Blank Darkness: Africanist Discourse in France* (Chicago: University of Chicago Press, 1985); and Frances Connelly, *The Sleep of Reason: Primitivism in Modern European Art and Aesthetics, 1725–1907* (University Park: Pennsylvania State University Press, 1995). For discussions of the primitivism of Picasso and his circle, see Rubin, "Picasso"; and Leighten, "White Peril" and *Picasso's "Les demoiselles d'Avignon."*

14. Salmon's novel may have been written as early as 1907–8, but was not published until 1920 (Paris: Éditions de la Nouvelle Revue Française).

15. André Salmon, "Histoire anecdotique du cubisme," in *La jeune peinture française* (Paris: Société des Trente, Albert Messein, 1912), 41–61; trans. in Mark Antliff and Patricia Leighten, *A Cubism Reader: Documents and Criticism, 1906–1914* (Chicago: University of Chicago Press, 2008), 357–67.

4

Vase, Gourd, and Fruit on a Table

Paris, winter 1908–9
Oil on canvas, 28¾ x 23⁹⁄₁₆ in.
(73 x 59.8 cm)
PROVENANCE: Leo and Gertrude
Stein, Paris; Gertrude Stein, Paris;
Alice B. Toklas, Paris, 1946–67;
purchased from the Stein estate by
John Hay Whitney, in 1968
REFERENCES: Zervos II, 126;
D.R. 211
Yale University Art Gallery,
John Hay Whitney, B.A. 1926,
M.A. HON. 1956, Collection,
1982.111.3

It is wonderfully appropriate that Gertrude Stein owned this painting, because her art and thought are central to understanding it (see introduction, fig. 8, for a photograph of Stein with this work). We know that Picasso engaged with the antirationalist philosophies of both Henri Bergson and William James through his close relations with the Steins, who purchased their first work by Picasso in 1905.[1] While at Radcliffe College in Cambridge, Massachusetts, from 1893 to 1897, Gertrude Stein had taken courses with James, and she attested herself to his lasting impact on her in *The Autobiography of Alice B. Toklas*.[2] Scholars of literature have studied the formative importance of James and Bergson on Stein's developing prose style, most notably in pre–World War I works such as "Melanctha" in *Three Lives* (1909), *The Making of the Americans* (1902–11), and *Tender Buttons* (1912–14).[3] In his memoirs, her brother Leo recounts the repeated discussions of James's theories at the Steins' Saturday evening soirees at 27, rue de Fleurus, frequently attended by Picasso, Guillaume Apollinaire, Georges Braque, André Derain, Juan Gris, Max Jacob, Marie Laurencin, Henri Matisse, Henri Rousseau, and numerous others.[4] In addition to Picasso's work, by 1906 Leo and Gertrude Stein had also acquired works by Pierre Bonnard, Paul Cézanne, Honoré Daumier, Matisse, Pierre-Auguste Renoir, Henri de Toulouse-Lautrec, and Félix Vallotton.[5]

James's *Principles of Psychology* (1890) posited a dualism within human nature premised on a tendency toward "indiscriminate" absorption of sensory data and the limitation of that sensory intake instigated by our faculty of "selective attention."[6] James thought "selective attention" served merely utilitarian ends, causing us to "ignore" most things in favor of whatever proved most useful as well as to value the "fixed and unchanging" rather than the dynamic and unending flux of phenomena entering the "stream of consciousness," resulting in utilitarian thought processes. "The classic extreme," he wrote in *A Pluralistic Universe* (1909), "is the denial of the possibility of change, and the consequent branding of the world of change as unreal."[7] James in *The Principles of Psychology* and Bergson in *Time and Free Will* (1889) both singled out language as an instance of such abstraction. Bergson drew comparison between words and mathematical symbols. Just as standardized mathematical units of time constitute impersonal representations of our individual experience of time, so words such as *sad* or *happy* are impersonal labels applicable to everyone regardless of the individual character of our emotions. As impersonalized representations of the self, words are convenient counters adapted to social discourse; yet from the standpoint of the personality experiencing the emotion, they are impoverished, generalized symbols. James and Bergson thought intuition potentially allowed us to transcend these fixed concepts and generalized symbols to give form to "durational" processes, including the temporal flux of our individual thoughts and feelings in all their freshness and novelty.

Stein aimed to capture this "durational" experience by turning language

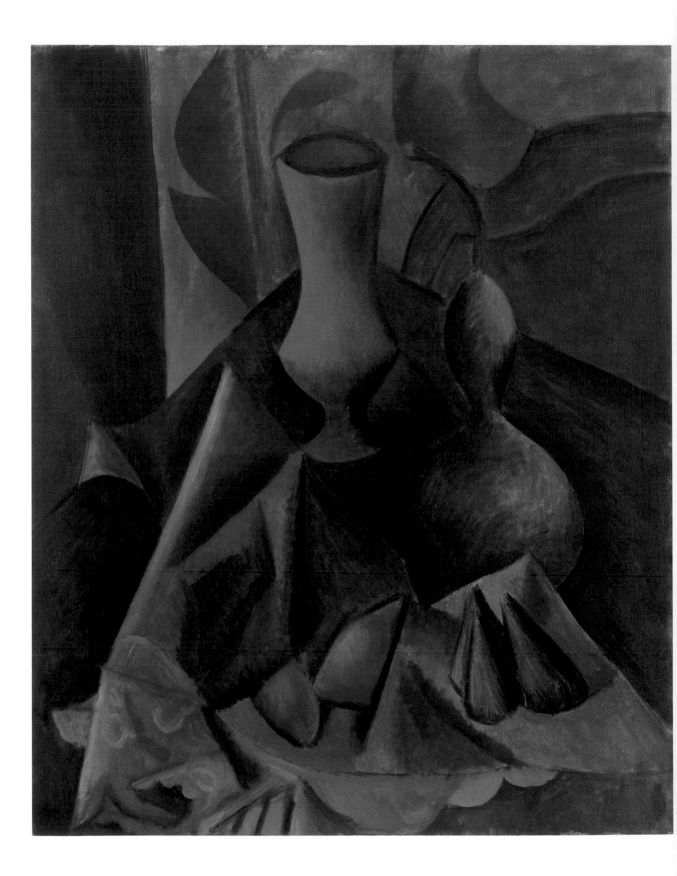

FIGURE 1
Paul Cézanne, *Still Life with*
Vessels, Fruit, and Tablecloth
1879–80
Oil on canvas
17¾ x 21¼ in. (45 x 54 cm)
Hermitage Museum, Saint Petersburg

against itself in order to immerse the reader in this stream of consciousness. As Lisa Ruddick has demonstrated, Stein's prewar technique showed signs "of a progressive disintegration of focus" that expressed Stein's rejection of "selective attention" in favor of the perceptual "disinterestedness" needed to grasp the stream of consciousness in all its plenitude.[8] This absence of focus refused narrative structure or dramatic highlights; instead her writings treat objects, events, and personages in a value-neutral, undifferentiated way, stripping her prose of any literary technique she would associate with "intellectualism." Stein herself claimed that this literary technique was inspired in part by the art of Cézanne; she said in a later interview that he "conceived the idea that in composition one thing was as important as another thing. Each part is as important as the whole, and that impressed me enormously."[9] Picasso shared her valuation of Cézanne. When Leo and Gertrude Stein divided their collection in 1913, Leo got all the Cézannes; to assuage Gertrude's devastation at this, Picasso painted her a watercolor of a Cézannesque apple (Mr. and Mrs. David Rockefeller, New York), dedicated on the back "Souvenir for Gertrude and Alice / Picasso / Christmas 1914."[10]

Vase, Gourd, and Fruit on a Table is a superb instance of Picasso taking such lessons from Cézanne and pushing them further. What Stein called his Green Period is more commonly called his Cézannian phase, at the cusp of Cubism. Part of a series of works painted over the fall and winter of 1908 to 1909, this painting depicts a still-life arrangement reminiscent of numerous Cézanne still lifes. For example, in Cézanne's *Still Life with Vessels, Fruit, and Tablecloth* (fig. 1), we see a wooden table, crumpled tablecloth, fruit, and containers of various sorts—a bowl, carafe, and pail—in front of flowered wallpaper. Although our view appears to be from directly in front of these

objects, Cézanne distorts the space by altering perspectives: to the left of the cloth we have one view of the table with the bottle and fruit sitting firmly on it, while to its right we look down on the table from a higher perspective, seeing much more of the inside of the bowl. As a result of this shift in perspective, the far edge of the table on the right is several surprising inches higher than its back edge on the left: indeed the bowl sits well above the level of the table, or plane, on which the bottle rests. The forms and spatial structure that result suggest Cézanne's own subjective view of the world, not *despite* his close attention to the visual world, but *because of* what Stein called his attention to "each part."[11]

These Cézannian still-life elements are all reassembled by Picasso in *Vase, Gourd, and Fruit on a Table* and throughout a related series of paintings and etchings. The wooden table is turned so that we are looking at its corner rather than at a level front edge, and its surface is tilted up at a dramatic angle; as a result, we look down onto a surface more nearly vertical than horizontal, yet we still look directly at various objects from the side rather than from above, for example the gourd. We may view the foot and bowl of the vase directly from the side, yet simultaneously look down into its mouth. Where the gourd meets this steeply angled surface of the table, which might reveal their spatial incompatibility, Picasso—like Cézanne—simply muffles it with the cloth. But in the Picasso, this only emphasizes the unfamiliarity of the work's conception of space—its difference from a filtered or "discriminate" view—rendering the still-life objects oddly weightless despite their solidity within firm, geometric outlines. Behind the table is the corner of a room with flowered wallpaper and the decorative top of a chair pushed under the table.

We see here an early stage of Cubism: the forms of the objects lack incidental detail and local color, rendered in a palette limited to green, brown, black, and white; light comes from several contradictory sources (the vase is lighted from the left, the gourd from the right, the fruit again from the left); and, most significantly, the linear shapes of things—whether straight or curved—echo each other in ways that emphasize the abstraction of the composition as a whole. For example, the reverse curve of the top of the wooden chair is echoed above it by the same shape in green, masquerading as part of the decorative wallpaper, which lines up almost comically with the long stem of the gourd. The lower part of the plantlike shape on the wall at left juts out at the same angle as the lower bowl of the vase; its upper form echoes the curves of the gourd. The cloth plays a similar role in forming sharp peaks that repetitively echo not only each other but also the forms of the fruit and the hidden corner of the table behind the vase. The two edges of the table also find their echo within the center of the composition: the left edge in a fold of the cloth that lines up with the left foot of the vase as well as the truncated edge of the lemon on the left; the angle of the right edge is repeated by a fold just to the left of the pears. All

FIGURE 2
Picasso, *Fruit Dish*
Paris, winter 1908–9
Oil on canvas
29¼ x 24 in. (74.3 x 61 cm)
Museum of Modern Art, New York,
Acquired through the Lillie P. Bliss
Bequest, 263.1944

these features signal the work's departure from anything like an objective or "rational" conception of reality.

The series as a whole explores like devices and techniques, all on a similarly large and ambitious scale. *Fish and Bottles* (winter 1908–9, Musée d'Art Moderne, Villeneuve d'Ascq, Collection Masurel) is an earlier version of the three pears as well as the gourd; similar distortions of viewpoint can be seen in the bottles, glass, and table.[12] *Fruit in a Vase* (1909, Hermitage Museum, Saint Petersburg) is much more geometric in form and restricted in color, repeating the three pears as cone shapes that line up with the cloth. In *Fruit Dish* (fig. 2), he boldly lines up the gourd with a highly decorative *compotier*, creating undulating rhythms that rise from bottom to top while playing pointedly with altering viewpoints: down onto the table and the foot of the fruit dish; straight at the side of the bowl of the dish and the gourd, then down again into the bowl with its mounting fruit. As if this playful, nearly decorative rhythm were not enough, he then placed this *compotier* with fruit in the background of *Queen Isabeau*, on a table fairly tipping it into our own space (fig. 3).[13] The female figure seems to wear the lace-edged cloth for the headdress and shawl of Isabeau of Bavaria (wife of Charles VI and regent of France, admired for her patronage of the arts but blamed for losing the battle of Agincourt).[14] With the wallpaper leaf shapes from *Vase, Gourd, and Fruit on a Table* on her dress, Isabeau embodies the rhythmic forces of the other works; her manifest imaginary presence as a fifteenth-

FIGURE 3
Picasso, *Queen Isabeau*
Paris, winter 1908–9
Oil on canvas
36¼ x 28¾ in. (92 x 73 cm)
Pushkin Museum of Fine Arts, Moscow

century French queen culminates this series. In this work Picasso, like Stein, rejects the "selective attention" required in bringing perceived objects into a unified one-point perspective in favor of the "disinterestedness" needed to grasp the stream of consciousness in all its perceptual plenitude. Indeed, this stream of consciousness may be said to run through the whole series as it unfolded in his imagination. Picasso's distortions—far more radical than Cézanne's—suggest a new way of affirming subjective perception, which would be strongly reinforced by awareness of the antirational philosophies of James and Bergson. This Jamesian approach intensified as Cubism developed, culminating in such works as *Shells on a Piano* of spring 1912 (cat. no. 6).

— Patricia Leighten

1. For a more extensive treatment of this subject in the Cubist movement generally, see Mark Antliff and Patricia Leighten, *Cubism and Culture* (New York: Thames and Hudson, 2001), 64–110.

2. James R. Mellow, *Charmed Circle: Gertrude Stein and Company* (New York: Praeger, 1974), 31–34; Gertrude Stein, *The Autobiography of Alice B. Toklas*, reprinted in *Selected Writings of Gertrude Stein*, ed. Carl Van Vechten (New York: Vintage, 1962), 73.

3. See Steven Meyer, "Writing Psychology Over: Gertrude Stein and William James," *Yale Journal of Criticism* 8 (1995): 133–63; Lisa Ruddick, "'Melanctha' and the Psychology of William James," *Modern Fiction Studies* 28, no. 4 (winter 1982–83): 545–56; and Ruddick, "William James and the Modernism of Gertrude Stein," in *Modernism Reconsidered*, ed. Robert Kiely with John Hildebidle (Cambridge, Mass.: Harvard University Press, 1983), 47–63.

4. Bruce Kellner, ed., *A Gertrude Stein Companion: Content with the Example* (New York: Greenwood Press, 1988), 144–45; see also Leo Stein, *Appreciation: Painting, Poetry, and Prose* (New York: Crown, 1947).

5. *Four Americans in Paris: The Collections of Gertrude Stein and Her Family*, exh. cat. (New York: Museum of Modern Art, 1970), 88–89.

6. William James, *The Principles of Psychology* (New York: Henry Holt, 1890).

7. William James, *A Pluralistic Universe: Hibbert Lectures to Manchester College on the Present Situation in Philosophy* (New York: Longmans, Green, 1909).

8. Ruddick, "William James," 53.

9. Robert Bartlett Haas, "Gertrude Stein Talking: A Transatlantic Interview," *Uclan Review* 8 (summer 1962): 8.

10. John Richardson, *A Life of Picasso*, vol. 1 (New York: Random House, 1991), 397; D.R. 801. For further aspects of the influence of Cézanne on Picasso, see William Rubin, "Cézannism and the Beginnings of Cubism," in *Cézanne: The Late Work*, exh. cat. (New York: Museum of Modern Art, 1977); and Pepe Karmel, *Picasso and the Invention of Cubism* (New Haven, Conn.: Yale University Press, 2003), 28–31, 38–40, and 69–70.

11. Haas, "Gertrude Stein Talking," 8.

12. Jean Sutherland Boggs, *Picasso and Things*, exh. cat. (Cleveland: Cleveland Museum of Art, 1992), 64–67, attempts to redate the works in this series on the basis of style, somewhat unconvincingly; I have followed the dates given by William Rubin, *Picasso and Braque: Pioneering Cubism*, exh. cat. (New York: Museum of Modern Art, 1989), adopted by the museums that own the works.

13. Redated by Rubin, *Picasso and Braque*, Addenda to the Exhibition Catalogue: Revision of Dates, n.p. For a discussion of the importance of different aspects of the decorative in Cubism, see Joseph Mashek, "The Carpet Paradigm: Critical Prolegomena to a Theory of Flatness," *Arts Magazine* (September 1976): 82–109; Karmel, *Picasso*, 7–10; and Antliff and Leighten, *Cubism and Culture*, 136–42.

14. Pierre Daix, *Picasso: Life and Art* (New York: Harper Collins, 1993), 400, describes this figure as a "studio joke which turns on the resemblance between this decorative figure taken from *Carnaval au bistrot* and the silhouette of the wife of King Charles VI at the end of the fourteenth century," though he cites no source for the information nor addresses why Picasso would bring a "studio joke" to such a degree of finish in a large-scale canvas. Josep Palau i Fabre, *Picasso: Cubism, 1907–1917* (New York: Rizzoli, 1990), 119–22, points out that Picasso worked on a running series of "symbolic figures" in this same period, including this work, as well as harlequins and several Temptations of Saint Anthony (see D.R. 242, 257–61, and 263, and Palau i Fabre, *Picasso: Cubism*, fig. 336). Such subjects may be an aspect of his exploration of Rousseau's work; see Palau i Fabre, *Picasso: The Early Years, 1881–1907* (New York: Rizzoli, 1981), 98. On the tremendous influence of Rousseau, see Christopher Green and Frances Morris, eds., *Henri Rousseau: Jungles in Paris*, exh. cat. (London: Tate Modern, 2005).

5

Saint Matorel

Max Jacob

Book, with 4 etchings by Picasso,
10½ x 7⅞ in. (26.7 x 20 cm)
Published by Daniel-Henry
Kahnweiler, Paris, 1911
Printed by Paul Birault, Paris, for
text and typography; Eugène
Delâtre, Paris, for etchings
Edition 106
INSCRIPTIONS: on colophon: *Picasso*
[and] *Max Jacob*
REFERENCES: Cramer 2;
Geiser/Baer I, 23–26
Gift of John Hay Whitney, Beinecke
Rare Book and Manuscript Library,
Yale University

Saint Matorel was the first book Picasso illustrated and the first Cubist-illustrated book. It belongs to a rich tradition of French *livres d'artistes* that includes Eugène Delacroix's 1828 illustrations for Johann Wolfgang von Goethe's *Faust* and Édouard Manet's 1875 lithographs for Stéphane Mallarmé's translation of Edgar Allan Poe's *Raven*. The *livre d'artiste* is not a mass-produced book, but a luxurious limited edition with original commissioned graphic works. In the case of *Saint Matorel*, both the illustrations and text were commissioned by the publisher, the dealer Daniel-Henry Kahnweiler. Kahnweiler had initially approached André Derain to illustrate *Saint Matorel*, a thinly disguised autobiographical novel by the poet Max Jacob. After reading the novel, however, Derain declined the invitation, saying that the prose would make any attempt at illustration "ridiculous."[1] Kahnweiler then turned to Picasso, who accepted the commission in spring 1910 before leaving for his summer sojourn at Cadaqués.

Unlike Derain, Picasso was unperturbed by the potential disconnect between text and image in *Saint Matorel*, or indeed, by its rather confusing narrative. Instead, he used the commission as an opportunity to work through pressing formal problems he had begun to explore the previous summer while in Horta de Ebro. In the Horta works, Picasso exploited the technique of *passage*—the blending of discontinuous surface planes—to dramatize the alternation between a picture's visual and tactile cues. In the *Saint Matorel* etchings, the vestigial traces of a nude, a still life, a woman in a chair, and a building in a landscape are further flattened, schematized, and made transparent.[2] The resulting play of shifting forms and linear marks crystallized the Analytic Cubist style with which Picasso and Georges Braque would work until 1912.

Very few of Picasso's images for illustrated books function as "illustrations" in any ordinary sense of the word, and *Saint Matorel* is a case in point. The novel tells the story of Victor Matorel, a Parisian metro worker who converts to Catholicism after a mystical encounter with Christ. After being pursued by demons, Matorel retreats to the convent of the Lazarists in Barcelona, where he is christened Frère Manassé, dies, and goes to heaven. Matorel is an alter ego for Jacob, who himself converted to Catholicism after having a vision of God in 1909. Picasso completed five etchings for *Saint Matorel*, four of which were included in the final publication. The first, *Mademoiselle Léonie*, is the least abstract of the group, the vertical figure reminiscent of Picasso's drawings from earlier in 1910, such as *Standing Nude* (fig. 1). In the second, *The Table*, the central massing of forms of *Mademoiselle Léonie* is distributed across the page, the still life's depicted objects vaguely discernible in the suggestion of a cup, a table leg, and a key. In this etching as well are hints of the orthogonal grid Picasso and Braque had developed in the winter and spring of 1910 in order to structure their canvases. The third etching juxtaposes the dramatic perspectival recession of a chaise longue with the insistent frontality of the increasingly abstract figure

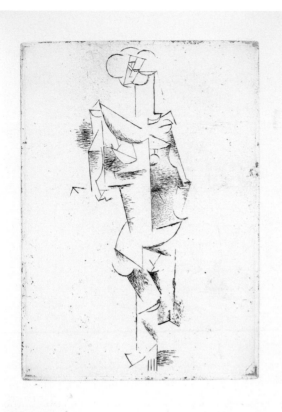

Mademoiselle Léonie

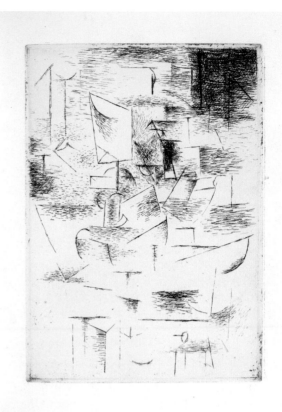

The Table

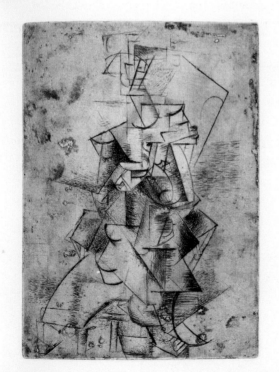

Mademoiselle Léonie in a Chaise Longue

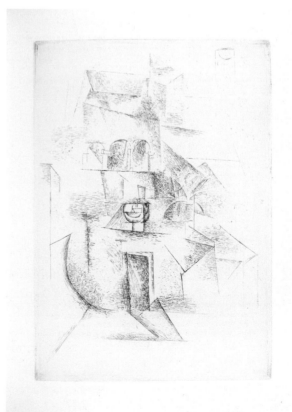

The Convent

FIGURE I
Picasso, *Standing Nude*
Paris, early 1910
Pen and ink
24³/₁₆ x 16⁹/₁₆ in. (61.5 x 42 cm)
Yale University Art Gallery, Gift of
Walter Bareiss, B.S. 1940S, 1978.107

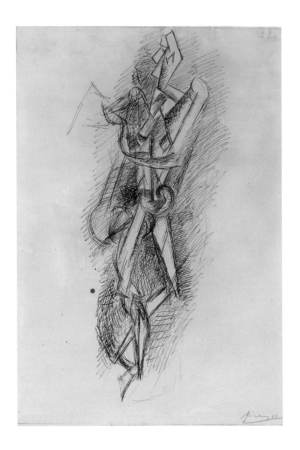

of Mlle Léonie. In the fourth, *The Convent*, architectonic forms are stacked one on top of another in discreet vertical layers, from the open door at bottom to the arcaded wall and bell tower at top. As in drawings Picasso made in 1909 in Barcelona on his way to Horta, the forms do not recede perspectivally, but suggest a concatenation of elements pressed into the shallow space of the page. This system of interlocking, heterogeneous spaces responds to the innovations of Braque's landscapes from L'Estaque in the summer of 1908 as well as Picasso's own *Reservoir, Horta de Ebro* of 1909 (fig. 2), first owned by the Steins, which apply the latticed structure of his *Three Women* of late 1907 to spring 1908 (Hermitage Museum, Saint Petersburg) to a general spatial scheme. In *The Convent*, however, a new system of interpenetration is visible, one that would compel Kahnweiler, in his 1915 study *The Rise of Cubism*, to declare that in the summer of 1910, Picasso "had taken the great step; he had pierced the closed form."[3]

While the etchings' titles refer obliquely to details of Jacob's novel (Mlle Léonie was Matorel's love interest; *The Convent* refers to the Santa Teresa monastery where Matorel retreats[4]), Picasso's illustrations neither depict specific incidents within the plot nor otherwise elucidate the text in any supporting manner. Indeed, in their rigorous breakdown of form, Picasso's etchings verge on an abstraction that renders the conventional idea of illustration, as Derain predicted, "ridiculous." In his 1915 study, Kahnweiler noted the important facilitating role titles played in Cubist art.[5] Faced with

FIGURE 2
Picasso, *The Reservoir,*
Horta de Ebro
Horta de Ebro, summer 1909
Oil on canvas
24⅛ x 20⅛ in. (61.5 x 51.1 cm)
Fractional gift of a private collector to
the Museum of Modern Art, New York,
81.1991

an unfamiliar formal language, Kahnweiler suggested, the viewer might use a work's title as a prompt for more familiar "memory images." Titles were thus a way to anchor or fix an image, thereby preventing the potentially endless proliferation of a picture's meaning.[6] Curiously, Kahnweiler did not publish titles for Picasso's illustrations for *Saint Matorel*, allowing them to further retreat into an independent, hermetic visuality of their own. Indeed, rather than responding to Jacob's existing text, Picasso's etchings may have prompted a new text by the poet, as if to retroactively cement the tenuous relationship between text and image set forth in *Saint Matorel*.

In his 1919 spiritual memoir *La défense de Tartufe*, Jacob described the vision of God that led to his 1909 conversion to Catholicism and the writing of *Saint Matorel* in 1910:

> *I came back from the National Library; I put down my briefcase; I hunted around for my slippers and when I looked up, there was someone on the wall; there was someone there! There was someone on the red wallpaper. My flesh fell away! I was stripped naked by a lightning bolt! . . . The Divine Body is on the wall of a shabby room. Why, Lord? Forgive me! He's in a landscape, a landscape I drew a long time ago . . .[7]*

Jacob's reminiscence is remarkable in the curious pictoriality of its description. Unlike his 1910 description of Matorel's vision, in which Christ enters Matorel's window and takes his hand, Jacob's 1919 apparition is not an embodied presence, but an image thrown upon a wall, its two-dimensionality emphasized by the wallpaper's pattern and flat red color. Jacob, moreover, describes the vision as occurring *within* a picture—"a landscape, a landscape that I drew a long time ago." The vision's effect, further, dematerializes the poet: he is "stripped," his flesh eviscerated by blinding light.[8] The poet's description is a memory refracted, and fixed, through images. While it serves to narrate the "real" events fictionalized in *Saint Matorel*, it also acts as a posterior link between the poet's original vision and Picasso's etchings for Jacob's novel. In Jacob's 1919 description, Picasso's four etchings are combined in a single ekphrastic account. Picasso's *Table* serves as a prompt for the quotidian environment of Jacob's apartment. The schematized Cubist figures stand in for the flat apparition of Christ upon the wall as well as the poet's own body, shattered and shot through with light. *The Convent*, most curiously, surfaces in the guise of a landscape drawn not by Picasso but by Jacob himself.

Jacob's retroactive inscription of himself as both the subject and the generator of the *Saint Matorel* images is rooted in the poet's engagement with Cubism as both a writer and an artist. Jacob was an amateur painter, and in 1909 had secretly resolved to teach himself Cubism. He worked on a number of still-life and landscape drawings through 1910, inscribing upon one of them, "Je m'essayais au cubisme" (fig. 3).[9] Cubism also impacted Jacob's writing; his 1917 book of poems *Le cornet à dés* (The Dice Cup), with its shifting perspectives, use of simultaneity, collage, and formal deconstruction, is often considered to have been inspired by Cubist pictorial strategies.[10] Thus, Jacob's ekphrastic account can also be read as an encounter with the groundbreaking formal language of Cubism, the divine vision both suggestive of a Cubist image and turning the subject into a Cubist effect.

If Picasso's *Saint Matorel* etchings generated a retroactive textual account by Jacob, however, it was surely because they had so radically disrupted the supporting relationship between text and image ordinarily enacted by representational illustration. In semiotic terms, a conventional illustration acts as a pictorial signifier for a signified "idea" conveyed by a text. Picasso's etchings for *Saint Matorel* split apart this narrative link, just as Cubism splits apart the representational link between pictorial mark and depicted object. The arbitrary nature of the sign demonstrated by Cubism in formal terms was thus applied to the overarching relationship between text and image in narrative terms.[11] Yet, if Cubism demonstrated the arbitrary nature of the sign and destroyed the illusionistic basis of painting, Picasso's subsequent works return to representation through various strategies of punning, deformation, appropriation, and pastiche. Similarly, Picasso's subsequent book projects, such as Balzac's *Le chef-d'oeuvre inconnu* (cat. no. 12) and Ovid's *Les métamor-*

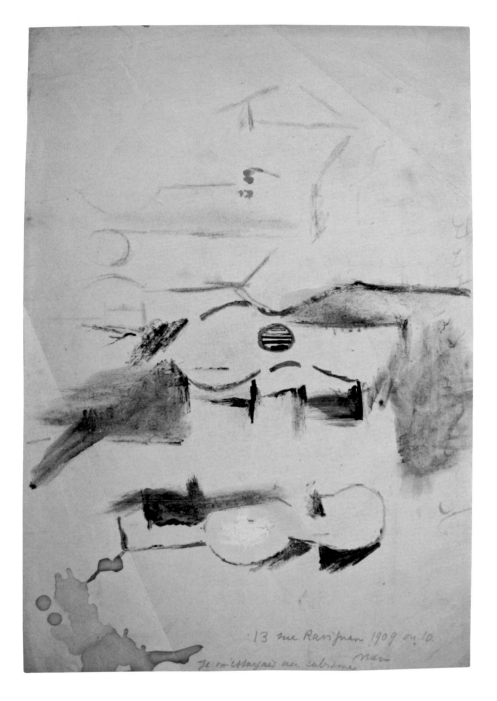

FIGURE 3
Max Jacob, *Still Life*
1909 or 1910
Ink, wash, gouache, watercolor, and
possibly coffee
10¹⁵⁄₁₆ x 7⁹⁄₁₆ in. (27.7 x 19.2 cm)
Private collection

phoses (cat. no. 13), reimagine, rather than repair, the link between image and text broken in *Saint Matorel*. In Picasso's illustrated books, word and image do not form a mutually reinforcing whole. Instead, they dialogue, circumvent, and struggle against one another as if partners in an ongoing match. This dynamic relationship is anticipated in the *jou* that appears in Cubist works such as the 1912 collage *Guitar, Sheet Music, and Wineglass* (cat. no. 7, fig. 3), a truncation of the word *journal* that transforms the objective text of the newspaper (*journal*) into the polysemic play of the game (*jou*).

— **Irene Small**

1. Derain wrote to Kahnweiler, "Pour le manuscrit il m'est impossible de faire quoi que ce soit avec cela. C'est une oeuvre admirable et qui ne me laisserait aucune place et d'ailleurs, cet admirable à part, les préoccupations qui font l'objet de mon travail sont complètement absentes de ce livre (c'est je crois ce qui en fait la beauté). Comme j'ai écrit d'ailleurs à Jacob, c'était quelque chose de beaucoup plus simplet, une historiette pleine de physique et non un si grand poème que infailliblement ridiculiserait toute tentative d'illustration. Le paradoxal et le déconcertant de ce livre donneraient à tout illustrateur l'allure d'un caricaturiste morne tant il supprimerait l'évocation puissante qui est l'idée de ce livre. . . . Pour illustrer bien dans le sens où nous avons commencé il faut que la littérature soit entendue une fois pour toutes entre le public et l'illustrateur sans cela on risque le chaos." Undated letter, printed in *Donation Louise et Michel Leiris: Collection Kahnweiler-Leiris*, exh. cat. (Paris: Centre Georges Pompidou, Musée National d'Art Moderne, 1984), 38. *Saint Matorel* was the first in a trilogy by Jacob; it was followed by *Les oeuvres burlesques et mystiques de Frère Matorel* (1912), with illustrations by Derain, and *Le siège de Jérusalem* (1914), with illustrations by Picasso.

2. John Richardson has suggested that the transparency of the *Saint Matorel* works may also relate to an unrealized illustration project for Guillaume Apollinaire's translation of Miguel de Cervantes's *El licenciado vidriera*, which features the notion of a body made of glass, and which Picasso was considering in 1910. John Richardson, *A Life of Picasso*, vol. 2 (New York: Random House, 1996), 153–54.

3. Daniel-Henry Kahnweiler, *The Rise of Cubism*, trans. Henry Aronson (New York: Wittenborn, Schultz, 1949), 10; written in 1915 and originally published 1920 in Munich as *Der Weg zum Kubismus*. The gridlike systems Picasso explored in the *Saint Matorel* etchings have roots in the lattice of curved lines and facets he established first in *Three Women*. On the movement between these various gridlike structures and their relation to three-dimensional projective space and the pictorial plane, see Pepe Karmel, *Picasso and the Invention of Cubism*

(New Haven, Conn.: Yale University Press, 2003), esp. chap. 2, "Spaces."

4. Picasso traveled to Barcelona in early August 1910. It is possible that he may have visited the Santa Teresa monastery where Matorel is meant to have his conversion at that time.

5. Kahnweiler, *Rise of Cubism*, 13.

6. Roland Barthes comments on this relationship between titles and (in his case, photographic) meaning in "The Rhetoric of the Image," in *Image, Music, Text*, trans. Stephen Heath (New York: Holl and Want, 1977).

7. "Je suis revenu de la Bibliothèque nationale; j'ai déposé ma serviette; j'ai cherché mes pantoufles et quand j'ai relevé la tête, il y avait quelqu'un sur le mur! Il y avait quelqu'un sur la tapisserie rouge. Ma chair est tombée par terre, j'ai été déshabillé par la foundre! . . . Le Corps Céleste est sur le mur de la pauvre chambre! Pourquoi, Seigneur? Oh! Pardonnez-moi! Il est dans un paysage, un paysage que j'ai dessiné jadis, mais Lui! Quelle beauté! Élégance et douceur!"; translated in *Hesitant Fire: Selected Prose of Max Jacob*, trans. Moishe Black and Maria Green (Lincoln: University of Nebraska Press, 1991), 36. Jacob's *La défense de Tartufe: Extases, remords, visions, prières, poèmes, et méditations, d'un juif converti* (Paris: Société Littéraire de France, 1919) was illustrated with works by both Picasso and Jacob. On the relationship between Picasso and Jacob, see *Max Jacob et Picasso*, exh. cat. (Paris: Éditions de la Réunion des Musées Nationaux, 1994).

8. Jacob's description here evokes Apollinaire's comment of 1913 that "a man like Picasso studies an object as a surgeon dissects a cadaver." Guillaume Apollinaire, *The Cubist Painters*, trans. Peter Read (Berkeley: University of California Press, 2004), 13.

9. As several commentators have observed, Jacob's dramatic religious conversion may bear a complicated relationship to his feelings toward Picasso. When Jacob was baptized in 1915, Picasso served as the poet's godfather. Moreover, as the French critic LeRoy C. Breunig has commented, Jacob's vision of Christ "coincides with Picasso's

departure from the Bateau-Lavoir," and while it would be "audacious to claim that Christ replaced Picasso in Jacob's life . . . Picasso had become . . . the shadow in the place of God and Jacob absolutely worshipped him." LeRoy C. Breunig, "Max Jacob et Picasso," *Mercure de France* (December 1957), cited in Gerald Kamber, *Max Jacob and the Poetics of Cubism* (Baltimore: Johns Hopkins Press, 1971), xxiv. Jacob dedicated Picasso's copy of the book "Saint Matorel à Picasso."

10. See, for example, Kamber's discussion in *Max Jacob and the Poetics of Cubism.*

11. Interestingly, Picasso's *Saint Matorel* etchings appeared precisely at the time when Cubism began to be debated within the discursive domain. Although the term *Cubism* dates to 1908, Apollinaire first used the word in print in 1910 while writing about a group show of the new Cubist painters Robert Delaunay, Marcel Duchamp, Henri Le Fauconnier, Albert Gleizes, Marie Laurencin, and Jean Metzinger. Apollinaire's writings on Cubism culminated in *Méditations esthétiques: Les peintres Cubistes,* published in March 1913. Meanwhile, André Salmon published his "Anecdotal History of Cubism" in *La jeune peinture française* in October 1912, and Gleizes and Metzinger published their treatise *Du "cubisme"* a month later. Thus, although Cubism was publicly launched through critical rhetoric, textual statements, and art-historical explanations between 1910 and 1913, both Picasso and Braque contributed no written statements about Cubism until 1923 and 1917, respectively.

6
Shells on a
Piano

Paris, spring 1912
Oil on canvas, 9½ x 16⅛ in.
(24.1 x 41 cm)
INSCRIPTIONS: on verso: *Picasso*
PROVENANCE: Galerie Kahnweiler,
Paris (archive photograph 215); 1st
Kahnweiler sale, Drouot, Paris, June
13–14, 1921, cat. no. 76; Daniel-
Henry Kahnweiler, Berlin; Edward
von Saher, Amsterdam; M. Knoedler
& Co., Inc., New York; purchased
from Knoedler by Katharine
Ordway, June 18, 1948
REFERENCES: Zervos II, 295;
D.R. 461
Yale University Art Gallery, The
Katharine Ordway Collection,
1980.12.8

Gertrude Stein's engagement with the perception theories of William James, with whom she studied at Harvard, plays an important role in the Cubism of Picasso and Georges Braque, who both attended Stein's Saturday evening salons, where these ideas were frequently discussed (for a discussion of James's thought and its influence on Stein's early writing, see cat. no. 4). James thought "selective attention" served merely utilitarian ends, causing us to "ignore" most stimuli in favor of whatever proved most useful and to value, as a result, the "fixed and unchanging" rather than the dynamic and unending flux of phenomena entering the stream of consciousness. James and French philosopher Henri Bergson, also influential for the Cubist movement, thought intuition potentially allowed us to transcend these fixed concepts in favor of the "durational" processes that form the temporal flux of an individual's thoughts and feelings.[1]

Responding to these ideas, Stein's prewar literary technique showed a "progressive disintegration of focus" that expressed her rejection of "selective attention" in favor of the perceptual "disinterestedness" needed to grasp the stream of consciousness.[2] This absence of focus refused narrative structure or dramatic highlights, treating objects, events, and persons in a value-neutral, undifferentiated way and deliberately stressing ambiguity rather than clarity. There is no sequential train of discrete thoughts in Stein's writing, nor are there single thoughts; instead Stein presents us with a complex intermingling of thoughts that dissolve into each other to form an unbroken, rhythmic stream. Initially Stein's prose appears to be repetitive; but on close inspection no two phrases are identical, and each overlaps or invades the next, conveying both mental continuity and diversity, what Bergson and James would call the "qualitative" multiplicity of our "duration." No sensation in our consciousness is identical to the next, but their permeability and intricate mutation captures, to quote Steven Meyer, "the process of someone working something through."[3] The opening lines of Stein's literary portrait of Picasso, written in 1909 and published in the August 1912 edition of *Camera Work*, illustrate this process perfectly:

> *One whom some were certainly following was one who was completely charming. One whom some were certainly following was one who was charming. One whom some were following was one who was completely charming. One whom some were following was one who was certainly completely charming.*[4]

With close attention we realize that the second and third sentences are identical to the first except in the absence of the adverb *completely* in the second and of *certainly* in the third. As Meyer notes, Stein uses the adverbial forms of completeness and certainty "to convey the partiality and uncertainty of any particular assertion one might make."[5] To arrive at a definitive statement, in the Jamesian mode, would be to fix the stream of consciousness by suspending discussion; Stein by contrast wishes to unfold her assessment of Picasso in a series of unending permutations. "Something had been coming

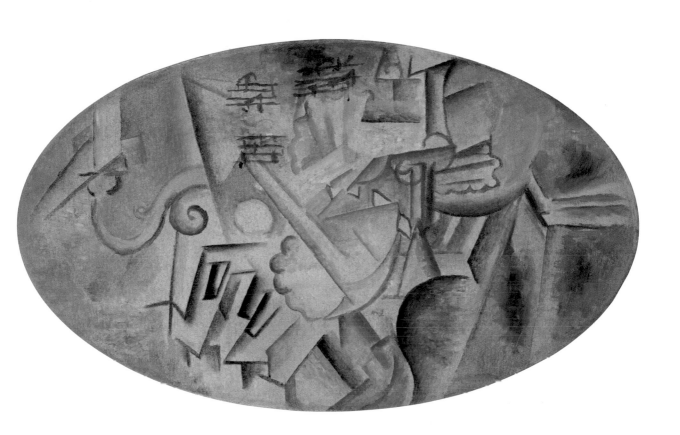

out of him," Stein continued, "and it had meaning, a charming meaning, a solid meaning, a struggling meaning."[6]

The "selective vision" rejected by Stein arguably had its counterpart in Picasso's and Braque's radical departure from single-vanishing-point perspective. Traditional perspective gave paintings a focal center where the perspective lines converged, as in Jean-Siméon Chardin's *Still Life with a White Mug* (fig. 1); in academic art, a painting's primary subject was often found at this point of convergence, while a secondary subject's relative importance could be gauged by its distance from this focal center. Picasso's Cubist subjects, by contrast, were situated in a nebulous space bearing none of the characteristics of traditional illusionism. Picasso underscored the contrast by including various bits of realism amid the confusing flux of abstract forms; three-dimensional perspective and the focal hierarchies intrinsic to it are banished from the canvas. The "logic" of illusionism is violated in other ways that approximate Stein's method. In Stein's prose, the rhythmic play of repetition and difference acts to undercut the separation of one thought from another. In Picasso's painting the elements of pictorial illusionism serve not to delineate objects but to confound our expectations, acting to merge objects with their surroundings.

Shells on a Piano constitutes a close visual equivalent to Stein's "disinterested" prose. The objects we would reduce to "stock types" by virtue of our linguistic labels—scallop shells, candelabra, and piano keys—dissolve into the confusing play of solids and voids that permeate the canvas. Picasso gives free play to his individual perception of the objects in the still life: a piano with its keys exposed and the corner of its upright top visible at right; a candelabra at left, casting its light downward; and sheet music, with its musical notations. While parts of these objects come into clear focus, their

curves and angles are confusingly repeated over the surface of the canvas so as to obscure any discrete or unified view (this technique had begun with *Les demoiselles d'Avignon* [cat. no. 3, fig. 5] and is visible in works like *Vase, Gourd, and Fruit on a Table* [cat. no. 4]). Light comes from every direction: down onto the candelabra, up onto the bottom of the central shell, from the right onto the corner of the piano case. Multiple or simultaneous viewpoints intersect each other, and the space in which they may be presumed to exist becomes multiple spaces that displace one another, setting the whole picture in restless motion.[7] Picasso subjects the still life to Steinian ambiguities: the piano is reduced to a few caricatural elements, such as the keys jangling in ragtime, while others disappear altogether. We can see musical notations on the sheet music but only one corner of the paper on which they are printed; the rest has merged with the surrounding flux, appearing to become musical notes heard as much as seen. Chiaroscuro—the use of shadow and light to define volume—is not used to define the borders and edges of objects, or to establish the origin of a single light source. Following the conventions employed in traditional still-life painting, as in Chardin, chiaroscuro should aid us in defining the three-dimensionality of the objects as well as their location in an interior space. Such expectations—the equivalent to "intellectualism" in the Jamesian vocabulary—are instead overturned by the alternating play of light and shade across surfaces that may or may not resolve into identifiable objects in our imaginations.

Other aspects of this work place it within the sphere of Bergson's influence, whose anti-Enlightenment emphasis on intuition went further than James's to consider a variety of other forms of knowledge. Rationality has since ancient times been associated with vision.[8] Bergson, in rejecting rationality and the intellect as limited, inferior forms of knowledge, privileged the other senses—hearing, touch, taste, and bodily motion—as well as memory. He compared our "duration" to a melody and argued that rhythm in the arts, including poetry and painting, could express this inner *durée*.[9] These ideas were central to the development of Cubism, as Mark Antliff has demonstrated, most notably among the Puteaux Cubists and other Parisian modernists.[10] Some of them undertook to paint "memory paintings," including Albert Gleizes, *Portrait of Jacques Nayral* (1911, Tate Modern, London); Gino Severini, *Souvenirs de voyage* (1910–11, private collection);[11] and Picasso, *Souvenir du Havre* (fig. 2). Italian Futurist Severini was resident in Montmartre in 1906 and close to the Picasso circle throughout this period.[12] According to Antliff, "By his own admission, Severini painted this image [*Souvenirs de voyage*] in response to his reading of Bergson's 'Introduction to Metaphysics.' . . . [He] selected a vast array of memory images related to travel and distributed them around a central image of a well, taken from his home town [Cortona]."[13] Severini recalls that:

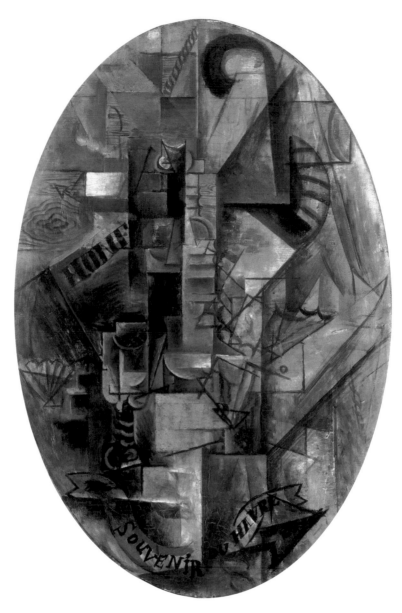

FIGURE 2
Picasso, *Souvenir du Havre*
Paris, May 1912
Oil on canvas
31⅞ x 21¼ in. (81 x 54 cm)
Private collection, Basel

*Once, before the Futurist exhibition [February 1912] as I recall, [Picasso]
came to my studio, and I showed him my painting,* Souvenirs de Voyage,
*which he liked very much. In that picture, I had assembled all the things that
had impressed and captivated me during a trip to Italy and also in Paris,
without worrying about the unity of time and place. Objects were depicted
only because I liked them, so they had to harmonize and fit together. A short
while later in his studio on rue Ravignan, he showed me his painting,*
Souvenir du Havre, *completely different from mine. Mine was ultra Neo-
Impressionistic, ultra Signac, and his ultra Corot. Braque was present and
seemed surprised at the painting. In a sweet-and-sour tone he said, "The rifle
has changed shoulders," but Picasso held his tongue. He went on smoking his
pipe behind us, wearing that typical smile of his which probably meant some-
thing like: "How do you like my little joke?"*[14]

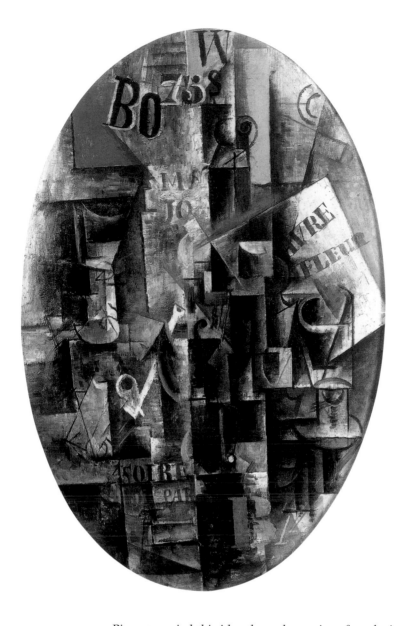

Picasso carried this idea through a series of works in spring 1912 substantive enough to suggest the seriousness of his engagement with the concept of memory as part and parcel of Bergsonian duration. *Shells on a Piano, Souvenir du Havre, The Scallop Shell ("Notre avenir est dans l'air")* (spring 1912, private collection, Chicago), *Violin, Wineglasses, Pipe, and Anchor* (fig. 3), and several related drawings in the Musée Picasso, Paris, are all based on his memories of a trip in April 1912 to Le Havre with Braque, who showed him around his hometown in Normandy with side trips to Rouen and Honfleur, a nearby fishing village.[15] In each work, memories of the scallops he enjoyed there mingle with other sensory experiences he shared with Braque on the trip: viewing the harbor, complete with ships, anchors, and ropes; listening to violin and piano music in the bars they visited; drinking rum, wine, and Bass ale; smoking pipe tobacco, as well as reading matter

leading to remembered conversations.[16] Each of these images evokes the senses of hearing, taste, and smell as well as other states of mind; the scallop shells act to evoke the harbor experiences, somewhat like Marcel Proust's madeleine. To locate these recollections, a poster of an event in HONF[LEUR] forms part of the background of *Souvenir du Havre*, while [H]AVRE and [HON]FLEUR reappear in *Violin, Wineglasses, Pipe, and Anchor*. These paintings clearly combine images that only coincide in Picasso's memory and not in a single café at a unified moment.[17] *Souvenir du Havre* even has the words of its title emblazoned on a floating rococo ribbon at the bottom, a device that stands out dramatically from the treatment of objects in the fictive space. The ribbon boldly announces Picasso's new theme—memory, token of remembrance—and is virtually unique in his oeuvre before 1914.[18]

— Patricia Leighten

1. Mark Antliff, *Inventing Bergson: Cultural Politics and the Parisian Avant-Garde* (Princeton, N.J.: Princeton University Press, 1993); and Mark Antliff and Patricia Leighten, *Cubism and Culture* (New York: Thames and Hudson, 2001), 64–110.

2. Lisa Ruddick, "William James and the Modernism of Gertrude Stein," in *Modernism Reconsidered*, ed. Robert Kiely with John Hildebidle (Cambridge, Mass.: Harvard University Press, 1983), 53.

3. Steven Meyer, "Writing Psychology Over: Gertrude Stein and William James," *Yale Journal of Criticism* 8 (1995): 133–63.

4. Gertrude Stein, "Picasso" (1909), *Camera Work* (August 1912): 29–30. This text is best known in an incomplete form; for the complete text see Mark Antliff and Patricia Leighten, *A Cubism Reader: Documents and Criticism, 1906–1914* (Chicago: University of Chicago Press, 2008), 50–52.

5. Meyer, "Writing Psychology Over," 151.

6. Stein, "Picasso."

7. The concepts of simultaneity and the fourth dimension were articulated in Cubist circles in this same period and are also crucial to an understanding of Cubist theory; see Linda D. Henderson, *The Fourth Dimension and Non-Euclidean Geometry in Modern Art* (Princeton, N.J.: Princeton University Press, 1983).

8. See Martin Jay, *Downcast Eyes: The Denigration of Vision in Twentieth-Century Thought* (Berkeley: University of California Press, 1993).

9. Antliff, *Inventing Bergson*, 65–66.

10. In addition to *Inventing Bergson*, see Mark Antliff, "Organicism against Itself: Cubism, Duchamp-Villon, and the Contradictions of Modernism," *Word and Image* 12, no. 4 (October–December 1996): 366–88; Antliff, "Cubism, Futurism, Anarchism: The 'Aestheticism' of the *Action d'art* Group, 1906–1920," *Oxford Art Journal* 21, no. 2 (1998): 99–120; and Antliff, "The Rhythms of Duration: Bergson and the Art of Matisse," in *The New Bergson*, ed. John Mullarkey (Manchester, England: Manchester University Press, 1999), 184–208.

11. *Souvenirs de voyage* was thought to be lost for many years, but in the 1990s was discovered in a private collection. Severini gave it a variety of dates in later years, ranging from 1909 to 1911; he dated it 1911 in his *Plastic Analogies of Dynamism*, written in 1913 but not published until 1957. See Anne Coffin Hanson, *Severini futurista, 1912–1917*, exh. cat. (New Haven, Conn.: Yale University Art Gallery, 1995), 63, who dates the work to 1910–11.

12. In 1906, his first year in Paris, Severini came to know Picasso, Braque, Juan Gris, the poet Max Jacob, and critic André Salmon; see his memoir, *The Life of a Painter: The Autobiography of Gino Severini*, trans. Jennifer Franchina (Princeton, N.J.: Princeton University Press, 1995), 32–34.

13. Antliff, *Inventing Bergson*, 53–56.

14. Severini, *Life of a Painter*, 96.

15. See Judith Cousins, "Documentary Chronology," in *Picasso and Braque: Pioneering Cubism*, ed. William Rubin, exh. cat. (New York: Museum of Modern Art, 1989), 389. For an extensive discussion of the visual relationship of *Violin, Wineglasses, Pipe, and Anchor* to this series, its allusions and numerous related drawings, see Pepe Karmel, *Picasso and the Invention of Cubism* (New Haven, Conn.: Yale University Press, 2003), 185–94.

It is very interesting that this work received one of the few titles given by Picasso, "le violon d'Ingres," in a manuscript list of spring 1912, in Laurence Madeline, ed., *"On est ce que l'on garde!": Les archives de Picasso*, exh. cat. (Paris: Éditions des Musées Nationaux, 2003), 57; the French phrase connotes something like an obsessive hobby and could humorously suggest that the series of memory paintings had become a lengthy preoccupation for the artist. Daniel-Henry Kahnweiler later changed the title to its present merely descriptive one; see Karmel, *Picasso and the Invention of Cubism*, 186 and 220.

16. In *The Scallop Shell*, the "ChB" likely evokes a packet of "tabac chébli"; see D.R. 464. The words "Notre Avenir est dans l'Air" come from the cover of a brochure advocating the military use of airplanes in the next war; for a discussion of its military and antimilitary context, see Patricia Leighten, *Re-Ordering the Universe: Picasso and Anarchism, 1897–1914* (Princeton, N.J.: Princeton University Press, 1989), 129.

17. My reading of this group of works as memory paintings reveals that the title *Shells on a Piano* is incorrect in suggesting that the scallop shells are resting on the piano; rather, they evoke a memory of an evening during which Picasso ate scallops and listened to music, not necessarily at the same time and place. I would therefore suggest renaming the work *Scallop Shells and Piano*.

18. Picasso played again with illusionistic labels in 1914 and after; for example, he painted a fake museum label with his name in capitals over the frames of *Pipe and Sheet Music* (cat. no. 28, fig. 4; D.R. 683); *Glass and Bottle of Bass* (private collection; D.R. 684); *Bottle of Bass, Ace of Clubs and Pipe* (location unknown; D.R. 685), all spring 1914; and *Bottle of Anís del Mono, Glass, and Playing-Card* (fall 1915, Detroit Institute of Arts; D.R. 838).

Dice, Packet of Cigarettes, and Visiting-Card

Paris, early 1914
Painted and printed paper, graphite,
and watercolor, 5½ x 8¼ in.
(14 x 21 cm)
INSCRIPTIONS: on verso: *Picasso*
PROVENANCE: Gertrude Stein, Paris;
Mrs. Charles Goodspeed, Chicago,
before 1939; Mrs. Gilbert W.
Chapman, New York (formerly Mrs.
Charles Goodspeed); gifted by Mrs.
Chapman to the Gertrude Stein and
Alice B. Toklas Collection, in 1981
REFERENCES: Zervos II, 490;
D.R. 661
Gertrude Stein and Alice B. Toklas
Collection, Yale Collection of
American Literature, Beinecke Rare
Book and Manuscript Library,
Yale University

This small, stunning collage reveals Picasso's artistic practice at its most playful, yet it also complexly, and quite purposely, rivals Gertrude Stein's own modernist writing (on Stein's writings, see cat. nos. 4 and 6). It starts with a story: one day Gertrude Stein and Alice B. Toklas called on Picasso, but he was out.[1] When he returned, he found their calling card, with the corner turned down to signify that they had been there in person. Picasso made the collage, pasting their card into the work, and then called on Stein and Toklas to present his clever gift. Unfortunately, they were not at home; he left it, as a calling card.

This collage is one of the artist's most visually austere. The way that it combines words and images, though, is extremely rich. Fictively, we are looking at part of a table, whose upper right corner is drawn in black crayon. Upon it lies a pair of dice, a packet of Élégantes cigarettes, and the *carte-de-visite.* All the objects on the table cast shadows down and to the left, creating an unusually consistent light source for a Cubist work. Picasso had earlier incorporated an image of Gertrude Stein's calling card into a painting—*The Architect's Table* of early 1912 (Caws, "The Meeting Place of Poets," fig. 7)—announcing her as "Mis[s] Gertrude Stein," an avant-garde artist like himself, a friend, and his patron. Incorporating her card acknowledged her support of his work in a variety of ways.[2] Here he suggests more pointedly the importance of Stein's and Toklas's support of his art by gluing the cigarette label from the packet alongside its cover, reading "contributions indirectes" (the label refers to the tax on consumable goods). Punning as well in English as in French, he honors their "contributions" to his art, which—ever protective of his independence—remain "indirect." The dice—one white, one black—suggest a game of chance or a domestic tabletop game.[3]

One of the most striking things in this work is the pair of female names on the card: Stein and Toklas openly present themselves as a pair, both residents at 27, rue de Fleurus (fig. 1), which surely constitutes a bold act for the time, announcing their cohabitation and love relationship. Toklas had moved into the house shared by Stein and her brother Leo in 1910; after three difficult years, Leo moved out in 1913.[4] Hence this card could have been their announcement of lesbian conjugality, and Picasso's use of it a sexual liberationist's act of support.[5] He goes further in the collage by not only incorporating their joint visiting card but also including a packet of cigarettes equally socially ambiguous in its signification. Toklas was a heavy smoker; this package, glued directly onto the ground, is decoratively feminized, with delicate leaves and vines depicted across the lemon yellow surface; indeed, these Élégantes may well have been targeted to women, a commercial shift that began in the mid-1880s when smoking remained, at least publicly, a male preserve. Smoking cigarettes in this period was still enormously daring for women, and even men mostly smoked pipes and cigars until World War I. Earlier in the century, women who smoked were widely

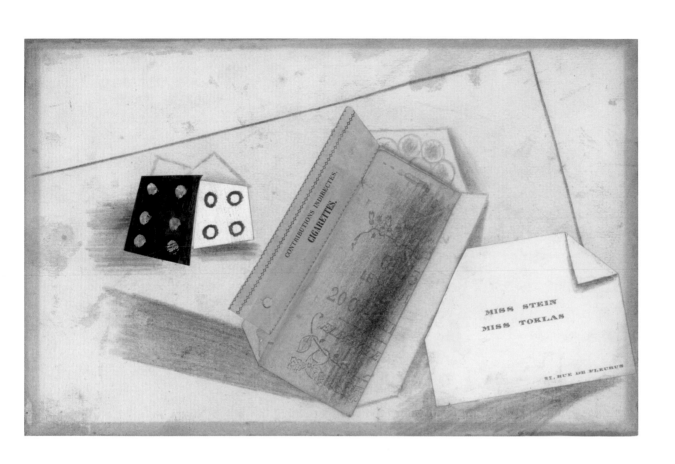

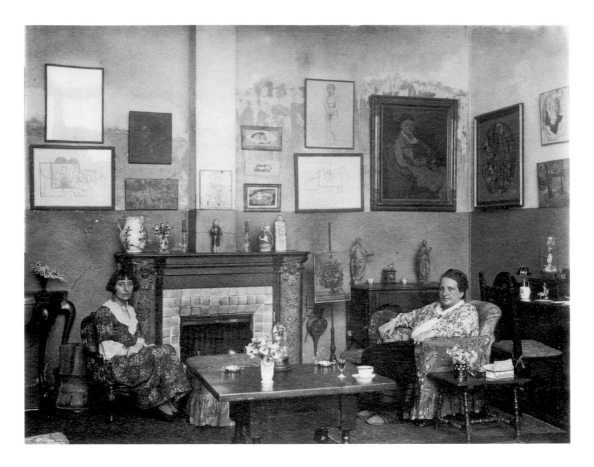

FIGURE 1
Man Ray, *Gertrude Stein and Alice B. Toklas in their Salon at 27, rue de Fleurus, Paris*
1922
Photograph
Gertrude Stein and Alice B. Toklas Papers, Yale Collection of American Literature, Beinecke Rare Book and Manuscript Library, Yale University Picasso's *Segment of Pear, Wineglass, and Ace of Clubs* (cat. no. 8) can be seen in the upper right.

assumed to be lower-class workers or prostitutes; beginning in the 1890s, "respectable" female smokers increasingly appeared, viewed as "eccentrics or feminists affirming the equality of the sexes."[6] Richard Klein in *Cigarettes Are Sublime* discusses the interesting link between cigarettes and "the idea of suspending the passage of ordinary time," which could suggest how the nearly omnipresent theme of tobacco in Picasso's Cubist period relates on yet another level to the ideas of William James and Henri Bergson.[7]

In form, the work is simple yet bold. Our view of the still life is directly down onto the table on which the dice, cigarettes, and card sit. The three objects jostle in scale as much as in space: the calling card is nearly as big as the cigarette pack, and the dice are comparatively even bigger. All three are too large for the table and seem to muscle each other within the distorted space. Illusion and abstraction also play tensely: the actual calling card has a drawn and merely fictive dog-eared corner; both the cigarette packet and its seal alongside are "real," yet they play the role of powerful abstract rectangles in comparison with the delicate drawing of the cigarettes themselves at the top of the packet, neatly rolled, stacked together, and seen from above, though with insufficient space for them to make three-dimensional sense. The dice are likewise seen from two different angles—and evidently from two different distances, resulting in their differing scales—with a view down onto another set of sides; but their pips, six and four, read with a cartoon-

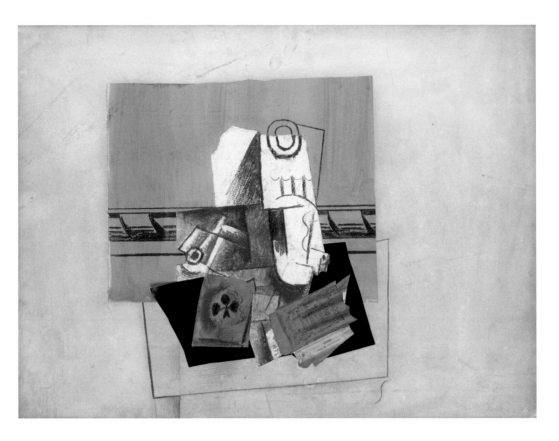

FIGURE 2
Picasso, *Wineglass, Ace of Clubs,*
Packet of Cigarettes
Paris, spring 1914
Pasted papers, charcoal, and pencil
20½ x 23⅜ in. (52 x 67 cm)
Musée Picasso, Paris, M.P. 379

like clarity. Picasso draws easily on his arsenal of Cubist visual tricks: altering scale, abstraction versus illusion, shifting points of view.

The overall abstraction of the depicted space and objects contrasts pointedly with the decorativeness of the cigarette packet, rendered in a commercial parody of academic naturalism. He employs this same contrast with another use of an Élégantes cigarette packet in *Wineglass, Ace of Clubs, Packet of Cigarettes* (fig. 2), where the decorative packet, with its fragile leaves and vines, subtly plays against an even more forcefully geometric set of forms. In a great variety of ways, Picasso pursued these pointed contrasts in a series of works to which *Dice, Packet of Cigarettes, and Visiting-Card* belongs, in order to contemplate and develop his new visual language, an abstract and increasingly fluid shorthand for the more hard-won abstractions of the previous seven years. He had used this idea throughout the Cubist period; one can easily think of the suggestive and highly readable still life of cut melon and grapes in the otherwise disturbingly violated forms of *Les demoiselles d'Avignon* (cat. no. 3, fig. 5). *Guitar, Sheet Music, and Wineglass* (fig. 3) overtly plays with this theme of representational difference in its contrast between the decorative wallpaper background, scattered over with feminine and naturalistic sprays of flowers, and the grandly austere geometric shapes obliterating that figurative language system's understanding of the world.[8] In the series of 1914, *Pipe, Wineglass, and Box of Matches* (fig. 4) makes

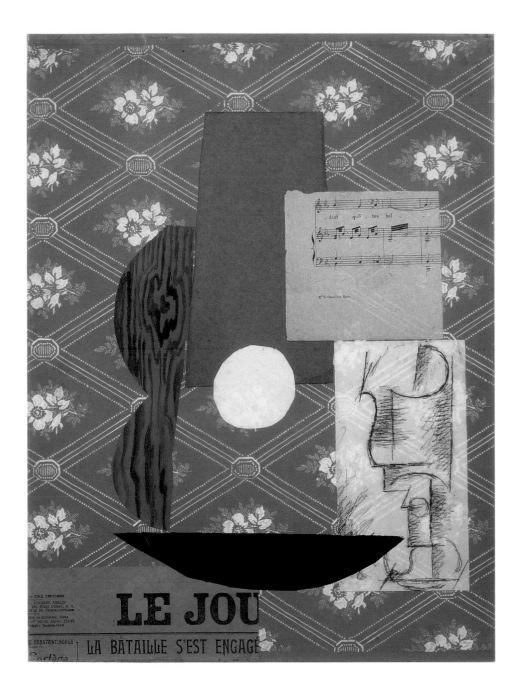

FIGURE 3
Picasso, *Guitar, Sheet Music, and Wineglass*
Paris, November 1912
Pasted papers, gouache,
and charcoal on paper
18⅞ x 14⅜ in. (48 x 36.5 cm)
Marion Koogler McNay Art Museum,
Bequest of Marion Koogler McNay,
San Antonio, Texas, 1950.112

Picasso's point most clearly, with its little patch of flowered wallpaper in the left background: the comparison of the decorative and naturalistic versus the abstract and geometric is unmistakable. Throughout the series, a decorative element contrasts with the austere Cubist forms, with increasingly playful results. *Glass* (fig. 5) juxtaposes a boldly figurative chrysanthemum wallpaper fragment with geometric rectangles and a greatly simplified Cubist rendering of a glass. Picasso has painted the lower rectangle of pasted paper to imitate commercial artificial wood-grain paper, cleverly playing with various levels of "imitation" and juxtaposing differing conceptions of the decorative.

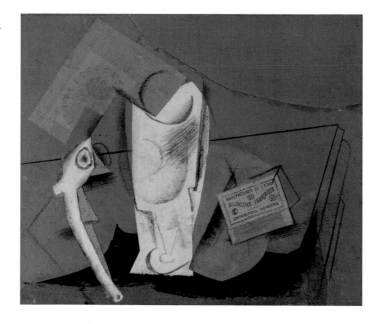

FIGURE 4
Picasso, *Pipe, Wineglass, and Box of Matches*
Paris, early 1914
Pasted papers, oil, charcoal, and India ink on canvas
11 x 13¾ in. (28 x 35 cm)
Private collection

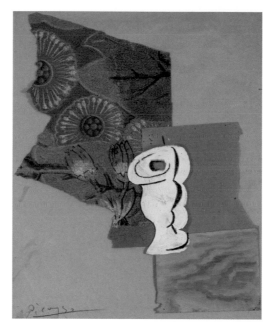

FIGURE 5
Picasso, *Glass*
Avignon, summer 1914
Oil, gouache, and papers pasted and pinned
10¹³⁄₁₆ x 9⅝ in. (27.5 x 24.4 cm)
Alsdorf Collection, Chicago

In *Dice, Packet of Cigarettes, and Visiting-Card*, these contrasts—of decorativeness and pattern on the one hand, with geometric austerity and spatial constriction on the other—force the issue of Picasso's new language of representation. If, as Alfred H. Barr, Jr., once suggested, this collage operates "almost in the manner of literary dedications," Picasso pays homage to this avant-garde pair's ongoing support for his art both as patrons and as fellow modernists (certainly Toklas believed fervently in Stein's project of stream-of-consciousness literature).[9] Of course, as a calling card, left in their absence, the work also figures Picasso himself, in the form of a Cubist collage dense with allusions tailored to their shared knowledge and cultural values.

— **Patricia Leighten**

1. Edward Burns, ed., *Gertrude Stein on Picasso* (New York: Liveright, 1970), n.p.

2. Picasso paid similar homage to another collector of his work, André Level, in *Bottle of Bass, Glass, Packet of Tobacco, Calling Card* of the same date (private collection, Paris; D.R. 660), drawing a fictive turned-down corner on the card left by Level, founder and chief adviser for La Peau de l'Ours (The Bear Skin), an avant-garde investment group that bought several Picasso works in the decade before World War I. Pierre Cabanne, *Pablo Picasso, His Life and Times*, trans. Harold J. Salemsen (New York: William Morrow, 1977), 132–33. For discussions of modernism and the art market, see Malcolm Gee, *Dealers, Critics, and Collectors of Modern Painting: Aspects of the Parisian Art Market between 1910 and 1930* (New York: Garland, 1981); Robert Jensen, *Marketing Modernism in Fin de Siècle Europe* (Princeton, N.J.: Princeton University Press, 1994); and Michael FitzGerald, *Making Modernism: Picasso and the Creation of the Market for Twentieth-Century Art* (Berkeley: University of California Press, 1996).

3. Comparing this work to other closely related works, it is clear that this depicts a pair of dice and not, as stated in D.R., p. 316, two aspects of one die; Daix and Rosselet assume that every work in this series depicts a single die, viewed from different angles. Yet a single die has a different number—one through six—on each of its sides, whereas most works in this series—*Pipe, Bottle of Bass, and Dice* (early 1914, private collection, Basel; D.R. 664); *Glass, Ace of Clubs, and Dice* (spring 1914, private collection, Basel; D.R. 697); *Pipe, Glass, Ace of Clubs, Bottle of Bass, Guitar, and Dice ("Ma Jolie")* (spring or early summer 1914, private collection, Switzerland; D.R. 742); and *Glass, Dice, and Newspaper* (spring 1914, Musée Picasso, Paris; D.R. 750)—show the two die faces with four pips each, indicating a pair. This also makes more sense of the stark contrast of color, black and white, for a pair of dice.

4. John Richardson, *A Life of Picasso*, vol. 1 (New York: Random House, 1991), 396–97.

5. See Patricia Leighten, "*Réveil anarchiste*: Salon Painting, Political Satire, Modernist Art," *Modernism/modernity* 2 (April 1995): 17–47, for the relation between anarchism and sexual liberationism. On Picasso's immersion in the anarchist movement, see Leighten, *Re-Ordering the Universe: Picasso and Anarchism, 1897–1914* (Princeton, N.J.: Princeton University Press, 1989). For discussions of Gertrude Stein's position as a lesbian, see Robert Lubar, "Unmasking Pablo's Gertrude: Queer Desire and the Origins of Cubism," *Art Bulletin* 74 (March 1997): 57–84; and Tamar Garb, "'To Kill the Nineteenth Century': Sex and Spectatorship with Gertrude and Pablo," in *Picasso's "Les demoiselles d'Avignon*," ed. Christopher Green (Cambridge: Cambridge University Press, 2001), 55–76.

6. Eugen Weber, *France, Fin de Siècle* (Cambridge, Mass.: Harvard University Press, 1986), 29.

7. Richard Klein, *Cigarettes Are Sublime* (Durham, N.C.: Duke University Press, 1993), 8.

8. The wallpapers Picasso used in the collages are an interesting subject in themselves, little treated in the scholarly literature. See Leighten, "Cubist Anachronisms: Ahistoricity, Cryptoformalism, and Business-as-Usual in New York," *Oxford Art Journal* 17 (fall 1994): 91–102; Elizabeth Cowling, *Picasso: Style and Meaning* (London: Phaidon, 2002), 248–52; and, for a general discussion of wallpapers in the late nineteenth century, Christine Woods, Joanne Kosuda Warner, and Bernard Jacqué, "Proliferation: Late 19th-Century Papers, Markets, and Manufacturers," in *The Papered Wall: History, Pattern, Technique*, rev. ed., ed. Leslie Hoskins (New York: Thames and Hudson, 2005), 150–83.

9. Alfred H. Barr, Jr., *Picasso: Forty Years of His Art*, exh. cat. (New York: Museum of Modern Art, 1939), 85.

8

Segment of Pear, Wineglass, and Ace of Clubs

Paris, spring 1914
Pasted paper, distemper (gesso),
gouache, and graphite on card-
board, 17¹⁵/₁₆ x 15³/₁₆ in.
(46 x 38 cm)
PROVENANCE: Gertrude Stein, Paris;
Alice B. Toklas, Paris, 1946–67; pur-
chased from the Stein estate by
John Hay Whitney, in 1968
REFERENCES: Zervos II, 486;
D.R. 690
Yale University Art Gallery,
John Hay Whitney, B.A. 1926,
M.A. HON. 1956, Collection,
1982.111.2

In 1990 Richard Shiff wrote a breakthrough essay that brilliantly charted Picasso's exploration of the realm of tactility in this collage.[1] "Capitalizing on the inherent physical properties of materials," he wrote, Picasso's "collages combine diverse elements that retain their individual distinctness, leading to conflicts of connotation generating ever more levels and chains of reference." Traditional artistic materials of paint and graphite are "essentially liquids and unusually malleable"; in contrast, collage materials—in this case various kinds of paper—have "stable or rigid structures and fixed physical dimensions." Thus, "the persistent physical identity and boundedness of its individual elements prevent this medium from attaining the 'transparency' or self-effacing quality that often characterizes paint in traditional painting or graphite in traditional drawing."[2] Instead, he carefully showed, Picasso emphasizes the ways he literally handled the various papers—cutting, tearing, gluing—focusing in particular on the colored pear on the left of the *papier collé*, with its fictional cut of the pear coinciding with the actual cut of the paper depicting it. Shiff concludes, "Collage itself, so dependent on cuts, is very much an art of touch and hand that encourages its viewer to attend to the most ordinary gestures and physical occurrences. The interpreter is required both to see and to think, not in the conventional pictorial ways, but through the experience of touch."[3]

Shiff's acute observations definitively corrected an overemphasis on the centrality of vision in previous (and several subsequent) discussions of the semiotics of collage.[4] We could add to this an awareness of contemporaneous debates on vision versus other perceptual senses in prewar Paris, which directly engaged both the Cubists and this work's first owner, Picasso's friend Gertrude Stein.[5] A collage in a series constructed so as to emphasize touch, and representing objects evoking taste (a juicy pear, a glass of wine), smell (a pipe, tobacco, or cigarettes), and domestic games of chance (dice, playing cards), the work alerts us to the importance of the wide range of senses lending information to vision in our construction of daily or quotidian experience. At the turn of the century, scientific developments—such as X rays, wave theory, and non-Euclidean geometry—supported rejections of nineteenth-century positivism in many fields, including physics, mathematics, and perception psychology.[6] In effect, scientific knowledge outstripped the perceptual limitations of human vision, and a focus on subjective and alogical experience—located in the other senses—came to supplant the idea of universal objective reality associated with logic and with vision. Philosophers Friedrich Nietzsche, Henri Bergson, and William James and mathematician Henri Poincaré argued the relativity of knowledge in a variety of ways; their ideas were not only debated in specialist journals but animatedly discussed in the popular press.[7] Hence a wide range of artists and intellectuals accessed and embraced these new ideas, translating them into their various fields of endeavor. It is important first to grasp something of these ideas in order to understand Picasso's Cubist collages.

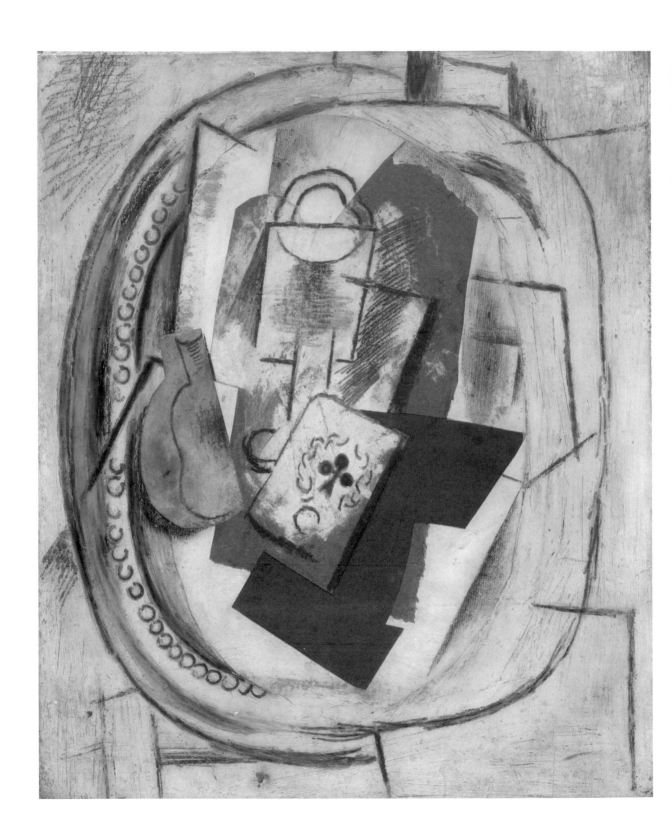

Poincaré set out to refute Immanuel Kant, arguing that three-dimensionality does not exist a priori (or before our experience of it), but that our models of space result from the experience of a fusion of visual and tactile sensations and "motor spaces": "Apart from the data of sight and touch, there are other sensations which contribute as much and more than they to the genesis of the notion of space. These are known to everyone; they accompany all our movements, and are usually called muscular sensations, an aspect of what we now call proprioception."[8]

Albert Gleizes and Jean Metzinger wrote a key tract called *Du "cubisme,"* responding to these ideas and their relevance for Cubism, echoing Poincaré's very words.[9] Although Picasso's dealer Daniel-Henry Kahnweiler later repudiated the artist's interest in Cubist theory or the work of other Cubists apart from his collaborator Georges Braque, we have direct evidence of Picasso's engagement with these writers in the form of a request to Kahnweiler himself in a letter of June 12, 1912: "And do tell me if the book on painting by Metzinger and Gleizes has come out yet."[10] Picasso doubtless knew that the authors of *Du "cubisme"* celebrated his work as emblematic of the art resulting from these dynamic new theories; Metzinger had written in 1910, "Cézanne showed us forms living in the reality of light, Picasso brings us a material account of their real life in the mind—he lays out a free, mobile perspective, from which the ingenious mathematician Maurice Princet has deduced a whole geometry."[11]

Henri Bergson was even more important for his influence on Cubist theory. Bergson lauded intuition as the key to creativity, distinguishing a felt or intuitive act from a "scientific" or nonemotive act. According to him, only a felt act is able to express the whole self, which is by definition both conscious and alogical. Gleizes and Metzinger echo Bergson when they declare their desire to give "instinct" to their "plastic [three-dimensional] consciousness."[12] Guided by the artistic state of mind, objects in Cubist works relate "qualitatively," in response to a range of the artists' other senses, including "taste." In *Du "cubisme,"* "qualitative space" produces a "complex rhythm" expressive of "notions of depth, density and duration (*durée*)," conceived by Bergson as intuited space. For Gleizes and Metzinger, the rhythm of this "inner duration" serves to bind the pattern of colors and shapes that make up a painting into an integral, organic whole.

Picasso was familiar with the related ideas of William James from his weekly visits to Gertrude Stein's Saturday soirees (see cat. no. 4). Her brother Leo was a witness to the fact that they discussed Bergson's thought as well: "Picasso began to have ideas. Bergson's creative evolution was in the air with its seductive slogan of the *élan vital* or life force. There was a friend of the Montmartre crowd, interested in mathematics, who talked about infinities and fourth dimensions. Picasso began to have opinions on what was and was not real."[13]

Guillaume Apollinaire was deeply influenced by Nietzsche, Bergson,

and Poincaré and bore witness to their importance for Picasso's Cubism. He attended the Stein soirees and knew Princet. His celebration of Cubism, especially Picasso's, in *Méditations esthétiques: Les peintres cubistes* of 1913 is steeped in Nietzschean and Bergsonian language and concepts. In a fully Nietzschean mode he wrote of Picasso: "A new man, the world is his new representation. He enumerates its elements, its details, with a brutality that can also be graceful. He is a newborn who orders the universe for his personal use."[14] And echoing Bergson while explaining his point further, he asserted in *Les soirées de Paris* in 1912:

> *One could give the following definition of art: creation of new illusions. Indeed, everything we feel is only illusion, and the function of the artist is to modify the illusions of the public in accordance with his own creation. . . . It is the function of Art, its social role, to create this illusion . . . [which] seems quite natural to me, since works of art are the most dynamic products of a period from a plastic point of view.*[15]

Segment of Pear, Wineglass, and Ace of Clubs, purchased by Gertrude Stein, reveals these intersecting ideas in its highly subjective approach to the still life, with its distorted forms, multiple perspectives, and exploration of touch, smell, and taste. A ground of hard brown cardboard with a rich gesso surface lends an almost low-relief feel to the collage.[16] Now cream colored, it was originally bright white, as the edges reveal. Picasso plays with both looking directly down onto an oval surface—a platter or café table—and looking straight at an oval picture on an easel.[17] The oval has a decorative beaded and deeply shadowed, molded "frame" on the left side, drawn in graphite through still-wet paint. Sometimes these strokes are so strong that he exposes the brown cardboard, making us aware of the gestures of his hand. The inner section of this elongated oval is formed from a collaged piece of light brown paper, with a thin wash of white gouache over its surface, though with two exceptions: two torn edges are left unpainted (upper left and bottom), which draws attention to the act of tearing. On this oval are still-life objects: a cut pear at left and playing card to its right; the stem of a wineglass rises behind the ace of clubs, its bowl shown both from the side and from above. The glass and playing card are drawn onto heavier dark brown paper, partly painted in glossy, viscous white, with both cut and torn edges. A thinner paper, now the color of burnt sienna (but a brighter red originally, as revealed by a scratch), was cut to fit around the playing card. On its right-hand side, Picasso cut a rectangular notch that frames a torn edge of the dark brown paper underneath, pointedly contrasting the rough tear with its sharply cut edges and calling attention to these two different gestures of his hand. The pear is painted in yellow, green, and red, with graphite drawing, on its own piece of brown paper, a quite distinct exploration of "qualitative" color experience (to paraphrase Gleizes and Metzinger) set in a dynamic relation to the great variety of other rhythms

FIGURE I

Picasso, *Fruit Bowl with Segment of Pear*
Paris, April 1914
Pasted papers, gouache,
and pencil on cardboard
13¾ x 12⅝ in. (35 x 32 cm)
Hermitage, Saint Petersburg

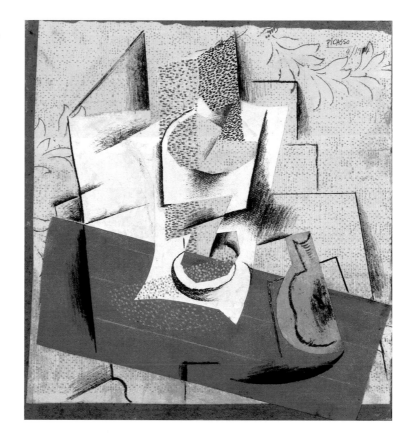

that play throughout its field: curvilinear, rectilinear, and circular lines and shadows. Picasso even differentiated acts of gluing in this collage: he painted the dark brown paper in the center, which wrinkled before he glued it down, while the reddish paper and the paper pear are smooth and flat.

This *papier collé* is part of a substantial series in which Picasso began to treat Cubist form as an already-established language and played with many elements of decoration. *Wineglass, Ace of Clubs, Packet of Cigarettes* of spring 1914 (cat. no. 7, fig. 2) repeats the glass and ace of clubs, this time with a pipe and matches sitting on a table before a piece of wallpaper molding. *Pipe, Wineglass, and Box of Matches* (cat. no. 7, fig. 4) and *Wineglass, Pipe, Lemon, Ace of Clubs, and Packet of Tobacco* (spring 1914, private collection, Basel) both feature a glass and pipe, the first with matches, the second with a packet of tobacco and ace of clubs. Picasso smoked both cigarettes and clay pipes. The cut pear—a sweet and juicy fruit—is also repeated in numerous related works in the series, for example *Fruit Bowl with Segment of Pear* (fig. 1). In fact, these works link this *papier collé* to the other collage owned by Stein, *Dice, Packet of Cigarettes, and Visiting-Card* (cat. no. 7), and in two works in this related series Picasso combined the dice and ace of clubs—both linked to games of chance played in domestic settings: *Glass, Ace of Clubs, and Dice* (spring 1914, private collection, Basel) and *Dice, Wineglass, Bottle of Bass, Ace of Clubs, and Visiting-Card* (fig. 2).[18] In the latter, he wittily imitated this collage series in paint, complete with marbling and wood grain

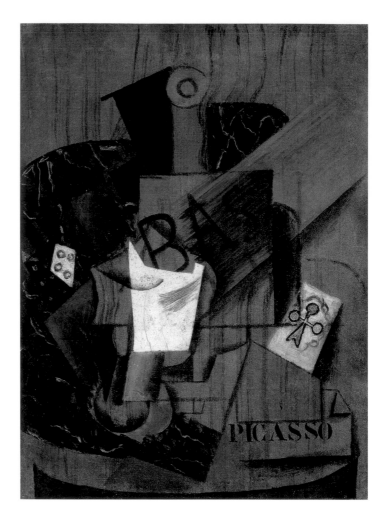

FIGURE 2

Picasso, *Dice, Wineglass, Bottle of Bass, Ace of Clubs, and Visiting-Card*

Paris, spring 1914

Oil on canvas

13 x 9⁷/₁₆ in. (33 x 24 cm)

Private collection

for decorative texture and a bottle of Bass ale for taste, with a stencilled calling card for signature. In each instance, Picasso has fluently manipulated the elements as shorthand for an experience of objects in a "felt space," personal objects whose usefulness, familiarity, and appeal to the artist— based on the senses of touch, smell, and taste—emphasize his subjective approach to art.

— **Patricia Leighton**

1. Richard Shiff, "Picasso's Touch: Collage, *Papier collé, Ace of Clubs*," *Yale University Art Gallery Bulletin* (1990): 39–47.

2. Ibid., 39.

3. Ibid., 41.

4. For a variety of debates on the semiotics —or analysis of visual language as parallel to linguistics—of Picasso's Cubism and collages, see Rosalind E. Krauss, "Re-Presenting Picasso," *Art in America* 68 (December 1980): 91–96; Krauss, "The

Motivation of the Sign," in *Picasso and Braque: A Symposium*, ed. Lynn Zelevansky (New York: Museum of Modern Art, 1992), 261–86; Krauss, *The Picasso Papers* (New York: Farrar, Straus, and Giroux, 1998); Yve-Alain Bois, "The Semiology of Cubism," in Zelevansky, *Picasso and Braque*, 169–208; and Christine Poggi, *In Defiance of Painting: Cubism, Futurism, and the Invention of Collage* (New Haven, Conn.: Yale University Press, 1992). For critiques of semiotics and the "social semiotics" of collage, see Francis

Frascina, "Realism and Ideology: An Introduction to Semiotics and Cubism," in *Primitivism, Cubism, Abstraction: The Early Twentieth Century*, ed. Charles Harrison, Francis Frascina, and Gill Perry (London: Open University, 1993), 87–183; and Patricia Leighten, "Cubist Anachronisms: Ahistoricity, Cryptoformalism, and Business-as-Usual in New York," *Oxford Art Journal* 17 (fall 1994): 91–102. For a probing exploration of semiotics in light of the formal development of Cubism, see Pepe Karmel, *Picasso and the Invention of Cubism* (New Haven, Conn.: Yale University Press, 2003).

5. On William James, Stein, and Picasso, see cat. nos. 4, 6, and 7.

6. See Linda D. Henderson, *The Fourth Dimension and Non-Euclidean Geometry in Modern Art* (Princeton, N.J.: Princeton University Press, 1983); "X Rays and the Quest for Invisible Reality in the Art of Kupka, Duchamp, and the Cubists," *Art Journal* 47 (winter 1988): 323–40; and "Editor's Introduction, II: Cubism, Futurism, and Ether Physics in the Early Twentieth Century," *Science in Context* 17, no. 4 (December 2004): 423–66.

7. Mark Antliff and Patricia Leighten, *Cubism and Culture* (New York: Thames and Hudson, 2001), 64–110; see also Henderson, *Fourth Dimension*, 10–43.

8. Henri Poincaré, *La science et l'hypothèse* (Paris: E. Flammarion, 1902).

9. Albert Gleizes and Jean Metzinger, *Du "cubisme"* (Paris: E. Figuière, 1912), trans. in Mark Antliff and Patricia Leighten, *A Cubism Reader: Documents and Criticism, 1906–1914* (Chicago: University of Chicago Press, 2008), 418–35. See Mark Antliff, *Inventing Bergson: Cultural Politics and the Parisian Avant-Garde* (Princeton, N.J.: Princeton University Press, 1993), 39–66, for an analysis of Bergsonism, Nietzscheanism, and the influence of Poincaré in the writings of Gleizes and Metzinger.

10. Daniel-Henry Kahnweiler, *The Rise of Cubism*, trans. Henry Aronson (New York: Wittenborn, Schultz, 1949), 10; written in 1915 and originally published 1920 in Munich as *Der Weg zum Kubismus*. See also Antliff and Leighten, *Cubism and Culture*, 203–5. Letter to Kahnweiler in Judith

Cousins, "Documentary Chronology," in William Rubin, *Picasso and Braque: Pioneering Cubism*, exh. cat. (New York: Museum of Modern Art, 1989), 394–95.

11. Jean Metzinger, "Notes on Painting," *Pan* (October–November 1910): 649–52. Princet was an actuary interested in the ideas of Poincaré and other mathematicians of the "fourth dimension" who became a friend of the Cubists and their circle of writers; see Henderson, *Fourth Dimension*, 64–72.

12. Gleizes and Metzinger, *Du "cubisme."*

13. Leo Stein, *Appreciation: Painting, Poetry, and Prose* (New York: Crown, 1947), cited in Antliff and Leighten, *Cubism and Culture*, 74; Stein is referring to Maurice Princet.

14. Guillaume Apollinaire, *Méditations esthétiques: Les peintres cubistes* (Paris: E. Figuière, 1913), trans. in Antliff and Leighten, *A Cubism Reader*, 477–514; see also Antliff and Leighten, *Cubism and Culture*, 74–77.

15. Guillaume Apollinaire, "The New Painting: Art Notes," in *Apollinaire on Art: Essays and Reviews, 1902–1918*, ed. LeRoy C. Breunig, trans. Susan Suleiman (New York: Viking, 1972), 223–25; originally published in *Les soirées de Paris* (April–May 1912).

16. I would like to thank Susan Greenberg Fisher and the conservation staff of the Yale University Art Gallery for the extraordinary experience of being able to look closely at this collage out of its frame; I am also grateful for access to the analysis of its fabrication by Theresa Fairbanks-Harris, Chief Conservator, Works on Paper, Yale Center for British Art and Yale University Art Gallery, and Kristin Hoermann, formerly Chief Conservator, Yale University Art Gallery.

17. For a discussion of this paradigm, see Christine Poggi, "Frames of Reference: *Table* and *Tableau* in Picasso's Collages and Constructions," in *In Defiance of Painting*, 58–89.

18. According to Jean Sutherland Boggs, *Picasso and Things*, exh. cat. (Cleveland: Cleveland Museum of Art, 1992), 154, the ace of clubs is also associated by the French with fortune-telling, where it suggests good luck and the coming of money.

Four Still Lifes

Picasso and
André Derain

Avignon, summer 1914
Oil on four ceramic tiles, 21 x 21 in.
(53.3 x 53.3 cm)
PROVENANCE: Galerie Léonce
Rosenberg, Paris, sale Amsterdam,
October 19, 1921, cat. no. 123;
Galerie Simon (Kahnweiler), Paris
(archival photograph 630, according
to D.R. 766); Buchholz Gallery, New
York, ca. 1939–40; purchased from
Buchholz Gallery by Philip L.
Goodwin, New York, in 1940
REFERENCES: Zervos II, 493;
D.R. 766
Yale University Art Gallery, The
Philip L. Goodwin, B.A. 1907,
Collection, Gift of James L.
Goodwin, 1905, Henry Sage
Goodwin, 1927, and Richmond L.
Brown, 1907, 1958.17.1

Alternating squares of words and pictures comprise this checkerboard-like object, unusual both in its ceramic substrate and uncertain function, if any. It was made by Picasso and André Derain in the summer of 1914, when Picasso worked in Avignon and Derain lived in nearby Montfavet (Georges Braque was also close by, in Sorgues). Picasso and Derain took loose kitchen tiles and painted them "in mutual homage," several days before the start of World War I.[1] Pierre Daix has noted that in Avignon, though Picasso was still close to Braque, he was drawn more to Derain, whose recent reinvigoration of figure painting led to expressive, haunting portraits such as his 1914 *Young Girl in White Shawl*, which Picasso acquired and kept in his private collection until his death (now Musée Picasso, Paris).[2] With the outbreak of war Derain and Braque were immediately called to duty, and Picasso accompanied these two artists, both so crucial to the development of his art for close to a decade, to the train station in Avignon. In a now-famous remark, Picasso said he "never saw them again," though both Derain and Braque survived the war.

During the war, Derain's wife, Alice, wrote to her husband that Picasso, who was now represented by the dealer Léonce Rosenberg (Daniel-Henry Kahnweiler, a German citizen, was exiled in Switzerland), would sell the ceramic piece on their behalf and split the proceeds among the two of them.[3] Picasso may have sold the work directly to Rosenberg, who in turn auctioned it off with other contents of his modern art gallery in 1921. The sale catalogue described the work as "left side by Picasso; right by Derain."[4] The style and content of the still-life images and the character of the handwriting in each square do appear to confirm this early designation of Picasso working on the left side and Derain on the right, and the subsequent catalogues raisonnés of Picasso's work reiterate these attributions. Yet the use of inside jokes, quotations, and appropriations of each others' styles, titles, and signatures in this unusual work deliberately challenges the idea of art-historical attributions, and the historian's desire to name and classify the individual work of art.

The spirit of the object is more like a game board, or an early "exquisite corpse" drawing, with clues and hints as to who painted what where, but no definitive answers. In the upper right, the word SOUVENIR (memory) floats on a banner, and recalls a similar white banner unfurling at the top of Derain's 1913–14 self-portrait (private collection), on which appear the words ANDRE. DERAIN. PEINTURE. Yet another white banner floats at the bottom of Picasso's earlier *Souvenir du Havre* (cat. no. 6, fig. 2). In the lower left of the ceramic piece there is more text, an envelope addressed to André Derain. The envelope's rectangular borders and full address were once clearly legible, as in the reproductions in Zervos and Daix/Rosselet, which reveal Derain's summer address in Montfavet.[5] The handwriting here is unmistakably that of Picasso, who writes Derain's name in fanciful script, in a playful forgery of his friend's signature. While Derain imitated his own

signature in a 1913 still life, *The Inkpot* (Kunstmuseum, Bern), which features a letter signed "André Derain," Picasso was more likely the instigator of this "forgery," since he often challenged conceptions of authorship and originality embodied by the artist's name and signature, as Robert Rosenblum has discussed in his seminal article on Picasso and the typography of Cubism.[6] In spring 1914, for example, several months before this work, Picasso created his own "calling card" in a small collage constructed from Gertrude Stein and Alice B. Toklas's calling card (cat. no. 7); at that time, he also made a series of collages complete with their own fake museum frames and artist identification labels (see cat. no. 28, fig. 4).

Diagonally across from these squares are two still lifes. On the left, a pack of tobacco and a goblet are recognizable as by Picasso, tinted green and decorated with stippling, as if pulled from his magnificent *Green Still Life*, also painted that summer and now in the Museum of Modern Art, New York. However, the quivering, dancing lines that decorate the pack of tobacco resemble the marks that animate Derain's still lifes of that year, as if Derain stepped in while Picasso was at work. On the right is a more primitivizing still life of figs, or perhaps some other fruit, unquestionably by Derain and very similar in style to his numerous depictions of bowls, tables, and fruit, often seen from above, from 1912 through 1914. Picasso's still life suggests a collaboration, but Derain here paints alone. Picasso and Derain in turn use different perspectives to show these objects: Picasso paints his still life as if standing in front of a table, while Derain paints his as if seen from above. In the same way, the "Derain" letter appears as if seen from above, lying on the table, while the banner rises vertically before us.

The work's playful evocation of a game board, and of both the vertical orientation of painting and the horizontal space of writing, is further enhanced by the possibility that this large ceramic object was intended to be not a painting but a tabletop. Though the work is traditionally reproduced upright, as in the 1921 auction catalogue of Rosenberg's collection, where it was included in the "Paintings" section, on the back of the object is a layer of plaster on top of the original mortar, which also contains holes in each of the plaster masses that suggest the insertion of legs.[7] The tiles may have been used at one time as a table, within a domestic setting with other furniture. This shift from vertical to horizontal, and from painting to tabletop, recalls the vacillation between table and tableau in Picasso's earlier collages such as *Segment of Pear, Wineglass, and Ace of Clubs* (cat. no. 8), whose circular boundaries evoke both the circular café table and the frame of the work of art.[8] This ceramic piece simultaneously calls to mind the acts of writing at a desk and of painting on an upright support.

The work's shifting orientation is nuanced still further by the possibility that Derain and Picasso took the four tiles from the floor, due to the presence of large round concavities in the mortar on the back of the tiles that were possibly formed by rocks in the ground. The square was also

probably removed as a single unit, since the original grouting between the tiles remains intact.[9] Given this simultaneous embodiment of floor, wall, and table, it is fitting that *Four Still Lifes* was owned by the architect Philip Goodwin, who, with Edward Durrell Stone, designed the Museum of Modern Art's International Style building, completed in 1939.

— Susan Greenberg Fisher

1. Letter from Derain to a collector's inquiry, cited in Jane Lee, *Derain*, exh. cat. (Oxford: Phaidon, 1990), 51.

2. Pierre Daix, "Derain et Braque," in *André Derain: Le peintre du "trouble moderne*," exh. cat. (Paris: Musée d'Art Moderne de la Ville de Paris, 1994), 78.

3. Jacqueline Munck, "Derain, ses marchands et ses collectionneurs," in *André Derain*, 413.

4. "Carré de quatre petites natures mortes. Partie gauche par Picasso; partie droite par Derain peintes à l'huile sur plaque de dallage en briques. Oeuvre unique." Sale cat., *Oeuvres de l'école française moderne: Collection réunie par "l'effort moderne,"* Galerie Léonce Rosenberg, Amsterdam, 1921.

5. See D.R. 766.

6. See Robert Rosenblum, "Picasso and the Typography of Cubism," in *Picasso in Retrospect*, ed. Roland Penrose and John Golding (New York: Praeger, 1973), 65–73.

7. See Galerie Rosenberg, *Oeuvres*. I thank Jennifer R. Gross, the Seymour H. Knox, Jr., Curator of Modern and Contemporary Art at the Yale University Art Gallery, for calling my attention to this aspect of the piece.

8. On this paradigm, see Christine Poggi, "Frames of Reference: *Table* and *Tableau* in Picasso's Collages and Constructions," in *In Defiance of Painting: Cubism, Futurism, and the Invention of Collage* (New Haven, Conn.: Yale University Press, 1992), 58–89. Rosalind Krauss first observed the fluctuation in Cubist painting and collage between horizontal and vertical, and picture and tabletop, and the viewers' indeterminate orientation to the picture surface; see Krauss, "The Cubist Epoch," *Artforum* 2 (1971): 32–38. On the relationship of the spaces of painting and writing, see also Yve-Alain Bois, "The Semiology of Cubism," in *Picasso and Braque: A Symposium*, ed. Lynn Zelevansky (New York: Museum of Modern Art, 1992), 186–87, 204.

9. I am grateful to Susan Holbrook, Objects Conservator, and Clarkson Crolius, Exhibitions Production Manager, both at the Yale University Art Gallery, for their input on this object.

Man with Dog (Rue Schoelcher)

Paris, spring 1915
Etching and engraving,
10¹⁵/₁₆ x 8⁹/₁₆ in. (27.8 x 21.7 cm)
Published by Lucien Vollard and
Marcel Lecomte, Paris, ca. 1947
Printed by Macquart (or Maquart;
publisher no longer existent), Paris
Edition 102
INSCRIPTIONS: lower right: *Picasso*
REFERENCES: Geiser/Baer I, 39iii/iii
Yale University Art Gallery, Gift of
Mr. and Mrs. Walter Bareiss,
B.S. 1940S, 1969.60.3

In this quirky and complex etching, *Man with Dog (Rue Schoelcher)*, Picasso evokes the daily activity of reading the newspaper. His cacophony of forms signals a radical departure from traditional interiors featuring a figure absorbed in a book, such as the quiet, luminous works of Jean-Siméon Chardin and Camille Corot.[1] Impressionist painters including Édouard Manet and Mary Cassatt updated these scenes and painted their contemporaries reading magazines or the daily paper (introduced in France in 1836 with the founding of *La presse*). By the 1880s, the newspaper found a mass audience. In 1866, Paul Cézanne showed his father reading *L'événement*, the very paper that contained reviews of his own work (fig. 1). Cézanne's painting was in fact owned by Ambroise Vollard, Picasso's patron, in 1915, when Picasso etched *Man with Dog*. Like Cézanne, Picasso shows a man, legs crossed and comfortably seated in an interior, but he is now only barely visible behind the towering and cumbersome folded sheets of the paper, capped by LE JOUR[NAL], the name of a popular Parisian paper as well as the word for "newspaper" in French.

Picasso's print further diverges from Cézanne and the Impressionists, as well as related paintings of seated or reading figures by Juan Gris and André Derain, in how it evokes the sea change in the very act of reading, brought about by the daily newspaper.[2] In the paper, various topics and news from around the world are condensed into countless short lines of text, causing the eye to dart to and fro, arriving at the end of the line only to quickly move on to the next.[3] The daily paper encourages the quick scan,

FIGURE 1
Paul Cézanne, *The Artist's Father, Reading "L'événement"*
1866
Oil on canvas
78⅛ x 47 in. (198.5 x 119.3 cm)
National Gallery of Art, Washington,
D.C., Collection of Mr. and Mrs. Paul
Mellon, 1970.5.1

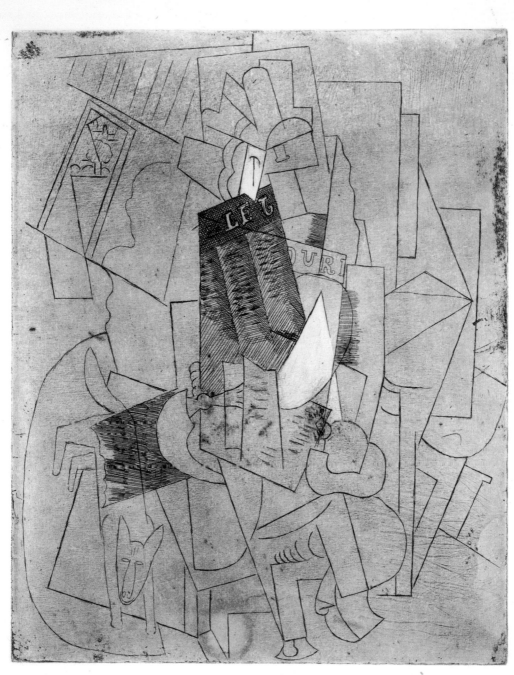

the skim, the momentary pause. In Picasso's etching, forms likewise emerge and then abruptly end; some are described and recognizable, like the figure's hat and stubby nose, while some are cut off before they can be fully understood. The first three letters of LE JOURNAL flow in one direction, from left to right (the J playfully reversed by Picasso, so that the curve of its lower half keeps the eye moving to the right, in the right direction), only to be interrupted by the folds of the paper, and continuing with the letters OUR behind. The final letters, NAL, are lost in its folds—and bluntly deleted. There are also snippets of reality, like the landscape framed by the door, or, more prominently, the loyal dog stretched out on a circular rug—a "nonreader" who looks directly at us, in a play of absorption and theatricality. The figure and dog are both surrounded by the more dominant, circumscribed forms of squares and rectangles. These geometries disperse across the print like pieces of paper or the newspaper columns themselves—their flat, empty forms suggesting the "thinness" of the paper, both materially and in terms of its ephemeral content—as if what the man reads is now projected outward, across the surface of the work.[4] In his subsequent paintings of men and women reading from the 1920s and 1930s (see, for example, cat. no. 16, fig. 2), Picasso would continue to explore how the subject's interiority could be projected outward and across the canvas, as Garrett Stewart has recently discussed in a fascinating study.[5]

Here the movement of shapes is not only outward; it also cascades downward, from upper left to lower right, like the shifting floor of a carnival funhouse. Picasso evokes the potentially chaotic act of reading the paper, which dictates no particular order or progression through its information. To the undisciplined reader, the newspaper can take hours to process. The phantomlike form of a male head, to the left of the central figure's head, suggests names and people mentioned in the paper, whose stories are read, momentarily considered, and quickly forgotten. Picasso also evokes the senses of touch and sound prompted by the physical act of turning and folding the newspaper's large sheets. He does this not through an emphasis on the man's hands, which are tiny, almost comical proto-Surrealist protrusions around the edges of the paper. Instead, abstracted wavy lines to the right of the sitter's head, floating as if in a Cubist painting and severed from any traditional referent, evoke rippling pages—that grating, unpleasant noise so familiar to us still today.

The newspaper, with its modern typography, vertiginous columns, and up-to-the-minute content, fascinated Picasso, and his decisive importation of its fragments and the elements of popular culture and mass communication into his radical collages of late 1912 and 1913 momentously challenged the autonomous, pure domain of painting.[6] Newspaper continued to structure and inflect Picasso's work long after the Cubist years, as in major paintings such as *Dog and Cock* (cat. no. 11) and *First Steps* (cat. no. 19).

— **Susan Greenberg Fisher**

1. On Chardin and absorption in eighteenth-century painting, see Michael Fried, *Absorption and Theatricality: Painting and Beholder in the Age of Diderot* (Berkeley: University of California Press, 1980).

2. For paintings by Gris and Derain, see, especially, Gris's *Man in a Café* (1914, private collection) or Derain's *Chevalier X* (1914, Hermitage Museum, Saint Petersburg), which interestingly was first created with a real copy of *Le journal* glued to its surface.

3. On critiques of the newspaper and this new mode of reading, particularly by the Symbolist poet Stéphane Mallarmé at the end of the nineteenth century, see Christine Poggi, "Mallarmé, Picasso, and the Newspaper as Commodity," in *Collage: Critical Views*, ed. Katherine Hoffman (Ann Arbor, Mich.: UMI Research Press, 1989), 171–92.

4. The paper's lack of depth was lamented by Mallarmé; see Poggi, "Mallarmé, Picasso," 174–75.

5. Garrett Stewart, *The Look of Reading: Book, Painting, Text* (Chicago: University of Chicago Press, 2006), 275–327.

6. See Poggi, "Mallarmé, Picasso," 184. See also Poggi's *In Defiance of Painting: Cubism, Futurism, and the Invention of Collage* (New Haven, Conn.: Yale University Press, 1992).

11
Dog and Cock

1921
Oil on canvas, 61 x 30⅛ in.
(159.4 x 76.5 cm)
INSCRIPTIONS: upper left: *Picasso 21*
PROVENANCE: purchased from the
artist by Galerie Paul Rosenberg,
Paris, in 1921; Jerome
Stoneborough, Paris; purchased by
Galerie Paul Rosenberg, Paris,
in 1939; purchased by the Museum
of Modern Art, New York, in 1942;
purchased from MoMA (sold to
raise funds to buy *Three Musicians*
[1921, Museum of Modern Art, New
York]) by Stephen Carlton Clark
REFERENCES: Zervos IV, 335
Yale University Art Gallery, Gift of
Stephen Carlton Clark, B.A. 1903,
1958.1

Dog and Cock is an appealing, colorful work that features a hungry black dog, his pink tongue hanging from his mouth, who strains for a dead bird waiting to be cooked on a table. Picasso most likely painted it in Paris soon after his monumental *Three Musicians* (Caws, "The Meeting Place of Poets," fig. 4), which has been interpreted by Theodore Reff as a memorial of his early bohemian days in the Bateau-Lavoir through the depiction of a trio that may represent Picasso as Harlequin, and the writers Max Jacob as a monk (he had converted to Catholicism in 1921) and Guillaume Apollinaire as Pierrot.[1] By 1921 the community of writers and poets that originated at the Bateau-Lavoir had dispersed or, like Apollinaire, fallen victim to injuries related to World War I.

A similar recollection of the prewar Cubist era suffuses *Dog and Cock*, yet here the focus is his past work and its innovative visual language. Picasso's thinking about his recent innovations appears to inform the painting's structure and meaning more powerfully than the influence of sources from the still-life tradition, such as Jean-Siméon Chardin's *Sideboard* (1728, Musée du Louvre, Paris), which is usually cited in relation to this work.[2] His process begins with self-quotation, and the five enigmatic round shapes painted on the right side of the table, perhaps eggs or fruit, restate the five chromolithographic apples and pears pasted on newsprint in his 1913 collage *Bowl with Fruit, Violin, and Wineglass* (fig. 1).[3] The cock hanging from the table recalls, through a visual shorthand of dashes and arrows, his poignant *Dead Birds* (Museo Nacional Centro de Arte Reina Sofía, Madrid), painted in Sorgues in summer 1912, in which two birds hang limply within a powerful admixture of blood, seeping somewhat gruesomely onto the bold mastheads of several daily newspapers.[4]

Picasso's citation of these works signals the pivotal role played by newspaper and language within a Cubist composition and its system of meaning. Newspaper, in the prewar Cubist paintings and collages, functioned as an active component that not only structured the forms within a system of relationships but could, through Picasso's inclusion of its headlines and texts, also serve as a call-out to major world events (see, for example, cat. no. 7, fig. 3).[5] In *Dog and Cock*, the painted form of a newspaper, with its uniform, tall columns and black dots and dashes signifying its text, animates the right side of the painting, and serves as a ground to the five round objects (which were perhaps once wrapped in the material after being purchased at a market, as was the custom in France). The flat form of the paper merges with the painterly field, and initially appears to relinquish its role as an active element in the work.

Yet its centrality resurfaces on the level of structure, and the newspaper's columns are repeated in the vertiginous, columnar shape of the painting itself. The two white table legs divide the painting into two columns, also like a paper—a division accentuated by the contrasting blue and brown background. The legs function like directional arrows to encourage us to "read" or scan the painting in the unusual manner of up and down, like a

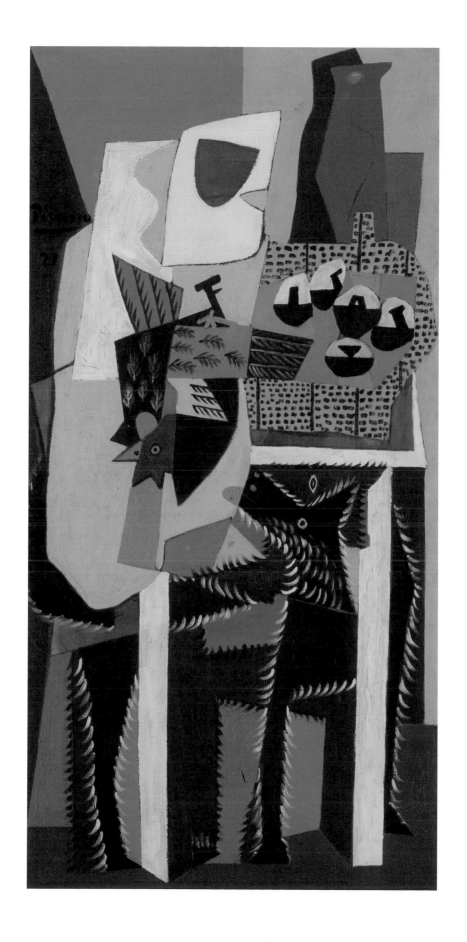

FIGURE I

Picasso, *Bowl with Fruit, Violin,*
and Wineglass
Paris, 1913
Charcoal, chalk, watercolor, oil paint, and
coarse charcoal or pigment in binding
medium on applied papers, mounted on
cardboard
25³⁄₁₆ x 19½ in. (64 x 49.5 cm)
Philadelphia Museum of Art, A. E.
Gallatin Collection, 1952, 1952.61.106

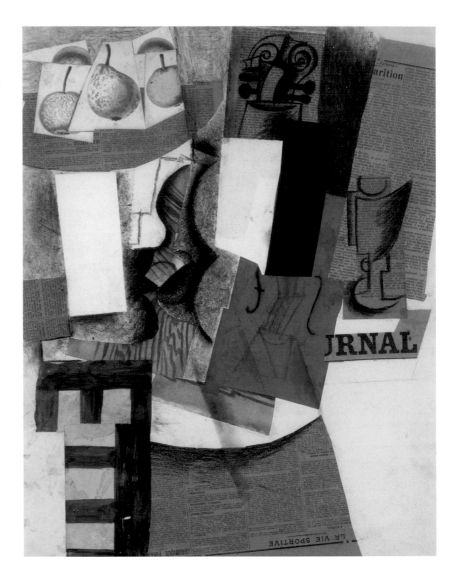

paper, and not from left to right, or all at once. Seen in this way, the five
round shapes that sit atop the paper resemble letters, ones that seem to be
magnified from the contents of the paper itself. Their forms are black and
sharp, as if hammered out of a typewriter. This little cluster of forms also
contains in miniature the same shapes that appear all over the rest of the
painting, in a cubistic repetition of form. The V in the bottommost shape,
for example, is similar to the V of the dog's head, or the upside-down V that
shapes the cock's red crown, or the V missing in the abstract white shape
above the cock. Language becomes form, and form becomes language—an
oscillation best represented in the overall shape of the newspaper, which,
with its stubby stem, resembles a large, sixth piece of fruit.

Newspaper thus may be understood to function as a point of origin for
the painting as a whole. While Chardin and the still-life tradition are sources
for the painting, the visual evidence in *Dog and Cock* asserts more loudly that
language and the forms of mass media—those "unbearable columns," as

Stéphane Mallarmé wrote—determine the shape of Picasso's art.[6] With considerable swagger, the painting also proclaims that the source of Picasso is Picasso himself (fig. 2). It may not be a coincidence that the overall shape of the cock resembles a large P, and the round shapes resemble the letters I, C, A, S, and O.

— **Susan Greenberg Fisher**

1. See Theodore Reff, "Picasso's Three Musicians: Maskers, Artists, and Friends," *Art in America* 68 (December 1980): 124–42. Elizabeth Cowling challenges this interpretation and relates *Three Musicians* to Picasso's studies for the theater (and, if it is to be read as a portrait, she notes it probably depicts Erik Satie as Harlequin, Manuel de Falla as the monk, and Igor Stravinsky as Pierrot); see Cowling, *Picasso: Style and Meaning* (London: Phaidon, 2002), 367.

2. See, for example, Jean Sutherland Boggs, *Picasso and Things,* exh. cat. (Cleveland: Cleveland Museum of Art, 1992), 194.

3. For a compelling structuralist reading of this collage and Picasso's oeuvre as a whole, see the seminal article by Rosalind Krauss, "Re-Presenting Picasso," *Art in America* (December 1980): 90–96.

4. See Zervos IIa, 339, and D.R. 494.

Picasso returned to the dead bird theme in 1919; see Boggs, *Picasso and Things,* 178–79.

5. The question of the role of newspaper and text in Picasso and Braque's collages has been a subject of much debate; see Patricia Leighten, *Re-Ordering the Universe: Picasso and Anarchism, 1897–1914* (Princeton, N.J.: Princeton University Press, 1989), as well as the debates in *Picasso and Braque: A Symposium,* ed. Lynn Zelevanksy (New York: Museum of Modern Art, 1992). See also Leighten, "Cubist Anachronisms: Ahistoricity, Cryptoformalism, and Business-as-Usual in New York," *Oxford Art Journal* 17 (fall 1994): 91–102; and, most recently, Rosalind Krauss, *The Picasso Papers* (New York: Farrar, Straus, and Giroux, 1998).

6. Cited in Christine Poggi, *In Defiance of Painting: Cubism, Futurism, and the Invention of Collage* (New Haven, Conn.: Yale University Press, 1992), 144.

MARY ANN CAWS

The Surrealist Impulse

THE REVIVAL OF A CLASSICAL STYLE in Picasso's illustrations of Ovid's *Métamorphoses* (cat. no. 13) and Aristophanes' *Lysistrata* (cat. no. 15) in the early 1930s nevertheless calls upon, particularly in the latter case, both the deep reserves and public display of eroticism so characteristic of the Surrealist impulse.[1] It brings to mind the poet Paul Éluard's meditation on how to make desire lasting: "le dur désir de durer" (the hard desire to last) and his work with Max Ernst on *Répétitions*, the insistence on rows of eyes and hands—and the sometime Surrealist poet René Char's maxim: "L'acte est vierge, même répété" (The act is virgin, when repeated). The simple lines call up from antiquity all the resonance we look back on with a sort of nostalgia, itself nourishing to the eroticism of longing. Desire is always about not having yet or then, any longer, whatever we would like to be most provocative to our full range of impulses. So Surrealism is anchored in the desire for desire.

In the margins of *Hercules Killing the Centaur Nessus* from the Ovid, a little boy reads. And at first glance, the spine of the book is striking enough to suggest both his reading and drawing—the metamorphosis from reading into drawing, from margin into center, from one language to another, gives the onlooker still more space for thought. Look at the different gestures of the hands in the *Lysistrata* etchings, at the banquet scene, with its tipped table, its fruit, its wine krater, bringing the observer toward the table, so we are part of the play. How those hands, upraised for the women's oath of abstinence until the cessation of war—or then slightly hesitating, or a bit uncertain in wonderment—how all these gestures signal the scenic, Picasso's so crucial scenic sensitivity, perfect for Aristophanes' play. Picasso's work with hands, his handling, fits in well with the Surrealist fascination with hands and handprints in general. And Picasso's off-to-the-side hands do just what the table for the banquet does: we feel beckoned. Take the upside-down hand on the left of the *Flute Player and Reclining Nude* (fig. 1): what a come-on or come-in.

The doodling and random sketching of initiating lines before the actual drawing itself that Picasso and the Surrealists practiced, and which Roberto Matta brought over to New York when the Surrealists were in exile during the war, was crucial to the drawing habits of Robert Motherwell, who passed it on to the other New York school, the Abstract Expressionists. The prime exemplar of the use of this initial doodle or drawing at random

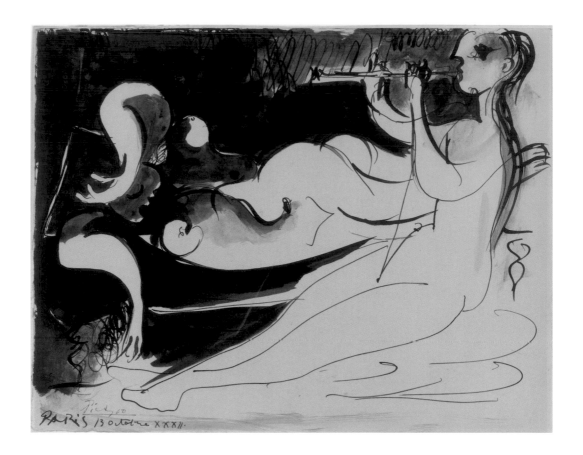

FIGURE I
Picasso, *Flute Player and Reclining Nude*
Paris, October 13, 1932
Ink
9¾ x 12⅝ in. (24.8 x 32.1 cm)
Yale University Art Gallery, Gift of Molly and Walter Bareiss, B.S. 1940S, 1999.9.14

before the drawing itself took shape was the great Surrealist Robert Desnos, the poet, novelist, and occasional artist who died so tragically in the concentration camp at Terezín. Picasso used to tell a story about the Catalan, the restaurant on the rue des Grands-Augustins where he and the *bande à Picasso* always lunched. In his telling in 1944, Desnos explains that Picasso had painted two canvases of a sideboard inside the restaurant, and then, the next day, it was gone. "It makes you believe," says Desnos, "that the painter had rendered its existence useless, or more real on the canvas." Desnos goes on to speculate on the possibility of having opened the drawers and doors of the piece of furniture: "Like all doors, they separate two spaces, the one in front and the one behind." What would have been in there, or would there simply have been an empty space? The value of the vision depends on that of the observer, since, he says, we carry our own imprisoning space with us everywhere. Picasso calls us to take up his position, "la place du peintre."

Desnos takes this entire tale as the key to Picasso: it is not his multiplicity we should stress but the unity of his work, in which all his paintings live and always resemble themselves, a generating work that he carries entire in his present and his future, about which we can predict nothing,

and which is above all a method of knowing. With Picasso, he says, all cheating is impossible: "You have first of all to love painting itself to penetrate his universe."[2] Can't we imagine, he says, that Picasso's painting contains the notions of lucidity and exaltation, desire and satiety, as the buffet contains "all the fruits of earth and life, the fullest and the juiciest, and the most abstract also? So the piece of furniture finds its true usefulness and its legitimate content in passing from a restaurant to a canvas by Picasso." This long dwelling on the painter's work and vision is one of the highlights of Desnos's meditations on art. Now the other telling of the story, by the painter, as Desnos quotes it, speaks principally about Picasso's humor and still more about his view of himself:

> *I had lunched at the Catalan for months, and for months, I looked at the sideboard without thinking more than "It's a sideboard." One day I decided to make a picture of it. I do so. The next day, when I arrived, the sideboard had gone, its place was empty. . . . I must have taken it away without noticing by painting it.*[3]

But he noticed a lot, all the same.

He had, after all, noticed a number of women, and when he saw her in the café Deux Magots, stabbing a penknife between her fingers, encased in little black lace gloves, he had certainly noticed the Surrealist photographer Dora Maar. He kept the gloves, and her: she was his mistress from 1936 to 1942. It was Dora Maar who found for Picasso his studio on the rue des Grands-Augustins, in the very building where Frenhofer, the doomed painter of Honoré de Balzac's *Le chef-d'oeuvre inconnu* (cat. no. 12) had holed up to paint his great work, so sadly illegible and unintelligible to viewers, but so well understood by Picasso in his 1931 illustrations of the story. It was also in the attic of the Grands-Augustins studio that Georges Bataille's group Contr'attaque met. Dora Maar had been a member of that group, and had been Bataille's mistress before belonging, talent and soul, to Picasso.

Bataille had explored the nether and darker regions of the imagination, relating Picasso's work to the intensely eroticized parts of the body, and had thus become anathema to André Breton's somewhat puritanical approach to the Surrealist movement he had founded, in 1923, after the excitement of the Dada group in Zurich. The Dada movement's cofounder, Tristan Tzara ("Papa-Dada"), had come to Paris in 1920, remaining there and coexisting

with the Surrealists; years later, in 1950, Picasso illustrated his *De mémoire d'homme* (cat. no. 26) after both had joined the Communist Party. It is often said that Dora Maar's experience with Bataille had well prepared her for the corporeal side of her relation to Picasso. Her portrait as bird graces the pages of Picasso's *40 dessins de Picasso en marge du Buffon* (cat. no. 17), where marginal drawings, additions, and doodles abound, and inside the book are some rather lubricious close-ups of Dora Maar, to understate the case.

When Dora Maar went into a crazed state and was taken off to the Clinique St. Anne for electroshock, Picasso called upon Éluard to rescue her, and his equally close friend Jacques Lacan (who was also his doctor) to treat her. Since Lacan had married Bataille's former wife, Sylvia Maklès, the entire affair became as intertwined as Picasso's relationships to poets and writers. Lacan summed up Dora's case by saying he had to choose between a straitjacket and the arms of the Catholic Church for her, and chose the latter. She became a partial recluse in the house in Ménerbes in the south of France that Picasso had given her, declaring, for posterity: "After Picasso, only God."

Dora's case has its own ironic aftermath. When called upon in 1921 to provide a statue for the monument to Apollinaire—"the prince of poets"— for the little square outside the church of Saint-Germain-des-Prés, Picasso, after proposing many suggestions to the committee, in the end supplied when it was unveiled in 1959 a head not of Apollinaire—out of superstition about the dead, it is alleged—but of Dora Maar. In fact, it was the second one of Dora Maar, because he had urinated on the first one, to give it the kind of patina that Aristide Maillol had bestowed on his statues by "watering them" that way. It had turned green.

Alas, it would have been a perfect Surrealist image—the natural and the human corresponding, shall we say intimately, with the work of art. André Breton's celebrated theory of the Surrealist image—two elements from realms as opposed as possible meeting with a flash of lightning—was based on the theory of the image stated by Pierre Reverdy in his journal *Nord-sud* (named in honor of a line on the Paris metro). Breton loved to imagine a still life not with the predictable fruits—an apple alongside an orange—but something like a horse galloping alongside a tomato. The dynamics of the still life were to illustrate the excitement of the conducting wire stretched between the observer and the object observed, or then the

ANDRÉ BRETON

CLAIR
DE
TERRE

AVEC UN PORTRAIT
PAR
PICASSO

1923

FIGURE 2

Picasso, *Portrait of André Breton*
(frontispiece) and title page, from
Breton's *Clair de terre* (Earthlight)
Published by the author, Paris, 1923
Beinecke Rare Book and Manuscript
Library, Yale University

communicating vessels of night and day, as in the scientific experiment with gases passing from one side to another. Clearly, this relates to the Cubist idea of *passage* between different planes.

Breton, whose noble profile Picasso so perfectly captured for his volume of *Clair de terre* (fig. 2), had always wanted to claim Picasso for the Surrealist movement, and had lauded him to the Surrealist skies. In 1925, when his "Surrealism and Painting" was first published in sections in *La révolution surréaliste*, Breton stated his admiration and reserve: "We claim him as one of ours, even though it is impossible—and would be impudent, furthermore—to apply to his means the rigorous critique that elsewhere we propose to institute. Surrealism, if one must assign it a line of moral conduct, has but to pass where Picasso has already passed, and where he will pass in the future."[4]

Breton had immensely cared about Picasso's flexibility as part of his great genius: when Picasso didn't have red, he used blue, and the result was even better. In "Picasso dans son élément," published in the first volume of *Minotaure* in 1933, which was devoted to Picasso's recent sculpture made at Boisgeloup, Breton described a visit to Picasso's studio, where he found

14 Décembre XXXV.

sur le dos de l'immense tranche
de melon ardent
arbre morceau de fleuve
table à rire
sous la menace de l'aile qui
serre pour le plaisir de voir
expirer entre ces dents
distraite de son ennui
un brin d'herbe
les deux petits boutons de prunus
tombées si bas
s'embrassent depuis deux ou trois jours
énervées par les pleurs
de la petite fille

FIGURE 3

Picasso, *Sur le dos de l'immense*
***tranche de melon ardent* (On the**
Back of the Immense Slice of
Burning Melon)
Paris, December 14, 1935
India ink and colored crayons
10 x 6⅝ in. (25.5 x 17.1 cm)
Musée Picasso, Paris, M.P. 1146

an incomplete painting, with a lump in the center. That, said Picasso, is a spot of excrement, which is supposed to give you the feel of discarded cherry pits, left by children walking through a forest. I am waiting, said Picasso, for it to be dry, and for the flies to come and rest on that lump. In a dream, Breton visualized a large brown mountain, gleaming and beautiful, with those "shiny brand-new flies. . . . Everything suddenly seemed bright and gay. . . . I plunged gladly into the woods."[5]

In 1935, when Picasso was in a moment of dudgeon and unable to paint, he began to write prose poems of the spontaneous sort that could be confused with Surrealist automatic writing (fig. 3). It was Breton who prefaced these poems in a special issue of *Cahiers d'art* published later that year, also with essays by the magazine's editor, Christian Zervos, and Éluard, whose close friendship with Picasso was marked around that time by the first of many drawings of the poet (see introduction, fig. 10). But Picasso's work was always in gestation, was in a state of constant reworking.[6] That was, after all, the excitement of language for him: its power to reshape the imagination, and with it, a painter's life and work.

1. See Mary Ann Caws, *The Surrealist Look: An Erotics of Encounter* (Cambridge, Mass.: MIT Press, 1996).

2. Author's translation. This and subsequent quotes are from "Les sources de la création: Le buffet du Catalan," 1944, in *Robert Desnos: Oeuvres* (Paris: Quarto Gallimard, 1999), 1177.

3. Picasso, quoted in Dore Ashton, *Picasso on Art: A Selection of Views* (New York: Viking Press, 1972), 82.

4. André Breton, *Surrealism and Painting,* trans. Simon Watson Taylor (Boston: MFA Publications, 2002), 101–13.

5. Ibid., 114.

6. Marie-Laure Bernadac and Christine Piot, eds., *Picasso: Écrits,* preface by Michel Leiris (Paris: Gallimard, 1989); translated as *Picasso: Collected Writings* (London: Aurum Press, 1989), xiii–xiv.

12

Painter and Model Knitting

for Honoré de Balzac's
Le chef-d'oeuvre inconnu
(The Unknown Masterpiece)

1927
Etching, 7⅝ x 10⅞ in.
(19.4 x 27.7 cm)
Published by Ambroise Vollard,
Paris, 1931
Printed by Louis Fort, Paris
Edition 99
INSCRIPTIONS: lower right: *Picasso*
REFERENCES: Geiser/Baer I, 126
Yale University Art Gallery,
University Purchase, 1948.65

"Strictly speaking, there is no such thing as drawing."[1] So saying, the aged master Frenhofer, antihero of Honoré de Balzac's 1837 tale *Le chef-d'oeuvre inconnu*, recounts the secret of his painterly technique to the young artist Nicolas Poussin. "I have not marked out the limits of my figure in hard, dry outlines," Frenhofer explains of his masterpiece portrait, *La belle noiseuse*, "for the human body is not contained within the limits of line. In this the sculptor can approach the truth more nearly than we painters. Nature's way is a complicated succession of curve within curve." Frenhofer's observation of the character of three-dimensional form is unarguably true. Yet, in *Le chef-d'oeuvre inconnu*, his attempt to translate the roundedness of a solid body onto a two-dimensional canvas without the aid of "hard, dry outlines" is also his downfall. When the young Poussin finally gains entry to Frenhofer's studio and sees *La belle noiseuse*, the "masterpiece" upon which the older painter has labored for ten years is revealed as an incomprehensible mass of abstract marks, a "dead wall of paint" from which emerges only the faintest outline of a foot.[2]

In 1926 Ambroise Vollard, art dealer and pioneering publisher of French *livres d'artistes*, approached Picasso to illustrate a deluxe edition of *Le chef-d'oeuvre inconnu*. Not surprisingly, line plays a central role in the resulting illustrations. Picasso executed fifteen etchings for the book in 1927, twelve of which were selected by Vollard for inclusion. In addition, Vollard published four reproductions of drawings Picasso made in 1926 at Juan-les-Pins, in southeastern France; sixteen pages of line-and-dot drawings the dealer selected from a 1924 notebook; and sixty-three wood engravings made after India ink drawings in the artist's 1925–26 curvilinear style. In these graphic works, line, that element which Frenhofer observes has no existence in nature, is demonstrated as the indispensable means of representation.

In Picasso's illustrations, however, line is not only a means to representation but its theme. This theme is introduced in the opening sixteen pages of the book, appropriately titled "En manière d'introduction par Pablo Picasso," which include the above-mentioned enigmatic line-and-dot drawings (fig. 1)—fifty-six in total. Although many of these abstracted, semiautomatic drawings evoke the forms of a woman or a guitar, they, like Frenhofer's *La belle noiseuse*, hover at the edges of representation, often refusing to coalesce into any definite form whatsoever.[3] Understood as literal illustrations of Frenhofer's failure, the drawings underscore the folly of the Pygmalion desire to breathe life into art. They demonstrate that imminent within any mimetic representation is its opposite, nonfigurative abstraction.

Yet, freed from the demands of mimesis, Picasso's constellations, doodles, and diagrams also offer a flip side to Balzac's fable of genius and artistic doubt, one in which the very abstraction of line can be activated as a tool of representation. As formal exercises, Picasso's preliminary drawings are experiments in the fundamental capacity of line to define form in space, a capacity the artist exploited in his paintings and graphic work as well as in

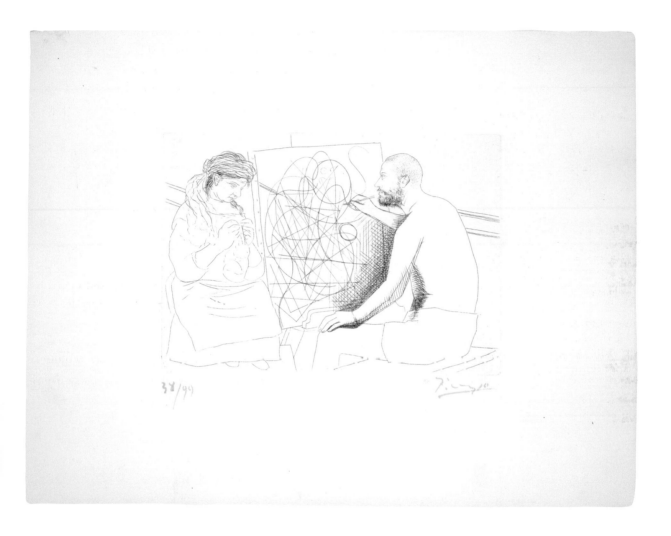

38/99 Picasso

FIGURE I

Picasso, page with line-and-dot drawings, from Honoré de Balzac's *Le chef-d'oeuvre inconnu*
Published by Ambroise Vollard,
Paris, 1931
Gift of John Hay Whitney, Beinecke
Rare Book and Manuscript Library,
Yale University

sculptures such as *Wire Construction* of 1928 (fig. 2). As such, they provide a pictorial rehearsal for the sixty-three India ink drawings that punctuate the text that follows. In the India ink drawings, Picasso moves fluidly between figuration and abstraction, often using a curving, continuous line to combine frontal and profile likenesses into a single, double-faced image (fig. 3). In light of these subsequent illustrations, the introductory line-and-dot drawings can be viewed as building blocks of the graphic medium, the most basic elements from which a picture is made.

In this sense, even the most representational works within *Le chef-d'oeuvre inconnu*—the twelve etchings executed specifically for the commission—have their material foundation in Picasso's abstract "introduction." In the commissioned etchings (figs. 4–7), line is applied as both outline and the rendering of volume, here curving sinuously as the contour of a figure, there marshaled into short strokes of hatching to describe areas of shadow and light. These twelve etchings are held together through the common theme of the artist, model, and studio. But among them, only the final image, *Painter and Model Knitting*, corresponds directly to Balzac's text. In this etching, Picasso depicts an artist at work on a canvas of abstract lines while an aging model, no longer the beautiful muse, knits in a chair by his side. Viewed in light of the various sets of illustrations within *Le chef-d'oeuvre inconnu*, this last etching suggests Picasso's personal inversion of the narrative of Balzac's plot. With this etching, Picasso successfully "illustrates"

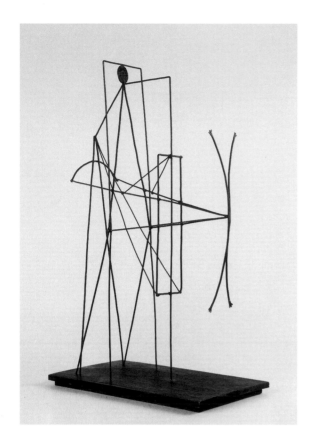

LE CHEF-D'ŒUVRE INCONNU

toute une vie, les fources de l'expreffion. Vous faites
à vos femmes de belles robes de chair, de belles
draperies de cheveux, mais où eft le fang qui engendre

le calme ou la paffion et qui cause des effets particuliers.
Ta fainte eft une femme brune, mais ceci, mon pauvre
Porbus, eft d'une blonde ! Vos figures font alors
de pâles fantômes colorés que vous nous promenez
devant les yeux, et vous appelez cela de la peinture
et de l'art. Parce que vous avez fait quelque chose

21

FIGURE 2
**Picasso, _Wire Construction_ (offered
as a maquette for a monument to
Guillaume Apollinaire)**
Paris, late 1928
Metal wire
23⅞ x 13 x 5⅞ in. (60.5 x 33 x 15 cm)
Musée Picasso, Paris, M.P. 265

FIGURE 3
**Picasso, page with curvilinear-style
drawing, from Honoré de Balzac's
Le chef-d'oeuvre inconnu**
Published by Ambroise Vollard,
Paris, 1931
Gift of John Hay Whitney, Beinecke
Rare Book and Manuscript Library,
Yale University

the story contained in Balzac's text by analogy, capturing the naturalistic
likeness of his model. Rather than ending with incomprehensible abstrac-
tion, as in Balzac's story, we arrive at representation, with the final discovery
of Frenhofer's failed masterpiece revealed "en manière d'introduction."

Taken as a whole, Picasso's combined illustrations function as a
rhetorical subversion of the aesthetic assumption that undergirds _Le chef-
d'oeuvre inconnu_, namely, that mimetic representation is the goal of the
painter's craft. Unlike Frenhofer, Picasso's claim to artistic mastery derived
from his ability to transform a figure's multiplicity and fracture into a for-
mally coherent work of art. The obsessive renderings and re-renderings
described in Balzac's tragic tale are therefore not Picasso's downfall, but his
trademark success.

It would be rash, however, to suggest that Picasso's illustrations for
Le chef-d'oeuvre inconnu are free of the modernist specter of Frenhofer's
doubt. Paul Cézanne, the painter Picasso called "my only master," explicitly
identified himself with Frenhofer. And, as Dore Ashton has observed,
"What Picasso specifically admired in Cézanne was the Frenhofer in him."[4]
As Picasso remarked in a 1935 statement, "What forces our interest is
Cézanne's anxiety—that is Cézanne's lesson."[5] Picasso's anxiety in _Le chef-
d'oeuvre inconnu_ is certainly not that of Frenhofer's; his leveling of styles in
the post-Cubist years proved that he could move between abstraction and
representation with glib and perfect ease. Rather, Picasso's illustrations for

FIGURE 4

**Picasso, Etching VIII (painter at
work, observed by nude model),
from Honoré de Balzac's**
Le chef-d'oeuvre inconnu
Published by Ambroise Vollard,
Paris, 1931
Gift of John Hay Whitney, Beinecke
Rare Book and Manuscript Library,
Yale University

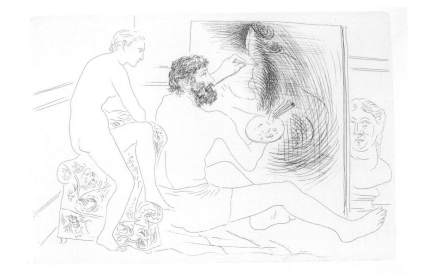

FIGURE 5

**Picasso, Etching III (bull and horse),
from Honoré de Balzac's**
Le chef-d'oeuvre inconnu
Published by Ambroise Vollard,
Paris, 1931
Gift of John Hay Whitney, Beinecke
Rare Book and Manuscript Library,
Yale University

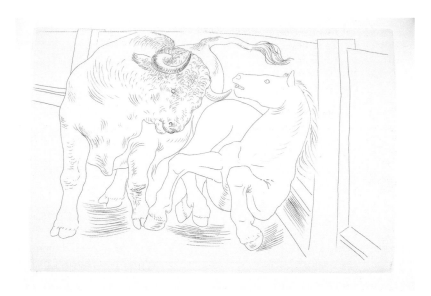

Le chef-d'oeuvre inconnu express another anxiety, one that emerges not from
Balzac's figure of the artist but from his figure of the model.

Picasso's twelve commissioned etchings shift the emphasis of Balzac's
story from the young Poussin and the spectacle of ruined artistic genius to
the more general theme of the artist and model, a recurrent motif in several
works of this period, including the Vollard suite (cat. no. 14) and the *Artist
and Model* series. Several etchings hint at the Pygmalion myth that underlies
Le chef-d'oeuvre inconnu. Etching VIII (fig. 4), for example, depicts the painter
entranced by his portrait, while his nude model, forgotten, observes from
behind. No longer a physical inspiration, she has become an abstract muse,
her transformation signified by the inert classical bust propped behind the
painting's right edge. In this etching, Picasso picks up a crucial subplot of
Balzac's fable: Poussin's sacrifice of his own mistress, Gillette, in exchange

FIGURE 6
Picasso, Etching I (sculptor facing his sculpture, with dressed model and head), from Honoré de Balzac's *Le chef-d'oeuvre inconnu*
Published by Ambroise Vollard, Paris, 1931
Gift of John Hay Whitney, Beinecke Rare Book and Manuscript Library, Yale University

FIGURE 7
Picasso, Etching V (sculptor with sculpture, with nude and head), from Honoré de Balzac's *Le chef-d'oeuvre inconnu*
Published by Ambroise Vollard, Paris, 1931
Gift of John Hay Whitney, Beinecke Rare Book and Manuscript Library, Yale University

for a glimpse of Frenhofer's painting of his lover, *La belle noiseuse*. Gillette reluctantly agrees to model for Frenhofer so that Poussin can learn of the secret portrait. Yet she realizes that once she does so, she will be forever changed in Poussin's eyes: she will become a *sign* of a woman, a painted picture deprived of intimate life.

Between the flesh-and-blood Gillette and the painted *Noiseuse* is the act of representation, an act Balzac suggests is one with irreversible and violent effects. In part, this violence is rooted in the heterosexual male artist's struggle between the erotic desire to fully possess the model by re-creating her on canvas, and the recognition that this transfiguration will deprive her of the eroticism of a real, physical body. In Etching III (fig. 5) this dilemma is allegorized in the encounter of the bull and the horse, animals that served as recurring emblems of the artist and model in Picasso's works. In this

FIGURE 8
Picasso, Table of Etchings
Paris, July 4, 1931
Etching
10¹³/₁₆ x 7¾ in. (27.5 x 19.7 cm)
Yale University Art Gallery,
Everett V. Meeks, B.A. 1901, Fund,
2008.65.1

encounter, the bull's conquest of the horse implies her annihilation. The two animals are thus pictured in the moment of struggle, that liminal period, by analogy, in which a representation is actually made.

But in Picasso's etchings for *Le chef-d'oeuvre inconnu*, representational anxiety surfaces in relation to not only the erotics of the female nude but the stability of the male artistic self. In order to depict the scene of representation, after all, the artist is compelled to depict himself, an act of externalization that disrupts the very immediacy the artist-and-model theme is intended to provide. In Picasso's etchings, this externalization is repeatedly staged as one riddled with apprehension and fear. In Etching I (fig. 6), the melancholic artist is disembodied, as if a two-dimensional representation upon the wall; in Etching V (fig. 7), he offers a sculpted effigy of himself to a painted portrait while a bust in profile looks on from the side. In each lurks the recognition that every self-portrait commits the self to the condition of a sign. In this hall of mirrors, the status of representer and represented shifts freely about the space of the studio, and no one—certainly not the artist—is free from its sway.

In expanding the theme of the artist and model to include the problem of self-portraiture, Picasso's illustrations offer a reworking of Balzac's original text in pictorial terms. Appropriately, the artist provided a visual guide to this elaborated, or alternate, "text" in the form of a pictorial table of contents at the end of the book. Etched in 1931 as an *avis au relieur* (fig. 8), or

instructions for the bookbinder, this table of contents assigns numbers to schematic renderings of the twelve etchings commissioned for the book. In practical terms, the *avis* was meant to guide the binder in placing each etching in its correct order. This idea originated with Vollard, who wanted to ensure that the images would progress according to the logic of Balzac's text.[6] Picasso's pictorial *avis*, however, does not correspond to this order. It develops independently, telling a different story, with a mind, and a hand, of its own.

— Irene Small

1. Honoré de Balzac, *The Unknown Masterpiece* (New York: Peter Fenelon Collier and Son, 1900), 39. Balzac's story was modified several times after its first publication in two installments in 1831. The definitive version dates to 1837.

2. Ibid. Curiously, Balzac's subsequent description of *La belle noiseuse* reads strangely like early critiques of Analytic Cubism.

3. Several of these line-and-dot drawings were reproduced in the January 1925 issue of *La révolution surréaliste*, in which context they were understood as automatic drawings.

4. Dore Ashton, *A Fable of Modern Art* (New York: Thames and Hudson, 1980), 9. In 1937, some six years after Vollard's publication of *Le chef-d'oeuvre inconnu*, Picasso rented an atelier in the same seventeenth-century building at 7, rue des Grands-Augustins that served as a setting for Balzac's tale.

5. "Statement by Picasso: 1935," in Alfred H. Barr, Jr., *Picasso: Fifty Years of His Art* (New York: Museum of Modern Art, 1946), 274; originally published as "Conversation avec Picasso," *Cahiers d'art* 10, no. 10 (1935): 173–78.

6. See *Le chef-d'oeuvre inconnu* in Cramer 20.

13

Hercules Killing the Centaur Nessus

for Ovid's *Les métamorphoses* (Metamorphoses)

Boisgeloup, September 20, 1930
Etching, 12¼ x 8¹¹/₁₆ in.
(31.1 x 22.1 cm)
Published by Albert Skira,
Lausanne, 1931
Printed by Louis Fort, Paris
Proof on Rives paper outside of
an edition of 30
REFERENCES: Geiser/Baer I, 16◦ii/ii
Yale University Art Gallery,
Katharine Ordway Fund, 1983.60

Picasso's etchings for *Les métamorphoses* are a rare example within the artist's book projects in which illustrations are fully integrated with text at both a narrative and formal level. The artist's full-page illustrations for the project, including this one and figures 1–4, depict discrete episodes from Ovid's mythological stories. In addition, Picasso also executed a number of half-page illustrations, which serve as pictorial headers or pauses at the beginning of each book. The bibliophile Albert Skira had proposed an illustration project to Picasso after opening his own publishing house in 1928, but it was not until 1930 that the artist accepted the commission and executed the works. Picasso had explored the *Métamorphoses* theme in his 1920 drawings of Nessus and Dejanira, but it was reportedly a dream that he had in 1930 of a woman turning into a fish that served as inspiration for the Skira commission. The artist completed twenty-seven large etchings between September and October 1930, fifteen of which were ultimately selected, and another fifteen smaller etchings in the spring of 1931. During this period he also began to work on the Vollard suite (cat. no. 14), the antique subject matter and narrative sequences of *Les métamorphoses* perhaps providing inspiration for the automythological impulse of the later work.[1] *Les métamorphoses* was published in October 1931 and immediately celebrated by the critic Christian Zervos as a "grand ouvrage de Bibliothèque."[2]

The *Métamorphoses* illustrations, with their fluid line, classical subject matter, and legible figuration, have typically been discussed as fine examples of Picasso's classical style. In Picasso's painting, this style developed during the postwar *rappel à l'ordre* and its call for a return to the classic lineage of French art, and ended around 1925, when he became increasingly interested in Surrealism, the movement launched in 1924 with André Breton's *La révolution surréaliste*.[3] Picasso's classical mode, however, continued in the artist's graphic works, the mediums of etching and drawing being particularly conducive to the hard-edged, linear style he had developed in the postwar period. Like his 1934 illustrations for Aristophanes' *Lysistrata* (cat. no. 15), the clear, lyrical lines of the *Métamorphoses* illustrations evoke both the linear style of Greek vase painting and the neoclassical outline drawings of John Flaxman. This line likewise anticipates the curvilinear Cubist style Picasso began to explore in paintings of the late 1920s and 1930s such as *Seated Woman* of 1936 (cat. no. 16).

But Picasso's continuous, cursive line also brings to mind the automatist drawings of the Surrealists. Indeed, just as Ovid's poem provided a vehicle for the Surrealist fascination with myth, the *Métamorphoses* etchings are embedded in a pictorial language of Surrealism as much as they are of classicism. In Picasso's renderings, the nude—the very emblem of classical purity and universality—is submitted to the deformations of violence and erotic desire, limbs splayed about the pictorial field and pressed along its edges in a manner akin to the artist's biomorphic acrobats of 1930 (fig. 5). In the *Acrobat* paintings, the body is reduced to a knot of flexed limbs and

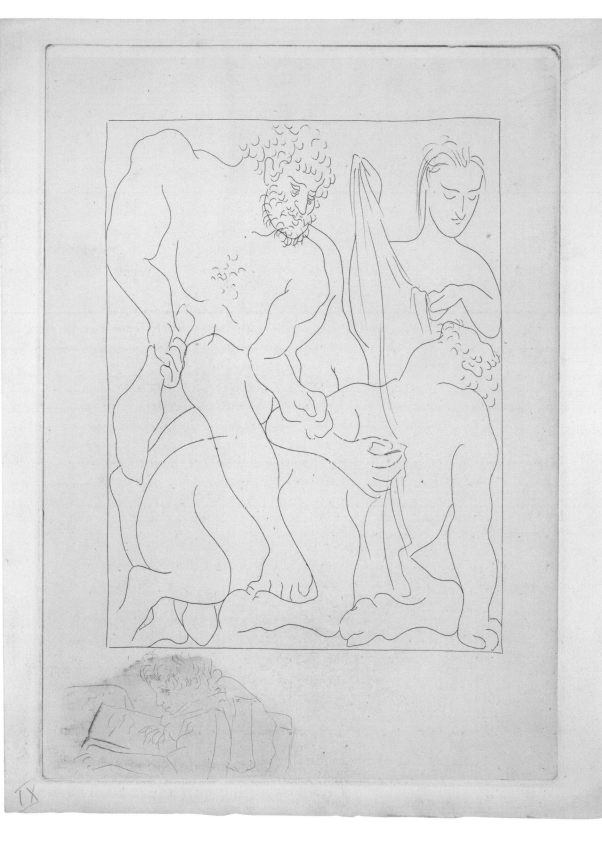

FIGURES 1–4

**Picasso, *Jupiter and Semele*, from
Ovid's *Les métamorphoses***

**Picasso, *Combat of Perseus and
Phineus*, from Ovid's
*Les métamorphoses***

**Picasso, *Tereus and Philomela*, from
Ovid's *Les métamorphoses***

**Picasso, *Death of Orpheus*, from
Ovid's *Les métamorphoses***

Published by Albert Skira, Lausanne,
1931
Gift of John Hay Whitney, Beinecke
Rare Book and Manuscript Library,
Yale University

an incongruous head, the canvas support determining the precise contortion of its dislocated parts. In the *Métamorphoses* etchings, by contrast, figural deformation is harnessed toward the suggestion of bodies in successive states of action. In these etchings, Picasso applies his purified, classical line to the structural innovations of Cubism, opening and distorting the boundaries between bodies to suggest figures simultaneously at rest and in motion. Thus, while the writhing, twisting, and straining bodies of the *Métamorphoses* are neither biomorphic nor disarticulated, the peculiar spatial ambiguity of their contours allows them to slide and shift freely around the page.

As Lisa Florman has observed, Picasso's use of open silhouettes and interpenetrating forms in the *Métamorphoses* demands the viewer's phenomenological participation in order to set each scene into motion.[4] In *Hercules Killing the Centaur Nessus*, for example, Florman notes how the doubled shoulder of Hercules' left arm effects a 180-degree rotation of the figure on the page. This rotation pivots, moreover, along the central axis of the image, as if approximating the turn of a folded page. In *Death of Orpheus* (fig. 4), meanwhile, the heads of the two women at the top appear to emerge from the same body, a distortion that allows the illustration to be read as both a group of women surrounding Orpheus and a single woman in successive stages of physical descent. The torsion of Orpheus's body, meanwhile, suggests both the upward thrust of the bull's head and the downward pull of gravity in the body's subsequent fall. This implied movement approximates the temporal, phenomenological experience of sculptural relief. Indeed, as Susan Mayer has argued, Picasso's antique sources for the *Métamorphoses* include Roman sarcophagi reliefs the artist may have seen at the Louvre.[5]

The condensation of temporal development into a single scene through recourse to a pregnant moment or a multiphase picture, however, is also a classic strategy of book illustration, as illustrators are often required to compress several narrative episodes into a single scene. Picasso's masterful elucidation of Ovid's text in the *Métamorphoses* illustrations therefore constitutes a certain repudiation of the unhinging of illustration and narrative in *Saint Matorel* (cat. no. 5). Yet Picasso's return to a more traditional relationship between word and image in the *Métamorphoses* is far from conventional, as he also used the commission to explore and subvert two interrelated structural aspects of the illustrated book: the margin and the frame.

Picasso included a hand-drawn rectangular frame in all of the etchings of the *Métamorphoses*. Often, the bodies depicted within this frame appear to strain at its edges, resulting in a sensation of tense spatial containment, as if the figures might spread out laterally if it were not for their rectangular circumscription. The frame thus contains and compresses action within the confines of the page, just as its images are controlled and bounded by their accompanying textual narrative. That Picasso *draws* the frame reveals the supporting function of images within an illustrated book as a literal pictorial constraint.

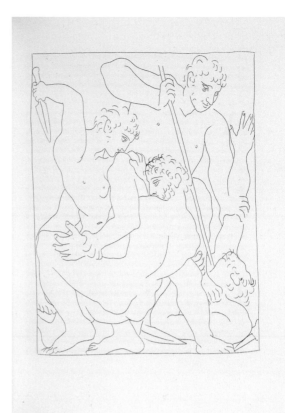

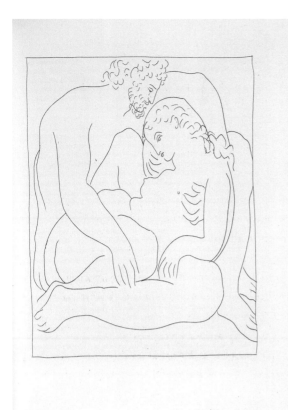

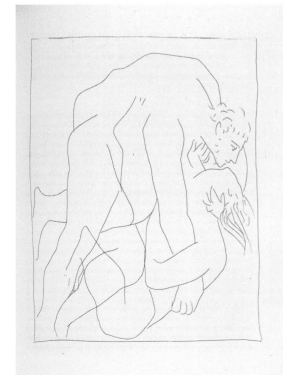

FIGURE 5
Picasso, *The Acrobat*
Paris, January 18, 1930
Oil on canvas
63⅝ x 51¼ in. (161.5 x 130 cm)
Musée Picasso, Paris, M.P. 120

Framing also occurs in the *Métamorphoses* by virtue of the white space of the margin, since the margin designates the boundary at which textual or pictorial activity normally comes to an end. But the margin is also a liminal space within the page, as it allows for the possibility of additions, commentary, and corrections. Thirty of the 145 copies of the *Métamorphoses* illustrations, for example, contain remarques, small marginal sketches Picasso etched below the framing edge of the images, occupying the space reserved for text in the half-page illustrations and filling the lower margin in the full-page illustrations.[6] Though at times the marginal illustrations suggest a working-through of some aspect within the image above—a head thrown back in anguish, an outstretched arm—more often they are completely independent of either the framed images or their corresponding text. As such, they suggest the doodles, scribbles, and experiments of the drawing hand unconstrained by the demands of narrative. As in medieval manuscripts, in which marginal illustrations acted as a gloss on an official text, these remarques offer counter-images to the dominant textual and visual narratives of the *Métamorphoses*.[7]

The margin is the physical buffer between image and text and the discursive worlds each represent. It is therefore a natural site from which to open a dialogue among the acts of reading, writing, illustrating, and viewing. In the loose print *Hercules Killing the Centaur Nessus*, Picasso's marginal illustration depicts a young boy reading a book, a visual pun on the image as a

Picasso, dessin, 1929 (15,5 × 21,5 cm.). — Atelier du peintre.

SOLEIL POURRI

Le soleil, humainement parlant (c'est-à-dire en tant qu'il se confond avec la notion de midi) est la conception la plus *élevée*. C'est aussi la chose la plus abstraite, puisqu'il est impossible de le regarder fixement à cette heure-là. Pour achever de décrire la notion de soleil dans l'esprit de celui qui doit l'émasculer nécessairement par suite de l'incapacité des yeux, il faut dire que ce soleil-là a poétiquement le sens de la sérénité mathématique et de l'élévation d'esprit. Par contre si, en dépit de tout, on le fixe assez obstinément, cela suppose une certaine folie et la notion change de sens parce que, dans la lumière, ce n'est plus la production qui apparaît, mais le déchet, c'est-à-dire la combustion, assez bien exprimée, psychologiquement, par l'horreur qui se dégage d'une lampe à arc en incandescence. Pratiquement le soleil fixé s'identifie à l'éjaculation mentale, à l'écume aux lèvres et à la crise d'épilepsie. De même que le soleil

173

self-reflexive representation of the act of reading and an intrusion or suspension of this same act. This "scene of reading" creates a pictorial *mise en abyme* in which the viewer's attention is split between different modes of rhetorical address. If at first we read Picasso's illustrations as pictorial comments on Ovid's text, the marginal remarques suggest a second order of commentary in which the marginal drawings comment in turn on the "text" of the illustrations, each new drawing shifting the anterior image from a primary to secondary condition. As Jacques Neefs has observed, the margin is therefore a place where "thought turns back upon itself," a literal supplement that reveals the original pictorial utterance as always divided, doubled, and incomplete.[8]

In April 1930, some five months before Picasso began the *Métamorphoses* illustrations, the dissident Surrealist Georges Bataille dedicated an entire issue of the journal *Documents* to the artist. In his own contribution to the issue, "Soleil pourri" (fig. 6), Bataille wrote of the sun as the most elevated and abstract of concepts and also the most base, violent, and mad.[9] The myth of Icarus is emblematic of this division, as it "splits the sun into two," revealing both the "shining moment of elevation" and the "screaming fall" of failure and doom. For Bataille, among contemporary artists only Picasso came close to the "blinding brilliance" of this internal rupture. In the *Métamorphoses*, Picasso demonstrates this division as the condition of narrativity itself.

— Irene Small

1. On the relationship between *Les méta-morphoses* and the Vollard suite, see Christopher Green, "Classicisms of Transcendence and Transience," in Elizabeth Cowling and Jennifer Mundy, *On Classic Ground: Picasso, Léger, de Chirico, and the New Classicism, 1910–1930*, exh. cat. (London: Tate Gallery, 1990), 267–82.

2. Christian Zervos, "Les métamorphoses d'Ovide illustrées par Picasso," *Cahiers d'art* 6, nos. 7–8 (1931): 369.

3. On the classical revival, see Jean Cocteau, *Le rappel à l'ordre* (Paris: Stock, 1926), and Cowling and Mundy, *On Classic Ground.* Picasso was included in this first issue of André Breton's *La révolution sur-réaliste* in 1924. He was also claimed by the dissident Surrealist group that gathered around Georges Bataille.

4. Lisa Florman, *Myth and Metamorphosis: Picasso's Classical Prints of the 1930s* (Cambridge: MIT Press, 2000).

5. On particular classical sources for *Les métamorphoses*, see Susan Mayer, "Greco-Roman Iconography and Style in Picasso's Illustrations for Ovid's *Metamorphoses*,"

Art International 23, no. 8 (November–December 1979): 28–35; and Jiri Frel, "Picasso and Greek Art, Two Illustrations," in *Scritti di storia dell'arte in onore di Federico Zeri*, ed. Mauro Natale (Milan: Electa, 1984), 2:924–28.

6. Artists often used remarques to test the strength of the etching acid or needle before moving on to the main image. As such remarques were normally removed from the plate for the final edition of a book, editions with remarques were particularly prized by collectors.

7. On marginal illustrations in medieval manuscripts, see Michael Camille, *Image on Edge: The Margins of Medieval Art* (Cambridge, Mass.: Harvard University Press, 1992).

8. Jacques Neefs, "Margins," *Word and Image* 13, no. 2 (April–June 1997): 135–57.

9. Georges Bataille, "Soleil pourri," *Documents* 2, no. 3 (April 1930): 173–74, trans. by Allan Stoekl in *Georges Bataille: Visions of Excess, Selected Writings, 1927–1939* (Minneapolis: University of Minnesota Press, 1985), 57–58.

Picasso's illustrations for Ovid's *Métamorphoses* (cat. no. 13) inspired a sequence of forty etchings, nearly all of them executed in a surge of activity in March 1933, illustrating another narrative: Picasso's own life as a sculptor, seen through the lens of the classical past. Picasso's interest in sculpture began in 1902, but it was not until the late 1920s that he devoted sustained attention to it, and in 1930 he purchased a château in Boisgeloup, forty-five miles northwest of Paris, where he used one of its stable buildings as a sculpture studio. There he created works inspired by Marie-Thérèse Walter (fig. 1), whom he met in Paris in 1927 in a surrealist attack of *l'amour fou*. Each 1933 etching is dated with the precise day and month, like a diary, so it is possible to follow the movement of Picasso's thought as he ruminates on the act of creation from one etching to the next. In 1939, Ambroise Vollard published one hundred etchings by Picasso including these depictions of the sculptor's studio, as well as scenes of the Minotaur and Rembrandt. The suite is now recognized as one of the major accomplishments in printmaking of the last century.[1]

Picasso's consideration of the sculptor's studio, as in the three etchings at the Gallery (cat. nos. 14a–c), is both simple and extraordinarily complex. Most of these images are structured by three basic terms: artist, model, and sculpture. Picasso's adjustment of each term from etching to etching creates different, though related, scenarios, each colored by a prevailing sentiment, like a lyric poem. They can range from intense love to warm contemplation to cold detachment, with many variations in between. When, in earlier prints

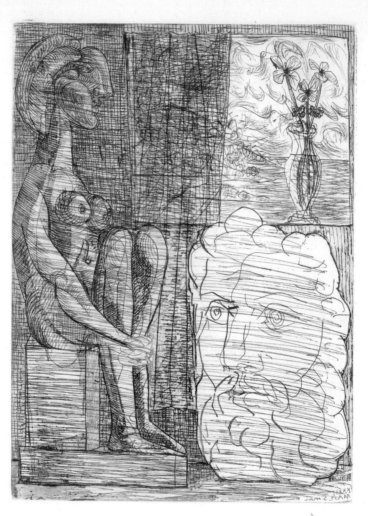

FIGURE 2
*Mask with Superstructure
Representing a Beautiful Mother
(D'mba)*
Baga, Sitem subgroup; Bulungits;
or Pukur
Guinea, late 19th–early 20th century
Wood and brass
52 x 15⅜ x 24³⁄₁₆ in.
(132.1 x 39.1 x 61.4 cm)
Yale University Art Gallery,
Charles B. Benenson, B.A. 1933,
Collection, 2006.51.390

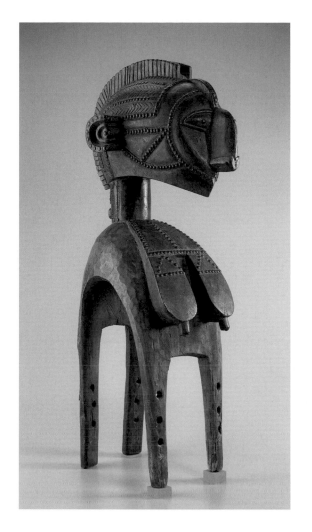

from the Vollard suite, these terms are reduced to one or even two figures, as in *Nude Seated before a Curtain, Reclining Women,* or *In the Bath* (figs. 3–5), the tensions and charge of the trios evaporate, though Picasso's elegant and innovative approach to the body remains.

In *Two Statues* (cat. no. 14a) the intense gaze of a disembodied classical head cannot penetrate the seated female sculpture at left. Her striking profile is clearly based on an African D'mba mask from Guinea that Picasso owned since at least 1918, now at the Musée Picasso, Paris; the Gallery's collection includes a very similar D'mba mask (fig. 2).[2] Picasso suggests a charged, almost magical confrontation between classical and African sculpture through a dense layer of frenzied etched lines that veil the image, and transform it from a depiction of the artist's studio into an evocation of the space of imagination itself. It is perhaps Picasso's evocation of the workings of the mind that led André Breton to reproduce three of the etchings, including *The Sculptor's Studio* (cat. no. 14c), in the first issue of the Surrealist journal *Minotaure* in 1933, along with photographs of Picasso's studio by Brassaï. In *The Sculptor's Studio,* Picasso's own love for Walter, cast within

14b
Sculptor, Reclining Model, and Sculpture

Paris, March 17, 1933
Etching, 10½ x 7⅝ in.
(26.6 x 19.4 cm)
Published by Édition Vollard,
Paris, 1939
Printed by Atelier Lacourière, Paris
Edition 260
INSCRIPTIONS: lower right: *Picasso*
WATERMARK: lower center: Picasso
REFERENCES: Geiser/Baer II, 298
Yale University Art Gallery, The
Ernest C. Steefel Collection of
Graphic Art, Gift of Ernest C.
Steefel, 1958.52.92

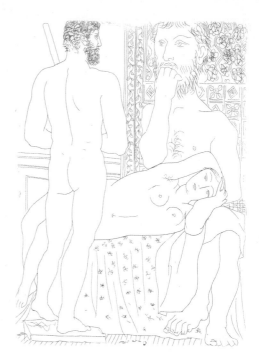

14c
The Sculptor's Studio

Paris, March 21, 1933
Etching, 10½ x 7⅝ in.
(26.6 x 19.4 cm)
Published by Édition Vollard,
Paris, 1939
Printed by Atelier Lacourière, Paris
Edition 260
INSCRIPTIONS: lower right: *Picasso*
WATERMARK: lower center: Vollard
REFERENCES: Geiser/Baer II,
304ii/ii
Yale University Art Gallery, The
Ernest C. Steefel Collection of
Graphic Art, Gift of Ernest C.
Steefel, 1958.52.91

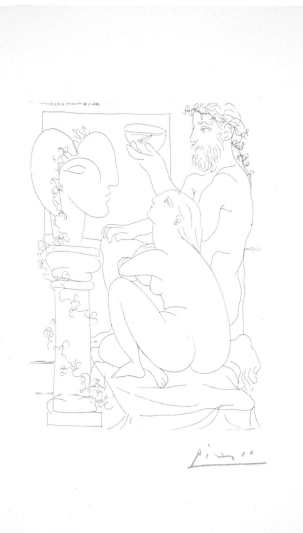

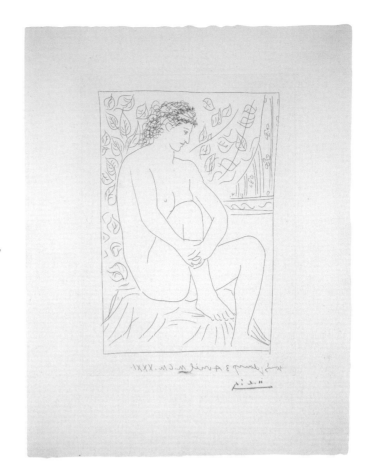

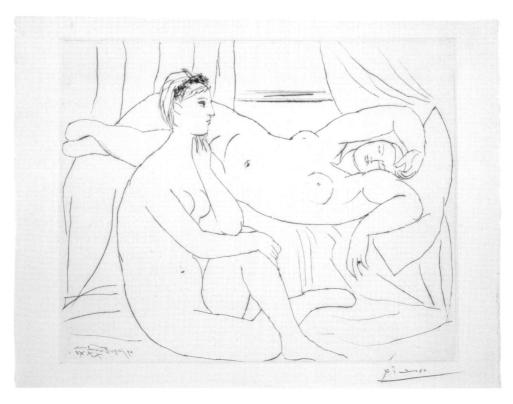

FIGURE 5
Picasso, _In the Bath_
Boisgeloup, October 1, 1930
Etching
12¼ x 8¾ in. (31.1 x 22.2 cm)
Yale University Art Gallery, The
Ernest C. Steefel Collection of
Graphic Art, Gift of Ernest C.
Steefel, 1958.52.89

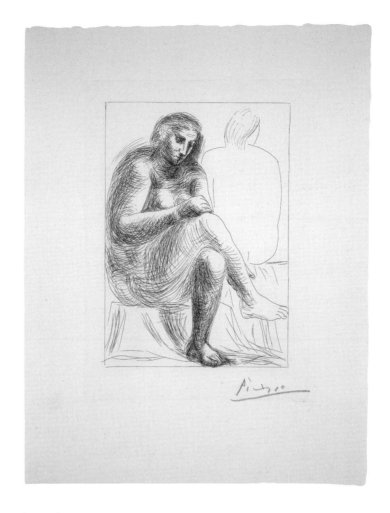

the etching in automythological terms, seems unbounded: he creates a swooping, exaggerated heart shape to define the female sculpture at left, repeating the heart again in the model's buttocks; the heart shape appears again and again elsewhere, as in a painting of Walter done after the suite, in 1936 (cat. no. 16).

– Susan Greenberg Fisher

1. For overviews of the Vollard suite, see _Picasso's Vollard Suite_, introduction by Hans Bolliger, trans. Norbert Guterman (London: Thames and Hudson, 1987); and _The Sculptor's Studio: Etchings by Picasso_, introduction by William S. Lieberman (New York: Museum of Modern Art, 1952). See also the more recent study, which relates the suite to Surrealist automatism, by Lisa Florman, "The Structure of the _Vollard Suite_," in _Myth and Metamorphosis: Picasso's Classical Prints of the 1930s_ (Cambridge: MIT Press, 2000), 70–139.

2. On the D'mba mask, see John

Richardson, _A Life of Picasso_, vol. 3 (New York: Random House, 2007), 449. Picasso lent the mask to an exhibition of African and Oceanic art in Paris at the Galerie du Théâtre Pigalle several years before this etching, in 1930. See Peter Stepan, _Picasso's Collection of African and Oceanic Art: Master of Metamorphosis_ (Munich: Prestel, 2006), 126. I am grateful to Frederick John Lamp, the Frances and Benjamin Benenson Foundation Curator of African Art at the Yale University Art Gallery, for suggesting to me the connection between Picasso's figure and the African mask.

15
Suite of Six Etchings for Aristophanes' Lysistrata

Suite of 6 etchings (2 with
aquatint), each 8$^{11}/_{16}$ x 6 in.
(22.1 x 15.2 cm)
Published by the Limited Editions
Club, New York, 1934
Printed by Atelier Lacourière, Paris
Edition 150
INSCRIPTIONS: each, lower left:
Picasso
REFERENCES: Cramer 24;
Geiser/Baer II, 387–92
Yale University Art Gallery, Gift of
Arthur Edwin Neergaard,
1959.23.1a–f

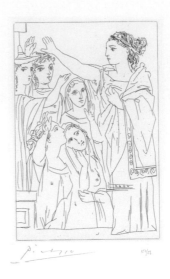

The Oath of the Women, January 15, 1934

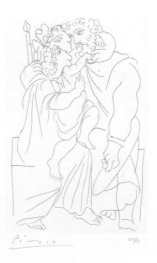

Cinesias and His Family, January 27, 1934

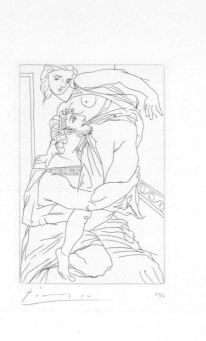

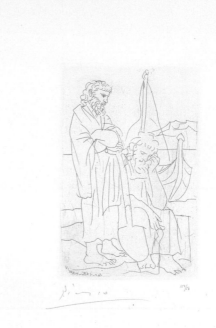

Myrrhine and Cinesias, January 17, 1934

Two Men by the Sea, February 4, 1934

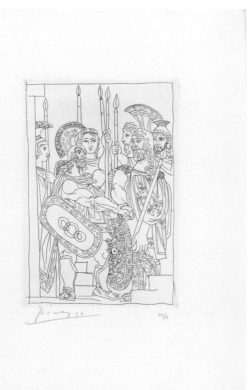

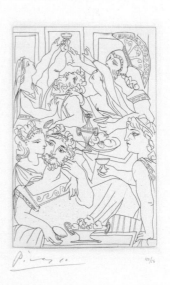

The Reconciliation of the Athenians and Spartans, January 13, 1934

The Banquet, January 17, 1934

Picasso's illustrations for Aristophanes' *Lysistrata* (written in 411 B.C.) were his only project undertaken for an American publisher, the Limited Editions Club, an association of bibliophiles based in New York. The club asked Picasso to illustrate the story following the recent translation by Gilbert Seldes, the American writer and cultural critic who was editor and drama critic of *The Dial*, whom Picasso had known since the 1920s.[1] Picasso undertook these six etchings for a limited edition between January 13 and February 4, 1934. He also made drawings for the thirty-four lithographs used for the book, published in an edition of 1,500.[2]

The story of Lysistrata opens in the twenty-first year of the Peloponnesian War, when there was little prospect of peace. Aristophanes, responding to this desperate state, suggests a burlesque solution to the impasse: the women of Athens, led by Lysistrata and supported by female delegates from the other states of Hellas, take matters into their own hands and refrain from sex with the men until the fighting stops. After the predictable resistance and struggle with the men following their decision, their strategy is ultimately effective, and peace comes; the play ends with a celebration of the two sides, the Athenians and Spartans.

Picasso's six illustrations convey this humorous story about civic action through a nostalgic recourse to the art of the past, namely the "grands sentiments" of neoclassical history painting by Jacques-Louis David and his school that Picasso admired at this time.[3] David permeates the suite, as Picasso's figures recall the raised arms of *The Oath of the Horatii* (1784, Musée du Louvre, Paris) and the emboldened women of *The Intervention of the Sabine Women* (1799, Musée du Louvre, Paris), or the raft and enjoined bodies of Théodore Géricault's *Raft of the Medusa* (1819, Musée du Louvre, Paris). Picasso's consideration of David also resulted in a more direct rethinking of his work, in a Surrealist version of *The Death of Marat* (1793, Musées Royaux des Beaux Arts de Belgique, Brussels) in July 1934; the etching was used as a frontispiece for *De derrière les fagots*, a collection of Surrealist poems by Benjamin Péret. The republican vision of citizens coming together as a unified social body imagined by David and his school reappears here in how individual bodies join together to become symbolically one body, through intimate pairings or raucous, joyous groupings.

— **Susan Greenberg Fisher**

1. Picasso inscribed a drawing to Seldes in 1920, as noted in Cramer 24.

2. A book from the edition of 1,500 is now housed in the Arts of the Book collection at Sterling Memorial Library, Yale University.

3. Picasso to Kahnweiler, ca. 1930; quoted in Lydia Gasman, "Mystery, Magic, and Love in Picasso, 1925–1938: Picasso and the Surrealist Poets" (PH.D. diss., Columbia University, 1981), 1:419.

16
Seated Woman

Juan-les-Pins, Antibes,
April 26, 1936
Oil on canvas, 28¾ x 23½ in.
(73 x 59.7 cm)
INSCRIPTIONS: on verso and on
horizontal member of buildout on
stretcher bar: *26 avril XXXVI*
PROVENANCE: Collection of the
artist, until at least 1961; Galerie
Louise Leiris, Paris; Charles B.
Benenson, Greenwich, Conn.
Yale University Art Gallery,
Charles B. Benenson, B.A. 1933,
Collection, 2006.52.22

In April 1935 Picasso, aged fifty-three, stopped painting and devoted himself to writing. He announced his activity to Jaime Sabartés: "I abandon sculpture engraving and painting to dedicate myself entirely to song."[1] He resumed his customary daily activity of painting one year later, in April 1936, while in Antibes. There he produced a painting almost every day that month, in a group of works based on his mistress Marie-Thérèse Walter that includes this painting, *Seated Woman* of April 26. By then, Picasso had written over one hundred poems in Spanish and French.[2] He wrote until 1959, leaving more than 340 poetic works, and he also penned two full-length plays, *Le désir attrapé par la queue* (Desire Caught by the Tail; 1941), which was first read in 1944 at the Paris apartment of writer Michel Leiris, and *Les quatres petites filles* (Four Little Girls; 1948).[3] Picasso's decision to prioritize writing in 1935 and 1936 has been variously linked by scholars to the emotional difficulties stemming from his separation from Olga Koklova, his wife since 1918, and his deep concern at this time over the rise of Fascism and the Spanish Civil War.[4]

Immediately after Picasso wrote the poems, younger Surrealist writers, including André Breton and Benjamin Péret, responded to the works with their own analyses and tributes in a 1935 special edition of *Cahiers d'art*, the Paris journal founded in 1926 by Christian Zervos. It also featured articles by Paul Éluard, Georges Hugnet, Salvador Dalí, and Man Ray. Reproductions of several of Picasso's original annotated manuscripts in Spanish, prefaced by Sabartés, were included along with French translations (fig. 1). Framing the poems were many reproductions of recent paintings by Picasso, mainly from 1934, and in particular a group that showed female figures, both alone and in pairs, in the act of reading and writing, such as *Two Girls Reading* (fig. 2). As the women huddle over cartoonishly animated books and pieces of paper covered with thick lines of text and scribbles, they form a lively context for Picasso's poems, and appear like pictorial preludes for his activity as a writer. André Breton went on to analyze the poems closely in an extended essay called "Picasso poète," and in considering several works from August 1935, clearly inspired, he wrote: "Picasso has joined together by red, yellow and blue lines in such a way that they can be read in various directions and that the handwritten page looks like a dew-laden spider's web under the first rays of the morning sun. Is it not thus that we interrogate the skies, beginning with no matter which constellation, and, if we have time, seek to read human destiny in the stars?"[5]

The *Cahiers d'art* issue also received attention from other writers, including Clive Bell in London, who noted that while a painter's excursion into writing is usually a lamentable move, in Picasso's case it was not, and that his poems should be taken seriously. Bell proclaimed in the *New Statesman and Nation*: "It goes without saying that, in [Picasso's] visual art, it is not the ideas, but the connection of ideas that matters. This is equally true of what he writes; just as it is true of what Mallarmé or Eliot write. Picasso

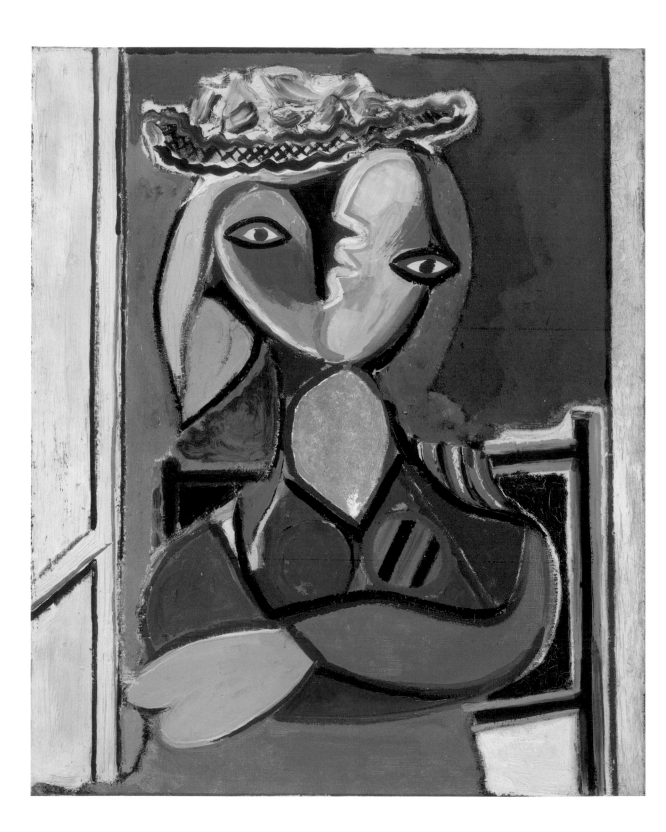

FIGURE I
Picasso, annotated poem manuscript
December 24, 1935
Musée Picasso, Paris

is a poet—a modern poet."[6] As French literature scholar Peter Read has discussed, Picasso's poetry, with its transgression of rules and grammar, and its constantly morphing imagery and Surrealist juxtapositions, came much closer to Surrealist automatic writing than his paintings.[7] Read goes on to note that the *Cahiers d'art* edition was the climax of the Surrealists' efforts to claim Picasso for the movement, which began in the mid-1920s, as discussed in this volume by Mary Ann Caws in "The Surrealist Impulse."

When considered in relation to Picasso's writing, *Seated Woman* evokes this complex period of engagement with Surrealism and its poets: it evidences Picasso's Surrealist impulse, but also his resistance to their aims and goals. On the face of it, the painting looks Surrealist and engages Surrealist

FIGURE 2
Picasso, *Two Girls Reading*
March 28, 1934
Oil on canvas
37⅞ x 25¹/₁₆ in. (96.2 x 63.7 cm)
Private collection

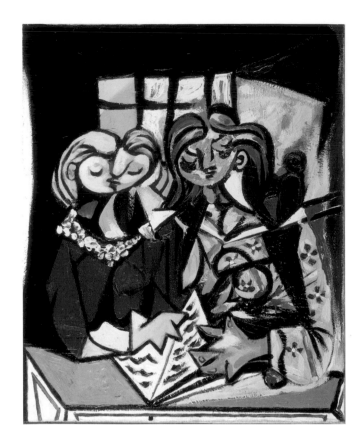

themes. It denigrates vision, as suggested in the woman's set of disjointed eyes, one high on her face and one low, which conveys the sense of not seeing things clearly, or of not knowing in which direction to look. The impairment of vision is further emphasized by the green-yellow sunlight that burns through the window to her left, its garish brightness casting a deep purple shadow under her eye and down her cheek. With vision downplayed, Picasso concentrates on the evocation of the many sides of her inner self, splitting her face in two with a thick black line to create a deep red chasm. Her face and head seem to be falling apart, and the pretty trappings of femininity—her dainty, Marc Chagall–esque straw hat, decorated with purple flowers—cannot prevent the ugly struggle within. To the right of her face, Picasso inserts the artist's shadowy profile (a strategy he had used since the late 1920s, in paintings of the artist's studio), merging his own self with hers like a corrective, though he faces in the other direction, escaping the sun's punishing glare.

The painting's evocation of a harsh sun and a familiar though strange interior, as well as its suggestion of the inner workings of the self, overlaps with the themes and ideas of Surrealist writing. Picasso's careful planning of the painting's composition, however, suggested through related drawings, reiterates his distance from the Surrealists' desire to overturn painting and the traditional means of art through automatic drawing and writing. By contrast, Picasso thought a great deal about the forms, sculptural shapes, and

FIGURE 3
Picasso, *Studies: Portrait of a Woman*
Juan-les-Pins, April 26, 1936
India ink on a sheet folded in two
10¼ x 6⅞ in. (26 x 17.5 cm)
Musée Picasso, Paris, M.P. 1160

FIGURE 4
Picasso, *Various Studies*
Juan-les-Pins, April 27, 1936
India ink on a sheet folded in two
10¼ x 6¹³⁄₁₆ in. (26 x 17.3 cm)
Musée Picasso, Paris, M.P. 1162

composition of *Seated Woman*, as in an ink drawing from the same day as the painting and now at the Musée Picasso, Paris, in which he considers various iterations of the seated woman's torso and face (fig. 3). After completing the painting, the next day Picasso continued to think about it in a drawing where the final work is now framed and presented publicly, before an onlooker to the left and a townscape behind (fig. 4). Framed and finished, Picasso now sees his work as a "Picasso," as if to reiterate to himself his power and authority as author. Below the scene of this imagined exhibition, in the lower half of the drawing, Picasso goes on to envision future possible compositions, such as a mother-and-child subject, perhaps inspired by the birth of his daughter Maya in September 1935.

As Susan Laxton has recently noted, even in his poetry Picasso countered the rapid effusion of his thoughts and words with the more slowed concentration on classicizing images, as if he could not fully give himself over to Surrealist automatic writing, with its emphasis on deskilling and the loss of authorial voice.[8] The flow of language on a page from June 7 and 15, 1936, for example (fig. 5), is countered by the silent immobility of a horse's head, the two poised in a precarious balance. In Picasso's career 1935–36 was a highly charged moment—one, understandably, long overshadowed by *Guernica* of 1937 (Museo Nacional Centro de Arte Reina Sofía, Madrid)—when he experienced profoundly the allure of language. The degree of its lure was arguably equaled only during the Cubist years, when

7 juin XXXVI.

au rideau détaché des mains volantes par les cheveux du large

l'échelle du perfum des feuilles de la verveine

fixé par les cris des irondelles aux vols géometriques du désir

le potau feu du grand galop du prisme

fleur-arme enfoncée au coeur

expire son indiference

son costume poudre la coupe faite en forme de tête d'aigle

des neiges deff la musique des flèches de l'arlequin

la faux moissonneuse d'étoiles

les bras sous le plumetis des manches du corsage

défait le noeud de vipères de l'arbre des veilleuses endormies?

sur les feux doux coupant l'odeur du silence

pendu aux lames de ~~elle~~ la persienne

sorte de tambour battant le rappel au point mathématique de son amour

dans l'oeil étend du toro ailes déployés

nageant nu dans l'odeur du bleu serré au cou du soleil en poussière

caché sous le lit grelottant

embourbé dans l'ombre du coup de fouet balbucié par le vert épanoui

bloti dans la boulette de souvenirs jetée dans la cendre

à l'instant ou la roue équilibre sa chance

15 juin XXXVI.

rit l'ail de sa couleur de etoile feuille morte

rit de son air ~~moqueur~~ à la rose le poignard

que sa couleur enfonce l'ail de l'étoile en feuille morte

rit de son air malin au poignard ~~des~~ roses l'odeur

de l'etoile tombant en feuille morte

l'ail de l'aile

FIGURE 5
Picasso, *Head of a Horse;*
Poems in French
Paris, June 7 and 15, 1936
Pen, India ink, and gouache
13 x 6¹¹/₁₆ in. (33 x 17 cm)
Musée Picasso, Paris, M.P. 1168

the poetry of words and wordplay permeated his art.[9] But the exhibition of *Guernica* at the 1937 International Exposition, and the careful documentation of its successive compositional stages at the Grands-Augustins studio in Dora Maar's photographs, proclaimed the primacy that painting continued to have for Picasso.[10]

– Susan Greenberg Fisher

1. Picasso to Sabartés, quoted in *The Burial of the Count of Orgaz and Other Poems by Pablo Picasso*, ed. Jerome Rothenberg and Pierre Joris (Cambridge, Mass.: Exact Change, 2004), vii.

2. Picasso's poems have been collected in Marie-Laure Bernadac and Christine Piot, eds., *Picasso: Écrits*, preface by Michel Leiris (Paris: Gallimard, 1989); published with essays translated into English as *Picasso: Collected Writings* (London: Aurum Press, 1989). They have been translated in Rothenberg and Joris, *Burial of the Count*, and studied in depth in Kathleen Brunner, *Picasso Rewriting Picasso* (London: Black Dog, 2004).

3. For a discussion of the latter play, see cat. no. 27.

4. See, for example, Peter Read, *Picasso and Apollinaire: The Persistence of Memory* (Berkeley: University of California Press, 2008), 204.

5. André Breton, "Picasso poète," quoted in *A Picasso Anthology: Documents, Criticism, Reminiscences*, ed. Marilyn McCully (Princeton, N.J.: Princeton University Press, 1982), 199.

6. See Clive Bell, "Picasso's Poetry," *New Statesman and Nation* 11 (May 30, 1936), quoted in *Picasso in Perspective*, ed. Gert Schiff (Englewood Cliffs, N.J.: Prentice Hall, 1976), 86–87. Bell also observed: "It is customary when a great artist in one medium tries his luck in another not to take him seriously. On this occasion custom must be dishonored. . . . Often in the poems, which are essentially visual, the connection of ideas, or, better, of ideas of images, is more easily apprehended than in the paintings and drawings. Picasso one realizes, whether one likes it or not, Picasso, the most visual of poets, is a literary painter. He always was: again and again his pictures express an emotion that did not come to him through the eyes alone. Matisse, by comparison, is aesthetic purity itself; and that may account to some extent for the wider influence of Picasso."

7. Read, *Picasso and Apollinaire*, 204.

8. Susan Laxton, "Stopping Painting: Picasso, Automatism, and the Exquisite Corpse," paper given for the session "Surrealist Drawing, 1915–50: Tracing the Subversive Line and the Wayward Mark," College Art Association conference, Dallas, 2008.

9. See, for example, the discussion in cat. no. 7.

10. As also noted in Laxton, "Stopping Painting."

40 dessins de Picasso en marge du Buffon (40 Drawings by Picasso in the Margins of Buffon)

1943
Book, with 40 drawings by Picasso,
14¹¹⁄₁₆ x 11¹⁄₁₆ in. (37.3 x 28.1 cm)
Published by Jonquières and
Berggruen, Paris, 1957
Printed by Imprimerie Priester
Frères, Paris, for text and
typography; Atelier Duval, Paris, for
reproductions; Robert Blanchet,
Paris, for linocut
Edition 36 of 226 deluxe copies on
Arches wove, with the linocut
Le pigeonneau
INSCRIPTIONS: *Le pigeonneau*, lower
right: *Picasso*
REFERENCES: Cramer 84
Yale University Art Gallery, The
Ernest C. Steefel Collection of
Graphic Art, Gift of Ernest C.
Steefel, 1958.52.172

In 1936, Ambroise Vollard commissioned Picasso to illustrate extracts from the comte de Buffon's *Histoire naturelle*. These thirty-six volumes, which Buffon began to publish in 1749, aspired to an encyclopedic description of the natural world. Picasso's illustrations, made in 1936, consist of thirty-one prints of animals, each identified by name, and, for the deluxe suite, a thirty-second image of Marie-Thérèse Walter, whose caption, "la puce" (the flea), is a pun on *la pucelle* (the virgin).[1] The book, delayed due to Vollard's death in 1939, was finally published in an edition of 226 by Martin Fabiani, Vollard's associate, in May 1942.

On January 24 the following year, Picasso visited his lover, the Surrealist photographer and painter Dora Maar, bringing with him a copy of the *Histoire naturelle* that he had dedicated to her. While at Maar's studio, Picasso proceeded to decorate the margins and blank pages of the book with human heads, animals, and fantastical hybrid creatures, beginning with Maar herself as a bird-woman sphinx on the title page. The dedication, "per Dora Maar / tan rébufona!" (for Dora Maar, so pretty!), is a pun on the name Buffon and the Catalan word for "pretty," *bufó*. In January 1957, the same month Maar opened an exhibition of paintings in Paris, the publisher Henri Jonquières released a book with facsimiles of these drawings along with a 1939 linocut, *Le pigeonneau*.

Maar's likeness appears in numerous paintings by Picasso between 1936 and 1945, most famously as "the weeping woman." Particularly in their early relationship, Picasso depicted Maar in states of metamorphosis between human, animal, and plant. Maar's own experiments in Surrealist photography, such as *Père Ubu* of 1936 (fig. 1), were likely an influence. Between 1936 and 1937, Picasso and Maar also collaborated on a number of projects using photographic techniques drawn from Maar's darkroom expertise. Picasso's 1943 drawings for his lover on Buffon's *Histoire naturelle* recall this period of fertile artistic exchange while he was negotiating and revising his own relationship between his past and present work.

FIGURE 1
Dora Maar, *Père Ubu*
1936
Gelatin silver print, mounted
15⅝ x 11½ in. (39.7 x 29.2 cm)
The Metropolitan Museum of Art, New York, Gilman Collection, Purchase, Gift of Ford Motor Company and John C. Waddell, by exchange, 2005, 2005.100.443

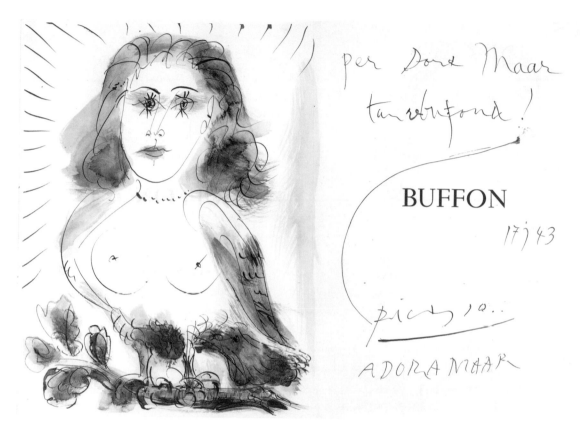

per Dora Maar

tandrefond!

BUFFON

17j43

picasso

ADORA MAAR

Title page: *Dora Maar as Bird-Woman* and Dedication

Page 31: *Woman Seen from Behind*

The 1943 additions to *Histoire naturelle* consist mainly of full-page heads drawn on blank or title pages. Animal and human qualities are often combined: the visage of a lion veers toward that of a young girl; a pensive faun perks a pair of pointy ears; a wizened sailor grins like a Cheshire cat. In *Woman Seen from Behind*, on page 31, an abstract wash of a figure's head evokes the disconcerting fetal form of Maar's *Père Ubu*. In *Bearded Man with Thick Hair*, on page 18, male and female traits mingle but do not fuse, the figure's exaggerated lashes and cloud of inky hair contrasting with the sharp strokes of the whiskers and beard. Several images suggest motifs and character types—the stripe-shirted sailor, the bull, the minotaur—from Picasso's repertoire of emblematic self-portraits. The human and animal forms thus sketch a catalogue of possible states of being, each one capable of transforming unexpectedly into the next.

Indeed, the entire project of supplementing and reworking a "finished" set of prints (the 1942 edition of *Histoire naturelle* that served as Picasso's base) suggests an ambiguity about the boundaries of the work of art itself. Marginal drawings, additions, and doodles on preexisting images and texts have various roles, from commentary and amplification to correction and parody. At the most basic level, however, they mark a passage of time from one inscription to the next. By drawing over and upon his previous works, Picasso engages in a form of graffiti, treating his images as if they were

Page 3: *Donkey*

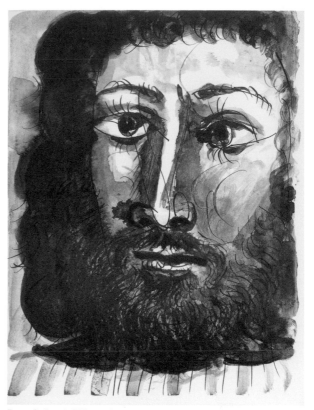

Page 18: *Bearded Man with Thick Hair*

found objects authored by another (see cat. no. 35). Yet this same process reincorporates the earlier image into a work in progress, thereby shifting the finality of the signature back into the present tense.[2] Shuttling between "finished," "in-progress," and even "made by someone else," the performativity of these pictures divides authorship against itself.

— Irene Small

1. On Picasso's depictions of animals, see Neil Cox and Deborah Povey, *A Picasso Bestiary*, exh. cat. (London: Academy Editions, 1995).

2. Picasso extended this practice of graffiti as a form of pictorial commentary on his own work the same year when he elaborated, decorated, framed, and otherwise notated his illustrations for a Jean Cassou monograph from 1940. This book, owned by Paul Éluard, was known as *Picasso revu par Picasso*. See Abraham Horodisch, *Picasso as Book Artist* (London: Faber and Faber, 1962). On Picasso's use of graffiti, particularly as it relates to photography, see Anne Baldassari, *Picasso and Photography: The Dark Mirror* (Paris: Flammarion, 1997). It is

particularly appropriate that he gave this "edited" edition of *Histoire naturelle* to Dora Maar. In 1937, she documented the various stages of Picasso's *Guernica* (1937, Museo Nacional Centro de Arte Reina Sofía, Madrid) in his studio at rue des Grands-Augustins. These photographs, subsequently published in *Cahiers d'art* in July 1937, were the first published images of a work-in-progress by Picasso, and vastly impacted the reception and interpretation of the painting. Subsequently, during the German occupation of France in World War II, Picasso was prohibited from exhibiting; as a result, his work was increasingly known and circulated in reproductions.

MARY ANN CAWS

Letters of Mourning

THOUGH PICASSO KNEW THE POET PIERRE REVERDY
from the early days of Cubism and the Bateau-Lavoir (fig. 1), it was not
until 1948 that they would collaborate, on the completed volume of *Le chant
des morts* (cat. no. 20), an extraordinary and never-to-be-repeated manifest-
ation of how the splendors of handwriting can merge with the depths of
poetic and pictorial musing. Picasso and the Surrealists were all fascinated
by the marks of the hand, like a self-portraiture of the artist at work, the
creator's tool for creation.[1] The large red abstractions are at once menacing
and full of dignity against the black of Reverdy's spaced-out handwriting,
and this baroque red and black against the white page, this blood and this
mourning, are like the life of death, the very opposite of moribund. They
remind me of Bach's *Musical Offering*, in a kind of noble mourning gesture
against space itself.

As a mourning gesture, tragically premonitory, one of the great
Surrealist photographs of all time is that by Dora Maar of her great friend
Nusch Éluard, with a cobweb over her face, entitled *The Years Lie in Wait for
You* (fig. 2). Nusch was the poet Paul Éluard's wife, who had once been a
circus performer, and whose image was seized so perfectly over and over by
Dora Maar's photographs of her, and by Lee Miller's of their picnics in the
summers of 1936 and 1937 at Mougins.[2] There they all were, Picasso and
Dora, Man Ray and his girlfriend, Éluard and Nusch, bare-breasted and
affectionate. It was Dora Maar with whom Nusch was to lunch on the day
she died, leaving Éluard devastated. Paul Éluard, one of Picasso's closest
friends since working together on *Minotaure* in 1933 and throughout his
life, was the most celebrated poet of Surrealism and a friend of artists,
as the many portraits of him testify (fig. 3). With Louis Aragon, Éluard
remained a firm member of the Communist Party when André Breton,
whose alliance was with Trotsky, led his followers in the Surrealist group
away from the party's hard line. Picasso's own allegiance to the Communist
Party after World War II was celebrated widely and loudly, and his 1943
sculpture *Man with a Lamb* (fig. 4) was taken as a true symbol of the
painter's faithfulness to the party line. His friendship with Éluard was
strengthened by this allegiance, even as his alliance with Breton was strained
past the breaking point, until Breton would no longer shake hands with him.
At Éluard's death in 1952, the procession through the streets of Paris was
massive: he had exemplified lyricism and political engagement together.

But all is not mourning. As in the greatest works of Catalonia and Spain in general, the tragic and the comic are inevitably intertwined. Indeed, Picasso's sense of humor colors his often somber postwar work: take *balzacs en bas de casse et picassos sans majuscule* (cat. no. 28). The way the great round face of the iconic coffee drinker morphs into an owl shape, the way the frame for the face is punctuated, or the way Alfred Jarry's *gidouille* of his *Ubu roi* enters his right cheek: how very cheeky of him. Nothing is too witty for Picasso.

In these years after the war, along with Reverdy and Éluard, Picasso collaborated with other poets and writers he had known since the early days, such as the Romanian Tristan Tzara. Tzara remained after his brilliant Dada period, just preceding the Surrealist period, also a member of the Communist Party. Tzara's great epic poem of 1931, "Approximate Man," of the same majestic force as T. S. Eliot's "Waste Land" (1922), Guillaume Apollinaire's "Zone" (1912), and Blaise Cendrars's "Prose du transsibérien et de la petite Jehanne de France" (1913), was in fact both Dada and Surrealist.[3] Later, during his work with Picasso in 1950, Tzara was a confirmed Communist, selling the party newspaper *L'humanité* on the streets of Paris. *De mémoire d'homme* (cat. no. 26), which Picasso illustrated, has that clarity and sun-swept spaciousness that we associate with partisan poetry, wanting to make sense to the multitudes. No gloom and approximation here: it is rather like Éluard's poem "Sans âge," which pictures mankind advancing always toward the summits, undiscouraged, undaunted, victorious. "Another day to bring into the world"—that kind of thing.

FIGURE 2

Dora Maar, *The Years Lie in Wait for You*

Ca. 1932–34

Gelatin silver print

14½ x 10 in. (36.8 x 25.3 cm)

Lucien Treillard Collection, Paris

FIGURE 3

Picasso, *Portrait of Paul Éluard*, frontispiece from Éluard's *Au rendez-vous Allemand* (At the German Rendez-Vous)

Published by Éditions de Minuit, Paris, 1944

Beinecke Rare Book and Manuscript Library, Yale University

But the major poet of Surrealism as we now look back at it is Robert Desnos.[4] His early writings in *Rrose Sélavy* of 1922–23 (dictated by the alter ego of Marcel Duchamp), in *L'aumonyme* and *Langage cuit* of 1923, and then his major collections of poems, *À la mystérieuse* of 1926 and *Les ténèbres* of 1927, and his novels *Deuil pour deuil* of 1924 and *La liberté ou l'amour!* of 1927, are widely considered the triumphs of Surrealist writing. After his departure from Surrealism in 1929 for work in radio and in journalism, he was deported, sent to a series of concentration camps, and died in Terezín of typhoid fever in June 1945, having reverted to a more traditional form of poetry, found in *Contrée* of 1944 (fig. 5) and *Calixto* of 1944–45. Desnos had always thought that the Spanish Baroque lyric poet Luis de Góngora y Argote, with his long poem *Las soledades*, was the single most significant ancestor of Surrealism as he knew it. The very structures of some of Góngora's sonnets are mirrored in some of Desnos's greatest poems—for example, the chiasmus or the X form, and the listing of elements one after the other in a long series. Picasso had the same reverence for his fellow Spaniard, whose *Vingt poèmes* (cat. no. 21) he illustrated in 1947–48, and whose melancholy and depth of perception in those poems were never far from his heart.

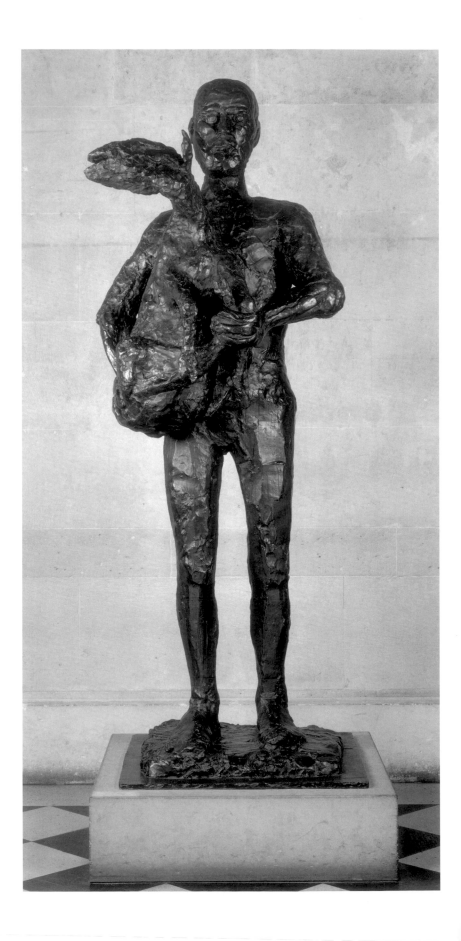

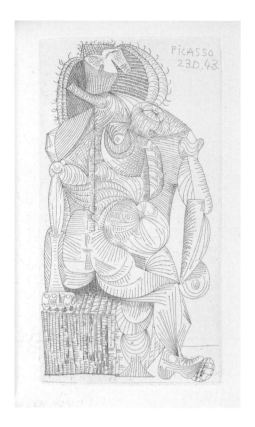

The Surrealist and ethnographer Michel Leiris provided another kind of companionship for Picasso after the war, when the two went together to bullfights, which featured so heavily in Picasso's art. Georges Bataille had already documented, in his "Soleil pourri" (cat. no. 13, fig. 6), how closely the bull was connected to Mithraic ritual and to sun worship. And for Picasso the Spaniard, always keen on the spectacle of the bullfight and its traditional rituals, Leiris was a perfect companion; many of his writings rely on those rituals, like the Surrealist journal *Minotaure*, as its name indicates. Violence, cruelty, incredible intensity: these make up the poetry of the bullring, which Leiris portrays so brilliantly, mirrored in the dynamics of Picasso's art and its mastery of its mysteries.

1. See, for instance, cat. no. 26, fn. 8, which refers to the article "Les révélations psychiques de la main," *Minotaure*, no. 6 (December 1934): 38–44.

2. Something of the brightness and joy of these summers is captured in the photographs of Françoise Gilot, who was to replace Dora Maar in Picasso's life, and whose radiance permeates both Picasso's portraits of her and photographs of her with their children. For Dora Maar, see Mary Ann Caws, *Dora Maar: With and Without Picasso* (London: Thames and Hudson, 2000).

3. See Mary Ann Caws, ed., *Tristan Tzara: Approximate Man and Other Texts* (Boston: Black Widow Press, 2005).

4. See Mary Ann Caws, ed., *Robert Desnos: The Essential Poems and Writings* (Boston: Black Widow Press, 2007).

18

Pablo Picasso

Georges Hugnet

Pamphlet, oblong, with 6
zincographs by Picasso, 3 reworked
with engraving, 3¾ x 5¹³⁄₁₆ in.
(9.5 x 14.8 cm)
Published by the author, Paris, 1941
Printed by Imprimerie
J. Grou-Radenez, Paris, for text,
typography, and zincographs
Edition 200
REFERENCES: Cramer 35;
Baer III, 720
Beinecke Rare Book and Manuscript
Library, Yale University

During the war years, Picasso understandably did not participate in the production of any luxurious, large-scale *livres d'artistes* like Balzac's *Le chef-d'oeuvre inconnu* (cat. no. 12) and Ovid's *Les métamorphoses* (cat. no. 13) of the early 1930s. He resumed this activity in late 1946, with the sumptuous *Vingt poèmes de Góngora* (cat. no. 21).[1] Picasso's involvement with writing and language continued, however, on a smaller and more intimate scale within the restrictive wartime conditions.[2] He wrote powerful poems that evoked the horror of bombings and objects falling from the skies, as well as the first of three plays, the absurdist *Le désir attrapé par la queue* (Desire Caught by the Tail), written from January 14 to 17, 1941, whose main character is Le Gros Pied (Fat-Foot).[3] He also created images for the writings of friends involved in the Resistance, including Robert Desnos (Caws, "Letters of Mourning," fig. 5) and the poet and writer Georges Hugnet, who met with Picasso on a daily basis during the war years. Hugnet, who had written some of the earliest commentaries on the international Dada movement in the early 1930s, and was a Surrealist until his banishment from the group by André Breton in 1939, joined the Resistance in 1940, and wrote one of the first Resistance texts with *Non vouloir* (figs. 1–2) of that year.[4] When it was republished in 1942, along with some fifty untitled poems written between 1940 and 1941, it included four illustrations by Picasso and a dedication to Paul Éluard, who joined the Resistance in 1942.

In 1941 Picasso also illustrated this small pamphlet, *Pablo Picasso*, featuring Hugnet's short, exuberant poem, which calls upon the entire world to rise up and dance. Hugnet had considered Picasso's relation to the increasingly turbulent world politics in 1935, when he was among a group of Surrealist writers who contributed to a special edition of *Cahiers d'art*.[5] In addition to *Pablo Picasso*, Hugnet published at the same time two additional brochures, *Marcel Duchamp* and *Au dépens des mots*. According to Herma Goeppert-Frank, inscriptions on some of the existing pamphlets suggest that they may have been distributed clandestinely among friends.[6]

Hugnet's text, dated January 1940, closes with:

> *Waltz you heads of leather of once-upon-a-times*
> *Masks destroyed by fire perpetual waltz waltz you sparrowhawk folios*
> *Waltz you olifants of needle-pierced wood*
> *Waltz you flowergirls waltz you looms*
> *Waltz you naphthas of scaffold betrothals serpent-eaters*
> *Fireplace mantles and marble fumes*
> *Waltz like both the blood and the blue sky waltz.*[7]

Framing his words are Picasso's Surrealist heads and swelling bodies. In some cases the shapes expand around the text; in others blackness cuts into the words, leaving just enough room to read them, in a play of spaciousness and confinement. Picasso evokes the threat to language and to human expression during wartime conditions—how words can be shut out, and silenced—a

La forêt se referme avec lenteur elle gagne sur le désordre
l'enjeu de l'amour.
Debout dans le soleil le losange du vent.
Valsez têtes de cuir des il était une fois
masques incendiés perpétuels valsez valsez in-folios éperviers
valsez olifants au bois traversé d'aiguilles
valsez bouquetières valsez métiers
valsez naphtes des échafauds fiançailles serpentaires
dessus de cheminées et vapeurs du marbre.
Valsez comme valsent et le sang et l'azur.

Janvier 1940 Georges HUGNET

Les aigles à taille d'éclair
portent les branches du charbon.
Les lumières se déchirent
sur le tambour de la nuit.
Allez toujours. Je frapperai au carreau.
Valsez cieux déteints
reins cassés des crépuscules.
Valsez destins
les cheminées sont hautes valsez.

Recto

La forêt belle comme un rendez-vous
attend la feuille qui court folle au bras de l'espoir.
Chaque buisson détient la soie ou le velours
qui vêtira la vagabonde.
Et le silence compte sur ses doigts.
Mais valsez tournesols aux squelettes de titgants.
L'homme est assis sur son talus d'aurore
il évalue les pierres il est fébrile
il noue le secret de sa passion.

Cors crocs socs à corps et à cris
les palissades découvrent leurs corps crevés
les affiches ouvrent des balcons sur le grand sommeil
la main de l'homme pend du haut de sa gloire
ors rocs sorts valsez.
Valsez sur la table à jeu
valsez mauves fils défunts grottes béantes
valsez minuits aux regards de carafe
valsez les eaux valsez les pièges
valsez les loups.

Tirage limité à 200 exemplaires, dont
20 sur Vélin de Rives et 6 sur Japon nacré.

PABLO PICASSO

PARIS 1941

Verso

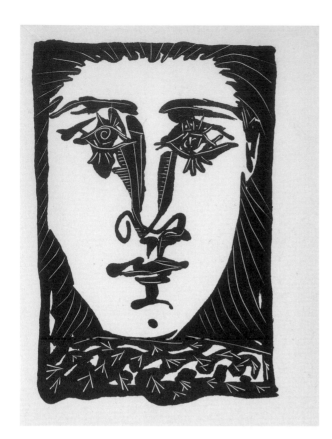

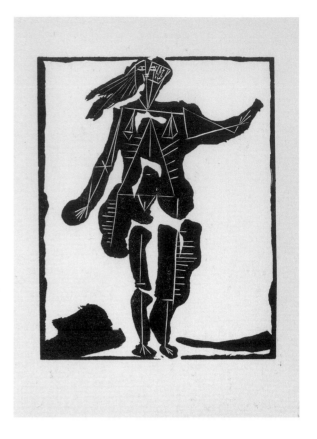

FIGURE I

Picasso, *Portrait of Dora Maar*, from Georges Hugnet's *Non vouloir* (Not Wanting)

Published by Éditions Jeanne Bucher, Paris, 1942

Beinecke Rare Book and Manuscript Library, Yale University

FIGURE 2

Picasso, *Dancer II*, from Georges Hugnet's *Non vouloir* (Not Wanting)

Published by Éditions Jeanne Bucher, Paris, 1942

Beinecke Rare Book and Manuscript Library, Yale University

reality summed up on the pamphlet's recto, where expressive, gestural strokes resembling Picasso's imaginary letters (see cat. no. 22) are written against a backdrop of barlike forms.

— Susan Greenberg Fisher

1. John Russell eloquently evokes the postwar climate in which Picasso's *Góngora* emerged in his introduction to George Braziller's translation and reprinting of the poem; see Pablo Picasso, *Gongora*, poetry by Luis de Góngora y Argote, trans. Alan S. Trueblood (New York: George Braziller, 1985).

2. On these years, see Jaime Sabartés, "With Picasso, 1935–1941," in *Picasso: An Intimate Portrait*, trans. Angel Flores (New York: Prentice-Hall, 1948). See also the important exhibition catalogue *Picasso and the War Years, 1937–1945*, ed. Steven A. Nash, exh. cat. (New York: Thames and Hudson, 1998).

3. On the poems, see Lydia Csató Gasman, "Death Falling from the Sky: Picasso's Wartime Texts," in Nash, *Picasso and the War Years*, 55–67.

4. Among his many other projects, Hugnet also translated into French and published two works by Gertrude Stein through his publishing company Éditions de la Montagne, her *Morceaux choisis de la fabrication des américains* (1929) and, with Virgil Thompson, *Dix portraits* (1930). A small group of photographs of Stein and Hugnet, who were close friends in these years, is in the Gertrude Stein and Alice B. Toklas Papers, Beinecke Rare Book and Manuscript Library, Yale University.

5. For a discussion of this special edition of *Cahiers d'art*, dated 1935 but which actually came out in 1936, see cat. no. 16.

6. Cramer 35.

7. Translation by Alyson Waters.

First Steps

Paris, May 21, 1943,
revised summer 1943
Oil on canvas, 51¼ x 38¼ in.
(130.2 x 97.1 cm)
INSCRIPTIONS: upper right:
Picasso; verso: *21 mai 43*
PROVENANCE: purchased from the
artist by Samuel M. Kootz Gallery,
New York, in 1947;
purchased from Kootz by Stephen
Carlton Clark, New York, in 1948
REFERENCES: Zervos XIII, 36
Yale University Art Gallery, Gift of
Stephen Carlton Clark, B.A. 1903,
1958.27

On October 6, 1944, the Salon d'Automne opened in Paris with a massive solo show of Picasso's wartime work (fig. 1). Dubbed the Salon de la Libération, it was the first exhibition of French art since the city's liberation from German occupation forces on August 25 that year. Picasso, a Spaniard, had never participated in the Salon. But on the invitation of Jean Cassou, curator of the Musée National d'Art Moderne and fellow member of the Communist Party, he exhibited seventy-four paintings and five sculptures, including *First Steps*, a canvas completed in 1943.

The Nazis considered Picasso a degenerate artist, and although his paintings appeared in a smattering of group shows, intimidation, searches, surveillance, and public attack prevented the realization of any solo exhibitions during the war.[1] Thus, although Picasso was extremely productive during the occupation, his work was largely invisible from public view. The Salon de la Libération proved a shocking end to this hiatus. Reactionary Beaux-Arts students offended by Picasso's brutal and distorted style, political conservatives protesting his newly announced allegiance to the Communist Party, and xenophobes decrying the contamination of the French national tradition stormed the galleries, demanding explanation and the return of state monies. Angry mobs even managed to pull several paintings from the wall. The controversy only dissipated after French intellectuals circulated petitions in Picasso's support.[2]

First Steps was closely associated with the notoriety of the Salon de la Libération, particularly for the American audience who first saw the work in a 1948 New York gallery exhibition organized by the dealer Samuel Kootz (fig. 2).[3] As Henry McBride wrote in a review of that show, the exhibition included "an extremely controversial 'Mother and Child' which you might let alone for the present unless you specialize in controversies."[4] Picasso had already reached new levels of celebrity immediately after the war, when journalists, photographers, and American GIs flooded his studio. Alfred H. Barr, Jr., who included *First Steps* in the catalogue of his 1946 Museum of Modern Art exhibition *Picasso: Fifty Years of His Art*, reportedly commented that it made Picasso "better known in Manhattan than in Paris."[5]

Commentators have frequently proffered the war as a thematic subtext to the portrayal in *First Steps* of the determined but uncertain first steps of a child, gesturing to the painting's evocation of hope in the face of precarious circumstances, or the revived classicism of its maternal theme.[6] And yet Picasso's rendering of mother and child is one violently inverted and deformed, the monumentalized, almost monstrous child pressing the mother upward and outward into the canvas's extreme margins, transforming the pliancy and extension of her body into a schematic architectural support. She appears as if an afterthought, a detail the photographer Brassaï noted: "Picasso painted the child first, taking his first steps, having a hard time balancing his plump little body. 'He would have fallen,' Picasso had said to me,

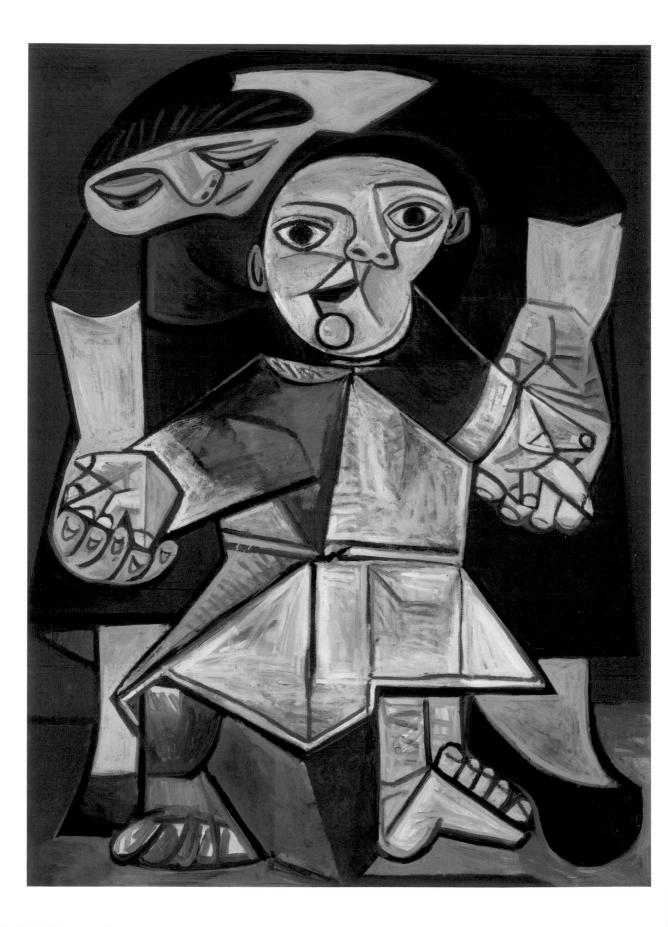

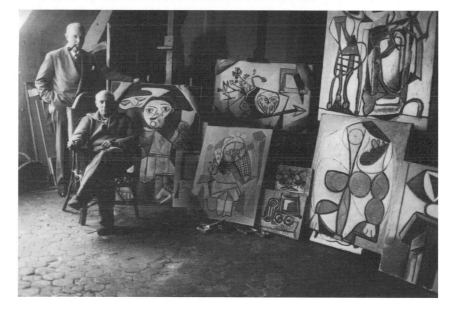

laughing, 'because he doesn't know how to walk yet. So I added his mother to the canvas later, to hold him up.'"[7]

In fact, X rays and raking-light photographs recently taken by the Yale University Art Gallery's Conservation Department reveal at least one prior version of the present composition, and possibly another composition altogether, beneath the painting's present surface (figs. 3–4). Analysis suggests that in an earlier version, the little boy is pictured alone, standing or sitting upon a chair rather than poised between his mother's legs.[8] This earlier configuration provides the structural scaffold for the final composition: the mother's lumpen, hooflike feet emerge from the chair's legs or other vertical support; preexisting trapezoids provide the basis for her clumpy wrists and

FIGURE 3
X ray of *First Steps*, showing earlier composition

FIGURE 4
***First Steps* in raking light**

the knotty join of the figures' hands; receding perspectival lines delineate the sharply angled contours of the child's jumper (fig. 4). The discovery of these earlier compositional layers suggests one resolution to a persistent problem in dating *First Steps*. Until now, the painting has been dated to May 21, 1943, as is marked on the back of the canvas. Yet, as some scholars have noted, this date is at odds with numerous drawings and oil sketches from later that year that appear to be preparatory studies, including an oil sketch of the child's feet on a page of the newspaper *Paris-soir* from June 2, 1943 (fig. 5), and a drawing of the child's head from August 17, 1943 (fig. 6).[9] In the newspaper study, the child's left foot terminates in a sharp triangle, a detail Picasso modified in the final painting. Similarly, the final round shape of the child's head, which conforms to the August drawing, masks an earlier version visible in the X ray in which the face narrows to a sharp triangle at right. We can now surmise that Picasso established the basic compositional conceit of the little boy in May, but returned to the painting several months later, repainting and reconceptualizing it as the composition we know now.[10] To Barr's characterization of the "momentous drama" of the child's first steps, then, we should add the painterly drama of the work's compositional metamorphosis, narratives that are in fact intimately intertwined.[11]

Two spatial systems are at work in the formal economy of *First Steps*. The mother is a single compressed volume, the encompassing, rounded arch of her body painted in flat, matte strokes, the half-moon disk of her face

FIGURE 5

Picasso, *Study of Feet*

1943

Oil on a full page of *Paris-soir*,

June 2, 1943

23⅝ x 17⅛ in. (60 x 43.5 cm)

Private collection

FIGURE 6

Picasso, Study for *First Steps*

August 17, 1943

Graphite

8⅝ x 5½ in. (22 x 14 cm)

Private collection

rhyming with the swelled curve of her left foot. The child, by contrast, is constructed from a series of concatenated polygonal shapes that recall the Cubist manipulation of flat planes.[12] The worked surface of these additive planes, their brushstrokes generated from the creased center of the child's belly, articulate the child's body as a thick layer of paint pleated across the canvas. In contrast to the smooth, continuous stretch of the mother's neck, the child's body is sharply disjointed, his left arm emerging incongruously from his chin, while his shoulder and pancake foot fold flat, like an envelope. Unlike several preparatory sketches for the mother's features, the final version of *First Steps* reserves Picasso's characteristic facial deformations solely for the child.[13] The result intensifies the spatial dichotomy between the two, the child's jigsaw frame unfolding flatly outward in pronounced differentiation from the solid bulwark of the mother behind him.

In an incisive 1983 entry, Ann Temkin suggests that the dislocations of the child's body derive from the painting's subject matter. As she writes, "[The child's] planar sections seem to confound one another, just as the boy's muscles and limbs defy his struggle for motor control. His left arm sprouts stubbornly from his chin and dispels any notion of coordination. This equally radical distortion of his face tells of the strenuous effort the child devotes to his task."[14]

In this light, the child's physical distortion enacts, formally, what psychoanalyst Jacques Lacan in his writings on the mirror stage of development described as a young child's "motor impotence," the turbulent, discombobulated sensation of its fragmented body and uncoordinated limbs.[15] Lacan's mirror metaphor provides a concise elaboration of the painting's contrasting spatial systems. In the psychoanalytic formulation, the mother's body offers the baby an ideal model of coordinated motor activity, an ideal transferred to the child when it sees itself in the mirror.[16] Thus, while the mother's body is both conceived and experienced as a three-dimensional whole, the child first appears to itself as a two-dimensional reflection. In *First Steps*, the distinction between these two conceptions of self is diagrammed in the painting's right corner, where the mother's sculpted foot makes way for the child's flattened foot, a foot that does not touch the ground but flexes awkwardly, searching for placement.

That this impossible flat foot is a pivotal element of the painting is suggested by the large newspaper study Picasso made in June 1943 (fig. 5). As Ludwig Ullmann has written, this study acts as an "ideogram" of *First Steps*, condensing and symbolizing the painting's formal reductions and abstractions and its central narratival drama: the shift from motherly care to the child's self-conscious entry into the world.[17] Ullmann, who could not have known of the earlier composition beneath *First Steps*, assumed that mother and child were conceived simultaneously, the dramatic emphasis migrating through a series of preparatory studies from the mother's furrowed brow to the child's theatrically suspended step. Yet, as conservational analysis sug-

gests, the mother was created after the child. It is therefore possible to read the newspaper study as a consequence of the mother's *addition*, as it is here that Picasso underscores the key element of flatness that distinguishes between the two.

In the study, the child's feet are aligned horizontally along the page, anchoring the painting's imagined edge to the vertical column of the newspaper. The two feet, meanwhile, are positioned symmetrically on either side of the newspaper's fold, a line demarcated by the angular nadir of the child's jumper. In the painting, this virtual fold travels up the child's body, generating its own series of pleats midway through the canvas. The study's newsprint ground is thereby transmuted into the final painting, first as a physical quality of the child's body, his upturned foot as flatly two-dimensional as a dog-eared page, and second as a schematized representation of the newspaper itself, the child's blocky left leg and quartered torso mimicking the newspaper's rectangular columns. Picasso had of course used the newspaper as a representational ruse before (see cat. no. 11). Indeed, as Anne Baldassari has noted, his use of newsprint during the occupation was only surpassed by its use in Synthetic Cubism.[18] In both instances, newsprint provided a ready-made surface, shape, and sign that both reiterated the planar surface of the canvas and acted as a metonymic emblem of that which lay beyond the canvas's frame. As both a physical object and an image of language (language as a system of signs), the newspaper is an index of the real that simultaneously functions as a sign of referentiality itself. In *First Steps*, Picasso channeled this representational circularity into a starkly gendered economy in which the folded forms of the newspaper double as the mirrored projection of the male child's burgeoning self. By returning to newspaper, moreover, a media intensely linked to his epochal Cubist years, Picasso engaged in a self-reflexive, intertextual act in which his corpus of works functions as both a formal language and a series of mutable texts.

In a key early painting such as *Les demoiselles d'Avignon* (cat. no. 3, fig. 5), the anxious workings of erotic desire result in the radical disfiguration of the female body, deformations key to Picasso's formal innovations of that period. *First Steps* marks a shift in this tense calibration of gender and form from a schema of erotic desire to one of biological reproduction. In *First Steps*, procreation is the central metaphor of the artistic process. This metaphor, however, does not entail the mother's bearing of her son, but the male child's arrogation of female reproductive power. The parental relation of *First Steps*, after all, is inverted, as Picasso created the child before the mother as a fantasy of male autogenesis. As Picasso commented to Sidney Janis, "The child becomes the father of the mother."[19]

In this anachronistic relation between mother and child, the folded newspaper returns as a central motif of the painting process. As is documented in Brassaï's photographs and firsthand accounts, Picasso used newspaper pages in place of a painter's palette (fig. 7). As Brassaï recounts, "He

FIGURE 7
**Brassaï, *The Palette in Picasso's
Workshop, rue des Grands-
Augustins***
1946
Gelatin silver print
Musée Picasso, Paris, M.P. 1986.37

mixed his colors on a folding table covered with a thick layer of newspaper. As soon as this paper became saturated with colors, linseed oil, and turpentine, he simply picked it up and threw it away."[20] Picasso's discarded newspapers are thus the inverse of his finished canvas, an *informe* double that retains both the genesis and the residue of a painting's transformation as the pure waste of the authorial process. The pictorial language developed in the painting, in other words, has its analogue in the obliteration of existing or potential languages on the newspaper palette. In *First Steps*, the spent excess of these smeared newspaper sheets is reincorporated, representationally, within the space of the painting itself, thereby closing the circuit of production. In so doing, Picasso's myth of male self-creation is also a fantasy of short-circuited pictorial regeneration, the abstract remainder of one painting impossibly represented as the finished image of itself.

In his 1965 book *The Success and Failure of Picasso*, John Berger wrote that *First Steps* marks Picasso's turn to mannerism. Contrasting the 1943 painting to *Woman Dressing Her Hair* of 1940 (fig. 8), Berger argues that the tortured emotional charge of the earlier painting is translated into empty self-reference in *First Steps*: "The experience is Picasso's experience of his own way of painting. It is like an actor being fascinated by the sound of his

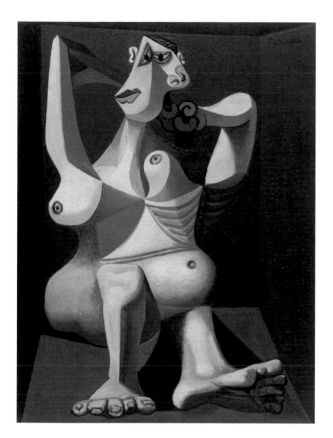

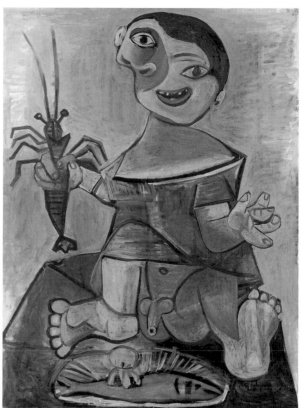

FIGURE 8
Picasso, *Woman Dressing Her Hair*
Royan, June 1940
Oil on canvas
51¼ x 38¼ in. (130.1 x 97.1 cm)
Museum of Modern Art, New York,
Louise Reinhardt Smith Bequest,
788.1995

FIGURE 9
Picasso, *Boy with a Crayfish*
Paris, June 21, 1941
Oil on canvas
51³⁄₁₆ x 38⁵⁄₁₆ in. (130 x 97.3 cm)
Musée Picasso, Paris, M.P. 189

own voice or the look of his own actions. Self-consciousness is necessary for all artists, but this is the vanity of self-consciousness. It is a form of narcissism: it is the beginning of Picasso impersonating himself."[21] Berger's charge is moral in nature. Yet his analysis is acute. In *First Steps,* Picasso thematizes his own seriality, a seriality conveyed through an image of maternity evacuated of precisely that natural inevitability the maternal myth is meant to provide.[22] In *Woman Dressing Her Hair,* a sharply recessed perspectival box provides a stage for the corporeal deformations of a female nude whose fleshy, upturned left foot is echoed in that of *First Steps'* child. In *First Steps,* this claustrophobic space and its deeply carnal inhabitant are collapsed together in the arched form of the mother, whose body substitutes for both volumetric space and the palpable human body. The gendered dichotomy between this space and that of the child is neatly plotted in the drawing of August 17, 1943, in which a recessed arch of empty space sits opposite the flattened planes of the child's head and shoulders, his dark halo of hair swinging sideways like a lever, the flap of his shoulder folded down beneath his chin.

The equation of the mother with illusory perspectival space and the male child with symbolic, flat space is as cliché as it is striking. But it is a central organizing principle of Picasso's work of this period.[23] In *First Steps,* the deep space of *Woman Dressing Her Hair* is visible in the earlier composition, the perspectival lines of the anterior painting's descending ceiling ghosted in raised vectors lying just beneath the present painted surface.

The psychospatial mechanics of this perspectival configuration are retained, however, in the perfect circle of the child's chin, the vanishing point of the earlier painting and locus around which the final image collapses inward. A nodal point of the painting's articulation of space and gender, this circle has its counterpart in the peculiar region between the child's legs. Here, space itself is hunkered into folded projections that combine the divergent spatial systems of mother and child. It is precisely this warped, impenetrable space that opens out like a drawer in *Boy with a Crayfish* of 1941 (fig. 9). In this painting, the boy flexes his left foot and splays his right knee in a variation of *First Steps'* child, revealing his prominent genitals above a platter of fish that doubles as a foreshortened mirror. The boy levels one eye at the viewer, the other at the reflected image of his sex flattened, transfigured, and reformed in Narcissus's mirror. *First Steps* is the fantasy of this mirror projected onto canvas.

— **Irene Small**

1. Works by Picasso were included in the Nazi-organized *Entartete Kunst* (Degenerate Art) exhibition in 1937. Although literature on Picasso and the war years frequently states that the artist was forbidden from exhibiting during the war, recent scholarship has demonstrated that his works did appear in a number of group shows. See Steven Nash, ed., *Picasso and the War Years, 1937–1945*, exh. cat. (New York: Thames and Hudson, 1998). Nash notes that Christian Zervos lists over 2,200 paintings and drawings from the nine years between the Spanish Civil War and the end of World War II. Although Picasso did not take part directly in the Resistance, his staunch refusal to concede to occupation forces increased his celebrity immediately after the war. In a letter to Alfred H. Barr, Jr., on March 28, 1945, Zervos clarified Picasso's political stance during the war: "The participation of Picasso in the Resistance is false. Picasso simply kept his dignity during the Occupation the way millions of people did here. But he never got involved in the Resistance. Realize that his work itself is the greatest form of resistance"; Michèle Cone, *Artists under Vichy: A Case of Prejudice and Persecution* (Princeton, N.J.: Princeton University Press, 1992), 233–34.

2. Picasso's decision to join the Communist Party was strategically announced two days before the opening of the 1944 Salon d'Automne. Petitions in his support were circulated by the Front National des Étudiants and the Comité National des Écrivains.

3. Kootz had bought the painting directly from Picasso the year before with the intention of selling it to the Museum of Modern Art, New York. Instead, it was purchased by Stephen Carlton Clark, who donated it to the Yale University Art Gallery in 1958. The authors are grateful to Sallianne Ontko for bringing this photograph of Kootz with Picasso to our attention.

4. Henry McBride, "Picasso Enthusiasts, Think Nothing of Flying to Paris for His Pictures," *New York Sun*, January 30, 1948. Kootz had held the first postwar Picasso exhibition in the United States in January 1947. A year later, he followed with *Picasso: The First World Showing of Paintings of 1947* (January 26–February 14, 1948), in which *First Steps* was shown under the title *Mother and Child*. In the spring of that year Kootz closed his gallery to focus exclusively on dealing Picassos. See Dorothy Seckler, "Interview with Samuel Kootz," New York, April 13, 1964, Archives of American Art, Smithsonian Institution, Washington, D.C.

5. Alfred H. Barr, Jr., cited in *Artists of the Kootz Gallery*, exh. cat. (Sarasota, Fla.: John and Mable Ringling Museum of Art, 1962).

6. In *Picasso and the War Years*, Nash writes, "Another optimistic signal is found in the large painting entitled *First Steps*, from 21

May 1943. A wobbly but determined child is being helped to take its first steps by a protective mother. Easy sentiment was not a common ingredient in Picasso's wartime work, and here, the strongly architectural quality of his composition, with the mother forming a compact arch over the angular structure of the child, overrides the sweetness of the theme. In essence, Picasso stresses not only the innocence of youth but also the hopeful future of a younger generation as it thrives and carries forward" (35). Pierre Daix, in *Picasso: Life and Art*, trans. Olivia Emmet (New York: Icon Editions, 1987), writes of "the transformation and transcendence of every subject into something else; and the baby, discovering its own autonomy, as it enters a world of war, a war whose outcome at that moment was still totally hidden, without even glimmers of a possible future" (271). Sallianne Ontko, in her unpublished study of *First Steps* ("Catalogue Entry for Pablo Picasso's *First Steps*," City University of New York, 2006), has offered a more direct link to the war, suggesting that Picasso's study for the child's feet on the sports page of the newspaper (fig. 5) evokes the marching feet of soldiers. She further suggests a resemblance between the child's hair and the berets of the Maquis, a rural guerilla band of French Resistance fighters that was growing in 1943. As she writes, "The child, as resistance fighter, leaves his family in search of personal freedom, and independence for his family and nation" (17). One can trace Picasso's maternal imagery to earlier paintings by Rembrandt van Rijn, Jean-François Millet, Vincent van Gogh, and Jean Charlot. On compositional precedents, see, in particular, Millet's pastel and chalk from ca. 1858–66 (Cleveland Museum of Art), which van Gogh copied in 1890. John Charlot, in "The Source of Picasso's 'First Steps': Jean Charlot's 'First Steps,'" *Zeitschrift Kunstgeschichte* 55, no. 2 (1992): 275–78, observed similarities between *First Steps* and Jean Charlot's lithograph *Mother and Child* of 1929 and a painting, a photograph of which was published in 1936, both of which Picasso may have seen in print form. The dramatically foreshortened head of the mother, which reiterates the form of the infant's head in Charlot's composition, bears perhaps closer affinities to

Picasso's studies on the theme in 1943 and 1944. See, in particular, Zervos XIII, 16–18 and 112–20. It is worth noting that aside from *Guernica* (1937, Museo Nacional Centro de Arte Reina Sofía, Madrid) and *The Charnel House* (1944–45, Museum of Modern Art, New York), the war did not surface directly in the majority of Picasso's paintings from this period.

7. Brassaï, *Picasso and Company*, trans. Francis Price (New York: Doubleday, 1966), 60. Brassaï remembered seeing the apparently finished painting in Picasso's studio on October 12, 1943.

8. We would like to thank Mark Aronson, Chief Paintings Conservator, Yale Center for British Art, and Patricia Sherwin Garland, Senior Conservator, Yale University Art Gallery, for their valuable expertise in the research and study of this painting. The author would also like to thank René Boitelle, Paintings Conservator at the Van Gogh Museum, Amsterdam, for conversations about the painting at the Getty Research Institute, Los Angeles, in December 2007.

9. Françoise Forster-Hahn appears to have been the first to note discrepancies in dating between the painting and preparatory studies; see her letter to Charles Zervos, September 8, 1964, Curatorial Files, Department of Modern and Contemporary Art, Yale University Art Gallery, and her subsequent entry on the painting in Forster-Hahn, *French and School of Paris Paintings in the Yale University Art Gallery* (New Haven, Conn.: Yale University Press, 1968). Here she states, "The many preparatory studies for *First Steps* indicate that the painting went through a rather long evolution from its first idea to the final state. In Zervos, nos. 16–18 are pencil drawings, showing the mother bending over her child who lies in her arms, barely suspended above the ground. Nos. 20 and 40 are very close to the painting, but with the fundamental difference that the child is smaller. No. 20 as well as no. 34 (head of the child) is dated later than the painting: no. 20 is dated August 31, 1943; no. 34, August 17, 1943. Both, however, are apparently preparatory studies, particularly no. 34; they are different steps of the final composition. Only in the painting does the child grow to

enormous size. Because these two drawings are dated later than the canvas, it is obvious that the painting was finished later than May 1943, probably after August 1943" (22). Anne Baldassari determined that the newspaper page used for *Study of Feet* was from the June 2, 1943, edition of *Paris-soir*; see Baldassari, *Picasso Working on Paper*, exh. cat. (London: Merrell, 2000). During her research on the painting in 2006, Sallianne Ontko also questioned the dating of the painting. There are numerous variations on the theme of the woman bending over a child in Picasso's drawings and sketches from both 1943 and 1944. In addition to those mentioned by Forster-Hahn are Zervos XIII, 14–15, pencil drawings from 1943 focusing on the mother's face; 112, a pencil drawing from September 1, 1943, which adds the scatological twist of the child defecating as his mother reaches down to lift him; and 113–20, pencil drawings from 1944, in which the baby is no longer positioned frontally, as in *First Steps*, but is either nestling or nursing in the mother's lap. Inès Sassier, Picasso's chambermaid and confidante, claimed that the painting was modeled on herself and her child, and that it once had the inscription "pour ma très chère Ines" on the back, which was later obliterated. Herbert T. Schwartz, correspondence with Anne Coffin Hanson, December 14, 1990, Curatorial Files, Department of Modern and Contemporary Art, Yale University Art Gallery.

10. This is supported by close analysis of raking-light photographs of the painting's surface, which reveals that areas such as the modification to the child's left foot as well as the mother's body are wet-on-dry applications. This indicates that the painted surface of the previous composition had already dried when Picasso returned to the work several weeks or months later. Cross-sectional analysis of various areas of the composition, such as the mother's neck, shoulder, and feet, and the child's face and feet, further revealed paint layering, at times up to five layers.

11. Barr, *Picasso: Fifty Years of His Art* (New York: Museum of Modern Art, 1946), 232. It was Barr who gave the painting its definitive title. Samuel M. Kootz, letter to Françoise Forster-Hahn, April 23, 1964,

Curatorial Files, Department of Modern and Contemporary Art, Yale University Art Gallery. The painting had been exhibited under the title *Mère et enfant* at the Salon d'Automne of 1944.

12. The Cubist aspect of the painting was observed early on. A reviewer of the 1948 Kootz exhibition noted that the painting exhibited a "reawakened attention to cubist principles long obscured for this artist by the passage of time"; "New Picassos," *New York Herald Tribune*, February 1, 1948. Just one year earlier, Zervos had published the second volume of Picasso's catalogue raisonné, focusing on the Cubist era. It may have been this retroactive look at the artist's earlier work that inspired Picasso to revisit some of its principles in *First Steps*.

13. See, in particular, Zervos XIII, 14–15.

14. Ann Temkin in *Yale University Art Gallery: Selections*, ed. Alan Shestack (New Haven, Conn.: Yale University Art Gallery, 1983).

15. Jacques Lacan, "The Mirror Stage as Formative of the *I* Function as Revealed in Psychoanalytic Experience," in *Écrits*, trans. Bruce Fink (New York: W. W. Norton, 1996), 84.

16. See, in particular, D. G. Winnicott's elaboration of the Lacanian scheme in his essay "Mirror-Role of the Mother and Family in Child Development," in *The Predicament of the Family: A Psycho-Analytical Symposium*, ed. P. Lomas (London: Hogarth, 1967), 26–33.

17. Ludwig Ullmann, *Picasso und der Krieg* (Bielefeld, Germany: Karl Kerber Verlag, 1993), 340–42.

18. In her study of Picasso's use of newsprint, *Picasso Working on Paper*, Baldassari notes that both periods of Picasso's intense use of the material correspond to periods of war: in the Cubist period, the Balkan War, and in the occupation period, World War II. Following on the scholarship of Patricia Leighten in *Re-Ordering the Universe: Picasso and Anarchism, 1897–1914* (Princeton, N.J.: Princeton University Press, 1989), Baldassari argues that newsprint is a sign and an index of historical time—a "short-cut to dating" that provided Picasso with yet another means of recording. She further observes that *Paris-*

soir, whose pages Picasso used as a support several times in the period between 1941 and 1943, was an organ of the German occupation forces. She writes, "The choice of *Paris-Soir* as a support for part of his work was tantamount to the inscription of some sort of physical marker of the unfolding political drama onto it" (23). Whether the Cubist newsprint collages were meant to operate as purely formal signifiers or to be actually read is subject to fierce debate among scholars of Cubism. See, in particular, Rosalind Krauss, "The Motivation of the Sign," and Yve-Alain Bois, "The Semiology of Cubism," in *Picasso and Braque: A Symposium*, ed. Lynn Zelevansky (New York: Museum of Modern Art, 1992); and Patricia Leighten, "Cubist Anachronisms: Ahistoricity, Cryptoformalism, and Business-as-Usual in New York," *Oxford Art Journal* 17 (fall 1994): 91–102.

19. Harriet and Sidney Janis, *Picasso: The Recent Years, 1939–1946* (Garden City, N.Y.: Doubleday, 1946), n.p., pl. 105, *Mother and Child*. In her article "Seductive Canvases: Visual Mythologies of the Artist and Artistic Creativity," *Oxford Art Journal* 18, no. 2 (1995): 59–69, Lynda Nead notes that "autogenesis allows for masculinity to be self-sufficient whilst appropriating female biology to a male myth of cultural production. These two aspects of artistic identity are frequently deployed in representations of Picasso" (61). She traces the male artist's incorporation of feminine characteristics as a father who gives birth to the work of art to nineteenth-century Romanticism. Interestingly, William Wordsworth's poem "The Rainbow" of 1802 includes a line, "The Child is father of the Man," that anticipates Picasso's observation to Janis. The fantasy of male autoreproduction has also been mythologized in the figure of Athena, who was said to have sprung fully formed from the forehead of her father, Zeus, after he swallowed her mother, Metis.

20. Brassaï, *Picasso and Company*, 47. Brassaï also notes that one of his photographs of Picasso's brush on his newspaper palette of *Paris-soir* was censored in 1939, perhaps because the newsprint (which included articles about the pope and cardinal) was still legible beneath Picasso's brush. In May 1944 Picasso contributed one of his used double-page newspaper palettes to an exhibition of artists' palettes titled *L'oeuvre et la palette, 1830 à nos jours* at the Galerie René Breteau, in Paris. Gertje R. Utley, "From *Guernica* to *The Charnel House*: The Political Radicalization of the Artist," in Nash, *Picasso and the War Years*, citing R. T., "Une curieuse exposition rue Bonaparte," *Aujourd'hui*, May 16, 1944.

21. John Berger, *The Success and Failure of Picasso* (New York: Pantheon, 1965), 151–52.

22. It is interesting to note that Picasso's meditation on pictorial seriality in *balzacs en bas de casse et picassos sans majuscule* (cat. no. 28) is continued in the artist's drawings from December 23, 1952, to January 3, 1953, of his daughter Paloma, whose face appears to be a formal continuation of that of Balzac.

23. As if to reiterate the point, the compressed spatial container of *Woman Dressing Her Hair* reappears in *The Sailor* of October 28, 1943 (private collection; Zervos XIII, 167), presumably made shortly after the completion of *First Steps*. In this painting, the central vertical fold of the child's body in *First Steps* is transformed into the spine of an open book. This book in turn serves as the torso of the melancholy male sitter, his flimsy, cutout arms bearing little resemblance to the profoundly corporeal distortions of *Woman Dressing Her Hair*.

In her 1938 book *Picasso*, Gertrude Stein remarked on the calligraphic quality of Picasso's work. "He had a certain way of writing his thoughts," she wrote, "that is to say of seeing things in a way he knew he was seeing them."[1] For Stein, Picasso's calligraphy was not simply a formal affair. It entailed a certain quality of line, doubtless. But it also meant painting as a kind of writing, a particular way of registering thought on a flat support. In 1938, Stein could not have anticipated the brilliant red lithographic illuminations Picasso would contribute to Pierre Reverdy's book of poems *Le chant des morts*, published in 1948. But this book, perhaps more than any other, demonstrates Picasso's "calligraphy" in Stein's double sense of the word.

Reverdy finished the forty-three poems of *Le chant des morts* in January 1945. Written in the abbey town of Solesmes, where the poet had withdrawn in 1926, the poems are meditations on human mortality, filled with the imagery and trauma of the recent war. Soon after their completion, Tériade (Stratis Eleftheriades), the critic and important publisher of *livres du peintres*, asked Picasso if he would contribute illustrations. The poet and artist had met and become close in the days of the Bateau-Lavoir. Reverdy's theory of literature, moreover, was strongly informed by Cubism's insistence on aesthetic autonomy, a view expounded in his short-lived literary journal *Nord-sud* of 1917–18. According to Reverdy, the poem had its own reality on the page, and should be read silently, rather than recited, as "poetry goes to the heart by way of the eyes."[2]

For *Le chant des morts*, Tériade wanted to preserve the visual quality of Reverdy's handwriting and decided to print the poems using lithographic

20
Le chant des morts (The Song of the Dead)

Pierre Reverdy

Book, with 125 lithographs in red by Picasso, 17 x 13 in.
(43.2 x 33 cm)
Published by Tériade, Paris, 1948
Printed by Draeger Frères, Paris, for text and typography; Mourlot Frères, Paris, for lithographs
Edition 270
INSCRIPTIONS: on colophon:
P. Reverdy [and] *Picasso*
REFERENCES: Mourlot II, 117; Cramer 50
Yale University Art Gallery, The Ernest C. Steefel Collection of Graphic Art, Gift of Ernest C. Steefel, 1958.52.168

FIGURE I
Robert of Bridlington, *Catena on 2 Corinthians*
England, second half of 12th century
Beinecke Rare Book and Manuscript Library, Yale University

Je ne pense plus qu'à la nuit
Le long hiver fondant des pensées
souveraines
A présent que le circuit se ferme
Un astre mort
Traîne dans le ciel noir un
feu sans étincelles
Moins froides déchaînées
mais toujours à la peine
Timides lueurs déformées
Autour de l'âtre sans abri
Au rond point des déconfitures
La misère plus blême qu'un œuf
Contre la palissade abattue
d'un souffle de haine

86

Je marche sur la piste sèche du bonheur
La distance ouverte à son heure
Dans le crépitement vageur des moelles
libérés
Des jours sans abandon retenus
à la chaîne
Plus de place ni là ni là
Immobile au point mort
La ruche de lumière

Pages 86–87

autography. He sent a sample of the poet's handwriting to Picasso, who apparently remarked that it was "almost a drawing in itself."[3] Consequently, the artist decided against figurative illustrations, which might repeat the curved quality of the poet's hand, in favor of abstract decorations in the manner of medieval manuscript illumination (fig. 1). In her memoirs, Françoise Gilot recalled that Picasso was particularly inspired by three fifteenth-century books he was shown by a bookseller around this time.[4] The idea may have also originated with Tériade, who frequently published illuminations from medieval manuscripts in his magazine *Verve*.[5] Medieval manuscripts or antiphonaries (musical scores) were certainly a direct reference: Picasso's dots, lines, and flourishes evoke both the practices of rubrication (the highlighting of letters or phrases in red) and illumination (the pictorial decoration of the margins of a page).

In November 1945, Picasso began to work intensely in the Paris lithographic studio of the master printer Fernand Mourlot, where he would produce several hundred lithographs over the next few years. Three of the earliest works from this period, including *Arabesque* (fig. 2), executed November 12 that year, show the emergence of the abstract pictorial language Picasso used in *Le chant des morts*. The artist began working directly on the lithographic plates for the poems shortly after, in early 1946, but these plates were ruined in an accident. The final illuminations were

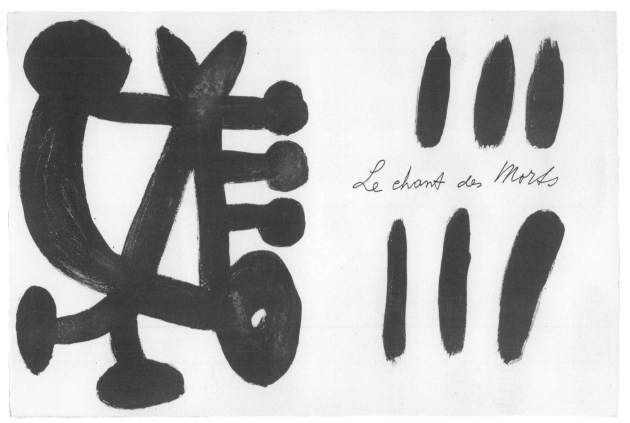

Title page 2

executed in the spring of 1948, with the edition published in fall of the
same year.

In 1950, the critic Jules René Thomé wrote that Picasso's illuminations
were an apt counterpart to Reverdy's texts of "suffering, misery and hope,"
and further, that the vivid red marks ran across the pages "as if a stream of
blood—the blood of the dead—had poured forth over the sheets."[6] This
tragic reading of the illuminations corresponds to the somber mood and
war imagery of Reverdy's poems. But Picasso's curving lines and flourishes
also have a whimsical, spontaneous quality that, combined with the gradual
repetition of elements, suggest the development of an idiosyncratic formal
vocabulary perhaps more than the mimetic rendering of blood. If one fol-
lows the course of the illuminations from beginning to end, it becomes
apparent that the circles, lines, and dots introduced at the beginning of the
book quickly coalesce into a distinct repertoire of forms. These forms vari-
ously frame the page (pages 20–21), demarcate its fold (pages 42–43), and
highlight its margins and edges (table of contents). If at first these abstract
shapes simply draw attention to the materiality of the page, by the middle
of the book Picasso appears to discover a new representational content
wherein the barbell forms that slide around the blocks of text begin to sug-
gest the metal clips used to bind together loose sheets of paper. This motif
is most explicit on the penultimate spread, which serves as the first half of

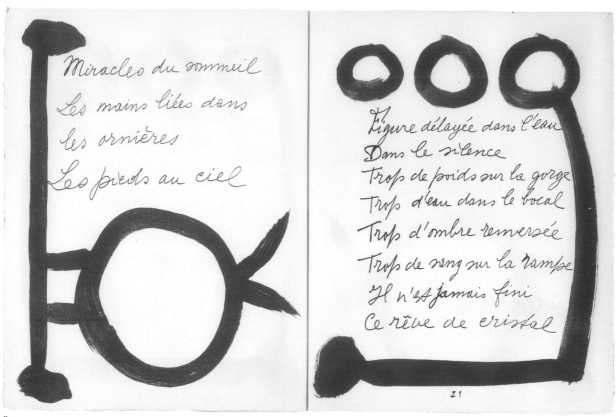

Pages 20–21

the book's table of contents. On these two pages, the "metal clip" appears on the left as an isolated formal motif, while on the right, a vertical bar crossed with horizontal marks suggests the open spine of a notebook.[7]

The development of the notebook motif in *Le chant des morts* recalls Reverdy's 1918 definition of the poetic image as "the juxtaposition of two more or less distant realities," a formulation cited by André Breton in his first Surrealist manifesto of 1924.[8] It is likewise indicative, as per Stein's idea of "calligraphy," of Picasso's creative technique, wherein images are registered as a process of seeing. But the notebook motif is also resonant of the particularities of the lithographic medium. Unlike the hard, scratching motion of etching, lithography is a painterly technique that allows for wide strokes of the moving arm. Yet it is also a flatbed printing process, recalling not the vertical stance of the painter's easel but the horizontal surface of writing. The motif of the notebook is therefore also a registration of painting pulled into the physical space of writing—the birth of calligraphy as the joining of two discrete modes of the mark.

In his 1972 essay "Other Criteria," Leo Steinberg argued that the emergence of the flatbed picture plane around 1950 represented an ontological shift from the Renaissance worldview and its conflation of the space of a picture with that of a window. According to Steinberg, the horizontal plane of the flatbed picture is "no longer the analogue of a visual experience of

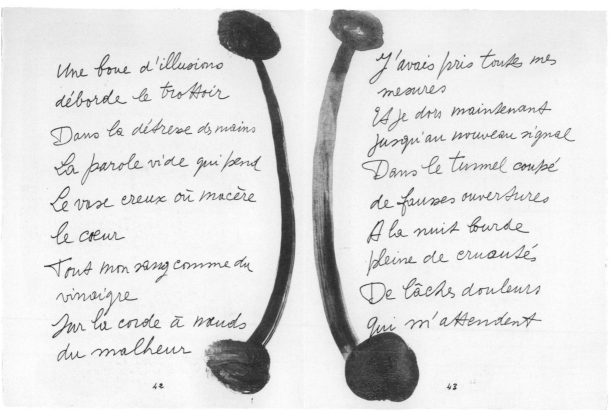

Une boue d'illusions
déborde le trottoir
Dans la détresse des mains
La parole vide qui pend
Le vase creux où macère
le cœur
Tout mon sang comme du
vinaigre
Sur la corde à nœuds
du malheur

J'avais pris toutes mes
mesures
Et je dois maintenant
Jusqu'au nouveau signal
Dans le tunnel coupé
de fausses ouvertures
A la nuit lourde
pleine de cruautés
De lâches douleurs
qui m'attendent

42 43

Pages 42–43

nature but of operational processes."9 It is a surface of inscription and recording. In place of the window, it offers up the desk. In *Le chant des morts*, Steinberg's flatbed picture plane is brought together with Stein's notion of calligraphy as a "special mode of imaginative confrontation."10 As a surface of registration, the book's pages testify to the process of their making. Picasso's swirling lines and punctuating blobs re-create the inkblot, the stain, and the scribble, the characteristic signs of the hand writing while thinking, its pauses documented in the pooling of ink upon a page. The "found" image of the notebook is therefore also an image of this notebook's inscription, an image sealed with Reverdy's autographic text.11

By producing an image of the artist's and poet's notebook in reproducible, lithographic form, *Le chant des morts* offers its reader/viewer intimate access to the primary scene of artistic creation in the sketchbook and the diary, respectively. The lithograph's indexicality, the very aspect that allows for its reproducibility, functions to ensure the authenticity of the artist's and writer's hand. *Le chant des morts*, then, is not a notebook, but a picture of a notebook. It offers up the look of the book as a picture that itself can be "read."

– Irene Small

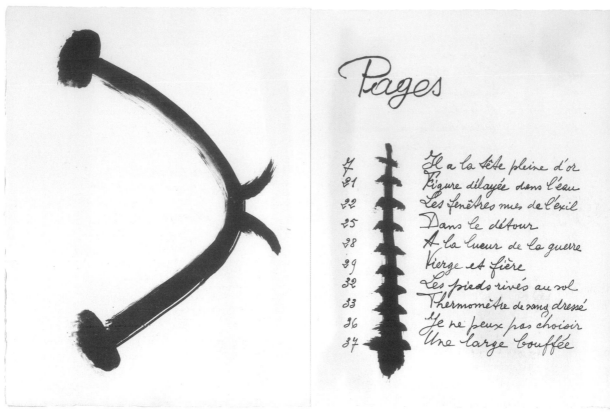

Table of Contents

1. Gertrude Stein, *Picasso* (1938; repr., New York: Dover Press, 1984), 38.

2. "Entretien radiophonique Henry Barraud-Pierre Reverdy," *Mercure de France*, ed. Maurice Saullet (n.p., 1950), 355, cited in Robert Greene, *The Poetic Theory of Pierre Reverdy* (Berkeley: University of California Press, 1967), 90.

3. Françoise Gilot with Carlton Lake, *Life with Picasso* (New York: McGraw-Hill, 1964), 193. See also *Tériade et les livres de peintres*, exh. cat. (Le Cateau-Cambrésis, France: Musée Matisse, 2002), 171.

4. The dissident Surrealist Georges Bataille, who worked at the Bibliothèque Nationale from 1922 to 1944 as a librarian and book-keeper of medieval manuscripts, may have also shown manuscripts or antiphonaries to Picasso. I would like to thank Pepe Karmel, Associate Professor and Chair of Art History, New York University, for bringing this connection to my attention.

5. Tériade wrote criticism for *Cahiers d'art* and *L'intransigeant*, cofounded *Minotaure* with Albert Skira in 1932, and founded the art and literary journal *Verve* in 1936. He published three special issues of *Verve* on Picasso, the first of which appeared in April 1948 (no. 19/20), the same year as *Le chant des morts*. Tériade published illuminations from medieval manuscripts in *Verve* particularly in the period between 1940 and 1949. A 1943 preface by Paul Valéry describes the progress of medieval illumination across the page in a manner surprisingly akin to Picasso's illustrations for *Le chant des morts*: "Illumination started off as a simple embellishment of letters that, little by little, took over the page and invaded the volume; pure ornament, extending downward from the majuscule through the margins, elaborated itself into emblems, symbols, leafage, spirals, crosiers, then incarnated itself into vegetation, animal-shapes, finally into human forms"; *Verve*, no. 9 (October 1943): 138.

6. Pierre Mornand and Jules René Thomé, *Vingt artistes du livre* (Paris: Le Courrier Graphique, 1950), 234, cited in Abraham Horodisch, *Picasso as Book Artist* (Cleveland: World, 1962), 73.

Table of Contents

7. See, for example, photographs of Picasso's notebooks in Laurence Madeline, ed., *"On est ce que l'on garde!": Les archives de Picasso*, exh. cat. (Paris: Éditions des Musées Nationaux, 2003). Richard L. Haatendorf has observed a similar effect. As he writes, "From the perspective of the reader's receptivity, the lithographs for the original cover of the folio edition recall the metal ribbing in the bindings of the large bound manuscripts of the Middle Ages. The swooping curves between round spots, the central circle, the closing arc, all are reminiscent of the large leather or parchment bound volumes that used to be found chained to the lecterns of parish and monastic churches"; see Haatendorf, "The 'Ensemble Concertant' of Reverdy and Picasso's *Le chant des morts*," *Comparatist* 16 (May 1992): 129.

8. As Reverdy wrote, "The image is a pure creation of the mind. It cannot be born of a comparison, but from the juxtaposition of two more or less distant realities. . . . The more distant and apposite the rela-tionships between the two realities, the stronger the image will be, and the more emotive power and poetic reality it will have"; *Nord-sud* (March 1918).

9. Leo Steinberg, "Other Criteria," in *Other Criteria: Confrontations with Twentieth-Century Art* (New York: Oxford University Press, 1972), 84. Rosalind Krauss has also written about Cubist collage in relation to the flatbed picture plane; see Krauss, "Rauschenberg and the Material-ized Image," *Artforum* 13, no. 4 (December 1974): 36–43.

10. Steinberg, "Other Criteria," 84.

11. In 1941, Picasso illuminated by hand fifteen autograph copies of Paul Éluard's *Divers poèmes du livre ouvert*. In *Le chant des morts*, this process is repeated in repro-ducible form. Interestingly, Reverdy also published his notebooks (including *Le livre de mon bord*, his notes from 1930 to 1936, the same year as the publication of *Le chant des morts*), though not in autograph form.

21a
Soneto burlesco (Burlesque Sonnet)

for Luis de Góngora y Argote's *Vingt poèmes de Góngora* (Twenty Poems by Góngora)

June 19, 1947
Aquatint and engraving, 15 x 11 in.
(38.1 x 27.9 cm)
Published by Les Grands Peintres Modernes et le Livre, Paris, 1948
Printed by Roger Lacourière, Paris
Edition 275
WATERMARK: lower center: Gongora
REFERENCES: Baer IV, 740ii/ii
The Lawrence and Regina Dubin Family Collection, Promised gift to the Yale University Art Gallery of Dr. Lawrence Dubin, B.S. 1955, M.D. 1958

The interplay of painting and writing in *Le chant des morts* (cat. no. 20) is also central to Picasso's simultaneous project, begun in late 1946 or early 1947, of a deluxe publication featuring twenty sonnets by the Spanish Baroque poet Luis de Góngora y Argote. A departure from Picasso's dozens of book projects, *Vingt poèmes de Góngora* inaugurated a number of postwar publications done in Picasso's native tongue.[1] The work is exceptional among these projects, however, because Picasso transcribed the poems himself, in his own charismatic handwriting, perhaps inspired by the poetic effect of Reverdy's handwritten poems in *Le chant des morts*.

In his important discussion of the publication, John Golding describes the long-standing significance Góngora had for Picasso.[2] Picasso grew up with his work and would have been familiar with him since his childhood in Spain. Picasso and Góngora were linked by the critic Félicien Fagus after Picasso's first one-man show in Paris in 1901, when there was a broader revival of interest in Góngora among poets, paralleling the revival of El Greco. Interest in Góngora was at its height in the 1920s, especially among the Surrealists and Robert Desnos, who met regularly with Picasso during the occupation. Desnos tragically died in a concentration camp in 1945. Perhaps *Góngora* resulted not only from Picasso's fascination and identification with the Spanish poet, but from his desire to create a tribute of sorts to his friend Desnos, through their shared love of Góngora's work.

Because the sonnets are both "written" and illustrated by Picasso (who expansively "signed" Góngora's name in imitation of the poet's own writing as the title page), the reader's experience of this publication is unique among Picasso's work. Every page of the book exudes a deeply personal interest in the author by the artist, who immersed himself, through the act of transcribing, in the work's complex language and Baroque imagery. Picasso also created marginal illustrations to the poems that mimic his expressive calligraphy in their exuberant underlines, strangely austere doodles, and elegant standing figures. Picasso's marginalia momentarily stop, however, with the poem about El Greco (cat. no. 21b), as if no image could compete with the master—a remarkable tribute to his predecessor. Góngora's theatrical, imaginary worlds look forward to Picasso's prints and drawings of the 1960s, filled with Rembrandt-like painters and courtly characters (see cat. nos. 35–36).[3]

Picasso's technique in this publication, undertaken with the master printer Roger Lacourière, also deserves special mention. For the text sheets, Picasso wrote Góngora's words on a sheet of paper that was transferred on to the sensitized copper plate by Lacourière; the plates were returned to Picasso, who then embellished the margins. Picasso also drew twenty female heads (figs. 1–2) to introduce each poem, using unusual techniques involving the liftground process, and in this case he worked the plates directly with brush and pen, as if working on paper.[4] The result is a dazzling display of technical experimentation and virtuosity, in what Herma

Soneto Burlesco.

A un excelente Pintor estrangero,
que le estava retratando.

Hurtas mi bulto, y cuanto más le deve
A tu pincel, dos vezes peregrino
De espíritu vivaz el breve lino,
En (pocos) colores, que sediento beve.

Vanas cenizas temo al lino breve,
Que emulo del barro le imagino,
A quien (ya etereo fuese, ya divino)
Vida le fió muda, esplendor leve.

Belga gentil, prosigue el hurto noble,
Que i su materia perdonará el fuego,
Y el tiempo ignorará su contextura.

Los siglos que en sus hojas cuenta el roble
Arbol los cuenta sordo, tronco ciego,
Quien más ve, quien mas oye, menos dura.

21b
Al sepulcro de Dominico Greco (On the Tomb of Dominico Greco)

for Luis de Góngora y Argote's *Vingt poèmes de Góngora* (Twenty Poems by Góngora)

June 26, 1947
Engraving, 15 x 11 in.
(38.1 x 27.9 cm)
Published by Les Grands Peintres Modernes et le Livre, Paris, 1948
Printed by Roger Lacourière, Paris
Edition 275
WATERMARK: lower right: unidentified
REFERENCES: Bacr IV, 752ii/ii
The Lawrence and Regina Dubin Family Collection, Promised gift to the Yale University Art Gallery of Dr. Lawrence Dubin, B.S. 1955, M.D. 1958

21c
Soneto funebre (Funerary Sonnet)

for Luis de Góngora y Argote's *Vingt poèmes de Góngora* (Twenty Poems by Góngora)

Golfe-Juan, February 6, 1948
Drypoint, 15 x 11 in.
(38.1 x 27.9 cm)
Published by Les Grands Peintres Modernes et le Livre, Paris, 1948
Printed by Roger Lacourière, Paris
Edition 275
WATERMARK: lower center: Marais
REFERENCES: Baer IV, 774ii/ii

The Lawrence and Regina Dubin Family Collection, Promised gift to the Yale University Art Gallery of Dr. Lawrence Dubin, B.S. 1955, M.D. 1958

FIGURE 1
Picasso, *Female Head*, from *Vingt poèmes de Góngora*

FIGURE 2
Picasso, *Female Head*, from *Vingt poèmes de Góngora*

FIGURE 3
Picasso, *Portrait of Góngora*, from *Vingt poèmes de Góngora*

Published by Les Grands Peintres
Modernes et le Livre, Paris, 1948
Gift of John Hay Whitney, Beinecke Rare
Book and Manuscript Library,
Yale University

Goeppert-Frank aptly calls a "feminine kaleidoscope."[5] Some of these heads are strikingly contemporary, while others evoke the *espagnolisme* reminiscent of Édouard Manet's portraits. The book also includes a lithographic portrait of Góngora (fig. 3), done after a 1622 painting by Diego Velázquez, now in the Museum of Fine Arts, Boston.

— **Susan Greenberg Fisher**

1. See, for example, José Delgado (alias Pepe Illo), *La tauromaquia* (1959; Cramer 100); Pablo Neruda, *Toros* (1960, in Spanish and French; see Cramer 107); and Camilo José Cela, *Gavilla de fábulas sin amor* (1962; Cramer 116). Picasso's own poem, *El entierro del conde de Orgaz*, written 1957–59, was published with accompanying etchings, engravings, and aquatints in 1969 (Cramer 146).

2. See John Golding, "Picasso's Góngora," in *Visions of the Modern* (London: Thames and Hudson, 1994), 201–9. The Golding essay on *Góngora* was originally published in the *New York Times Review of Books*, November 21, 1985, as a review of the publication of George Braziller's full-scale translation, which includes reproductions of Picasso's illustrations. See Pablo Picasso, *Góngora*, introduction by John Russell, poetry by Luis de Góngora y Argote, trans. Alan S. Trueblood (New York: George Braziller, 1985).

3. Golding proposes this connection of Góngora and Picasso's late work: "Work on Góngora must have helped to set the stage for the extraordinary visual pageant—and much of the late work can only be described in terms of theater—that was still to come." Golding, "Picasso's Góngora," 201.

4. Cramer 51. Golding also describes Picasso's technique in depth: "Basically it differs from ordinary aquatint in that the artist works on the plate as he would on paper, in darks on to a light ground, rather than in lights on to the dark ground of the prepared plate, as is normal in other etching techniques. Sugarlift aquatint thus allows for direct painterly and brushy effects as well as for a particularly broad and bold use of line. Picasso's use of the technique in this volume is absolutely direct, very quick and improvisatory: for example, the plates were not immersed in an acid bath, and the acid was simply dabbed on with swabs. With the greys being bitten into in this way, some of the true blacks were achieved by painting on to the plate with brushes dipped in full-strength acid. Picasso also at times used his fingers to smear on the sugarlift solution and he used sandpaper and muslin to achieve some of the halftone textural effects. Throughout he combined the sugarlift technique with direct, traditional dry point etching"; Golding, "Picasso's Góngora," 208.

5. Cramer 51.

22
Poésie de mots inconnus (Poetry of Unknown Words)
Iliazd, editor

Poems by Akinsemoyin, Albert-Birot, Arp, Artaud, Audiberti, Ball, Beauduin, Bryen, Dermée, Hausmann, Huidobro, Iliazd, Jolas, Khlébnikov, Krutchonykh, Picasso, Poplavsky, Schwitters, Seuphor, Téréntiev, Tzara
Images by Arp, Braque, Bryen, Chagall, Dominguez, Férat, Giacometti, Gleizes, Hausmann, Laurens, Léger, Magnelli, Masson, Matisse, Metzinger, Miró, Picasso, Ribemont-Dessaignes, Survage, Taeuber-Arp, Tytgat, Villon, Wols

Book, with sheets folded in 4, with 1 engraving and 2 lithographs by Picasso, 7 x 5¼ in. (17.8 x 13.3 cm)
Published by Degré 41, Paris, 1949
Printed by Imprimerie Union, Paris, for text and typography; Atelier Roger Lacourière, Paris, for engravings; Mourlot Frères, Paris, for lithographs
Edition 158
REFERENCES: Mourlot III, 181; Cramer 54; Baer IV, 839
Yale University Art Gallery, The Ernest C. Steefel Collection of Graphic Art, Gift of Ernest C. Steefel, 1958.52.160

Picasso's wartime poetry was a featured element of *Poésie de mots inconnus*, an anthology of sound, visual, and concrete poetry from 1910 to 1948 (chiefly Futurist Russian and "Zaoum" texts and Dada writings in various languages) published by the Russian poet-cum-editor Iliazd (Ilia Zdanevitch). Iliazd published the anthology in response to claims by the Lettrist movement in 1948–49 that they invented sound and visual poetry.[1] Picasso was somewhat of a guest author in this otherwise Dada-heavy publication, lending to it considerable star quality.[2] Iliazd and Picasso had known each other since the 1920s, but it was after the war that Iliazd's reputation as a publisher grew significantly, and he became one of the greatest publishers of the *livre d'artiste* in the postwar years. He and Picasso would collaborate on a total of nine books, elegant and experimental publications that are "permeated by a shared faith in the magic of words and letters freed from accepted rules of logic, grammar and style," as Lydia Gasman has stated so well.[3] Iliazd's books were particularly known for their use of fine materials, and this book, enclosed in elegant parchment, is no exception. With its whimsical vignette, "Ne coupez pas mes pages" (Do not cut my pages), by Georges Ribemont-Dessaignes printed on the front, the entire book masquerades as an animate object. Iliazd's instruction to leave *Poésie de mots inconnus* unbound collapses the distinction between book and art object, inviting the viewer to actively fold, handle, manipulate, and even rearrange the pages at will.

For the book's *achevé d'imprimer*, Picasso contributed a lithograph of imaginary letters that evoke Surrealist automatic writing as well as the overall theme of Iliazd's publication, the "poetry of unknown words." Picasso

opposite:
Achevé d'imprimer for *Poésie de mots inconnus*, with Picasso's transfer lithograph *Unknown Letters* in the lower-right quadrant

LES TEXTES

LES GRAVURES

ONT ÉTÉ
COMPOSÉS
LES TEXTES
SUR LES
MAQUETTES
D'ILIAZD
ONT ÉTÉ
COMPOSÉS
SUR LES
MAQUETTES
À
D'ILIAZD
L'IMPRIMERIE
UNION
A
DE DMITRI
L'IMPRIMERIE
SNÉGAROFF
UNION
DE DMITRI
ET WOLF
SNÉGAROFF
CHALIT
ET WOLF
13 RUE
CHALIT
MÉCHAIN
13 RUE
PAR
MÉCHAIN
PAR
ALEXANDRE
ZALEXANDRE
DU 25AVRIL
AU 28JUIN
1949

LES GRAVURES
SUR
CUIVRE
ONT ÉTÉ SUR
TIRÉS CUIVRE
ONT ÉTÉ
SUR LES
TIRÉES
AINSI SUR LES
QUE PRESSES
LES A PRESSES
BOIS QUE DE ROGERAS
GRAVÉS LES LACOURIERE
BOIS LACOURIÈRE
ET LE II RUE
LINOLÉUM FOYATIER
MATISSEDE PAR
MAISSE GUY
PAR ANER
ET
PIERRE GEORGES
BREUILLET CHERTUNTE
DU 5 MAI DU 1 AVRIL
AU 23 JUIN AU 6 MAI
1949 1949
1949

TIRÉS
TIRÉS
AINSI
QUE
LES
BOIS
GRAVÉS
ET LE
LINOLÉUM
MATISSE
PAR

L'EAU-FORTE
DE CHAGALL
L'EAU-FORTE
DE CHAGALL
A ÉTÉ
A ÉTÉE
TIRÉER
SUR A PRESSE
LA PRESSE
A BRAS
DE PAUL
HAASEN
23 RUE
VANDRÉ
ZANNE
PAR
ÉMILE
GONTHARET
LE 24 MAI
1949

LES LITHO
GRAPHIES
LES LITHO
GRAPHIES
ONT
ONÉTÉ
ÉTÉIRÉES
TIRÉER
SUR LES
LES
PRESSES
PRESSES
A BRAS
A BRAS
DE
MOURLOT
FRÈRES
FRÈRES

18 RUE
CHABROL

18 RUE
CHABROL PAR PIERRE
DERUE
JOSEPH
PAR PIERRE LEGRAS
DERUE ÉMILE
JOSEPH
LEGRAS
ÉMILE RAPP ET
GEORGES
RAPP ET
SAGOURIN
GEORGES
SAGOURIN
SURVEILLANCE
DE
SURVEILLANCE
DE
JEAN
JEACÉLESTIN
CÉLESTIN AVRIL
DUAL PVRIN
AU 1949 JUIN
1949

APRÈS
APRÈS LE
TIRAGE
TIRAGEDES
FIGURES
FIGURES
LES
PLANCHES
LES ONT
PLANCHES
ONT RAYÉES
ÉTÉ
RAYÉES LES
PIERRES
EFFACÉES
LES
PIERRES FAITES
EFFACÉES
ET QUATRE
FAITES
SUITES
JUSTIFICATIVES
SUR
LES QUATRE CHINE
SUITES
JUSTIFICATIVES
SUR
CHINE

CE
CE
LIVRE
CONTIENT
CONTIENT
29
29
FEUILLETS
FEUILLET3
DONT
DONT 26
DE TEXTE
DE TEXTEDE
FIGURES
FIGURES
AVIS
AU
AVIS
AU RELIEUR
RELIEUR
ET DEUX
GARDES
ET DEUX
GARDES

ACHEVÉ
D'IMPRIMER
LE
2 AOUT
1949
A
PARIS
PARIS
POUR
POUR
LE
DEGRÉ 41
DEGRÉ 41

26 Avril 43. AUX CARESSES SAVONNÉES DE LA
FEUILLE mille fois entrouverte et fixe détachée
offerte en musique aux pages et longues traînées de
paillettes agitées et folles dits et éclaboussés en gloires
et prises, criées et peintes aux tresses nacrées distinctes,
aux solitudes épousées entremêlées aux caressantes distillations
brûlées aux branches et aux teintures soulevées aux entre-
terses et aux importunes découvertes en digestions premières
vomies de point en long éprises fastidieuses arabesques
et retournées des décompositions et larmes aux arcs
élaborées et festonnés labours arrachées en passant
et en couronnes et diaboliques défilés repassant aux
timbrages accomodé disparu et défait si
tard de tout son trajet révolté enveloppé
tend en forêt aux franges crochues déchi-
rées à pleine main et os déployés
aux voiles et aux velums claquant des
rames dressées en flammes et en adieux
rigoureusement projetée en pâture à la
foule de miroirs siégeant l'apparition,
traînée au fond de lacs du soleil dressés
peignant à grands coups de brosse les trois
quart du buffet enfoui dans le bouillie
des poils et de la fourrure fourrant
s'étoupe le ventre ouvert sur la lumière
à grands traits du toit glacé du drap tendu de
l'armure d'eau criée à la fenêtre de toile
la sorgue du gai toquant en écailles parures à
toute danse trisque imaginée.

II

APRÈS MIDI D'ARRA-
-CHER DOUCEMENT
AVEC MES ONGLES
LA PEAU A TOUTES
LES FLAMMES

A UNE HEURE CINQ
DU MATIN ET PLUS
TARD MAINTENANT
TROIS HEURES MOINS
DIX MES DOIGTS

I

Mardi 5 novembre 40

AU BUCHER EN
FEU OÙ GRILLAIT
NUE LA SORCIERE,
JE ME SUIS AMUSE
DU BOUT DES
LEVRES DE CETTE

III

...SENTAIENT
ENCORE LE PAIN
CHAUD LE MIEL
ET LES JASMINS.

Picasso, *Litho du poète*, transfer lithograph for *Poésie de mots inconnus*

CHANT 2

L'AVION

VRRON(I) -----ON-----ON -----ON -----ON -----ON
 VRRR VRRR VRRR
 HIHIHI
 OUOUOUITT
 OUOUOUITT
 OUOUOUITT
TRRRA TRRRA TRRRA TRRRA TRRRA
 TRRRATRRRA TRRRATRRRA
HI
 VRRR VRRR
(2) OUA OUA´ OUA OUA OUA OUA OUA
 OUA OUA OUA OUA OUA OUA OUA
(2) III
 OUOUOUITT
 OUOUOUITT
 OUOUOUITT
 VRR VRR
(2) II

SIC 23 1917

POÈMES A CRIER ET A DANSER

CHANT 1

POUR DADA

AN AN AN AN AN AN AN AN
AN AN AN
IIII I I
POUH POUH POUH POUH RRRA
SL SL SL
DRRRRRR OUM OUM
AN AN AN AN
AAA AAA AAA TZINN
III IIIIII
HA HA HA HA HA HA HA
RRRRRRRRRRRRRRRRRRRRRRR É

DADA 2 1917

CHANT 3

 ÊÊÊÊ ÈÈÈ ÉÉ
 A OUOU A OUOU ÊÊ
(I) BING----------- BING-------------
(I) BRRRRRR------BRRRRRRRRR TZINNN
 (I) O----- O----- OOO
 A III A III A III III
AO AO AO AO AO AO AO TZINNN
AO AO AO AO A AO TZINNN
 RRRRRRRRRRRRRR RRRRRRRRRRRR
 RRRRRRRRRRRRR
(2) OUOUOUOUOUOUOUOUOU
 OUOUOUOUOUOUOUOUOUOU
(3) UUUUUUUUUUUUUUUU
 UUUUUUUUUUUUUUUUUU
 I

SIC 27 1918

(I) PROLONGER LE SON
(2) METTRE LA MAIN
 EN SOUPAPE SUR LA BOUCHE
(3) METTRE LA MAIN EN PORTE - VOIX

Sound poems by Pierre Albert-Birot in *Poésie de mots inconnus*, with Picasso's
engraving in the upper-left quadrant

first seems to have used this form of writing in a "letter" to André Breton in 1938, on stationery for the "Fédération Internationale de l'Art Révolutionnaire Indépendant."[4] The almost-decipherable text, which spreads in thick black, alluringly elusive markings across the page, echoing Picasso's earlier use of near-letters in his painting (see cat. no. 11), is in turn surrounded by Iliazd's double printing of letters, in two colors, one slightly above the other, to create a texturing of words that is pictorial, like a canvas or a tapestry, as Herma Goeppert-Frank notes.[5] Further inside the book, Iliazd featured a lithograph of two wartime poems handwritten by Picasso. The layout is similar to that used in Picasso's *Poems and Lithographs*, a set of fourteen lithographs with thirty images and twenty-six pages of text, which he made several months earlier in April and May 1949, and later published in an edition of fifty with Galerie Louise Leiris in 1954.

One of the poems featured here dates from November 5, 1940, written after Picasso returned to Paris from Royan, following the arrival of German troops in August. Now transcribing the earlier poem as a lithograph, Picasso allows cross-outs and ink pools to remain in the final work and conveys visually the process of writing. The poem reads:

> *Tuesday 5 November 40*
>
> *on the blazing pyre where*
> *the witch was roasting naked*
> *I had fun*
> *paying lip-service*
> *to this afternoon*
> *with my nails*
> *gently flaying*
> *the skin of all*
> *the flames*
> *at five past one*
> *in the morning and later*
> *now ten minutes*
> *to three my fingers still*
> *smelled of warm bread honey*
> *and jasmine*[6]

The second poem, in the upper-left quadrant of the sheet, dates from April 26, 1943, during the occupation of Paris. Picasso's handwriting is significantly more compact and claustrophobic:

> *To the salmon-pink caresses of the leaf a thousand times half-opened and*
> *fixed detached offered as music to the fires and long trains of spangles waved*
> *and crazy so said and splashed in glory and rockets screamed and painted to*
> *the pearly distinct braids to the solitudes seen all mixed up with the caressing*
> *burned distillations to the branches and to the raised hangings to the sordid*

*little secrets and to the unfortunate discoveries in digestions and prayers vom-
ited from a point into far enamored sumptuous arabesques and ritornellos of
the decompositions and tears to the spattered and festooned arcs labors torn
in perfumes and in crowns and diabolic sated processions to the tendernesses
prepared disappeared and undone so late of each long trajectory revolted
enveloped stretched in the woods to hooked and shredded trances in meat and
bone unfolded into veils and vellums oars smack raised in flames and good-
byes rigorously projected as bait to the crowd of mirrors aping the drained
apparition at the bottom of the raised lakes of the sun with large brush
strokes painting three quarters of the sideboard buried in the mess of hairs
of the fur caulking with cotton waste the belly open to the light with large
strokes of the icy roof of the stretched sheet of the water armor screamed at the
window with all the strength of the gay bouquet in plucked apparel to all
chance and risk imagined.*[7]

Picasso also contributed an engraving of a plantlike object to illustrate
"Poèmes à crier et à danser" (Poems to Shout and Dance) of 1917–18 by
Pierre Albert-Birot, a poet who had been editor of the journal *SIC* (Sons
Idées Couleurs, or Sounds Ideas Colors) from 1916 to 1919, which had
featured Surrealist, Futurist, and Dada writings. The object combines an
identifiable vegetal form with an esoteric hieroglyph-like symbol, blurring the
boundaries between text and image. The engraving also plays on the audio-
visual potential of representation. Evoking Birot's sound poems, the mouth
of Picasso's plant opens wide, and two stamens shoot outward, like cries
from within.

— **Susan Greenberg Fisher**

1. See Joanna Drucker, "Iliazd and the Book
as a Form of Art," *Journal of Decorative and
Propaganda Arts* 7 (winter 1988): 45.

2. As Drucker notes about their relation-
ship: "Picasso functioned for Iliazd as a
kind of inverted shadow figure, as the
image of the artist which he was not.
Through his association with Picasso, Iliazd
could also project that image as his own, lay
claim to the status of major figure through
the collaboration with Picasso as a peer";
ibid.

3. Lydia Gasman, "Mystery, Magic, and
Love in Picasso, 1925–1938: Picasso and the
Surrealist Poets" (PH.D. diss., Columbia
University, 1981), 2:977. Their other col-
laborations were: *Afat* (1940), *Escrito*
(1948), *La maigre* (1952), *Chevaux de minuit*
(1956), *Sillage intangible* (1958; introduc-
tion, fig. 10), *Le frère mendiant* (1959),
Rogelio Lacourière pêcheur de cuivres (1968),
and *Pirosmanachvili* (1972). See *La rencontre
Iliazd-Picasso: Hommage à Iliazd*, exh. cat.
(Paris: Musée d'Art Moderne de la Ville de
Paris, 1976).

4. The letter is reproduced in Marie-Laure
Bernadac and Christine Piot, eds., *Picasso:
Collected Writings* (London: Aurum Press,
1989), 198.

5. Cramer 54.

6. Translated by Pierre Joris, in Jerome
Rothenberg and Pierre Joris, eds., *The
Burial of the Count of Orgaz and Other Poems
by Pablo Picasso* (Cambridge, Mass.: Exact
Change, 2004), 225–26.

7. Translated by Pierre Joris, in ibid., 259.

23
Seated Woman

April 2, 1947
Oil on canvas, 39⁵⁄₁₆ x 31¾ in.
(99.9 x 80.7 cm)
INSCRIPTIONS: top left: *Picasso*;
on verso: *2.4.47*
PROVENANCE: Samuel M. Kootz
Gallery, New York; purchased from
Kootz by Katharine Ordway,
February 13, 1950
REFERENCES: Zervos XV, 49
Yale University Art Gallery, The
Katharine Ordway Collection,
1980.12.21

This complex portrait of Françoise Gilot, painted the month before the birth of her and Picasso's first child, Claude, is rife with the artist's observation of the complex psychological and physical transformation that motherhood would bring to bear upon his partner and their life together. Picasso signifies her metamorphosis through the enfolding metaphor of black lines that frame her face and figure. The painting has been cited as an extension of the *Woman-Flower* portrait series the artist began in May 1946, with the well-known image of his young lover Gilot depicted as an iconic conflation of woman and flower embodying the essence of natural beauty.[1] In June 1946 he undertook ten lithographic head studies of Gilot, which culminated in an eleventh of her imaged as a radiant sun.[2] By August of that year, however, when Gilot became pregnant, such elemental beauty did not adequately capture the complex woman the artist saw literally taking shape before him.

Seated Woman is not the fecund, exuberant lover seen in the *Woman-Flower* portraits but an abject, conflicted persona. Picasso's formal study of her in the paintings and lithographs undertaken from 1947 to 1949 speaks to his anticipation of the loss of the carefree intimacy that characterized the onset of the artist's relationships with the significant women in his life. Although he had already experienced the altering effects that a child could have on the relationship between a man and woman—when Paulo was born to Olga Koklova more than twenty-five years earlier and, more recently, with the birth in 1935 of Maya to Marie-Thérèse Walter—in the independent, beguiling Gilot, the transformation, as observed by Picasso, would be especially intimidating.

To meet the challenge of emulating the many facets of his sitter, Picasso would turn to melding characters excerpted from Lucas Cranach the Elder's painting *David and Bathsheba* (1526, Gemäldegalerie, Berlin): the seated Bathsheba, her dignified lady-in-waiting, and her foot-washing servant (fig. 1). Gilot is depicted in *Seated Woman* as a conflation of the noticeably pregnant Bathsheba and her standing attendant. Her imperial costuming and physiognomy are abstract variations on Cranach's sensuous gowns and jaunty hats. Picasso saw her simultaneously as a lady waiting for the birth of her child and the noblewoman who was to give birth to his heir. While Gilot endures in Picasso's oeuvre primarily as a seated, regal figure, Picasso would reiterate her status as a standing lady-in-waiting when she was pregnant with their second child, Paloma, in the 1949 lithograph *The Young Artist*, although at that time he would recognize her as an artist, positioning her at her easel.[3]

Picasso's lithographic study of Cranach's historical precedent began in March 1947, just before *Seated Woman*, at which time he completed six states.[4] Four additional states would not be completed until 1949. In Cranach the Elder's painting, King David is depicted in a parapet, looking down upon the pregnant Bathsheba as a maid washes her feet. At Bathsheba's left stands a lady-in-waiting, while two additional serving women are set

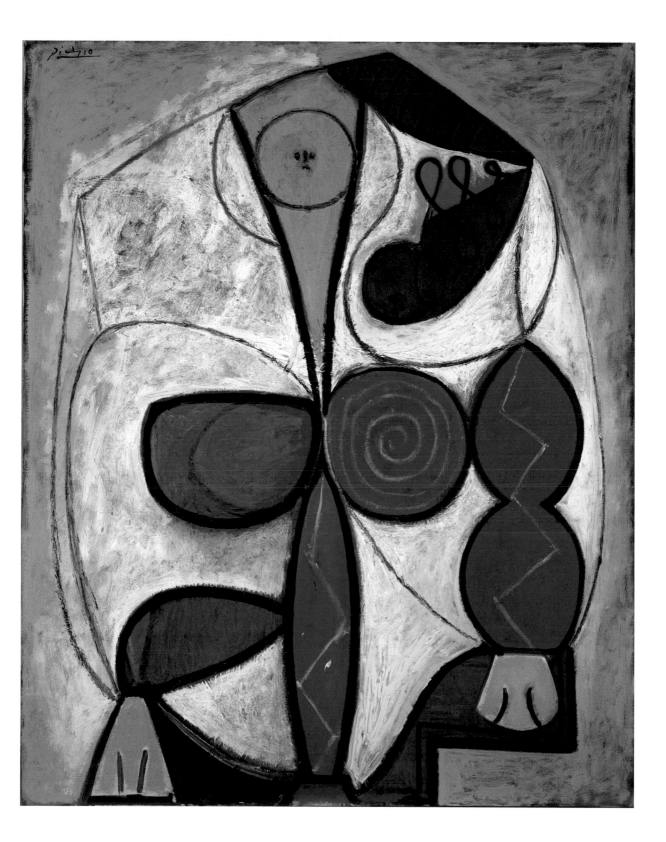

FIGURE I
Picasso, *David and Bathsheba*, after
Lucas Cranach the Elder
March 30, 1947
Lithograph
25⅞ x 19¹¹/₁₆ in. (65.7 x 50 cm)
Graphikmuseum Pablo Picasso, Munster

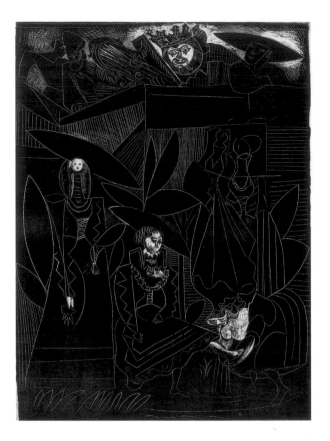

off to the right beyond a shrubbery. Picasso emulated this composition exactingly.

The biblical narrative that inspired Cranach the Elder, and subsequently Picasso, is a troubled source for an intimate portrait.[5] Certainly, Picasso's choice of this narrative as the backdrop for the depiction of his muse Gilot and the impending birth of their first child did not induce consideration of the prospect as an unfettered good in the artist's mind. The pregnancy was seen by the artist as a snare, for him as well as Gilot, even if it was a trap of his own making, conceived according to Gilot in order to bind her independent, youthful self to him.[6]

Building from the 1946 *Woman-Flower* portraits, in the states of the print Picasso grafted the shrubbery and costume of the figures into voluminous organic forms that assimilate Gilot's signature sweep of hair. Picasso also fluctuated between naturalistic depiction and minimal characterization in the lady-in-waiting's visage. Dot eyes, and a smudge for her nose and face, dominate to form an expressionless face that stares blankly but directly at the viewer, in contrast to the other characters, who remain engrossed in the scene. It is this expressionless countenance that he chose for *Seated Woman*.

This small face began to feature in Picasso's paintings of Gilot in January 1947. In earlier paintings there is a disproportionate but not ungainly juxtaposition of a head and the articulation of the face. *Seated Woman* is

unique in that it follows the motif of the *Woman-Flower* series. In *Seated Woman* Gilot's face is composed of two stamens (the pollen-producing reproductive organ of a flower) and a pollinated anther (the organ that receives the pollen), with the face of their child suspended between them. The muted palette of the painting contrasts with the rough impasto, which reveals it was heavily worked by Picasso, its propagator. The stamens also read as the antennae of a butterfly attached to a slim bodice, centered in graceful sweeping lines that evoke the wings of a beautiful insect with the powers of self-transformation, one evoked three years later in his illustrations to Tristan Tzara's poetry (cat. no. 26). It is clear that Picasso is unsure who Gilot is in this incarnation, and how distinct her identity will be in relation to the growing presence of their child. Picasso would take this depiction of her assimilation by motherhood to a frightening extreme in a 1949 sculpture of Gilot when she was pregnant with Paloma (Musée Picasso, Paris), in which she has no head at all, just a tiny face scored at the juncture of outstretched arms.[7]

The small face was also used in the late 1920s by Picasso in his paintings and drawings of bathers at Dinard, who most likely included his young son Paulo, his wife Olga Koklova, and his clandestine lover, Marie-Thérèse Walter, who accompanied him on holiday. While there is a precedent for Picasso infantilizing the women in his life throughout his oeuvre, what is difficult to explain is that the most immediately recognizable precedent for this small face is in Picasso's studies and maquettes for his proposed monument to the poet Guillaume Apollinaire of 1928 (cat. no. 12, fig. 2). This open wire construction grew out of a group of drawings of 1924 that were to introduce Honoré de Balzac's *Le chef-d'oeuvre inconnu* (cat. no. 12), published in Paris by Ambroise Vollard in 1931. The tiny button face floats above a mass composed of an open network of metal rods that effect the volume of Apollinaire's ungainly body.

In *Seated Woman* of 1947, Gilot's face and figure are also suspended in a network of black lines that are used to create a sense of volume and space within the composition. In photographs of Apollinaire, his eyes literally read as blank dots in his head (see Caws, "The Meeting Place of Poets," fig. 2), and Picasso caricatured this eccentricity in his physiognomy. However, why Picasso depicted this gentle literary giant, whom he greatly admired, in the same manner as his frolicking children and their mothers is difficult to discern. Certainly in the case of Apollinaire and Gilot, Picasso was addressing two powerful and complex adult subjects. The result of his efforts was to create artworks that conveyed his experience of the difference, or disengagement, between the face or image of the subject and its form. He would further this observation in later portraits of Gilot in print and in paint in which he would draw a small box around her head, demarcating the boundaries of her image as a portrait, and then compose her body, often in a distinct color or style, around it.

FIGURE 2
Picasso, *Woman Drawing with Her Children*
Vallauris, April 23, 1950
Oil on plywood
81⅞ x 51³/₁₆ in. (208 x 130 cm)
Private collection

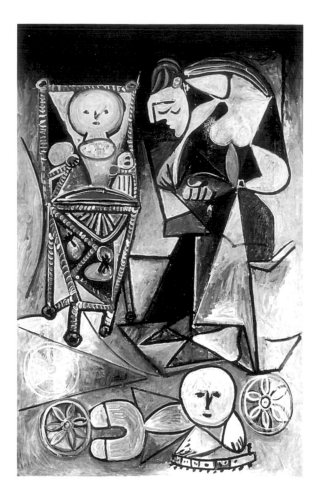

It is also in the David and Bathsheba lithographs that we see Picasso fuse the head of the lady-in-waiting with her elongated neck, wrapped in lace, to create the significant form of a keyhole shape. Picasso emphasized this shape through outline in his own lithographs, and the shape emerges as a distinct form inside Gilot's head in the second state of a series of color lithographs, *Woman in an Armchair* (cat. no. 24, fig. 1), in November 1948, when Gilot was halfway through her pregnancy with Paloma. In 1950 he would once again revisit the characters from the David and Bathsheba series in the painting *Woman Drawing with Her Children* (fig. 2) and reintroduce the keyhole shape, this time in his depiction of the children. In this work he appears to be sympathetic to Gilot's role as a mother when he presents her as the foot-washing servant from the lithograph *David and Bathsheba* in a painting of her with Claude and Paloma. In contrast to his regal seated portraits of her, Gilot appears mournfully stooped in service to her children, and clearly observed as a variation on the maid who is thought to have been his model for the mother figure in *First Steps* of 1943 (cat. no. 19).[7] The children are mere caricatures without limbs, button faces inset within keyhole-outlined heads and necks. Paloma floats in a high chair, while Claude plays on the floor.

Sigmund Freud's *Three Essays on the Theory of Sexuality*, which included his theory on primal-scene manifestations, was published as early as 1905 and would have been well known to Picasso by the late 1940s, following his intellectual dalliance with the Surrealists in the 1930s. Freud's documentation of the traumatic effects that the observation and consciousness of parental sexuality could possibly cause in a child had been popularly discussed. Picasso, with his perpetual interest in sexuality and its lore, myths, and facts, would have been familiar with Freud's popular accounting of a child's discovery of sex by peeking through the keyhole of his mother's boudoir, and observing her in the uncanny act. In Freud's writings the keyhole symbolized the literal and psychological threshold of discovery and was also understood to represent the vagina.

In the 1950 painting, by representing Claude and Paloma as keyholes, Picasso transferred Gilot's identity and sexuality back onto her now physically autonomous children. The painting is his depiction of the displacement of her sexuality and his consciousness of her sexuality as the portal through which he observed their children. Where their tiny faces might have originally conveyed innocence in Picasso's mind, as portrayed in *Seated Woman*, the manifestation of the keyhole a few years later certainly indicates its loss, marking a threshold between Gilot's independence, sexuality, and fantasy and her sense of duty, maternity, and the reality defined by motherhood.

— **Jennifer R. Gross**

1. For a comparison between *Seated Woman* and the *Woman-Flower* works, see Jean Sutherland Boggs, *Picasso and Man*, exh. cat. (Toronto: Art Gallery of Toronto, 1964), 137.

2. See Mourlot I, 38–48.

3. See Mourlot II, 150. Picasso explained the shift in stance to Gilot as specifically descriptive of her: "I don't see you seated. You're not at all the passive type. I only see you standing"; cited in Michael C. FitzGerald, "A Triangle of Ambitions: Art, Politics, and Family during the Postwar Years with Françoise Gilot," in *Picasso and Portraiture: Representation and Transformation*, ed. William Rubin, exh. cat. (New York: Harry N. Abrams, 1996), 418.

4. For the Cranach series, see Mourlot II, 109.

5. The moralizing account underlying this banal scene is one that reveals that the characters have come to this quiet place through treachery and deceit, will suffer greatly, but eventually find absolution and restoration. David, having coveted Bathsheba's beauty, seduced and impregnated her. When her unwitting husband, Uriah, a devout soldier in David's army, failed to cooperate with the king's attempt to cover up the pregnancy (David had Uriah brought home from the war front to have sex with his wife, but Uriah's devotion to the king was such that he would not indulge himself, as he considered it a distraction from duty), David had him murdered. Honor has rarely been so poorly rewarded. David repented of his evil deeds, and God forgave him but did not absolve him of the effects of his sin. Bathsheba became one of David's wives and gave birth to a son who quickly died, according to prophecy, as the punishment for David's sin.

6. Françoise Gilot with Carlton Lake, *Life with Picasso* (New York: Doubleday, 1964), 131, 336.

7. Ann Temkin in *Yale University Art Gallery: Selections*, ed. Alan Shestack (New Haven, Conn.: Yale University Art Gallery, 1983), 84.

Woman in an Armchair No. 4

January 3, 1949
Lithograph, 27½ x 21½ in.
(76.7 x 56.6 cm)
Edition 50
INSCRIPTIONS: lower right: *Picasso*
REFERENCES: Mourlot II, 137v/vii
Yale University Art Gallery, Gift of
Mr. and Mrs. Walter Bareiss,
B.S. 1940s, 1969.60.1

Françoise Gilot's bearing and demeanor would succumb to Picasso's further scrutiny and metamorphosis in the lithographic *Woman in an Armchair* series. While the composition—a closely cropped view of Gilot seated on a ceremonial chair enrobed in the period dress refined in the Cranach series—would remain constant throughout the multiple plates and twenty-seven states, each state bears evidence of the caliber of Picasso's radical transformation of his subject in this medium. Although Picasso produced more states of this lithograph than any other in his oeuvre, only plate no. 284 was actually published.[1] Executed in the same years as the illuminations to *Le chant des morts* (cat. no. 20), a similar, distinct repertoire of barbell-like forms emerges in this series of lithographs.

The first two states of *Woman in an Armchair No. 4* were undertaken in five colors (fig. 1), but this idea appears to have been quickly abandoned by the artist, who switched to developing the five plates individually in black. Perhaps Picasso's foray into the use of color was initially inspired by the elaborately embroidered coat that he had purchased for Gilot while attending the World Congress of Intellectuals for Peace in Wrocław, Poland, in August 1948, and which informed the initial styling of the costume.[2] The subtle shifts of form engendered by the sweeping gestures of color in the first two states gave way to his compulsive and eccentric study of line, and contrasts of light and dark, that unfurl in the remaining states.

In this rendering, the fifth state of the fourth (violet) plate, we see an arresting melding of Picasso's Renaissance ideal of a noblewoman, strongly evoking the face shape and costuming of the central figure of the child princess from Diego Velázquez's *Las Meninas* (1656, Museo Nacional del Prado, Madrid), and his hauntingly beautiful naturalistic study of Gilot's face from the previous red plate. The garment, which began as an ermine-trimmed mantle in the first state of the print, has transmogrified into a Renaissance cloak akin to the garment in the preceding lithographs and paintings of Gilot. The lithograph is printed with the dry, sooty quality Picasso greatly admired and frequently emulated in Francisco de Goya's prints.[3] The network of capped lines that he developed in the mid-1920s in his studies for his monument to Apollinaire (cat. no. 12, fig. 2) is applied here to detail Gilot's hair, bodice, and sleeves, transforming her from a person into a slightly mechanized aesthetic icon. While Picasso continued the extensive innovation in the form and use of line evidenced in the earlier versions of this image, here his process is subsumed to the realization of a clarified, final image. The lithograph is balanced in its use of black and white to define field and realize line, and the detailing is less wrought than in most other states, which also assists in the fine balance between abstraction and realism that Picasso achieved in this work.

The only affectation in Picasso's imaging of Gilot that would stay constant throughout all twenty-seven states of the lithograph was his dramatic treatment of her hands. Here her left hand is realized as a tight, mittlike

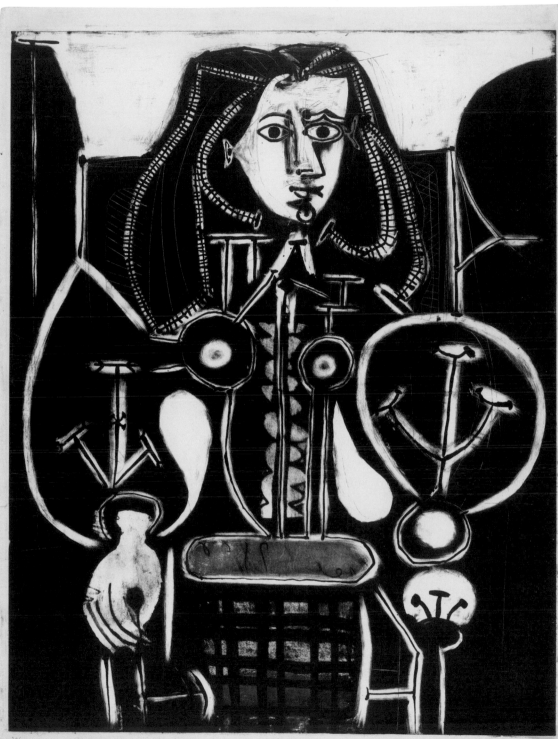

FIGURE I

Picasso, *Woman in an Armchair*
November 1948
Lithograph
25¹³/₁₆ x 19⁹/₁₆ in. (65.6 x 49.8 cm)
Graphikmuseum Pablo Picasso, Munster

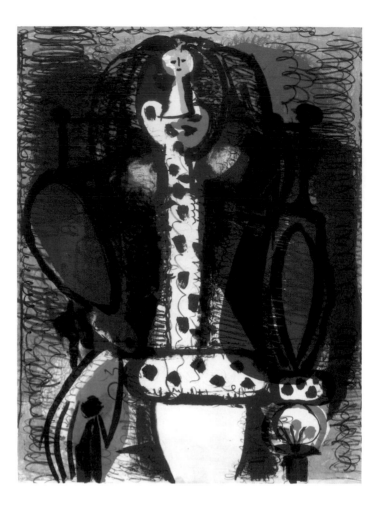

form that firmly grasps the finial of the chair arm. Her right hand, in contrast, is grossly exaggerated in size and contour, often taking the threatening shape of a claw.

Picasso would continue his study of Gilot in the medium of lithography until their relationship ended in 1953, but these portrait busts were much more conventional in their depiction of the sitter and much less experimental than this work in their mark making, perhaps a reflection of the ever-increasing distance from which the artist observed his subject.

— **Jennifer R. Gross**

1. See Arts Council of Great Britain, *Picasso: Fifty Years of Graphic Art*, exh. cat. (London: Arts Council of Great Britain, 1956), 31. For a discussion of the Cranach series, see cat. no. 23.

2. Françoise Gilot with Carlton Lake, *Life with Picasso* (New York: Anchor Books, 1964), 216. Gilot writes, "He had brought me a coat from Poland. It was brown leather decorated with peasant embroidery in red, blue, and yellow and was lined with black sheep's wool."

3. Tim Hilton, *Picasso* (London: Thames and Hudson, 1975), 201.

25
Corps perdu (Lost Body)
Aimé Césaire

Book, with 20 engravings,
10 aquatints, and 2 etchings by
Picasso, 15⁹/₁₆ x 11⁵/₁₆ in.
(39.5 x 28.7 cm)
Published by Éditions Fragrance,
Paris, 1950
Printed by Pierre Bouchet
for typography; Roger Lacourière,
Paris, for prints
Edition 220
INSCRIPTIONS: on colophon:
Picasso [and] *A. Cesaire*
REFERENCES: Cramer 56;
Baer IV, 840–70
Gift of John Hay Whitney, Beinecke
Rare Book and Manuscript Library,
Yale University

Picasso's illustrations for *Corps perdu*, a book of ten poems describing the search for black selfhood by the Martinican poet-philosopher and anticolonialist Aimé Césaire, were undertaken in the spring and early summer of 1949, after the two men had come to know each other in late 1947 through the Parisian gallerist Pierre Loeb. Césaire was by then known among Surrealist circles through his friendships with André Breton and Wifredo Lam, but particularly through his most famous poem, "Cahier d'un retour au pays natal" (Notes from a Return to the Native Land), published in France in 1939, which introduced his concept of negritude. According to a letter of October 20, 1947, from Césaire to Picasso and now in the archives of the Musée Picasso, Paris, Picasso had first accepted a commission, from Césaire via Loeb, to create a monument in memory of the abolition of slavery for Martinique, though the project was never realized.[1] Césaire had been elected mayor of Fort-de-France, Martinique, in 1945, a position he held until 2001, with the exception of 1983–84 (Césaire died in April 2008). Césaire and Picasso were also active members in the Communist Party in the immediate postwar years, and in August 1948 both participated in the World Congress

Picasso, aquatint for "Mot" (Word) in *Corps perdu*

of Intellectuals for Peace in Wrocław, organized by the Franco-Polish committee, where they were among 370 participants who signed an anticolonialist manifesto. Soon after the Congress, Césaire wrote to Picasso on October 14, communicating "tout ma joie à l'idée que vous illustrerez mes poèmes. De tout coeur, merci" (my joy at the idea that you will illustrate my poems. With all my heart, thank you).[2]

Picasso's collaboration with Césaire soon after the Communist peace conference signals a little-studied but nevertheless key instance in the intersection of art, politics, and literature in his work. Picasso's experience in Poland had been an impetus for his *Woman in an Armchair* series of lithographs, begun in the months after his return to France in September 1948, in which Françoise Gilot, clad in an ornate coat from Poland, is transformed into a Baroque-era aristocrat (see cat. no. 24). Certainly in the months following the conference, at which Picasso spoke out about the release of Pablo Neruda, a victim of persecution in Chile, the two men's shared commitment to a radical vision of creativity and the liberation of language, in art and in poetry, would be at the forefront of their minds and work. In *Corps perdu*, a brooding, somber late work in which Césaire revises his conception of

FIGURE I

Wifredo Lam, *The Jungle*

1943

Gouache on paper, mounted on canvas

7 ft. 10 in. x 7 ft. 6½ in.

(238.6 x 229.9 cm)

Inter-American Fund, Museum of

Modern Art, New York, 140.1945

negritude, the poet evokes mythological forces that are continually coming under attack—by eruptions of madness, or moments of abrupt violence, as in the poem "Au large." Themes of metamorphosis in Césaire's poems undoubtedly appealed to Picasso, who now no longer described the far-off world of the ancient poet Ovid (cat. no. 13) but that of a contemporary, defining his place in a turbulent postwar world.

Picasso's illustrations follow suit, and in contrast to the Ovid, which look to classical line drawing for their formal starting point, here Picasso appropriates the innovative style of a fellow painter. His twenty burin engravings of plants, bugs, crescent moon, and flowerlike figures are indebted to the Cubo-Surrealist work of Lam, whose spectacular painting from earlier in the decade, *The Jungle* (fig. 1), features many of these forms, as Herma Goeppert-Frank notes.[3] Picasso abstracts from Lam, however, and inflates his heads, bugs, and flower figures so that they engage every square inch of the sheet. As a contrast, Picasso's aquatints for the publication, such as his frontispiece for the poem "Mot," use framing to point inward, to Césaire's short, elegant titles. For about half the prints Picasso drew a rectangular internal frame around the image (or an abbreviation in the form of a line along one edge), to reiterate this awareness of the page itself, and the space within. While in Picasso's earlier Ovid drawings this strategy of the internal frame created a sense of containment, here it calls attention to the pumped-up expansiveness of the forms, and the spaciousness of the paper around them. Picasso evokes a burgeoning natural world, one that is central to Césaire's poetry.

Picasso, etching and drypoint in
Corps perdu

While the two men appear to have ceased correspondence after the project, on the occasion of Picasso's eightieth birthday in 1961, Césaire wrote on behalf of himself and his wife, Suzanne:

> *On the occasion of your birthday we embrace you and send warm wishes from both of us and from countless people of color across the world who you helped make visible to themselves.*[4]

— **Susan Greenberg Fisher**

1. For their correspondence, see Laurence Madeline, ed., *"On est ce que l'on garde!"*: *Les archives de Picasso* (Paris: Éditions des Musées Nationaux, 2003), 221. On their relationship, see also Annette Smith and Clayton Eshleman's introduction to Braziller's translation and later publication, *Lost Body (Corps Perdu)* (New York: Georges Braziller, 1986), vii–xxvii. The above discussion is indebted to their

engaging overview of Césaire's life and work.

2. Letter, October 14, 1998, cited in Madeline, *"On est ce que l'on garde!,"* 221.

3. Cramer 56.

4. Author's translation. Telegram, October 28, 1961, cited in Madeline, *"On est ce que l'on garde!,"* 221.

De mémoire d'homme (In Living Memory)

Tristan Tzara

Book, with 9 lithographs by Picasso,
13 x 10 in. (33 x 25.4 cm)
Published by Bordas, Paris, 1950
Printed by G. Girard, Paris, for text
and typography; Mourlot Frères,
Paris, for lithographs
Edition 350
REFERENCES: Mourlot III, 187;
Cramer 59
Yale University Art Gallery, The
Ernest C. Steefel Collection of
Graphic Art, Gift of Ernest C.
Steefel, 1958.52.170

In 1949 Tristan Tzara wrote to Picasso, asking if he would contribute illustrations to his recently completed book-length poem, *De mémoire d'homme*. Tzara had founded the Dada movement in Zurich in 1916 and was subsequently close with the Surrealists. During World War II, he became increasingly politically active, and joined the French Resistance and the Communist Party in 1947. The poems of *De mémoire d'homme* reflect the pensive, lyrical orientation of this later period.

In his 1949 letter to Picasso, Tzara proposed several images that would correspond thematically to the four parts of his poem: "Le temps détruit," "Le déserteur," "La boeuf sur la langue," and "Le poids du monde." Picasso agreed to illustrate the book but disregarded Tzara's suggestions, instead elaborating a whimsical flora-and-fauna theme across the book's title page and eight single-page lithographs. All nine lithographs were executed on April 16, 1950, the same day that Picasso completed the cover for Fernand Mourlot's second volume of *Picasso lithographe* (fig. 2). In both projects, the artist experimented with a new technique, using his finger as a painting instrument rather than a lithographic brush. In his cover for Mourlot's first volume of lithographs (fig. 1) a year earlier, he had achieved a similar spotlike effect with the tip of a lithographic brush. In the April 16, 1950, lithographs, Picasso created this *tache* by applying his finger directly to the lithographic stone.

In French art, the word *tache* (blot, spot, or stain) is closely linked with Tachisme, a variant of Art Informel, the European counterpart to Abstract Expressionism. Tachisme is gestural abstraction: it privileges spontaneity and the expressive mark, the speed of painting often registered in the drips, spots, and scribbles of a rapidly moving brush. In Paris, Art Informel had been shown since shortly after the war in exhibitions such as *L'imaginaire* of 1947, in which Picasso himself contributed works. The term *Art Informel* began to be used in 1950, and *Tachisme* was coined a year later.[1] In the United States, Abstract Expressionism received wide-scale attention around the same time. In 1949, *Life* magazine asked if Jackson Pollock was "the greatest living painter" in the country. In 1950 his *Number 1A, 1948* (fig. 3), with its repeated imprint of the artist's hand, was prominently displayed at the Venice Biennale. The same year, Pollock joined the group of Abstract Expressionists dubbed "The Irascibles" in signing an open letter of protest against the conservative policies of the Metropolitan Museum of Art.

Though Picasso was largely removed from such debates, his increasingly sacrosanct stature as the master of twentieth-century art made him a symbol for younger American painters: he represented both "the old" and a formidable obstacle to be overcome. Grace Hartigan, whose 1950 painting *The King Is Dead* (Snite Museum of Art, University of Notre Dame, South Bend, Ind.) metaphorically invokes Picasso's "dethroning," once recalled that Pollock said he was out to "kill Picasso."[2] Picasso's own antipathy to Tachisme and Abstract Expressionism, meanwhile, was well known. In a 1957 review of Picasso's work, the American critic Clement Greenberg cited

12

te souviens-tu — c'est à moi que je parle
si je parle ce n'est pas dit ce n'est ni bien ni mal
mais il y avait toujours pour l'œil une bonne parole
un grattement d'oiseau sur la joue fine
pourquoi dès lors de tous les grincements d'apocalypse
choisir le mot amer coupant le pont derrière lui
j'étais celui pour qui est dit que seul dans la solitude
grandit le blé de la douleur
et la douleur voyait sa face meurtrie
sous le signe des prairies
ô cœur saisi entre bien d'autres
et la mer toujours plus belle à se moquer de l'avenir
soleil en tête mille oiseaux et les palmiers
les sabres palpitants de leur langage
jouant à pile ou face la lumière et le savoir

"Le temps détruit" (Time Destroyed) in *De mémoire d'homme* with Picasso's lithograph

FIGURE 1

Picasso, cover from Fernand Mourlot's *Picasso lithographe I*
Published by André Sauret/Éditions du Livre, Monte-Carlo, 1949
12 ⁹⁄₁₆ x 20⅛ in. (31.9 x 51.2 cm)
Yale University Art Gallery, 1983.1.24

FIGURE 2

Picasso, cover from Fernand Mourlot's *Picasso lithographe II*
Published by André Sauret/Éditions du Livre, Monte-Carlo, 1950
12 ⁹⁄₁₆ x 20¼ in. (31.9 x 51.4 cm)
Yale University Art Gallery, 1983.1.25

a *Times* magazine article about the artist: "He believes a work should be constructed, is distressed by the work of many abstract expressionists, once grabbed an ink-stained blotter, shoved it at a visitor and snapped 'Jackson Pollock!'"[3] Other critics have read a humorous critique of gestural abstraction in drawings such as Picasso's *Painter and Model* (private collection, Switzerland) from December 24, 1953, in which the scribbled marks on the painter's canvas bear no relation to the model standing behind him.[4] In Picasso's lithographs for *De memoire d'homme*, however, one can detect a more subtle critique registered at the level of the lithographic mark.

In the nine lithographs for Tzara's book, Picasso limited himself to three types of mark making: the fingerprint or spot, the line "painted" with the finger, and the line drawn in lithographic chalk. The indexical mark of the finger is made first, creating the basic compositional structure. Lithographic chalk is applied afterward, defining and anchoring the developing form. The

FIGURE 3
Jackson Pollock, *Number 1A, 1948*
1948
Oil and enamel on unprimed canvas
68 in. x 8 ft. 8 in. (172.7 x 264.2 cm)
Purchase, Museum of Modern Art, New
York, 77.1950

FIGURE 4
Guillaume Apollinaire, "Il pleut"
(It's Raining), from *Calligrammes*
Published by Mercure de France, Paris,
1918
Beinecke Rare Book and Manuscript
Library, Yale University

reduced formal and iconographic vocabulary of the lithographs showcases Picasso's ability to coax limited means into widely creative application. On one page, his fingerprints form a sprig of berries; on the page for "Le temps détruit," spots of a butterfly; on another, the wings of a praying mantis, and so on. By concentrating on three basic mark-making units, moreover, Picasso draws a direct analogy between the written and pictorial mark: just as words are created from a finite repertoire of letters, Picasso's illustrations are created from a finite repertoire of marks. The illustrations revisit the classical doctrine of *ut pictura poesis* ("as in painting so in poetry") on the level of syntax. In these works, painting (or in this case, lithography) is like poetry not because it shares a similar content, but because it is a language, a means of communication whose very expressivity derives from the combination of conventional signs.

But Picasso, never content with mere parity between the "sister arts," also used the classic Surrealist strategy of axial shift as a tool of pictorial one-upmanship.[5] In the second lithograph of the first poem, "Le temps détruit," the peculiar "snowman" figure beneath the tree is transformed into a butterfly when one views the page from the horizontal. This move to the horizontal requires an axial shift of the entire book, resulting in a new pictorial reading but also creating a fundamental textual deformation, as images are legible in multiple orientations, but text only in one. The axial shift has the further effect of not only making the text illegible but turning it into an image. Viewed on the horizontal, Tzara's poem resembles a rain cloud, an inadvertent calligram appropriated for Picasso's pictorial aims. In so doing, the two-page spread makes a literary reference to Guillaume Apollinaire's calligrams, such

IL PLEUT

Il pleut des voix de femmes comme si elles étaient mortes même dans le souvenir

c'est vous aussi qu'il pleut merveilleuses rencontres de ma vie ô gouttelettes

et ces nuages cabrés se prennent à hennir tout un univers de villes auriculaires

écoute s'il pleut tandis que le regret et le dédain pleurent une ancienne musique

écoute tomber les liens qui te retiennent en haut et en bas

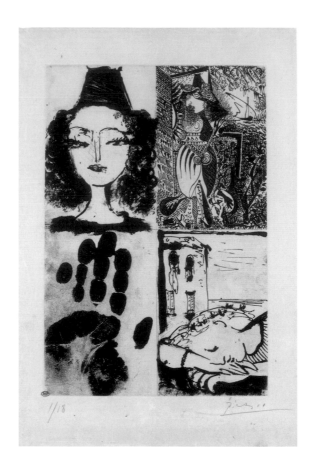

as "Il pleut" (fig. 4), written in 1914 and first published in the journal *SIC*
in 1916, through purely visual means.

By demonstrating the painterly *tache* as a unit of language, Picasso's
lithographs undermine a central tenet of Tachisme and Abstract Expression-
ism: the spontaneous authenticity of the gestural mark. Particularly in early
gestural abstraction, the painterly trace was treated as a registration of the
artist's interior self, an equation reminiscent of Surrealist automatic drawing.
But as Picasso himself acknowledged, "That was a bit of a joke . . . because
when you want to be completely automatic, you never can be."[6] Indeed,
between 1948 and 1950, Informel painting experienced an art-historical shift,
wherein the "pure" expression of the automatic mark began to be codified
into a series of signature styles. Picasso's lithographs comment on this shift
from the "automatic to the autographic" by revealing the gestural mark as
a combination of conventional signs and, further, by literalizing "the auto-
graphic" in the imprint of the artist's hand.[7] As in a lithographic proof for
Paul Éluard's *La barre d'appui* of 1936 (fig. 5), which contains an imprint of
Picasso's drawing hand, Picasso's fingerprints in *De mémoire d'homme* function
as a double signature.[8] They assert the primacy of the artistic self through the
reproductive medium of print, thereby revealing this self as the product of its
own repetition.

— Irene Small

1. The French art critic Michel Tapié first used the term *Art Informel* in 1950; he elaborated on the style in his 1952 book *Un art autre où il s'agit de nouveaux dévidages du réel* (Paris: Gabriel-Giraud et Fils, 1952). The exhibition *L'imaginaire* took place at the Galerie Luxembourg in Paris and included Jean Arp, Hans Hartung, Georges Mathieu, Picasso, Otto Wols, and others.

2. Quoted in Kirk Varnedoe with Pepe Karmel, "Comet: Jackson Pollock's Life and Work," in *Jackson Pollock*, ed. Varnedoe, exh. cat. (New York: Museum of Modern Art, 1998), 59. For more on the relationship between Pollock and Picasso, see also Michael FitzGerald, *Picasso and American Art*, exh. cat. (New York: Whitney Museum of American Art, 2007).

3. Clement Greenberg, "Picasso at Seventy-Five," *Arts Magazine* (October 1957); revised in John O'Brian, ed., *Clement Greenberg: The Collected Essays and Criticism* (Chicago: University of Chicago Press, 1986–93), 4:35.

4. See, for example, Karen L. Kleinfelder, *The Artist, His Model, Her Image, His Gaze: Picasso's Pursuit of the Model* (Chicago: University of Chicago Press, 1993), 137–38.

5. On the use of axial shift in Surrealism, see Rosalind Krauss, "No More Play," in *The Originality of the Avant-Garde and Other Modernist Myths* (Cambridge: MIT Press, 1986); and Krauss, "Horizontality," in *Formless: A User's Guide*, ed. Krauss and Yve-Alain Bois (Cambridge: Zone Books, 1997).

6. As cited by Françoise Gilot in Gilot with Carlton Lake, *Life with Picasso* (New York: Doubleday, 1964), 270.

7. On the shift from the "automatic to the autographic," see the entry "1947b" in Hal Foster et al., *Art since 1900: Modernism, Antimodernism, Postmodernism* (New York: Thames and Hudson, 2004).

8. Picasso's 1934 handprint on the plate for *La barre d'appui* may also be related to an article that appeared two years earlier in the Surrealist journal *Minotaure*, "Les révélations psychiques de la main," *Minotaure*, no. 6 (December 1934): 38–44, which reproduced (with handprint analysis) the handprints of André Breton, André Derain, Marcel Duchamp, Paul Éluard, André Gide, Aldous Huxley, Maurice Ravel, and Antoine de Saint-Exupéry. Brassaï, in his 1964 book *Conversations avec Picasso* (Chicago: University of Chicago Press, 1999), also noted that Picasso made several casts of his left and right hands. Describing a series of sculptures Picasso unpacked from crates on May 5, 1944, the photographer wrote, "I am struck by the novelty of these plastic experiments. Picasso has done no more than contrive encounters with familiar materials and structures, assigning them new meanings and new destinies. The artist's hand—the sculptor's thumb—modeling the clay and leaving its imprint in it is totally absent. Without intervening directly, he let his figures model themselves, denying his own hand. . . . But curiously, I find this eliminated, prohibited hand as subject and as object in many casts and impressions, as if Picasso had shifted to his hands the attention he once granted to his face. With his left hand, he had made a whole series of charcoal sketches, gouaches, and pastel drawings 'from nature' about twenty years earlier. Here, he pressed them into fresh plaster and made casts, a closed fist at the end of a strong wrist, as if he wanted to seize all its concentrated power. I also see a cast of his right hand. . . . It stands alone and autonomous, a monument of supreme potency, equilibrium: fleshy palm, Mount Venus sensually jutting out, willful thumb, fingers pressed tight against one another, preventing any light from passing between them" (186).

PORTRAIT D L'AUTEUR

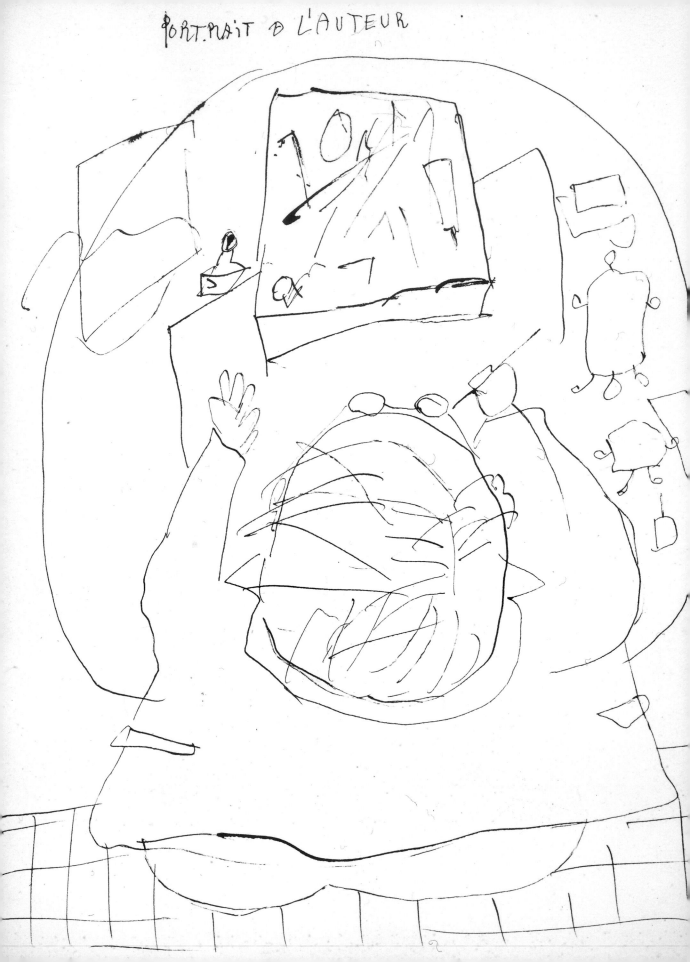

MARY ANN CAWS

Writing Picasso

OF COURSE IT WAS BOUND TO BE. Inescapable. The world's most famous artist was bound to be endlessly pounced upon as a topic, subject, icon of modernism. His writings as well as his paintings elicited, and elicit, the kind of reverence that only such past painters as Diego Velázquez and Rembrandt aroused. Which would certainly not have displeased Picasso—he very much wanted to be compared to that other Spanish painter, Velázquez.

Myself, Picasso; *Yo, Picasso* (he was young, but then, he was always young). And by not a very long stretch of the imagination, his attachment to the idea of works in series seems to me related to this valuing of the self as object, as an object in differing states and set at different angles for his own perusal. He would do a *Picnic on the Grass*, his own and not his own, and do it repeatedly, always slightly differently—like so many ways of self-multiplication, the artist as his own text not just for others, but for himself— a kind of self-celebrating we don't so often recognize in other painters. Goya did this, these horrors of war? Me too, says Picasso: Look at *Guernica*. Manet did this outdoor luncheon? Me too. What a picnic! Like Lee Miller's photograph of a glorious picnic with all of us there: Paul and Nusch and Man Ray and Ady and Dora and me. Pretty nice. In every case, what they did, I can do just as well, probably better.

The proliferation of studies of the artist and the model, the artist in his studio, the artist as minotaur—of course all of this is self-modeling, and this self-perception haunts all the rest of the work, and our relation to it and to the icon of modernism who was and is Picasso. Picasso as classicism reborn, Picasso as the founder of Cubism, Picasso semi-Surrealist, and on and on. *Le mystère Picasso*, certainly. He likes to participate in that mystery, to be the enactment of it. Picasso as actor of Picasso.

Witness all the furthering of the self-mystery by those profiles that don't say it all, those curtains that might hide something, or then not, the words beginning thoughts not spelled out. Picasso always leaves room for the imagination, his and ours. He leaves space for all his critics, and enjoys playing in it. He and his critics, all of us, are complicit in the act.

But looking again, what seems striking in this moment of writing somehow turns out to be the intense emotional drive behind the concentration on death (*Le chant des morts* of Reverdy, cat. no. 20), on the importance of human memory (*De mémoire d'homme* of Tzara, cat. no. 26), on the

203

joyousness of being able to put together text and drawing. Picasso's effusiveness about certain lines and structures and their extension into series is only equaled by his enthusiasm for friends and the communication with them over the years. To the crucial and lifelong importance of this relation of self to others there are endless witnesses: all those cafés and portraits and celebrations of common moments. Picasso's language is the language of relation.

What Michel Leiris says of Picasso's Balzacs (cat. no. 28) and of the painter behind and in them, having become himself, his name in lowercase letters like any familiar object, no longer having to be singled out in uppercase letters, is at once true, moving, and itself as familiar to us as is Picasso, our picasso. The passage passes without commentary:

> *Between the Pablo Picasso working tirelessly and the Picasso framed well or dreadfully to be hung on a wall, between the Picasso as a friend and the object "Picasso" who could do without his capital letter (like the little picasso breads sold by some Provençal bakers) there's an abyss that the critic has to traverse. . . .*
>
> *Neither men nor books nor fictions, these Balzacs of Picasso aren't reflections of the real Balzac but Balzacs of a fourth species . . . living people you might cross on the street. . . .*
>
> *But these lower-case balzacs, less passers-by than ordinary objects (like a landscape or a still-life), . . . have no place in the scenario of any drama or comedy. Balzacs whose tribulations are only their lines. Balzacs without any episodic continuity, the contrary of all those acrobats, minotaurs, and disemboweled horses whose legendary stories are easily reconstituted. Balzacs who don't need to stride across the stages of history or mythology. Balzacs whose only prestigious adventure is that of existing as what they are and something else than what they are and, each time, being and not being this in a different way: these are Picasso's* Honoré de Balzac, *in other words, balzacs who are picassos at the same time, picassos, that is, just as one is a Stradivarius, a Waterman, a Citroën or a Miura, along with being just balzacs as one is thomas . . . balzacs just as there are basins, marbles, gods, vases, and begonias.*[1]

1. Author's translation. Michel Leiris, *balzacs en bas de casse et picassos sans majuscule* (Paris: Galerie Louise Leiris, 1957), n.p.

Study of Profiles

December 8, 1948
Lithograph, 30 x 22¼ in.
(76.2 x 56.5 cm)
Edition 50
INSCRIPTIONS: lower right: *Picasso*
REFERENCES: Mourlot II, 132
Yale University Art Gallery,
Gift of Mr. and Mrs. Walter Bareiss,
B.S. 1940S, 1969.60.12

Picasso's *Study of Profiles* takes part in the chatty, semiautomatic character of a sketchbook. Consisting of a series of faces overlapping in a shallow frieze, the sheet treats the profile as a basic module for variation and experimentation. Shaded, caricatured faces clustered along the bottom give way to abstracted, linear delineations toward the top. The entire group forms a latticed graphic block stretching from the punctuated eye at lower left to its wide-open counterpart at upper right. These floating eyes anchor a diagonal carried by the slopes of the profiles' noses, each outline defining shape from space, figure from provisional ground. Unlike the serial portraits Picasso would make of Balzac four years later (cat. no. 28), these versions and variations share the same physical space, their profiles encroaching one upon another.

In *Study of Profiles*, Picasso does not explore the formal distortion of a single figure or figural group, but rather how the sheer repetition of a pictorial unit begins to unhinge its stability and internal coherence. Repetition leads to abstraction, like saying a word over and over again, as does a character in Picasso's second play, *Les quatre petites filles* (The Four Little Girls), also of 1948. As the fourth *jeune fille* pronounces at the end of act 1, "The blue, the blue, the azure, the blue, the blue of the white, the blue of the rose, lilac blue, the blue of yellow, the blue of red, the blue of lemon, the blue orange, the blue that oozes from blue and the white blue, and the red blue and the blue of the palms from the lemon blue of white doves, to the jasmine in the fields of oats, in great almond emerald green songs."[1] The stream-of-conscious, one-thing-after-another syntax of this passage has its counterpart in the quick succession of profiles in the *Study*, the slant of one forehead giving way to the angled lobe of an ear, an eye bleeding into a mouth, a jowl turning into a chin.

This casual, improvisational aspect gives *Study of Profiles* the quality of a preliminary study or even a doodle. Yet its size, monumental for a print, lends it a formality distinct from the sketchbook or journal. Picasso's lithograph has something of the manifesto-like pronouncement of William Hogarth's 1743 etching *Characters and Caricaturas* (fig. 1), with its gaggle of profiles crowded upon the page. In this sheet, Hogarth sought to distinguish the subtly expressive pictorial humor of his own work, which he defined as "character," from the gross exaggerations of "caricature," which creates "monsters, not men."[2] In antithesis to Leonardo da Vinci's and Ludovico Carraci's imaginary grotesques, pictured at lower right, Hogarth offered Raphael's portraits at lower left as the appropriate model for the phalanx of "characters" in the upper section of the page.

Picasso's *Study of Profiles* strays far from the realist description that concerned Hogarth. Yet it too cites caricature in order to depart from it. Formally, caricature is a genre that schematizes description: it creates a non-mimetic likeness through abstraction, exaggeration, and distortion. Precisely for this reason, scholars have often noted its affinities to modern art.[3] Adam

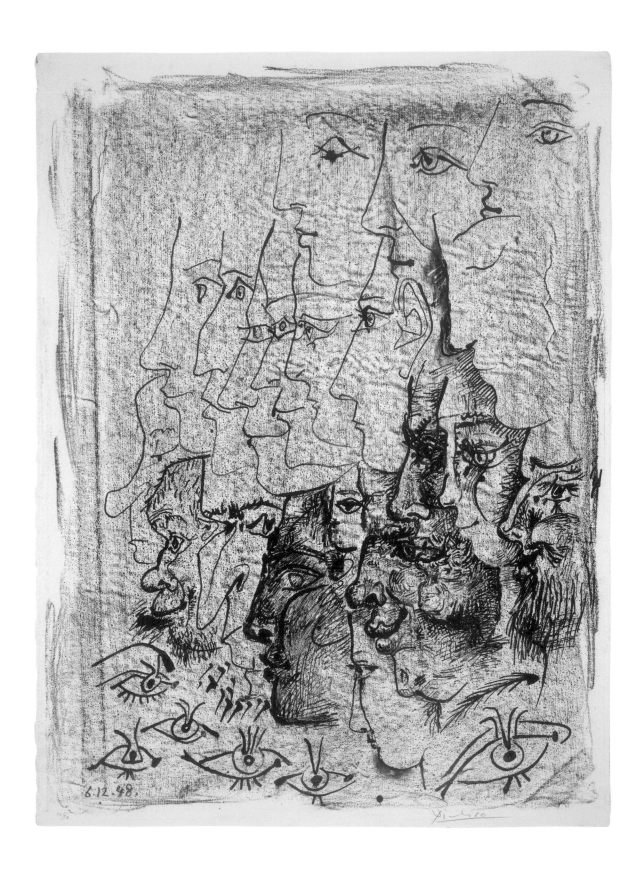

6.12.48.

FIGURE 1

William Hogarth, *Characters and Caricaturas*, subscription ticket for *Marriage à la Mode*

1743
Etching
11⅛ x 9½ in. (28.3 x 24.1 cm)
Yale Center for British Art,
Gift of Chauncey B. Tinker, B.A. 1899,
B1994.4.1138

FIGURE 2

Picasso, *Portrait of André Salmon*

1907
Charcoal
23⅝ x 15¾ in. (60 x 40 cm)
Musée Picasso, Paris, M.P. 2000–2 (recto)

Gopnik, for example, has argued for a direct link between caricature and Picasso's experiments with primitivism, a relation key to the fractured and simplified forms of early Cubism.[4] In studies such as his 1907 *Portrait of André Salmon* (fig. 2), Picasso hybridized the visual languages of primitivism, caricature, and high art portraiture, thereby throwing into relief the representational conventions of each. For this reason, Gopnik writes, "Caricature is in embryo what the Cubist syntax brought to maturity: a working representational code that comments on the way representational codes work."[5] And yet while Cubism revealed the operations of such representational codes, it also inaugurated a new "style" prey to its own orthodoxies and imitations. The 1948 *Study* reverses this process of stylistic condensation, atomizing any sense of a discrete visual code into multiple, coexisting stylistic possibilities. If anything is caricatured in *Study of Profiles*, it is not physiognomy but the concept of style itself.[6]

– Irene Small

1. Pablo Picasso, *The Four Little Girls*, trans. Roland Penrose (London: Calder and Boyers, 1970), 34; originally published as *Les quatre petites filles* (Paris: Gallimard, 1949).

2. In the etching, Hogarth refers the viewer to the preface of Henry Fielding's novel *Joseph Andrews* (1742), in which Fielding praises Hogarth for his comic, rather than burlesque, or caricatural, visual humor: "He who should call the ingenious Hogarth a burlesque painter, would, in my opinion, do

him very little honour; for sure it is much easier, much less the subject of admiration, to paint a man with a nose, or any other feature of a preposterous size, or to expose him in some absurd or monstrous attitude, than to express the affections of men on canvas. It hath been thought a vast commendation of a painter to say his figures *seem to breathe*; but surely it is a much greater and nobler applause, *that they appear to think*"; *The History of the Adventures of Joseph Andrews and of His Friend Mr. Abraham Adams* (New York: Rinehart, 1959), xx.

3. In *Caricature from Leonardo to Picasso* (New York: Crown, 1957), for example, Werner Hofmann wrote that caricature is "the first step in a series of 'symptomatic' metamorphoses, a protest against Art with a capital 'A' and against the principle of individual styles." Ernst Gombrich has also made numerous references to caricature in his writings. See also Valeriano Bozal et al., *Picasso: From Caricature to Metamorphosis of*

Style, exh. cat. (Burlington, Vt.: Lund Humphries, 2003).

4. Adam Gopnik, "High and Low: Caricature, Primitivism, and the Cubist Portrait," *Art Journal* 43, no. 4 (winter 1983): 371–76. See also "Caricature," in Adam Gopnik and Kirk Varnedoe, *High and Low: Modern Art and Popular Culture*, exh. cat. (New York: Museum of Modern Art, 1993).

5. Gopnik, "High and Low," 373.

6. On stylistic pastiche in Picasso's work, see in particular Rosalind Krauss, *The Picasso Papers* (New York: Farrar, Straus, and Giroux, 1998). The authors are also grateful for the insights of Betsy Scherzer, who draws from Krauss's analysis in her paper "Étude de Profils: Profiling Picasso's Stylistic Motivations," completed for Susan Greenberg Fisher's fall 2006 modernism seminar at Yale University; copy in departmental files, Department of Modern and Contemporary Art, Yale University Art Gallery.

28

balzacs en bas de casse et picassos sans majuscule (balzacs in lowercase and picassos without capitals)

Michel Leiris

1952
Portfolio, with 8 transfer lithographs
by Picasso, 13½ x 10¼ in.
(34.3 x 26 cm)
Published by Galerie Louise Leiris,
Paris, 1957
Printed by Imprimerie Union, Paris,
for text and typography; Mourlot
Frères, Paris, for lithographs
Edition 100
INSCRIPTIONS: on colophon: *Picasso*
REFERENCES: Mourlot III, 217–24;
Cramer 86
Yale University Art Gallery, The
Ernest C. Steefel Collection of
Graphic Art, Gift of Ernest C.
Steefel, 1958.52.174

In the fall of 1952, the publisher André Sauret asked Picasso, via the lithographer Fernand Mourlot, for a portrait of Honoré de Balzac for the frontispiece of a new edition of *Le père Goriot*, perhaps the most famous of the novels and stories that comprise the writer's sprawling masterpiece *La comédie humaine*. Picasso complied, and on November 25 made a series of eleven portraits, the second of which was chosen to illustrate the proposed edition. Four years later, the Surrealist writer Michel Leiris published eight of these portraits through his wife's Paris gallery, Galerie Louise Leiris.[1] Michel Leiris met Picasso in 1923; the Galerie Louise Leiris, meanwhile, was directed by Picasso's longtime dealer, Daniel-Henry Kahnweiler, who had transferred the gallery to his stepdaughter's name in order to avoid possible confiscation of works during the war.[2] The Balzac portraits, accompanied by an essay by Leiris, were released in an edition of one hundred in February 1957 shortly before a large exhibition of recent paintings opened at the gallery in March, followed by the Museum of Modern Art's *Picasso: Seventy-fifth Anniversary Exhibition* in New York in May.

These details are not in themselves extraordinary. Over the years, Picasso made dozens of frontispiece author portraits, from his Cubist rendering of Guillaume Apollinaire (fig. 1) to his neoclassical André Breton for Breton's 1923 *Clair de terre* (Caws, "The Surrealist Impulse," fig. 2) to his own (self) portrait, coyly titled *Portrait of the Author* (fig. 2), for *Le désir attrapé par la queue*. Neither was Picasso's working method for the

FIGURE I
Picasso, *Portrait of Guillaume Apollinaire*, frontispiece from Apollinaire's *Alcools: poèmes (1898–1913)*
Published by Mercure de France, Paris, 1913
Beinecke Rare Book and Manuscript Library, Yale University

Plate I

Plate III

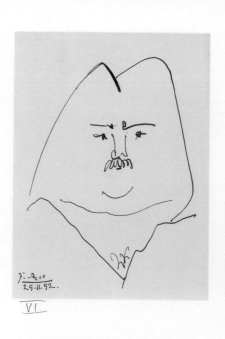

Plate VI

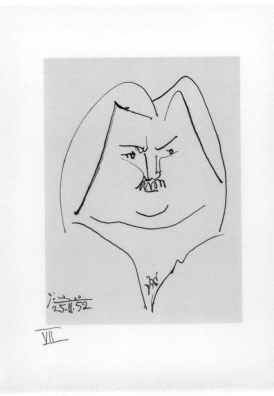

Plate VII

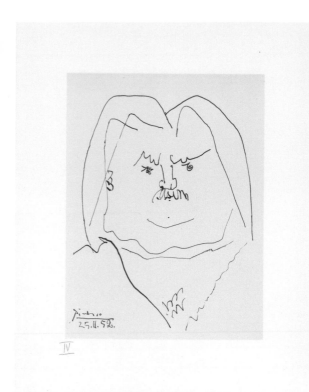

Plate IV

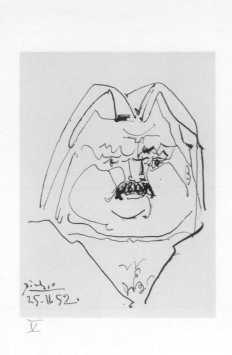

Plate V

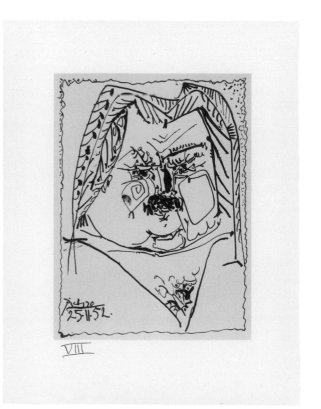

Plate VIII

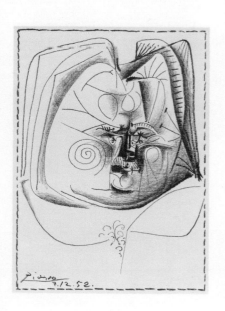

Unnumbered plate

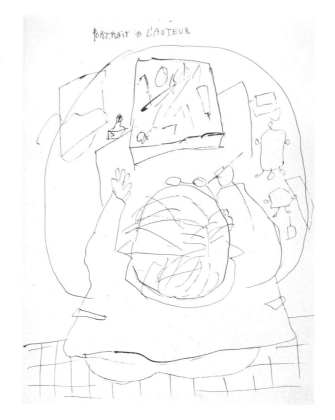

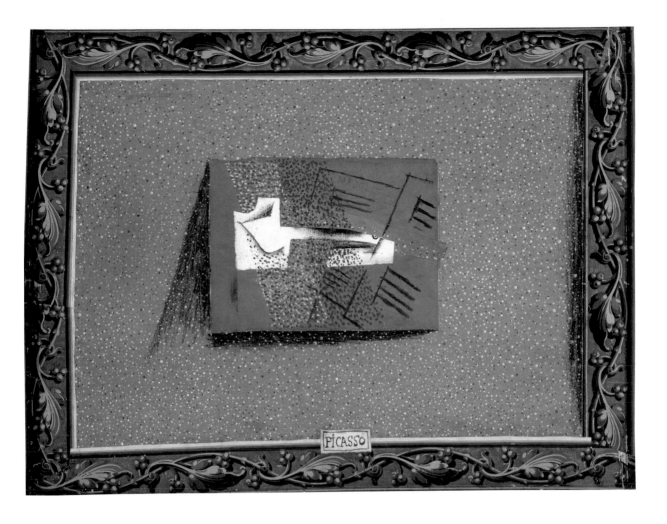

FIGURE 4
Picasso, *Pipe and Sheet Music*
Paris, spring 1914
Gouache and graphite on pasted papers
20¼ x 26¼ in. (51.4 x 66.6 cm)
The Museum of Fine Arts, Houston,
Gift of Mr. and Mrs. Maurice McAshan

Balzac portraits unusual. In preparation for paintings and even significant prints, Picasso often made multiple renderings of his subject. Sometimes, as in his obsessive preliminary drawings for major paintings such as *Les demoiselles d'Avignon* (cat. no. 3, fig. 5) or *Guernica* (1937, Museo Nacional Centro de Arte Reina Sofía, Madrid), these variations worked through formal and narrative possibilities subsequently resolved in the final work. As posterior sketches for *Demoiselles* demonstrate, however, any such "resolution" did not necessarily involve a termination of the creative process. Sometimes the process of modification generated its own pictorial narrative, as in the erotic sequences of the artist's 1961 sketchbooks inspired by Édouard Manet's *Déjeuner sur l'herbe* (1863, Musée d'Orsay, Paris).[3] And sometimes Picasso's variations amounted to inflections of, rather than alternatives to, a theme, as in the artist's lithographic portraits of Kahnweiler, completed on June 3, 1957, shortly after the previously mentioned gallery show (fig. 3).

And yet since Picasso's signature, if not simply the registration of his graphic mark, was enough to turn even the most ephemeral study into a work of art, these variations, versions, sketches, and reproductions were increasingly procured as certifiable "Picassos" in their own right. As early

FIGURE 5
Picasso, *Il neige au soleil*
(It's Snowing in the Sun)
January 10, 1934
India ink
10¼ x 12¾ in. (26 x 32.5 cm)
Musée Picasso, Paris, M.P. 1130

as 1914, Picasso commented on this feedback loop of production and reception in the trompe l'oeil nameplates of works such as *Pipe and Sheet Music* (fig. 4).[4] Here, the imitation museum tag acts as a substitute for Picasso's signature. Its faux frame, meanwhile, ironizes the work's transformation into an image of itself by virtue of the artist's proper name. Indeed, with Picasso's increasing fame, his signature became such a convention of genius that in 1930 the poet Robert Desnos wrote, "Certain of his pictures, marvelous because they are by him . . . would be indefensible if they were signed by another. . . . I always look at the signature of a picture, and most of the time, before looking at what it represents."[5] Leiris's 1957 edition, titled *balzacs en bas de casse et picassos sans majuscule*, is an engagement with this condition of serial originality. It thematizes artistic celebrity as an inevitable subjective trap.

Although seven of the eight portraits of the 1957 edition were numbered and completed on the same day, Picasso's Balzac lithographs do not constitute a progression or formal evolution. The Balzac of plate VIII is more graphically dense than that of plate VII, the former's webbed marks,

scalloped frame, and stylized facial line in marked contrast to the notational character of the latter, whose likeness is conveyed with a few terse strokes of the lithographic pen. Yet the Balzac of plate VI is a radically simplified version of that of plate III or IV, the writer's hair and face reduced to a single contour, his eyes to two rapid knots of tangled line. In their deliberate stylistic range and refusal of linear development, the eight lithographs amount to a composite portrait of Balzac as well as a pictorial pun on the literary "sketch." Like Balzac's works, which were published serially as well as in multiple revised and unfinished states, Picasso's portraits approach their subject through a series of unfolding descriptive acts.[6] These acts delineate the outlines of their subject through repetition and variation, their "narrative" formed by the nonhierarchical movement from one possibility to the next. They do not fix their subject but multiply it, offering up not Balzac, but balzacs.

In the lithographs, then, picturing is analogized to writing first in terms of creative process. By portraying not simply the object of description but the descriptive mode by which this object is known, Picasso's Balzacs throw into relief the act of making: its obsessive revision, its potentially endless iterations, its continual choice of this or of that. But the lithographs also analogize picturing and writing in terms of the graphic mark. The viewer is compelled not only to look, but to read and decipher. Letters and numbers proliferate in the portraits of Balzac: a V defines the writer's shirt; the letter M describes his various hairs, from those on his chest to those which frame his face, sit jauntily atop his lip, or furl his pensive brow; a 3 denoting an ear on the right in plate I is subtracted into a 2 in plate III, which then migrates, along with Picasso's signature and date, to the left in plate IV. As in the artist's eleven notebook variations of *Il neige au soleil* of 1934 (fig. 5), in which the letters of *neige au* shift from linguistic to mimetic units in the falling snowflakes of the O of *soleil*, the Balzac portraits place writing and drawing on a flexible graphological scale.[7] Rather than mutually exclusive practices of mark making, writing and drawing are employed as linked registers of a single graphic language distributed across the space of the page.

In so doing, Picasso's Balzacs exploit the limit at which a mark concretizes into a legible symbol, or, conversely, slips from conventional language into another realm of the graphic sign. Curiously, the artist's signature and date act as controls within the relational field formed by each lithographic sheet.[8] In plate VI, for example, the P of *Picasso* is repeated in the opening arabesque of the eyebrow on the right; in plate III, a 2 put to use as an ear also functions as a digit in the "1952" of the print's date. Signature and date—the most common irruptions of language within visual art—thus provide an instance of "actual" text against which "potential" signs scattered across the portrait can be compared.

Although composed of conventional linguistic units, however, a signature is also an icon, or auratic visual image, of the artist. It is proof of the

artist's presence, and its temporal registration is sealed by the work of art's date. At least in theory, a signature is indexical, nontransferable, and graphically unique. This is why each of the one hundred editions of *balzacs en bas de casse et picassos sans majuscule*, although clearly produced through the mechanical reproduction of print, was also signed individually by Picasso in ink. Yet the repetition of this signing, with its ceaseless inscribing of the self, induces another kind of mechanization. It releases the self as a series of objects, turning the proper name into a generic type. It is for precisely this reason that Leiris's title invokes the standardized settings—*bas de casse* and *majuscule*—of the typesetter's case, calling to mind not language written by hand but language impressed on a page through the mechanical repetition of metal stamping ink upon ground. It is, after all, in Picasso's signature—that most individual and idiosyncratic of graphological marks—that Picasso the automaton lurks, endlessly manufacturing himself.

By 1957, "Picasso" was an identity at once suspended and fractured in multiple parts. As Leiris observed in his essay for the portfolio, "Between the Pablo Picasso working tirelessly and the Picasso framed well or dreadfully to be hung on a wall, between the Picasso as a friend and the object 'Picasso' who could do without his capital letter (like the little picasso breads sold by some Provençal bakers) there's an abyss that the critic has to traverse." Thus, just as there is the "Balzac of the dictionary," the "novel Balzac," the "Balzac of an ensemble of sheets upon which this same novel is printed," and even the Balzac of the "series of rectangular objects" exhibited on a shelf, "Picasso" is not a singular entity but a proliferating effect. Products of a person, a system, a symbol, even a brand, the Balzac portraits reveal "Picasso" confronting "picasso" in the lowercase.

— Irene Small

1. Of the eleven portraits of November 25, eight were small and three large. The frontispiece for *Le père Goriot* was the second of the smaller series. On December 7, Picasso executed a twelfth portrait in lithographic chalk on transfer paper. The eight portraits of the 1957 Galerie Louise Leiris edition consist of the seven small portraits from November and the single portrait of December 7. Although Michel Leiris signed André Breton's 1924 Surrealist manifesto, he was closely associated with the dissident Surrealist Georges Bataille, with whom he would cofound the Collége de Sociologie in 1937. After World War II, Leiris was also associated with Jean-Paul Sartre's political and literary journal *Le temps moderne*.

2. Kahnweiler opened Galerie Kahnweiler in Paris in 1907. At the beginning of World War I, he was forced to leave the country because of his German citizenship; the French government, meanwhile, confiscated and sold works held by the gallery. Kahnweiler returned to Paris in 1920 and opened a new gallery with André Simon called Galerie Simon. During World War II, he was forced to leave France again, this time because he was Jewish. In order to prevent the confiscation of works, the gallery was transferred to Kahnweiler's stepdaughter, Louise Leiris, and renamed Galerie Louise Leiris. In March 1957 the gallery opened in new quarters with an exhibition of Picasso paintings from 1955 to 1956.

3. Rosalind Krauss has analyzed the quasi-mechanical, "flip-book" character of these sketchbooks in *The Optical Unconscious* (Cambridge, Mass.: MIT Press, 1993), arguing that Picasso traced the contours of one

drawing onto the next, thereby allowing for a handmade "reproduction" ready for subsequent modification.

4. Braque was the first to employ this particular trompe l'oeil technique. In contrast to this playful foregrounding of each artist's proper name, Picasso and Braque often left their early Cubist works unsigned. On Picasso's use of words and type during the Cubist period, see Robert Rosenblum, "Picasso and the Typography of Cubism," in *Picasso in Retrospect*, ed. Roland Penrose and John Golding (New York: Praeger, 1973), 65–73.

5. Author's translation. Robert Desnos, "Bonjour Monsieur Picasso" [1930], in *Écrits sur les peintres* (Paris: Flammarion, 1984), 130–31. Picasso's personal celebrity has strongly impacted art-historical writing on his work. In her essay "In the Name of Picasso," in *The Originality of the Avant-Garde and Other Modernist Myths* (Cambridge, Mass.: MIT Press, 1985), Rosalind Krauss criticizes the "art as autobiography" tendency within Picasso scholarship and links it to what she calls an "art history of a proper name" wherein pictorial signs are treated as conduits of identifiable meaning rather than formal elements operating within a differential semiotic field.

6. As Michel Leiris observed in his essay for this portfolio, "In the hands of Picasso, the Balzac of *The Human Comedy* multiplies as rapidly as the model of novels that constitute the aforementioned 'comedy.'" The authors are also grateful for the insights of Chris Winkler, who analyzed this work in his paper "Balzac and Picasso on Eight Yellow Pieces of Paper," written for Susan Greenberg Fisher's fall 2006 modernism seminar at Yale University; copy in the departmental files, Department of Modern and Contemporary Art, Yale University Art Gallery. Winkler noted that Picasso's sequence "is a conscious embodiment of the writer's system." He also noted that Picasso's letterlike shapes create a "linear language" of form. Picasso's graphic experimentation in the Balzac portraits continued in a series of portraits of his daughter Paloma created in India ink and lithographic crayon in December 1952. The solid, frontal character and webbed detailing of Paloma's face continue specific formal elements Picasso introduced in the last Balzac plate of the prior series.

7. In this series of India ink drawings, Picasso rewrote the words "Il neige au soleil" with varying calligraphic emphases. The black marks of the words eventually act as schematic notations for snow falling within the O of *soleil*. See Christine Piot, "Picasso and the Practice of Writing," in *Picasso, Collected Writings*, ed. Marie-Laure Bernadac (London: Aurum Press, 1989), 27–33; Louis Marin, "Picasso: Image Writing in Process," *October* 65 (summer 1993): 89–105; and Garret Stewart, *The Look of Reading: Book, Painting, Text* (Chicago: University of Chicago Press, 2006).

8. Kahnweiler was the first to suggest a link between Cubist works and what he called "scripts" or sign systems. Expanding on this insight, Rosalind Krauss and Yve-Alain Bois have shown how Cubism demonstrated that the painted or collaged picture is a relational field composed of differential signs, much like a language. See in particular Yve-Alain Bois, "Kahnweiler's Lesson," in *Painting as Model* (Cambridge, Mass.: MIT Press, 1990), 65–97. Picasso's exploration of "potential" signs in the Balzac lithographs also recalls Iliazd's *Poésie de mots inconnus* (cat. no. 22), to which he had contributed in 1949.

29
The Studio of the Old Painter

Vallauris, March 14, 1954
Lithograph, 19¾ x 26¹⁄₁₆ in.
(50.2 x 66.2 cm)
Edition 50
INSCRIPTIONS: lower right: *Picasso*
REFERENCES: Mourlot III, 260
Yale University Art Gallery, Gift of
Mr. and Mrs. Walter Bareiss,
B.S 1940S, 1969.60.4

30
The Two Models

Vallauris, March 18, 1954
Lithograph, 19¾ x 24¾ in.
(50.2 x 62.9 cm)
Edition 50
INSCRIPTIONS: lower left: *Picasso*
REFERENCES: Mourlot III, 253
Yale University Art Gallery, Gift of
Mr. and Mrs. Walter Bareiss,
B.S 1940S, 1969.60.8

31
Nude Pose

Vallauris, March 18, 1954
Lithograph, 21³⁄₈ x 14⁷⁄₈ in.
(54.3 x 37.8 cm)
Edition 50
INSCRIPTIONS: lower right: *Picasso*
REFERENCES: Mourlot III, 255
Yale University Art Gallery, Gift of
Mr. and Mrs. Walter Bareiss,
B.S 1940S, 1969.60.11

32
Two Nude Models

Vallauris, March 18, 1954
Lithograph, 22⁷⁄₈ x 15 in.
(58.1 x 38.1 cm)
Edition 50
INSCRIPTIONS: lower right: *Picasso*
REFERENCES: Mourlot III, 256
Yale University Art Gallery, Gift of
Mr. and Mrs. Walter Bareiss,
B.S 1940S, 1969.60.13

In 1952, Picasso's considerations of the great romantic writer Honoré de Balzac materialized in a set of eleven lithographs of the author's portrait, one of which became the frontispiece for an edition of *Le père Goriot*, Balzac's 1835 novel from the colossal *La comédie humaine* series (see cat. no. 28). Following his attention to the portraiture of a canonized author, Picasso indulged in his own *"Comédie humaine,"* a series of 180 drawings created between November 1953 and February 1954, so-titled by Surrealist writer Michel Leiris in his introduction to the suite's 1954 publication in *Verve* magazine.[1] As in Balzac's literary masterpiece, Picasso's series featured a sprawling variety of characters and settings: aging men and coquettish young maidens, nymphs and masked putti, circus clowns, medieval knights, and acrobats, in acts of coupling, seduction, contemplation, or even dancing, their situations often repeated in successive drawings. And while no overarching narrative supports Picasso's *Comédie humaine*, the central figure of the suite is the artist, in the various guises and approaches that he undertakes in the seduction of the model. Though executed during a time of marked personal difficulty and artistic frustration, the 180 drawings are not simply self-portraits or autobiographical sketches (the artists do not at any point resemble Picasso or his working process, which was not at the easel or with a palette, but with newspaper [see cat. no. 19] or with the canvas laid flat).[2] Rather, these drawings are a broader reflection on the external and internal conditions of art making. Through the use of masks and grotesque bodies

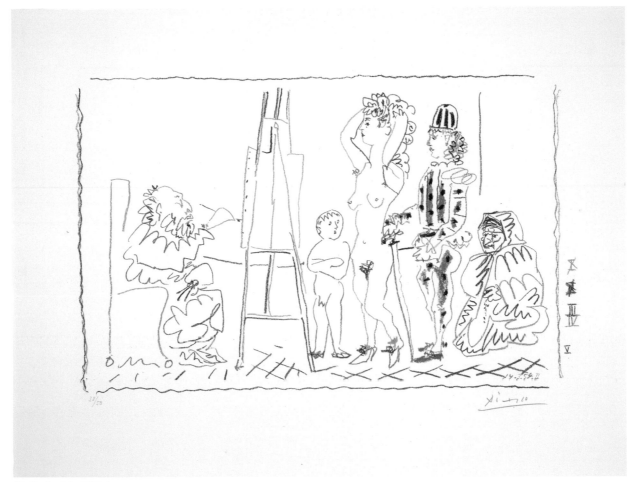

The Studio of the Old Painter

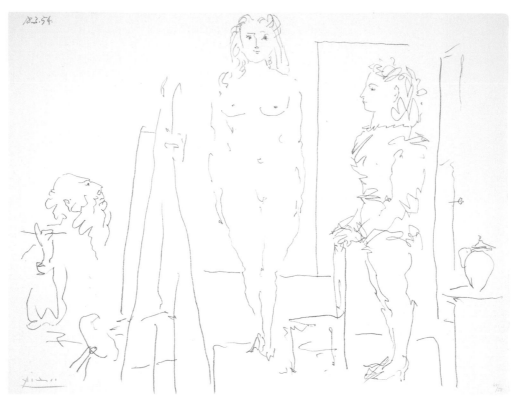

The Two Models

in various and vulgar positions, Picasso stretches the artist's physical and emotional role in the studio through a litany of visually imagined possibilities, while still maintaining the artist's traditional performance as a "creator" and the model's as "created," and ultimately considering the artist as a textual construct in a new studio language.

These four lithographs, executed just after the completion of the *Comédie humaine*, repeat and expand upon the cast of characters and compositions of the suite, and especially, the consistent figure of the aging artist, who is here shown alternately balding, bearded, and bespectacled. He is always pictured as a flattened character, seen in two dimensions, and confined to the margins of the page, in marked contrast to the full-bodied nudes and vibrant characters who fill and often exceed the pictorial space on the other side of the easel. Each element in the studio becomes a carefully lettered meme, perhaps phrased differently in each depiction but standing in the same linguistic relationship to its counterpart(s). In *The Studio of the Old Painter* (cat. no. 29), for example, the artist, his own shapeless form concealed by indistinct attire and his face obscured by tufts of beard, serves as a two-dimensional counterpart to the lively troupe on the other side of the easel: a boy urchin, a towering nude female, a Renaissance jester in a polka-dot and striped costume, and a Caravaggesque old woman, in a vivid contrast of gender, age, and historical periods. The unseen painting forms a barrier between artist and model, and suggests two distinct

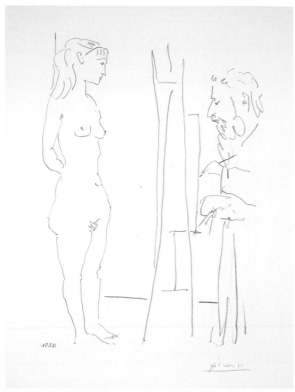

Nude Pose

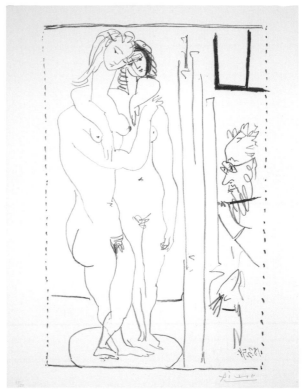

Two Nude Models

realms: that of the living models, or "life," and that of the artist, who ingests
the outside world and then transfers it into the text of his own visual lan-
guage, which occurs between his compressed figure of creative potential,
and the hidden, profiled canvas that receives its ire.[3] Subtle spatial differ-
ences, too, accentuate the artist's flattened dimensionality compared to the
vivacity of his Courbet-like assembly of model-onlookers; while the artist's
theoretical creative endeavor materializes through the singular directional
force of his body toward the turned canvas, many directions and dimensions
are angled through the models' side of the canvas. A black vertical line
defines a corner—a meeting of two planes—on the more voluminous studio
space on the right side, where an animated crosshatch also describes the
flooring, in contrast to the horizontality of the artist's side, and the stark,
simpler lines around his feet. Picasso would continue these experiments
with flatness and spatiality in his innovative sheet metal sculptures several
years later, combining the two sides of the studio: the real, tangible subject,
and the artist who perceives it as an assembled collection of spaces and
planes (fig. 1).

 The Two Models (cat. no. 30) continues Picasso's reduction of the artist
figure to a simple, flattened receptor of the studio scene at the bottom cor-
ner of the drawing, with angles, open doors, and open figures characterizing
the studio space. But it is *Nude Pose* (cat. no. 31) that makes most evident
Picasso's working formula, stripped to its barest elements. Instead of two

FIGURE 2

Brassaï, *Matisse Drawing a Nude Model at Villa d'Alésia*

1939

Gelatin silver print

9¼ x 10¾ in. (23.5 x 27.3 cm)

Yale University Art Gallery, The Allan Chasanoff, B.A. 1961, Photography Collection, 2004.130.132

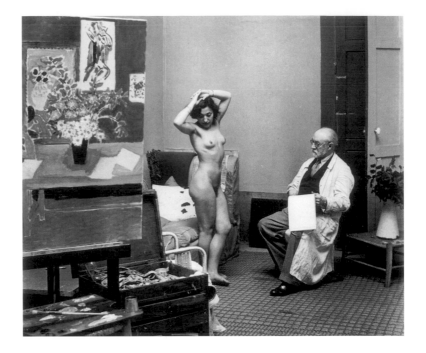

models, only one is necessary. Instead of frivolity, gravity; a single vertical line behind the model retains the meaning that all the podiums, desks, doors, knobs, and pots held, creasing her space while evoking fullness. We view the model's body—sculptural, with one breast facing us and the other in profile—almost in the round, while on the other side of the canvas-barrier, and just barely falling onto the page, the artist, withdrawn, exists only to relate this scene on his canvas. The rest of his body, without function here, disintegrates; lost and inutile, aged and apart from real life, the artist instead can only observe and harvest.

In *Two Nude Models* (cat. no. 32), the female forms are fused into a single, embracing element on a circular platform. Envisioned in the round, and barely contained by the image's edges, their massive, elongated shapes are reminiscent of the sixteenth-century school of Fontainebleau, while opposite the canvas, the artist is seen in profile, barely peeking in from the right side, with only his head and hand involved in the depiction of the bodies. He works with his nose almost touching the canvas, absorbed in the contents of its surface, and drawing close despite thick, round glasses, which emphasize his impaired vision. In the figure of the bespectacled artist working so near to his voluptuous model, Picasso's image recalls Brassaï's photographs of Matisse at work, studiously and almost clinically inspecting the nude's lush form (fig. 2).[4] By abstractly conjoining the models' shapes, Picasso also alludes to a central problem in the very practice of models, one raised much earlier in his career; after multiple sittings for a portrait of Gertrude Stein in 1906 (introduction, fig. 1), the artist complained he "could no longer see her," and subsequently gave the subject a masklike face. By emphasizing the play of power within the studio—the place of the model,

as a field of space to be replicated, and the function of the artist—Picasso highlights the role, or nonrole, of the model in an increasingly abstract modern art.

The unusual internal framing of this particular print—a solid line along top and bottom, and two vertical dotted lines on each side—stresses the horizontal continuity and the discontinuity of the studio space. The tenuous border suggests that the studio and its related dynamics (idea/nature; age/ youth; desire/refusal; blindness/vision; subject/object) extend beyond this simple enclosure, inclusively bringing to mind other artists, and other studios—an entire language to be interpreted—at left and at right, which use the same studio vocabulary in a fractured treatment of each element.

— S. Zelda Roland

1. See Michel Leiris, "Picasso et la Comédie Humaine ou Les avatars de Gros-Pied, Suite de 180 dessins de Picasso, 28 Novembre 1953 au 3 Février 1954," *Verve* 7, nos. 29–30 (1954).

2. In March 1953 Picasso published a controversial commemorative portrait of Joseph Stalin in the Communist journal *Les lettres françaises*, around which there was considerable backlash from the party and the media. On the controversy see Gérard Gosselin, "L'affaire du portrait," in *Picasso et la presse* (Paris: Éditions Cercle d'Art,

2000), 140–47; in September 1953, Françoise Gilot, Picasso's mistress since 1943, left the artist with their two children.

3. On the idea of the canvas as barrier, see the important study by Karen L. Kleinfelder, *The Artist, His Model, Her Image, His Gaze: Picasso's Pursuit of the Model* (Chicago: University of Chicago Press, 1993), 124–85.

4. As noted by Kleinfelder; see ibid., 133–37.

33
The Painter in His Studio

Mougins, March 14–15,
May 13, and June 4, 1963
Oil on canvas, 23 x 35½ in.
(58.4 x 90.2 cm)
INSCRIPTIONS: lower left: *Picasso*;
on verso: *14.3.63, 15, 13.5.63, 4.6.63*
PROVENANCE: Galerie Louise Leiris,
Paris; Charles B. Benenson,
Greenwich, Conn.
REFERENCES: Zervos XXIII, 172
Yale University Art Gallery, Charles
B. Benenson, B.A. 1933, Collection,
2006.52.23

Picasso returned with great fervor to the subject of the artist and model earlier examined in the *"Comédie humaine"* of 1953–54, with a group of nearly thirty drawings and over fifty paintings produced between February and May 1963.[1] On March 27, 1963, in the midst of this work, Picasso wrote across the back flyleaf of a sketchbook the now well-known statement, "La peinture est plus fort que moi, elle me fait faire ce qu'elle veut" (Painting is stronger than I am; it makes me do whatever it wants).[2]

In most of the paintings and drawings from this three-month period, Picasso succumbs to the same formulaic composition: the artist at left, seated in profile at the easel, with a reclining model, or at times a statue, filling the space at right. With these terms set, Picasso allowed himself to examine more fully the shapes and colors of the space in and around the forms, offering new visions of the same configurations of artist-model-easel. Given Picasso's severe reduction to these three basic elements, the elimination of the model in this particular painting, *The Painter in His Studio*, has profound results. In her place, on the right side of the canvas, stands an elaborately painted easel, no longer the flat barrier at center of previous drawings and lithographs (see cat. nos. 31–32) but a rich and animated "figure" itself. It is a more decorative easel than those in the related works, with a volute top, and an embellished form resembling the easels used by artists and dealers to display finished works of art.[3]

The elaborate easel, as well as the painting's overall composition, recalls the post-Cubist work of Picasso's great contemporary Georges Braque. Braque's depictions of the studio from the 1930s (fig. 1), or his important *Atelier* series of the postwar period, were among the seventy-seven works featured in a 1961 retrospective at the Louvre, called *L'atelier de Braque*, which also included a reconstruction of the artist's actual studio.[4] Picasso had often contemplated Braque's series—John Richardson comments that Braque's studios were "paintings whose profundities had once left him [Picasso] baffled to the point of resentment."[5]

FIGURE I
Georges Braque,
Artist and Model
1939
Oil and sand on
canvas
51⅛ x 70⅞ in.
(129.9 x 180 cm)
Norton Simon Art
Foundation

Picasso's work is an homage of sorts; it is also a rethinking of Braque. In contrast to Braque's elegant and subdued visions of the studio, a testament to Braque's own sense of peace with the process of painting, Picasso shows the studio and the process of creation as one of great vitality. As Braque told John Richardson in 1955, "You see, I have made a great discovery. I no longer believe in anything. Objects don't exist for me except in so far as a rapport exists between them or between them and myself. When one attains this harmony one reaches a sort of intellectual non-existence—what I can only describe as a sense of peace, which makes everything possible and right. Life then becomes a perpetual revelation. That is true poetry."[6]

In *The Painter in His Studio*, Picasso uses Braque's idea of the subtle relationships between objects to represent both the literal object and the artist's notion of it, and emphasizes a distinct, formulaic treatment of each element in the studio. Picturing the figured artist as a flattened object, as in earlier images of the studio (see cat. nos. 29–32), Picasso depicts him in thick, black, gestural strokes over large fields of empty white. The artist's head is painted in lines that only skim the white surface, and to his left, fields of color never intersect, instead intermingling on top of similarly white, empty space, evoking the blank canvas itself and suggesting that the artist is also a subject, posing while creating. In contrast, Picasso uses the right side of the painting to exaggerate the studio space, where he spiritedly paints layer upon layer of color all around the easel—greens on pinks in swirling motions between the artist and the easel, with whites on reds to the right, and shades of blue and violet below, emphasizing the sculptural, lively qualities associated with creative studio space. The colors reach upward into the background behind the window. At the brush's collision with the canvas, Picasso's paint is at its thickest, rising physically above the rest of the painting's surface, reaching into the external. The artist's swollen hand, like a boxer's glove (evoking the strength of painting, greater than Picasso's own physical vigor), exaggerates the impact of its movement toward the painting, and between hand and canvas, Picasso piles on fat layers of black and white paint.

Though Braque's death came in August 1963, several months after Picasso's own studio paintings, such as this one, Picasso's ensuing paintings and drawings would continue to examine the notions and "rapports" of represented subjects, instead of their static, spatial existences: the revelation of Braque in abandonment of recognizing simple "objects." Thus, privileging his own relationships to his subjects over the visual existence of the painted things themselves, Picasso created his artworks less as "representations" and more as "texts" in which visual objects (a particular easel, a particular object, a particular model) concede to the artist's larger understanding of them.

– S. Zelda Roland

1. See Zervos XXIII, 122 to roughly 277. Picasso's activity during this time has been described vividly by Hélène Parmelin; see, for example, Parmelin, *Picasso, the Artist and His Model, and Other Recent Works* (New York: Harry N. Abrams, 1965). For a discussion of the *"Comédie humaine,"* see cat. nos. 29–32.

2. Words written on the inside back cover of sketchbook no. 171, Musée Picasso, Paris, dated February 10–21, 1963; quoted in Michel Leiris, *Picasso peintures, 1962–1963*, exh. cat. (Paris: Galerie Louise Leiris, 1964), 3.

3. John Golding, "The Late Paintings: An Introduction," in *Braque: The Late Works*, exh. cat. (New Haven, Conn.: Yale University Press, 1997), 4.

4. See *L'atelier de Braque*, introduction by Jean Cassou (Paris: Éditions des Musées Nationaux, 1961).

5. John Richardson, "L'époque Jacqueline," in *Late Picasso: Paintings, Sculpture, Drawings, Prints, 1953–1972*, exh. cat. (London: Tate Gallery, 1988), 44. David Sylvester also considers Picasso's consideration of Braque in his *Las meninas*; see Sylvester's "End Game," in *Late Picasso*, 138–39.

6. Quoted in Golding, *Braque*, 10.

The Smoker

Mougins, August 27, 1964
Color aquatint, 16⅜ x 12½ in.
(41.6 x 31.8 cm)
INSCRIPTIONS: lower right: *Picasso*
Yale University Art Gallery, Gift of
Dorothy and Marvin Small,
1969.77.1

In the summer of 1964, Picasso drew a highly animated series of several dozen close-up images featuring a man smoking a cigarette.[1] In work after work, a youngish-looking male figure, often shown with close-cropped hair, a stubbly beard, and wearing the same striped shirt often worn by Picasso in celebrity photographs, raises his hand to his mouth to draw on a cigarette. In some drawings, the smoker is shown seated with a nude model, suggesting this figure as Picasso's prototypical male Artist, with his clichéd guise of beret, beard, and cigarette, perhaps a stand-in for Picasso himself. He continued with the figure in a print series, emphasizing through the medium a repetition as well as a variability in the theme.[2]

In many of the earlier drawings, Picasso showed the figure in profile, but in later iterations, as in this print, the artist is viewed frontally, though the former profile view remains like an afterimage in the yellow zigzag that extends down the middle of his face. With the fringe of hair that frames his head, the smoker resembles more a little boy than the balding, bespectacled sages of Picasso's other artist images (see cat. no. 32). His cigarette, a soft gray cone, culminates in a green O, a shape repeated in the circles of his two uneven nostrils and his disparate eyes, echoing the combined perspectives in which he exists. Here, as in many of the Smoker depictions, the figure is the sole subject, a compression of the artist-model-easel-studio dynamic (see cat. nos. 29–33) into the one, layered face. Where once Picasso used models, corners, and intersections to indicate life and the outside world, he now uses two solid panes of sky blue and soot gray at either side. At their intersection, Picasso left the bare white of the page—a nod to the canvas in the studio—on top of which he layered the flattened, two-dimensional cues that characterize the artist's, or smoker's, own features. Reading himself into the language of the studio, the artist's face becomes a play of loosely related forms that swim atop the empty page of bold, expressive white, thus highlighting the texture of the bare material as the medium of the artist's portrait, as in the studio painting of 1963 (cat. no. 33), where the empty white of the canvas participates heavily in depicting the painter. At the top, branding his own image, Picasso foregrounds the fact of its making: the same canvas-white of the artist's skin bleeds into the inscription of the print's date of production.

– S. Zelda Roland

1. See Zervos XXIV, 151–202. Most of these drawings are in private collections; one, dated August 22, 1964, and not in Zervos, is in the Musée Picasso, Paris, M.P. 136.

2. See Georges Bloch, *Catalogue of the Printed Graphic Work, 1904–1967* (Bern: Éditions Kornfeld and Klipstein, 1968), nos. 1164–76.

21/50 Picasso

35

The Painter

Mougins, October 13, 1964
Gouache and India ink, on a repro-
duction of *The Painter*, March 30,
1963 (Zervos XXIII, 198), 37⅞ x
29⅛ in. (96.2 x 74 cm)
INSCRIPTIONS: upper left: Picasso;
on verso, bottom: *13.10.64 III*; lower
left, on original print (partially
obscured by gouache): *8/350*
PROVENANCE: Galerie Louise Leiris,
Paris; Walter Bareiss, until 1980
REFERENCES: Zervos XXIV, 222
Yale University Art Gallery, Gift of
Walter Bareiss, B.S. 1940s, 1980.63

Picasso's outpouring of images of the artist at work in the 1960s continued in this series, undertaken October 10–24, 1964, when he painted over multiple print reproductions of the same painting, also titled *The Painter*. Picasso had collaborated on the print with Paris publisher Guy Spitzer, who reproduced the painting in an edition of 350 serigraphs with hand-applied *pochoir* coloring (fig. 1). Over the course of these two weeks Picasso embellished twenty-nine of the prints to create a new series of works.[1]

In this version, Picasso restyles and fills out the painter figure from the original work (whose edges are still visible in this drawing), giving him long hair and a curly beard. As in many of the works from the series, he adds a large, charismatic hat, in this case black with a soft rim, which frames the enormous, wide-open eyes that take the place of the figure's earlier downcast gaze. Across the series, the artist becomes other artists: in one instance he is clad in the straw hat of Vincent van Gogh; in others, in striped shirts like those preferred by Picasso himself. In all the drawings Picasso exaggerates the artist's hand, here poised before the canvas with the somewhat comical gesture of a haughtily raised pinkie.

The result of these revisions is a much more expansive work, and in the Gallery's version, the new figure expands beyond the margins of the print and onto the sheet itself. Through these transformations, *The Painter* becomes not just a representation of representation, but of Picasso's specific habit of representation: his ease with constant revision and the writing over of previously existing works.

— **Katherine M. Wyman**

1. For the series, see Zervos XXIV, 215–43.

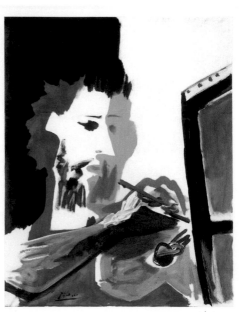

FIGURE I
Picasso, *The Painter*
1964
Collotype with *pochoir* coloring
29¾ x 23⁷⁄₁₆ in. (75.6 x 59.5 cm)
Masterworks Fine Art, Inc.

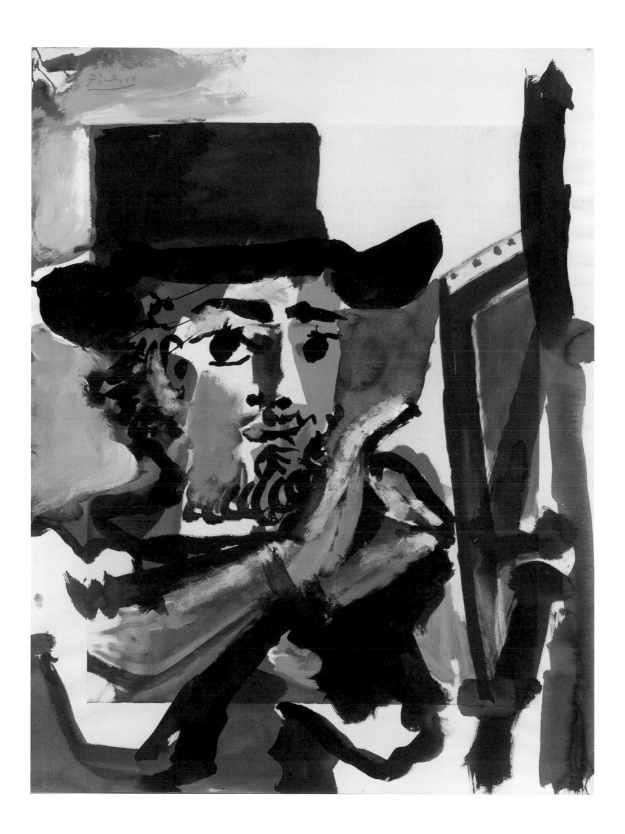

Four Figures and a Head in Profile

Mougins, January 10, 1969
Pen and ink and wash, 11 ¹⁵/₁₆ x
17¹/₁₆ in. (30.4 x 43.4 cm)
INSCRIPTIONS: upper right:
10.1.69 Picasso
PROVENANCE: Walter Bareiss,
from at least 1971
REFERENCES: Zervos XXXI, 7
Yale University Art Gallery, Gift of
Molly and Walter Bareiss, B.S. 1940S,
1999.9.15

The ensemble of characters that came to inhabit Picasso's late drawings and lithographs embodied aspects of the artist's persona melded with people from his life, historical characters, and mythological creatures. With the reduction of outside stimuli, Picasso drew more and more on his lush memory, and on what he himself described as his "novelist" side: "I spend hour after hour while I draw," he told the photographer Roberto Otero, "observing my creatures and thinking about the mad things they're up to: basically it's my way of writing fiction."[1]

The appearance of these subjects marked his return to the population of entertainers who inhabited his Rose Period work (see cat. no. 2), although this time, these characters functioned as caricatures rather than transposed subjects whom he would summon to indwell the landscapes of his imagination. The central player in these multicharacter scenes is a naked woman or model who displays or parades herself before a changing array of spectators comprising artists, clowns, fauns, prostitutes, jesters, or an enthroned lord. Unlike the more numerous works of encounters between artist and model, these group scenes of exhibited types read as psychological narratives with a predominantly melancholic aura. The iconography of id and ego that developed represented the guises the physically diminished artist assumed to display his conscious intentions to himself and his viewers.

In this period the studio as subject became the theater for Picasso's memory and fantasy. His work focused on the primary relationship between the artist and his model, but even in these images of one-on-one encounters, characters replaced the artist, and the duet no longer physically engaged one another. The artist surrogates affect the postures of dispassionate voyeurs, the embodiment of the artist's waning virility. While the artist's model as sexual doppelgänger had always been a voluptuous and primarily playful counterpart, she is now transformed into an autonomous provocateur who, in her role as a seducer, attempts to entice her dull suitors, who passively gaze at her in startled amazement.

In many of these images, where there are only two figures and a troubadour character is seated in a chair, he is contented in his role as a voyeur, and the woman is actively engaged in pleasuring and amusing the still-dominant male. But in some cases, as in this work, the female overwhelms the male or males, who are seated on the ground or stand inertly before her. Here the male characters appear abject and infantilized, and drawings undertaken in August 1969 reveal Picasso's development of the seated character as a deliberate conflation of infant and musketeer, a suitor who can only please his lady through charm and romantic gesture but not reciprocate her passion.[2]

While in the past the seated male spectators were dominant, or at least able, counterparts to the nude model, in this drawing we see two miniaturized and clearly submissive males: a jester and a turbaned scholar/artist. These two bearded types read as artist archetypes and are amalgamations of

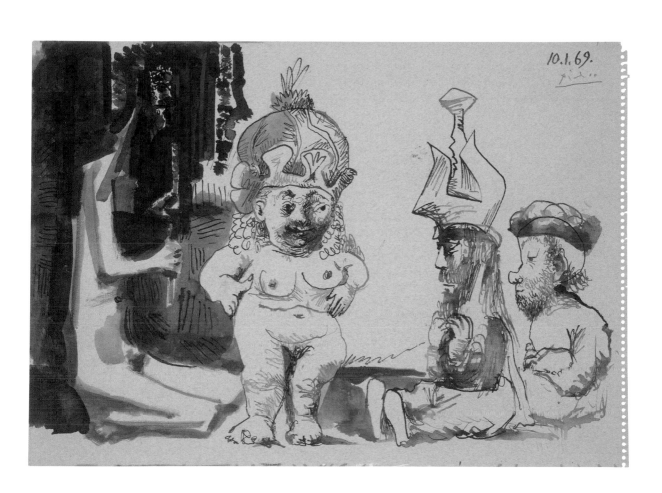

10.1.69.

Picasso's representations of himself, the artist Edgar Degas, and his own father, who was also an artist. In this drawing, the artist type is accompanied by a jester, and we are uncertain whether Picasso or Degas is the joker or the butt of the joke.

Degas fascinated Picasso, not only as a remarkable artist and entrepreneur in the development of the market for his work but particularly for the body of sexually graphic monotypes of brothels in Paris that Degas developed and kept private throughout his life. Picasso admired and even acquired some of these monotypes for his own collection in 1958.[3] Picasso, who prided himself on his sexual prowess, was perhaps fascinated that Degas, whose work he so greatly admired for its sexual veracity, was thought to be impotent, and yet was able to generate this explicit expression through mere voyeuristic projection. As Picasso's own virility diminished, this Degas character became a mainstay in Picasso's drawings.

The dwarfed female in this drawing is an enfant terrible, her hands set boldly on her hips in challenge to the male onlookers who sit dumbly before her, their hands retracted at once nervously and passively against their chests. Despite her nakedness, the dwarf commands this encounter; even the serenading flutist to her left has been struck silent by her presentation, and holds his flute before him in an awestruck pause. This serenading muse is enveloped in an inky ether that removes him from the primary interaction between the two seated males and the female. The mask that projects in front of his head is a modest variation on the multiple masking of characters that Picasso often used in his drawings. Not only did he study variations on faces for his compositions through this masking (see cat. no. 27), but these variants also served to multiply the complex nature of the subject, a practice he had developed in self-representation as Minotaur in encounters with sleeping models in the studio.

This drawing is unusual in Picasso's oeuvre in that he has arrayed the female nude in an elaborate, oversize crown. Such a direct sign of empowerment was rarely bestowed on Picasso's women, the closest approximation being Picasso's variation on Eugène Delacroix's *Women of Algiers* painted on January 24, 1955 (Helly Nahmad Gallery, London), in which one of the women has a tight turban on her head that merely reaffirms her, despite her staid positioning as a witness, as a slave or servant.[4] What is more likely than Picasso's recognition of woman as a powerful counterpart is his development of this female as a variant on the hermaphroditic characters that begin to inhabit the late studio scenes. In fact this female shares the visage of the curly-haired, chubby male infant drawn by Picasso the previous day, who stares knowingly out at the viewer while other onlookers, a standing bearded male, a jester, and a small female character gaze on a seated nude.[5] The infant and the crowned female are more likely caricatures of the artist's own youthful libido, and in his side-by-side seating of the jester and artist he is making a joke about his own sexuality.

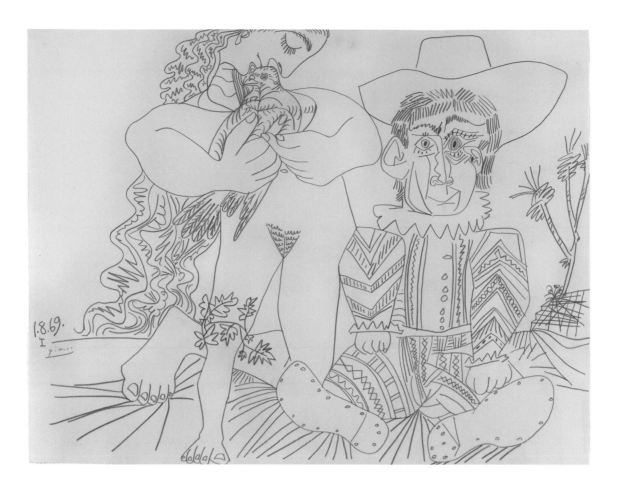

FIGURE I
**Picasso, *Man and Woman
with a Bird***
Mougins, August 1, 1969
Pencil
20 x 26 in. (50.8 x 66 cm)
Yale University Art Gallery, Gift of
Mr. and Mrs. Walter Bareiss, B.S. 1940s,
1983.103

The iconographic disguises of the amorous suitor in Picasso's oeuvre were many; one of the last figures to appear in the late 1960s was a nobleman with a ruff collar, boots, and a plumed hat. This absurd romantic soldier and historical witness was a nobleman of the Siglo de Oro (Golden Age), who was half Spanish, half Dutch.[6] He represented for Picasso the ideal of the Spanish Renaissance and Baroque culture in the sixteenth and seventeenth centuries, as exemplified in the paintings of Diego Velázquez, El Greco, and Francisco de Zurbarán. This amorous surrogate shared his seated position with the jester and Degas character in Picasso's work, and together they evocatively represent the artist as they bear witness to his labors in the greater arc of art history. This seated character in costume can be seen in the Gallery's pencil drawing *Man and Woman with a Bird* (fig. 1). Here the neutered troubadour sits numbly before a voluptuous woman; she seductively strokes a pigeon while leaning into the infantilized male, who tightly clenches his small hands. Picasso's frustrations with the physical limitations of his age were here clearly expressed.

Four Figures and a Head in Profile and *Man and Woman with a Bird* were given to the Yale University Art Gallery by Walter Bareiss and his wife, Molly, through whose generosity more works by Picasso have been given to the Gallery than by any other donor. Bareiss, who served on the Gallery's

governing board for almost fifty years and as its chairman from 1987 to 1995, began collecting Picasso's work when he was thirteen years old. He came to own over twenty works by the master, and in 1971, as Chairman of the Committee on Painting and Sculpture at the Museum of Modern Art in New York, accompanied by chief curator William Rubin and art dealer Ernst Beyeler, helped secure Picasso's gift of his *Guitar* (1912) to the Museum of Modern Art (see dedication, pages iv–v). In honor of Picasso's ninetieth birthday in 1971, Walter and Molly Bareiss sponsored an exhibition of the artist's work at the Gallery. In the introduction to the brochure for that exhibition, Bareiss fondly recollected his and his wife's four-day studio visit with the artist: "He talked about his paintings, drawings and sculptures as well as his early relations with the Steins, explained happily and lucidly his fondness for Cézanne, Matisse, Degas, Balthus and other artists, without either claiming to be better than they or cowtowing [*sic*] to their genius. There was no arrogance or presumption in the way he talked, but humor and a great sense of humanity and love for his work and his friends."[7]

— Jennifer R. Gross

1. Roberto Otero, *Forever Picasso: An Intimate Look at His Last Years* (New York: Harry N. Abrams, 1973), 170.

2. See Zervos XXXI, 353–55.

3. John Richardson, *A Life of Picasso*, vol. 2 (New York: Random House, 1996), 455n.49. On Picasso and Degas, see also Richardson, "L'époque Jacqueline," in *Late Picasso: Paintings, Sculpture, Drawings, Prints 1953–1972*, exh. cat. (London: Tate Gallery, 1988), 38–41.

4. Françoise Gilot wrote that Picasso took her almost monthly to see Delacroix's *Women of Algiers* at the Louvre when they lived in Paris and spoke of making his own version of the painting; Françoise Gilot and Carlton Lake, *Life with Picasso* (New York: Doubleday, 1989), 203.

5. See Zervos XXXI, 4.

6. Marie-Laure Bernadac, "Picasso, 1953–1972: Painting as Model," in *Late Picasso*, 81.

7. *Picasso Drawings from the Collection of Mr. and Mrs. Walter Bareiss*, exh. cat. (New Haven, Conn.: Yale University Art Gallery, 1971).

All works are by Picasso unless otherwise indicated.

Café Scene
Paris, October–December 1900
Oil on panel, 10 x 14¹³/₁₆ in. (25.4 x 37.7 cm)
Gertrude Stein and Alice B. Toklas Papers,
Yale Collection of American Literature,
Beinecke Rare Book and Manuscript
Library, Yale University
Cat. no. 1

La danse barbare (The Barbaric
Dance), from **Les saltimbanques**
Paris, 1905
Drypoint, 7¼ x 9⅛ in. (18.4 x 23.2 cm)
Edition 250
Yale University Art Gallery, Gift of Dorothy
and Marvin Small, 1969.30.2
Not illustrated

Salomé, from **Les saltimbanques**
Paris, 1905
Drypoint, 15¾ x 13¹¹/₁₆ in. (40 x 34.8 cm)
Edition 250
Yale University Art Gallery, Gift of Molly
and Walter Bareiss, B.S. 1940s, 1999.9.13
Cat. no. 2

Head of a Jester
Paris, spring 1905
Bronze, H. 16 in. (40.6 cm)
Promised gift to the Yale University Art
Gallery of Thomas Jaffe, B.A. 1971
Cat. no. 3, fig. 7

Head of Fernande
Gósol, summer 1906
Oil and gouache on canvas, 14¾ x 13 in.
(37.5 x 33.1 cm)
Promised gift to the Yale University Art
Gallery of Susan and John Jackson,
B.A. 1967, and the Liana Foundation
Cat. no. 3, fig. 1

Head of a Woman
Paris, winter 1906–7
Gouache and ink, 25 x 18¹¹/₁₆ in.
(63.5 x 47.5 cm)
Yale University Art Gallery, Gift of
Katherine S. Dreier to the Collection
Société Anonyme, 1949.83
Cat. no. 3

Vase, Gourd, and Fruit on a Table
Paris, winter 1908–9
Oil on canvas, 28¾ x 23⁹/₁₆ in. (73 x 59.8 cm)
Yale University Art Gallery, John Hay
Whitney, B.A. 1926, M.A. HON. 1956,
Collection, 1982.111.3
Cat. no. 4

Standing Nude
Paris, early 1910
Pen and ink, 24³/₁₆ x 16⁹/₁₆ in. (61.5 x 42 cm)
Yale University Art Gallery, Gift of Walter
Bareiss, B.S. 1940s, 1978.107
Cat. no. 5, fig. 1

Georges Braque, **Fox**
Céret, 1911
Drypoint, 21³/₈ x 14⁷/₈ in. (54.3 x 37.8 cm)
Edition 100
Yale University Art Gallery, University
Purchase, 1949.79
Not illustrated

Georges Braque, **Bass**
Céret, 1911
Etching, 25 x 19⅝ in. (63.5 x 49.8 cm)
Edition 100
Yale University Art Gallery, Gift of Walter
Bareiss, B.S. 1940s, 1956.31.12
"The Meeting Place of Poets," fig. 5

Georges Braque, **Job**
Paris, 1911
Etching, 5⅝ x 7⅞ in. (14.3 x 20 cm)
Edition 100
Yale University Art Gallery, University
Purchase, 1948.62
"The Meeting Place of Poets," fig. 6

Max Jacob, **Saint Matorel**
Published by Daniel-Henry Kahnweiler,
Paris, 1911
Book, with 4 etchings by Picasso, 10½ x
7⅞ in. (26.7 x 20 cm)
Edition 106
Gift of John Hay Whitney, Beinecke Rare
Book and Manuscript Library, Yale
University
Cat. no. 5

Shells on a Piano
Paris, spring 1912
Oil on canvas, 9½ x 16⅛ in. (24.1 x 41 cm)
Yale University Art Gallery, The Katharine
Ordway Collection, 1980.12.8
Cat. no. 6

Guitar

Sorgues, summer 1912

Graphite, 24 x 18¾ in. (61 x 47.6 cm)

Yale University Art Gallery, Gift of Mr. and Mrs. Walter Bareiss, B.S. 1940S, 1981.123

"The Meeting Place of Poets," fig. 3

Georges Braque, **Black and White Collage**

1913

Collage, pencil, and black and white chalk, 28¹¹⁄₁₆ x 18¾ in. (72.9 x 47.7 cm)

Yale University Art Gallery, Gift of Katherine S. Dreier to the Collection Société Anonyme, 1949.138

Not illustrated

Dice, Packet of Cigarettes, and Visiting-Card

Paris, early 1914

Painted and printed paper, graphite, and watercolor, 5½ x 8¼ in. (14 x 21 cm)

Gertrude Stein and Alice B. Toklas Collection, Yale Collection of American Literature, Beinecke Rare Book and Manuscript Library, Yale University

Cat. no. 7

Segment of Pear, Wineglass, and Ace of Clubs

Paris, spring 1914

Pasted paper, distemper (gesso), gouache, and graphite on cardboard, 17¹⁵⁄₁₆ x 15³⁄₁₆ in. (46 x 38 cm)

Yale University Art Gallery, John Hay Whitney, B.A. 1926, M.A. HON. 1956, Collection, 1982.111.2

Cat. no. 8

Picasso and André Derain, **Four Still Lifes**

Avignon, summer 1914

Oil on four ceramic tiles, 21 x 21 in. (53.3 x 53.3 cm)

Yale University Art Gallery, The Philip L. Goodwin, B.A. 1907, Collection, Gift of James L. Goodwin, 1905, Henry Sage Goodwin, 1927, and Richmond L. Brown, 1907, 1958.17.1

Cat. no. 9

Man with Dog (Rue Schoelcher)

Paris, spring 1915

Etching and engraving, 10¹⁵⁄₁₆ x 8⁹⁄₁₆ in. (27.8 x 21.7 cm)

Edition 102

Yale University Art Gallery, Gift of Mr. and Mrs. Walter Bareiss, B.S. 1940S, 1969.60.3

Cat. no. 10

Harlequin

Ca. 1919–20

Watercolor, 13 x 9½ in. (33 x 24.1 cm)

Yale University Art Gallery, Bequest of Edith Malvina K. Wetmore, 1966.80.24

Introduction, fig. 11

Pedestal Table with Guitar and Sheet Music

Ca. 1920

Pochoir print, 10³⁄₈ x 8 in. (26.4 x 20.3 cm)

Edition 100

Yale University Art Gallery, Gift of Mrs. Gilbert W. Chapman in memory of Gertrude Stein, 1955.41.1

Introduction, fig. 7

Georges Braque, **Fruit Dish, Glass, and Newspaper**

1920

Oil on canvas, 12⁵⁄₈ x 21⁷⁄₈ in. (32.1 x 55.6 cm)

Yale University Art Gallery, Gift of Mr. and Mrs. Paul Mellon, B.A. 1929, 1983.7.5

Not illustrated

Dog and Cock

1921

Oil on canvas, 61 x 30¹⁄₈ in. (159.4 x 76.5 cm)

Yale University Art Gallery, Gift of Stephen Carlton Clark, B.A. 1903, 1958.1

Cat. no. 11

Painter and Model Knitting

1927

Etching, 7⁵⁄₈ x 10⁷⁄₈ in. (19.4 x 27.7 cm)

Edition 99

Yale University Art Gallery, University Purchase, 1948.65

Cat. no. 12

Figure

May 1929

Lithograph, 9⁵⁄₁₆ x 5⁷⁄₁₆ in. (23.6 x 13.8 cm)

Edition 300

Yale University Art Gallery, Gift of Mr. and Mrs. Walter Bareiss, B.S. 1940S, 1969.60.7

Introduction, fig. 9

Hercules Killing the Centaur Nessus

Boisgeloup, September 20, 1930

Etching, 12¼ x 8¹¹⁄₁₆ in. (31.1 x 22.1 cm)

Proof on Rives paper outside of an edition of 30

Yale University Art Gallery, Katharine Ordway Fund, 1983.60

Cat. no. 13

In the Bath

Boisgeloup, October 1, 1930

Etching, 12¼ x 8¾ in. (31.1 x 22.2 cm)

Edition 260

Yale University Art Gallery, The Ernest C. Steefel Collection of Graphic Art, Gift of Ernest C. Steefel, 1958.52.89

Cat. no. 14, fig. 5

Honoré de Balzac, **Le chef-d'oeuvre inconnu** (The Unknown Masterpiece)

Published by Ambroise Vollard, Paris, 1931

Book, with 13 etchings by Picasso, 13¹⁄₁₆ x 10¹⁄₈ in. (33.2 x 25.7 cm)

Edition 305

Gift of John Hay Whitney, Beinecke Rare Book and Manuscript Library, Yale University

Cat. no. 12

Ovid, **Les métamorphoses** (Metamorphoses)

Published by Albert Skira, Lausanne, 1931

Book, with 30 etchings by Picasso, 13³⁄₁₆ x 10⁷⁄₁₆ in. (33.5 x 26.5 cm)

Edition 125

Gift of John Hay Whitney, Beinecke Rare Book and Manuscript Library, Yale University

Cat. no. 13

Head of a Woman

1931, cast 1973

Bronze, 34 x 14⅜ x 19¼ in. (86.4 x 36.5 x 48.9 cm)

Edition 2

Raymond and Patsy Nasher Collection, Dallas

Cat. no. 14, fig. 1

Nude Seated before a Curtain

Boisgeloup, April 3, 1931

Etching, 12⁵⁄₁₆ x 8¾ in. (31.3 x 22.2 cm)

Edition 260

Yale University Art Gallery, Gift of Ralph Kirkpatrick, 1976.102.5

Cat. no. 14, fig. 3

Table of Etchings

Paris, July 4, 1931

Etching, 10¹³⁄₁₆ x 7¾ in. (27.5 x 19.7 cm)

Edition unknown

Yale University Art Gallery, Everett V. Meeks, B.A. 1901, Fund, 2008.65.1

Cat. no. 12, fig. 8

Reclining Women

Boisgeloup, September 29, 1931

Drypoint, 11¾ x 14½ in. (29.9 x 36.8 cm)

Edition 260

Yale University Art Gallery, Gift of Jacob and Ruth Kainen, MUS.B. 1950, 1991.57.5

Cat. no. 14, fig. 4

Flute Player and Reclining Nude

Paris, October 13, 1932

Ink, 9¾ x 12⅝ in. (24.8 x 32.1 cm)

Yale University Art Gallery, Gift of Molly and Walter Bareiss, B.S. 1940s, 1999.9.14

"The Surrealist Impulse," fig. 1

Sculptor, Reclining Model, and Sculpture

Paris, March 17, 1933

Etching, 10½ x 7⅝ in. (26.6 x 19.4 cm)

Edition 260

Yale University Art Gallery, The Ernest C. Steefel Collection of Graphic Art, Gift of Ernest C. Steefel, 1958.52.92

Cat. no. 14b

The Sculptor's Studio

Paris, March 21, 1933

Etching, 10½ x 7⅝ in. (26.6 x 19.4 cm)

Edition 260

Yale University Art Gallery, The Ernest C. Steefel Collection of Graphic Art, Gift of Ernest C. Steefel, 1958.52.91

Cat. no. 14c

Two Statues

Paris, May 5, 1933

Etching, 10⅜ x 7½ in. (26.4 x 19.1 cm)

Edition 260

Yale University Art Gallery, The Ernest C. Steefel Collection of Graphic Art, Gift of Ernest C. Steefel, 1958.52.90

Cat. no. 14a

Suite of Six Etchings for Aristophanes' Lysistrata

1934

Suite of 6 etchings (2 with aquatint), each 8¹¹⁄₁₆ x 6 in. (22.1 x 15.2 cm)

Edition 150

Yale University Art Gallery, Gift of Arthur Edwin Neergaard, 1959.23.1a–f

Cat. no. 15

Seated Woman

Juan-les-Pins, Antibes, April 26, 1936

Oil on canvas, 28¾ x 23½ in. (73 x 59.7 cm)

Yale University Art Gallery, Charles B. Benenson, B.A. 1933, Collection, 2006.52.22

Cat. no. 16

Vase of Flowers and Pitcher

March 1937

Oil on canvas, 23⁷⁄₁₆ x 27½ in. (59.5 x 69.9 cm)

Yale University Art Gallery, Gift of Stephen Carlton Clark, B.A. 1903, 1954.29.1

Foreword, p. ix

Portrait of Vollard

Paris, March 4, 1937

Aquatint, 17¼ x 13¼ in. (34.3 x 24.1 cm)

Edition 250

Yale University Art Gallery, Purchase for the Edward B. Greene Collection of Portrait Engravings, 1954.9.13

Not illustrated

Georges Hugnet, **Pablo Picasso**

Published by the author, Paris, 1941

Pamphlet, oblong, with 6 zincographs by Picasso, 3 reworked with engraving, 3¾ x 5¹³⁄₁₆ in. (9.5 x 14.8 cm)

Edition 200

Beinecke Rare Book and Manuscript Library, Yale University

Cat. no. 18

Exhibited at the Yale University Art Gallery only

Georges Hugnet, **Non vouloir** (Not Wanting)

Published by Éditions Jeanne Bucher, Paris, 1942

Book, with 4 zincographs by Picasso, 8 x 5¹³⁄₁₆ in. (20.2 x 14.8 cm)

Edition 426

Beinecke Rare Book and Manuscript Library, Yale University

Cat. no. 18, figs. 1–2

Exhibited at the Yale University Art Gallery only

40 dessins de Picasso en marge du Buffon (40 Drawings by Picasso in the Margins of Buffon)

1943

Published by Jonquières and Berggruen, Paris, 1957

Book, with 40 drawings by Picasso, 14¹¹⁄₁₆ x 11¹⁄₁₆ in. (37.3 x 28.1 cm)

Edition 36 of 226 deluxe copies on Arches wove, with the linocut *Le pigeonneau*

Yale University Art Gallery, The Ernest C. Steefel Collection of Graphic Art, Gift of Ernest C. Steefel, 1958.52.172

Cat. no. 17

First Steps

Paris, May 21, 1943, revised summer 1943

Oil on canvas, 51¼ x 38¼ in. (130.2 x 97.1 cm)

Yale University Art Gallery, Gift of Stephen Carlton Clark, B.A. 1903, 1958.27

Cat. no. 19

Seated Woman

April 2, 1947

Oil on canvas, 39⁵⁄₁₆ x 31¾ in. (99.9 x 80.7 cm)

Yale University Art Gallery, The Katharine Ordway Collection, 1980.12.21

Cat. no. 23

Soneto burlesco (Burlesque Sonnet)
June 19, 1947
Aquatint and engraving, 15 x 11 in.
(38.1 x 27.9 cm)
Edition 275
The Lawrence and Regina Dubin Family
Collection, Promised gift to the Yale
University Art Gallery of Dr. Lawrence
Dubin, B.S. 1955, M.D. 1958
Cat. no. 21a

Al sepulcro de Dominico Greco
(On the Tomb of Dominico Greco)
June 26, 1947
Engraving, 15 x 11 in. (38.1 x 27.9 cm)
Edition 275
The Lawrence and Regina Dubin Family
Collection, Promised gift to the Yale
University Art Gallery of Dr. Lawrence
Dubin, B.S. 1955, M.D. 1958
Cat. no. 21b

Pierre Reverdy, **Le chant des morts**
(The Song of the Dead)
Published by Tériade, Paris, 1948
Book, with 125 lithographs in red by
Picasso, 17 x 13 in. (43.2 x 33 cm)
Edition 270
Yale University Art Gallery, The Ernest C.
Steefel Collection of Graphic Art, Gift of
Ernest C. Steefel, 1958.52.168
Cat. no. 20

Luis de Góngora y Argote, **Vingt
poèmes de Góngora** (Twenty Poems
by Góngora)
Published by Les Grands Peintres
Modernes et le Livre, Paris, 1948
Book, with 41 etchings and aquatints by
Picasso, 15³⁄₁₆ x 11⁵⁄₁₆ in. (38.5 x 28.7 cm)
Edition 275
Gift of John Hay Whitney, Beinecke Rare
Book and Manuscript Library, Yale
University
Cat. no. 21

Soneto funebre (Funerary Sonnet)
Golfe-Juan, February 6, 1948
Drypoint, 15 x 11 in. (38.1 x 27.9 cm)
Edition 275
The Lawrence and Regina Dubin Family
Collection, Promised gift to the Yale
University Art Gallery of Dr. Lawrence
Dubin, B.S. 1955, M.D. 1958
Cat. no. 21c

Study of Profiles
December 8, 1948
Lithograph, 30 x 22¼ in. (76.2 x 56.5 cm)
Edition 50
Yale University Art Gallery, Gift of Mr. and
Mrs. Walter Bareiss, B.S. 1940s, 1969.60.12
Cat. no. 27

Iliazd, editor, **Poésie de mots
inconnus** (Poetry of Unknown Words)
Published by Degré 41, Paris, 1949
Book, with sheets folded in 4, with 1
engraving and 2 lithographs by Picasso,
7 x 5¼ in. (17.8 x 13.3 cm)
Edition 158
Yale University Art Gallery, The Ernest C.
Steefel Collection of Graphic Art, Gift of
Ernest C. Steefel, 1958.52.160
Cat. no. 22

Woman in an Armchair No. 4
January 3, 1949
Lithograph, 27½ x 21½ in. (76.7 x 56.6 cm)
Edition 50
Yale University Art Gallery, Gift of Mr. and
Mrs. Walter Bareiss, B.S. 1940s, 1969.60.1
Cat. no. 24

Goat's Head in Profile
1950
White earthenware clay, decoration in
oxidized paraffin, and glaze bath, DIAM.
approx. 10½ in. (26.7 cm)
Edition 60
Yale University Art Gallery, The Katharine
Ordway Collection, 1980.13.57
Not illustrated

Aimé Césaire, **Corps perdu** (Lost Body)
Published by Éditions Fragrance, Paris, 1950
Book, with 20 engravings, 10 aquatints,
and 2 etchings by Picasso, 15⁹⁄₁₆ x 11⁵⁄₁₆ in.
(39.5 x 28.7 cm)
Edition 220
Gift of John Hay Whitney, Beinecke Rare
Book and Manuscript Library, Yale
University
Cat. no. 25

Tristan Tzara, **De mémoire d'homme**
(In Living Memory)
Published by Bordas, Paris, 1950
Book, with 9 lithographs by Picasso,
13 x 10 in. (33 x 25.4 cm)
Edition 350
Yale University Art Gallery, The Ernest C.
Steefel Collection of Graphic Art, Gift of
Ernest C. Steefel, 1958.52.170
Cat. no. 26

Large Bird, Black Face
1951
White earthenware clay, decoration in
engobes, knife engraved, 21⁷⁄₁₆ x 16¹⁵⁄₁₆ in.
(54.5 x 43 cm)
Edition 25
Yale University Art Gallery, The Katharine
Ordway Collection, 1980.12.46
Not illustrated

Horseman, Page, and Monk
Vallauris, February 24, 1951
Gesso and oil on wood panel, 17 x
21¾ in. (43.2 x 55.2 cm)
Yale University Art Gallery, Charles B.
Benenson, B.A. 1933, Collection, 2006.52.21
Foreword, p. x

Michel Leiris, **balzacs en bas de
casse et picassos sans
majuscule** (balzacs in lowercase and
picassos without capitals)
1952
Published by Galerie Louise Leiris, Paris,
1957
Portfolio, with 8 transfer lithographs by
Picasso, 13½ x 10¼ in. (34.3 x 26 cm)
Edition 100
Yale University Art Gallery, The Ernest C.
Steefel Collection of Graphic Art, Gift of
Ernest C. Steefel, 1958.52.174
Cat. no. 28

Bullfight
March 11, 1953
White earthenware clay, oxidized paraffin
decoration, white enamel bath, DIAM.
17⅛ in. (43.5 cm)
Few copies produced
Yale University Art Gallery, The Katharine
Ordway Collection, 1980.13.55
Not illustrated

The Studio of the Old Painter

Vallauris, March 14, 1954
Lithograph, 19¾ x 26¹⁄₁₆ in. (50.2 x 66.2 cm)
Edition 50
Yale University Art Gallery, Gift of Mr. and Mrs. Walter Bareiss, B.S. 1940s, 1969.60.4
Cat. no. 29

The Two Models

Vallauris, March 18, 1954
Lithograph, 19¾ x 24¾ in. (50.2 x 62.9 cm)
Edition 50
Yale University Art Gallery, Gift of Mr. and Mrs. Walter Bareiss, B.S. 1940s, 1969.60.8
Cat. no. 30

Nude Pose

Vallauris, March 18, 1954
Lithograph, 21⅜ x 14⅞ in. (54.3 x 37.8 cm)
Edition 50
Yale University Art Gallery, Gift of Mr. and Mrs. Walter Bareiss, B.S. 1940s, 1969.60.11
Cat. no. 31

Two Nude Models

Vallauris, March 18, 1954
Lithograph, 22⅞ x 15 in. (58.1 x 38.1 cm)
Edition 50
Yale University Art Gallery, Gift of Mr. and Mrs. Walter Bareiss, B.S. 1940s, 1969.60.13
Cat. no. 32

Diaulos Player and Faun

1956
White earthenware clay, DIAM. approx.
12½ in. (31.8 cm)
Edition 100
Yale University Art Gallery, The Katharine Ordway Collection, 1980.12.48
Not illustrated

Flute Player and Cavaliers

1956
White earthenware clay, DIAM. approx.
14½ in. (36.8 cm)
Edition 100
Yale University Art Gallery, The Katharine Ordway Collection, 1980.12.47
Not illustrated

Seated Figure and Reclining Figure

Cannes, 1956
Lithograph, 17⅛ x 20½ in. (43.5 x 52.1 cm)
Edition 50
Yale University Art Gallery, The Ernest C. Steefel Collection of Graphic Art, Gift of Ernest C. Steefel, 1958.52.99
Not illustrated

The Small Bullfight

1957
Lithograph, 12½ x 9¼ in. (31.7 x 23.5 cm)
Edition 50
Yale University Art Gallery, The Ernest C. Steefel Collection of Graphic Art, Gift of Ernest C. Steefel, 1958.52.101
Not illustrated

Head of a Woman (Head of Jacqueline)

1957
Painted steel, 30⅜ x 13¾ x 10⅛ in. (77.2 x 34.9 x 25.7 cm)
Raymond and Patsy Nasher Collection, Dallas
Cat. nos. 29–32, fig. 1

Portrait of Daniel-Henry Kahnweiler

Cannes, June 3, 1957
Lithograph, 25½ x 19⅞ in. (64.8 x 50.5 cm)
Edition 50
Yale University Art Gallery, The Ernest C. Steefel Collection of Graphic Art, Gift of Ernest C. Steefel, 1958.52.103
Cat. no. 28, fig. 3

Lucien Scheler, **Sillage intangible**
(Intangible Trace)
Published by Degré 41, Paris, 1958
Book, with portrait of Paul Éluard by Picasso, 10 x 8¾ in. (25.4 x 22.2 cm)
Edition 50
Yale University Art Gallery, The Ernest C. Steefel Collection of Graphic Art, Gift of Ernest C. Steefel, 1958.52.175
Introduction, fig. 10

Jacqueline's Profile

1962
Red earthenware clay, DIAM. 14⅜ in. (36.5 cm)
Edition 100
Yale University Art Gallery, The Katharine Ordway Collection, 1980.13.56
Not illustrated

The Painter in His Studio

Mougins, March 14–15, May 13, and June 4, 1963
Oil on canvas, 23 x 35½ in. (58.4 x 90.2 cm)
Yale University Art Gallery, Charles B. Benenson, B.A. 1933, Collection, 2006.52.23
Cat. no. 33

In the Studio

December 5, 1963
Etching and drypoint, 12⅜ x 16⅜ in. (31.4 x 41.6 cm)
Edition 50
Yale University Art Gallery, Gift of Dorothy and Marvin Small, 1969.77.2
Not illustrated

The Smoker

Mougins, August 27, 1964
Color aquatint, 16⅜ x 12½ in. (41.6 x 31.8 cm)
Yale University Art Gallery, Gift of Dorothy and Marvin Small, 1969.77.1
Cat. no. 34

The Painter

Mougins, October 13, 1964
Gouache and India ink, on a reproduction of *The Painter*, March 30, 1963, 37⅞ x 29⅛ in. (96.2 x 74 cm)
Yale University Art Gallery, Gift of Walter Bareiss, B.S. 1940s, 1980.63
Cat. no. 35

Four Figures and a Head in Profile

Mougins, January 10, 1969
Pen and ink and wash, 11¹⁵⁄₁₆ x 17¹⁄₁₆ in. (30.4 x 43.4 cm)
Yale University Art Gallery, Gift of Molly and Walter Bareiss, B.S. 1940s, 1999.9.15
Cat. no. 36

Man and Woman with a Bird

Mougins, August 1, 1969
Pencil, 20 x 26 in. (50.8 x 66 cm)
Yale University Art Gallery, Gift of Mr. and Mrs. Walter Bareiss, B.S. 1940s, 1983.103
Cat. no. 36, fig. 1

Index

Page references in *italic* refer to illustrations.

243

Credits